30-

Colors on Desert Walls:
The Murals of El Paso

Colors on Desert Walls:
The Murals of El Paso

by Miguel Juárez

Photographs by Cynthia Weber Farah

Foreword by José Antonio Burciaga

Spanish translation by Richard Ford

**Texas
Western
Press**
The University of Texas at El Paso
1997

© 1997 by Texas Western Press
The University of Texas at El Paso
El Paso, Texas 79968-0633

First Edition
Library of Congress Catalog No. 96-60099
ISBN 0-87404-236-4

∞ Texas Western Press books are printed on acid-free paper, meeting the
guidelines for permanence and durability of the Committee on
Production Guidelines for Book Longevity of the Council on Library Resources.

Publication of this book was made possible
by the generous support of
Norwest Bank of El Paso, Texas.

Contents

PREFACE

This book is the product of field work which Cynthia Weber Farah and I undertook in the summer of 1988 to document El Paso's murals.[1] My initial discussions about working with her were with librarian César Caballero and artist Marta Arat at Freddy's Cafe on El Paso street, a forum for people interested in community affairs, in the late 1980s. I wanted to research El Paso's murals and so did Farah. Caballero and Arat suggested we work together. The results can be seen on the following pages.

Farah had begun photographing murals in South El Paso in 1979. She was able to record several works in Chihuahuita and El Segundo Barrio that were subsequently painted over.

My interest in the documentation of murals evolved from having sought works to present to the Texas Regional Steering Committee for the exhibit "Chicano Art: Resistance and Affirmation, 1965- 85," in 1985. As a result of my experience on the CARA selection committee and the viewing of slides of murals in other Texas cities, I began exploring El Paso's Chicano art history, specifically the mural movement.

Our initial research in local archives produced only one set of slides of murals from El Segundo Barrio/the Second Ward, at the University of Texas at El Paso (UTEP) Library. We were amazed that a more comprehensive effort to document the murals had not been undertaken.

To date, the photographic documentation conducted during our field work has amassed over two thousand slides. The interviews with artists have also yielded a rich collection of primary historical materials. Farah continued to photograph emerging works and events associated with the creation of murals while I was away at graduate school from 1989 to 1991. I kept abreast of developments through frequent visits and telephone calls. We never lost sight of the goal of someday uniting our research in a book. We began our search for works without formal guidelines, under the auspices of the Juntos Art Association. The project stemmed from a sincere desire to preserve a unique facet of the arts in El Paso. Additionally, Farah and I complemented each other in our efforts, each with access to a different group of people unknown to one another. We approached artists and activists in a spirit of the sharing of the project.

Once we shared our goals with community leaders, they assisted us in our efforts. Key individuals who contributed immensely to our work included Salvador "Chava" Balcorta, John Estrada, Chevo Quiroga, Nicolás Domínguez, and the artists interviewed.

The excellence of Farah's photographs—as documents and as art works in their own right—speaks for itself. I chose to interview muralists and have them explain their works in the oral tradition described by historian Mario T. García as closer in form and content to a Latin American testimonio.[2] I felt the artists could offer the best interpretations of their work, their definitions of mural making, and summaries of their artistic careers.

Some of the information presented here was the basis for a four-page mural guide by Al Harris, director of the Bridge Center for Contemporary Art, for the gallery's "Direct Expression" exhibit in 1988. Then in 1990 the Junior League of El Paso used our information to produce a twenty-page, four-color, envelope-sized guide to the murals of El Paso, now in its third printing with more than 30,000 copies in English and Spanish. In December 1994 the League also published a full-color calendar featuring thirteen murals, which was given to those attending the League's Twenty- first Christmas Fair.

El Paso photographer Bruce Berman in 1975 began documenting El Paso's murals and neon art, the latter commercial work by Luis Jiménez, Sr., the father of the noted sculptor, Luis Jiménez, Jr. Tucson-based photographer Terrence Moore in 1976 photographed the Segundo Barrio murals. His photo of *Tribute to Joe Battle* in Chihuahuita appeared on the cover of *On the Border* by Tom Miller (Tucson: University of Arizona Press, 1985).

Because of the ephemeral nature of murals, several works documented have been destroyed since this project began. They remain only in photographs and community memories. This is an on-going process we should all cherish—to document and develop awareness of community murals, to help in their preservation, to recognize their creators, and finally, to celebrate their very existence.

MIGUEL "MIKE" JUAREZ

ACKNOWLEDGMENTS

 The development of this book has spanned eight years. Numerous individuals and institutions have contributed toward its publication.

First and foremost, I would like to thank Cynthia Weber Farah for her tireless work and selfless devotion to this project. I would like to thank her for providing superb photographs, many of them the only records of some murals. I also want to thank her for being there for me in the good and the not-so-good times and for agreeing to disagree. I'm also grateful to César Caballero and Marta Arat who insisted that Farah and I work together on the much-needed project.

We are fortunate to have José Antonio Burciaga's foreword. Our dilemma in finding the right voice to open this text was solved when the late author agreed to write his insightful essay as an artist, a historian, and a Paseño (El Pasoan).

Thanks are owed to the various community scholars and activists who initially shared their information with us including: Salvador "Chava" Balcorta, Juan Contreras, Dr. James M. Day, Nicolás Domínguez, Pete Duarte, John Estrada, Carmen Félix, the late Mr. and Mrs. Francis Fugate, Arturo "Tury" Morales, and Chevo Quiroga. Special thanks to artist Steve Beck for providing information on Mexican artist Pedro Medina; Mary Sarber at the El Paso Public Library; Claudia Rivers and Juan Sandoval at the UTEP Library for providing access to collections; and Stephen Vollmer, curator, and Prince McKenzie, assistant curator at the El Paso Museum of Art, for information on T. J. Kittilsen's murals. I also am grateful to Rosario G. Holguín for providing information on her late uncle, Jesús Helguera.

Numerous artists shared their thoughts, histories, and information on their works: the late Manuel Acosta, Felipe Adame, Marta Arat, Manuel Arias, Arturo "Tury" Avalos, Carlos Callejo, Gaspar Enríquez, Carlos E. Flores, Mago Orona Gándara, Ernesto P. Martínez, Manuel Anzaldo Meneses, José Olivas, Carlos Rosas, John Valadez, and Salvador Valdez.

 Institutions, departments, and organizations which supported the creation of this work include: Dr. Samuel Schmidt, formerly director of the UTEP Center for Inter-American and Border Studies, for a stipend and the use of equipment as well as general direction for preparation of the manuscript; Teresa Nevarez, formerly with that center, for proofreading Carlos E. Flores' preliminary Spanish interview; Dr. Howard Campbell for editing the interviews and providing direction on the manuscript; and Dr. Dennis Bixler-Márquez for assistance in manuscript development.

Marcia Daudistel, associate director of Texas Western Press, deserves special mention for resurrecting the project countless times. Special thanks also go to Nancy Hamilton's editing skills and her recollections of historical events and people. Thanks also to the Texas Western Press editorial board members for agreeing to publish the book and finally to UTEP President Diana Natalicio for believing in the project.

Dr. Timothy Drescher edited the final draft except for the interviews and his suggestions enabled the work to come to its final fruition. Thanks for his commitment, encouragement, and advice.

Three friends inspired me to pursue this project but did not live to see its end result: Alberto Bonilla, José Antonio Parra, and Ruth S. Ortego. Others who influenced my work in the arts include Paseños Michael Mills, David R. Fleet, Andrés Mares, Trish Winstead, and Adolfo Zavala; New York City artists Paul H. Ramírez and Barbara Postelnek; artist and arts administrator Joe Bastida Rodríguez of San Jose; Dr. Miguel Dominguez of California State University-Dominguez Hills; Gloria E. Alvarez, Ann Brace, Barbara Carrasco, Yreina D. Cervántiz, Harry Gamboa, Jr., Mia Kuwada, Gilbert "Magu" Luján, all of Los Angeles; Stephen Thralls Vessels of Santa Barbara and curator Patricio Chávez of San Diego.

Recognition also goes to Dr. Richard Ford for providing the fine translation of the text into Spanish and the Flores interview from Spanish to English. And of course, thanks are due John Downey for his design of the final product.

I would like especially to thank my wife, Mona Padilla-Juárez, who accompanied Farah and me as we documented El Paso's mural history, and who has been my greatest supporter in this endeavor. Lastly, both Farah and I extend our appreciation for our families, who have accompanied us on this extraordinary journey of discovering El Paso's murals.

MIGUEL "MIKE" JUAREZ

FOREWORD

COLORS ON DESERT WALLS

Forget "murals" for a second and think of the thousands of walls sprawled throughout the desert town of El Paso as nothing more than what they are—barriers, bastions, ramparts, parts of compounds and buildings used to keep people in or out—walls built to protect people or property. The primary definition of a mural in a dictionary is "relating to a wall," coming from the Latin word murus, French mur, Spanish muro.

In the length and breadth of history great walls have successfully accomplished their objective of protection, if not division. From the cave dwellings of our prehistoric ancestors to the monumental Wall of China, the former Berlin Wall, hundreds of walls around ancient towns, castles, convents, monasteries, cathedrals, ranches, and even the infamous Tortilla Curtain, walls have served their primary purposes well: to protect and isolate from the elements and from people. But from prehistoric times, society has resisted living with what seemed unnatural, a bunker. The bare walls served to remind us of their initial intention.

Ideal architectural models did exist at one time, from the Aztec capital of Tenochtitlán with its great circular lake city enclosing a rectilinear system of streets to the Renaissance cities of Venice and Florence with their ornate and triumphal architecture. The cities of Tenochtitlán, Venice, and Florence reflected a common social concern and commitment to the aesthetics of architectural planning that enhanced, defined, and empowered their societies, like a Tower of Babel or a Utopia.

Call this the social function of architectural space, but today, modern urban planning in a capitalist consumer society has totally lost touch with the original philosophy of an ideal architecture to serve social organization or for the ideal social structure to serve architecture.

Enter the Mexican Revolution, an insurrection that not only reformed the soul of Mexico but whose aesthetic cinders continue to seethe and light throughout and beyond her *fronteras al sur y al norte.*

In 1919 David Alfaro Siqueiros and Diego Rivera made contact in Europe and noted the modern changes occurring in the plastic arts. Their impressions of the great capitals of Europe must have been many and profound, including similarities between some of the colonial architecture of Mexico and that of Europe.

Rivera and Siqueiros came in contact with the ancient form of muralism, a collective art form that had practically disappeared. To quote Siqueiros in a lecture to artists, "At the end of the Renaissance, the bourgeoisie or the embryo of the bourgeoisie, with its concept of individualism and private property, had taken art out of the cathedrals and public centers; they had put it in their pockets and taken it home. Private art came forth—landscapes and portraits as well as still lifes; and in the same way other unilateral currents developed little by little, finally arriving at abstractionism and 'tachisme.' The new 'patrons of the arts' had no desire to have in their houses bloody religious scenes, descents from the cross, or Virgin Marys bathed in tears; they had no need of this — they wanted happiness, tranquility, they wanted something to correspond to their own euphoria."

Under the visionary leadership of José Vasconcelos, a philosopher and Mexican secretary of education after the Revolution, a national mural program was instituted. And out of the initial chaos was born an art form that became *netamente mexicano*. Pause to consider the indignant outrage of the deposed Porfiristas and the aristocracy when a motley crew of talented Mexican artists began to paint murals on the palace walls: the Palace of Fine Art in Mexico City, the National Palace, and other national walls depicting the true history and reflection of Mexico.

In its evolution Mexican muralism was transformed into a science. The concept of the "folkloric" was attacked as being "false nationalism." Murals carried deeper and more profound importance and significance. Only by depicting and validating a people in their natural and sociopolitical environment could one appreciate the greater knowledge of a universal people. Shakespeare had written Hamlet in English, Cervantes had written Don Quixote in Spanish, and Netzahualcóyotl had written beautiful poetry in Nahuatl. Just as these had not been folkloric works, neither would their murals be defined as folkloric.

To begin an appreciation of the murals in El Paso, it is essential to return to a Mexican Revolution that transformed its Eurocentric aesthetic to that of a more realistic indigenous aesthetic. Basic as it may seem, it is essential to recognize the social, political, and environmental purposes of walls and how artists redefine them to create a more humane, realistic, and aesthetic point of reference to live in.

It is no quirk of chance or irony that El Paso is the birthplace, the crib, *la cuna* of so much of Chicano history and culture. El Paso has forever been the entrance and the exit between the old country and the new country, between Old Mexico and New Mexico. To wit, the following historical account:

On 20 April 1598, Juan de Oñate's expedition of conquest from Mexico City arrived on the banks of the Rio Grande, close to what is now El Paso. Tortured by thirst and exhaustion, the expedition rested and recuperated. This was twenty-two years before the Pilgrims landed at Plymouth Rock. Ten days later, on Ascension Thursday, they celebrated with a solemn sung high mass. Juan de Oñate took possession of the land in the name of His Catholic Majesty Philip II, and called this territory the Kingdom of New Mexico. Capitán Marcos Farfán de los Godos presented a comedy, a theatrical piece he had authored. This became the first theatrical play presented in the United States. Of particular interest is Juan de Oñate's wife who was the daughter of don Hernando Cortés. As the great-granddaughter of Moctezuma, she was a descendant of the two great leaders who had clashed and merged to create a new race of Mexicanos and Chicanos.

The first Thanksgiving by white people in this country was by these Hispanics. The first European-style theatrical production in this country was by these same conquistadores on that same day. Lest we forget, the indigenous people of this area have forever practiced the spiritual rite of giving daily thanks and their own theater of reality is acted out through these rites of thanksgiving.

For centuries, El Paso served as an oasis in the vast Chihuahuan desert, the doorway to the New Mexico. Throughout the past two centuries, El Paso's location was of strategic importance. Located at the southern midway point of the vast southwestern desert, El Paso was a stopping and refueling point for buses, trains, and planes. Artists and musicians traveling from the East and the South to the West found an amenable climate and audience. Ciudad Juárez, Mexico, presented an opportunity to step into another culture, another world, and then continue on to points east or west. During Prohibition, Ciudad Juárez became a wet oasis for imbibers and musicians, artists, and bohemians.

The immediate dual influences of Juárez and El Paso on Mexicano and Chicano artists has had impact on both nations. Some of Mexico's most creative talents have come from Juaritos: Juan Gabriel credits El Paso radio stations as an influence; Germán Valdez, better known as Tin Tan, took El Paso's pachuco, complete with zoot suit, caló dialect, and attitude to become a star of Mexican cinema. It was in Tijuana, another sister border city, that Carlos Santana began to mix Mexican sounds with the emerging sounds of African-American and Anglo-American rock music.

The impact of El Paso's Chicano artists on the national scene has been impressive. Artists such as Luis Jiménez, John Valadez, Manuel G. Acosta, Mago Orona Gándara, Carlos Callejo, José Cisneros, Felipe Adame, Lupe Casillas-Lowenberg, Arturo

Avalos, Carlos Rosas, Ernesto P. Martínez, Gaspar Enríquez, Joe Olivas, and many others form part of a group of artists that nurtured and inspired other muralists in larger metropolitan centers such as Los Angeles and Chicago. Just as important are the Anglo-American artists who were nourished by the strong Mexican culture in El Paso and Juárez. Among them Tom Lea, Jr., stands out, followed by other luminaries such as the late University of Texas at El Paso art professor Robert Massey and, most recently, Hal Marcus.

The border as a political line of demarcation between two countries has only existed since this century. And so El Paso became the Ellis Island of the Southwest. Lacking a Statue of Liberty, the new immigrant had no point of reference save for the tall buildings with walls that reach into the sky. The newly arrived Mexicano settled just inside the doorstep of the country in South El Paso, also known as El Segundo Barrio. So close to Mexico, it is a mystery why it became El Segundo Barrio instead of el primero.[3] While the ousted and exiled Mexican aristocracy immigrated to the finer residential neighborhoods of El Paso and the Southwest, the poorest Mexicanos came to settle in El Segundo Barrio, not to assimilate but to transculturate and form a new culture. It was very natural, not a phenomenon, that graffiti began to appear on the walls of South El Paso long before the Chicano Movement gave birth to Chicano murals. Graffiti, like murals, were expressions, assertions, declarations, expositions, venting voices that spoke of belonging, self-identity, integrity; placas, as license plates that certified, validated, and asserted the existence and experience of a people caught in the flood of a foreign mainstream. The c/s, con safos, sign was invented as a legitimate Chicano copyright, imprimatur, or hex on anyone dishonoring a statement. If graffiti baptized the walls, then murals became the cultural confirmation. Murals are not only a part of our dual cultural heritages from Europe and Meso-America, but they express a real and valid need to return to a more humane and aesthetic urban environment, of an architectural plan to enhance, define, and empower our urban existence, our youth, our future in a Utopia, a Tower of Babel, Aztlán, the land reconquered through culture—colors on desert walls.

JOSE ANTONIO BURCIAGA

In Memory of
José Antonio Burciaga
†October 7, 1996

Paseño José Antonio Burciaga was a nationally-recognized Chicano author, a stong-willed essayist, poet, humorist, muralist, and a founding member of Culture Clash. He graduated from the University of Texas at El Paso and later attended the Corcoran School of Art and the San Francisco Art Institute. His book *Undocumented Love* won a Before Columbus American Book Award for poetry.

He also authored *Weedee People; Drink Cultura: Chicanismo* and *Spilling the Beans/Lotería Chicana*. Shortly before his death, he was in the midst of completing his next book, titled *The Temple Gang*. Burciaga was also a columnist in the Hispanic Link News Service throughout the 1980s.

As an artist, he participated in many exhibits and created numerous drawings and paintings, many of which were printed on greeting cards and posters. At Stanford University, where he was a resident advisor at Casa Zapata, a Latino student dormitory and hall, he invited numerous Chicano artists to paint murals throughout the facility.

In 1985, he was inducted into the *El Paso Herald-Post* Writers at the Pass Hall of Fame and was a featured speaker at the First Border Voices Festival held in conjunction with the El Paso Public Library's Centennial Celebration.

Beyond his many accolades, Burciaga's work and his love for El Paso and la Raza was well-known and respected. He was loved by the many who miss him. He is survived by his wife Cecilia, his son and daughter José Antonio and Rebecca Burciaga from Carmel, California, and his sister Margarita Burciaga's family in El Paso.

MIGUEL JUAREZ
CYNTHIA WEBER FARAH

CHAPTER 1

INTRODUCTION

The Pass to the North and to the South

Geography provides one context for the development of murals in El Paso del Norte/The Pass of the North. The pass was cut by the Rio Grande through the southernmost reaches of the Rocky Mountains. It became a natural gateway for hundreds of years for nomadic tribes making their way across the continent. Preceding the arrival of the Spanish explorers, it was the home of the Suma and Manso Indians.

In 1536 Alvar Núñez Cabeza de Vaca and three companions, shipwrecked off the gulf shore, trekked across Texas, crossing the Rio Grande below El Paso del Norte. Upon reaching Mexico City, he told the Spaniards of legendary riches to the north, inspiring further exploratory expeditions.

The first party of Spaniards to reach the Pass on the way north was led by three Franciscans, Fray Agustín Rodríguez, Fray Francisco López, and Fray Juan de Santa María, in 1581. In 1598 the Spanish decided to colonize present New Mexico and sent Juan de Oñate with four hundred men as well as families and livestock. They reached the valley on 20 April, when Oñate claimed the territory drained by the Rio Grande for Spain and a ceremony of thanksgiving was held, predating that in Plymouth by twenty-two years.

A group of Franciscans, led by Fray García de San Francisco y Zúñiga, started a settlement in present-day Ciudad Juárez, centered around a mission founded for the Mansos Indians in 1659. Named for Nuestra Señora de Guadalupe, the church still stands.

The Pueblo Revolt of 1680 in northern New Mexico sent a flood of Spanish refugees and some Pueblo Indians south to the Pass. A chain of villages was formed along the river, with Tigua and Piro groups remaining behind when the Spaniards returned north. The Ysleta mission of the Tiguas was the first to be founded in Texas, with the Socorro mission started soon afterward. Both erected permanent buildings in 1691. A third community just below Socorro, San Elizario, was started in 1780 when a Spanish presidio was relocated there. Its church, although often called a mission, was a military chapel.

Spanish rule lasted until 1821 when Mexico won its independence. In 1827 Juan María Ponce de León received a land grant of five hundred acres on the north side of the river on which he built a house and planted fields in what is now downtown El Paso.[4] The Pass became a stopping-place for traders on the road from Mexico City to Santa Fe.

Hostilities between rebel Texans and Mexicans led to the 1836 declaration of independence from Mexico and the founding of the Republic of Texas.[5] Conflict continued in the War with Mexico from 1846 to 1848, settled by a treaty making the Rio Grande the international boundary. A significant battle of that war was fought near El Paso, after which Col. Alexander Doniphan led his troops into Chihuahua.[6]

At the close of the war, Ponce sold his land to an American trader named Benjamin Franklin Coons, whose middle name was applied to the town and the mountains overlooking it. In 1849 the first American troops sent to the area established a post to protect the citizenry from the Apaches. By 1850, three significant property holdings for what was later to become El Paso were established: the adobe home of Santa Fe trader James Magoffin, the ranch of Hugh Stephenson, and a flour mill built on the rapids of the Rio Grande by Simeon Hart, which is now La Hacienda Restaurant.[7] Anson Mills' town plat of 1859 called the place El Paso. The Mexican town of El Paso del Norte would be renamed Ciudad Juárez in 1888.

The presence of the military made El Paso a favorable destination for travelers making their way from north to south, but the population did not grow significantly until the coming of the railroads in 1881. First the Southern Pacific arrived and doubled El Paso's population; then came the Santa Fe line and the next year, the Texas and Pacific. Finally the Mexican Central Railroad, a 1,224-mile project backed by a group of Boston investors, was constructed from Mexico City to El Paso, making the community a key border crossing for Mexican-U.S. commerce and travel.[8]

Almost overnight the town, now linked to points in the United States and Mexico, was transformed into a growing city. The *El Paso Times* and the *El Paso Herald*, both still in business, made their debut in 1881. At the end of the decade, the population had swelled to 10,000 with more arriving every day.[9]

For the next twenty years the railroads helped bring in needed supplies and building materials for much of the city's infrastructure. During this period, streets were paved and real estate developers built residential neighborhoods away from the downtown area. By the turn of the century the population was 15,000. Beginning in 1890 and through the turn of the century, the churches which later became landmarks in the communities were established.[10]

After 1910 many of the city's major buildings were constructed, and at the same time the flames of the Mexican Revolution were being lit by Francisco Madero with his Plan de Potosí. The state of Chihuahua, bordering Texas, was pivotal in the conflict because it was there that the rebel movement continued to grow even after Pres. Porfirio Díaz curtailed it in Mexico. The revolution reached a critical climax with the takeover of Ciudad Juárez by revolutionaries in late spring of 1911. Against Madero's orders, Pascual Orozco, Jr., led the attack to capture Juárez, a stronghold in the north, on 8 and 9 May. Many El Pasoans watched the actions from the rooftops of their homes.[11]

As a result of the ten-year war, thousands of people entered the United States via railroad. In his *Occupied America: A History of Chicanos* (New York: Harper & Row, 1988), historian Rodolfo Acuña states:

> The importance of the railroads cannot be overemphasized. As in the case of the Southwest, they unified the area internally and they linked the country with the United States. Railroads accelerated the nation's industrial and agricultural growth. They stimulated the flow of capital into the economy, increasing the possibility of commerce and exploitation of Mexico's resources. The decline of the ruralism and the uprooting of the Mexican peasant resources would be a prime factor in migration to the United States.[12]

The thousands of families who came to El Paso created an informal network which helped even more people come to the Southwest. Many Mexicans moved into South El Paso, nearest the border, and stayed there on a temporary basis until they could continue their journey to other western states to start their new lives. Others remained in El Paso awaiting the day when they could return to *La Patria*, Mexico.

During this period, El Paso became a center for the recruitment of cheap labor for northern and midwestern industries. Many of the brick *presidios* (tenements) of South El Paso were built to house these *enganchados*, laborers who were brought to the border on the railroad.[13]

While the migrating laborers crowded into Segundo Barrio/Second Ward, more prosperous Mexican citizens settled in neighborhoods surrounding downtown such as Sunset Heights. But life in Segundo Barrio was far from depressing. The people made do with their situation and created a viable social community. Enterprising individuals built their own stores and supported one

another in times of need. Mexican families brought their strong sense of family and traditions. For many of them, reaching the Pass signified a new beginning.

Following the revolution, the town which had numbered 700 people seventy years earlier was by the end of the 1920s a growing border city of 102,000. It had mass transportation and benefits such as city parks and paved streets.

The development of the Works Progress Administration in the 1930s, which paid for the hiring of laborers to improve the infrastructure, aided in the development and expansion of the city. Streets were paved, outdoor facilities and sewage systems were built for South Side residents, and a significant portion of funds went to support the painting of murals in area.

A later event of international significance was the Chamizal Treaty of 1963, under which a century-old land dispute between Mexico and the United States was settled. The international boundary line between El Paso and Ciudad Juárez was adjusted with a new river channel, and acreage was returned to Mexico.

As we have seen in the development of both countries sharing one border, the constant historical, political, and social events which shaped both the United States and Mexico caused conflict and change in each country. These events and their tensions set parameters for artists as they produced murals in El Paso. The history of the region, including the revolutions of Texas and Mexico, frequent border skirmishes, the influx of refugees, and racial tensions between Anglos and Mexican immigrants, would later be addressed and challenged within the Movimiento—a cultural, social, and political affirmation movement by Mexican-Americans in the United States.

Early El Paso Murals

The earliest murals in El Paso were primarily official commissions sponsored by business and government (through the WPA programs in the 1930s). After World War II, murals continued to be painted in places of business, especially restaurants. The double significance of these early works is that they provide examples of monumental public art for residents of all classes to see, thus establishing murals as an appropriate medium for later community-based expressions beginning in the 1970s. Secondly, some of the early artists, such as Manuel G. Acosta, continued painting murals as part of the community movement of the 1970s, providing a direct link of experience and knowledge from which more recent painters benefitted.

Occasional murals for theater sets had been painted since the turn of the century in vaudeville houses and as decorative motifs in parlors and saloons, but it was not until 1917 that important public works would be commissioned. Eight murals of historic scenes by T. J. Kittilsen were displayed in the lobby of the El Paso County Courthouse for forty years before being removed in 1956 during renovation of the building. Six of them are now in the collection of the El Paso Museum of Art.

In 1922 James G. McNary, president of the First National Bank, commissioned Edward Holslag of Chicago to paint ten murals, also based on historical themes. Two of them are now displayed in El Paso International Airport.[14]

During the early 1930s, the New Deal's Works Progress Administration provided funds to provide living skills training and employment services in South El Paso, where improvements included paved streets. As in other cities, unemployed writers, artists, and craftsmen found work through a series of federal programs from 1934 to 1943. The Federal Arts Project, operating from 1935 to 1939, made possible the painting of several murals in the El Paso area.

Emilio Cahero, who had painted frescoes in Mexico and had a team of assistants, was commissioned to paint murals for Holliday Hall at the Texas College of Mines (now University of Texas at El Paso) in 1936. Titled *Mining* and *Metallurgy*, they were the only works painted in watercolor and plaster under the Works Progress Administration.[15] They were painted over in the late 1960s when the building was remodeled.

In 1935, as one of his first works in El Paso, Tom Lea, Jr., painted mural vignettes on three walls of the game room in the basement of the Dorrance D. Roderick home at 4801 Cumberland Circle. Mary Olga Barnard remembers them as "wonderful works of art" in the home of her late grandfather.

Lea went on to paint *Pass of the North* in the United States Courthouse in 1937-38. The finished mural measures 11 by 54 feet, arching over a doorway where the theme is spelled out: "O Pass of the North—Now the old giants are gone—We little men live where heroes once walked the inviolate earth." He won a competition of the Treasury Department, Section of Fine Arts, among artists in nine states.[16] Lea had previously won a similar competition to paint a mural, *The Nesters*, for the Benjamin Franklin Post Office Building in Washington, D.C.

Lea studied at the Chicago Art Institute under muralist John Norton from 1927 to 1933. He worked with Norton and alone on several projects in the Chicago area before returning to the Southwest. He painted other works throughout the region and in other Texas cities. Assisted by his wife Sarah, he painted an oil on canvas mural, *Southwest*, on the interior wall of the El Paso Public Library

in 1956. He was honored with a retrospective exhibition of his work in 1994 at the El Paso Museum of Art, El Paso Centennial Museum at UTEP, and Adair Margo Gallery.[17]

One of the earliest notable Mexican artists was José Aceves, who was born in Chihuahua City on 14 December 1909. The youngest of eight, he moved with his family to Segundo Barrio during the Mexican Revolution. He attended San Jacinto and Alamo schools, receiving his first formal art training. In 1938 Aceves was contracted to paint a mural for a new post office at Borger, Texas. The work on canvas, *Big City News*, measured 4 by 9 feet and depicted various modes of transportation in the Old West, from the Pony Express to the stagecoach to delivery by airplane. He was given six months to complete the work and was paid $570.[18]

In November 1939, Aceves painted *McLennan Looking for a Home*, another oil on canvas measuring 5 by 12 feet, for the Mart, Texas, Post Office. Also sponsored by the Section of Fine Arts, it depicted a pioneer family from the area traveling across the prairie.[19]

During World War II, Aceves joined the U.S. Navy, serving as an illustrator. After his discharge, he returned to El Paso and studied at El Paso Technical Institute, then attended the Chicago Art Institute. At the insistence of a professor with whom he studied in Chicago, he tried to create paintings that reflected the social conditions of Second Ward, but he was unsuccessful, probably because there was no market for this work at the time.[20] The economic gaps and limited opportunities for Mexicans, especially in the arts in El Paso, were large, and it seems that Aceves experienced limited success both as an easel painter and as a muralist. What makes him important to this study of murals is that he was one of seven Texas artists to receive government stipends to paint murals in Texas in the late 1930s. He also may have been the first artist of Mexican descent to be awarded such a mural commission. He died 13 August 1968.[21]

For several years, Salvador López was employed as an artist technician at the El Paso Centennial Museum of the Texas College of Mines and Metallurgy (now UTEP). He prepared diorama cases and backgrounds for exhibits, and restored various items displayed in the museum. In 1945 he painted a mural on the wall opposite the registration desk in the entrance hall, showing Coronado and a group of conquistadors around a squatting Native American who is showing them how to extract a prickly pear fruit from a plant.

López, who was in his early thirties, died in Ciudad Juárez in 1945 of osteomyelitis. Several of the dioramas he created are still displayed in the museum.[22]

In 1967 the blasting for a building addition across the street caused the López mural to crack so badly, it was sealed over with plywood.[23,24] James M. Day, who became museum director in 1980, had Tom O'Laughlin, the curator, uncover the work. Art Prof.

Robert Massey was asked to restore the mural. It had been originally painted in oil and casein on gesso. Massey and an assistant spent two months filling the cracks with gesso and painstakingly restoring the work.

Manuel Gregorio Acosta, one of El Paso's most notable artists, was born in 1921 in Adame, Mexico, near Chihuahua, to Ramón P. and Concepción Sánchez Acosta. His family emigrated to El Paso when he was one year old and settled in El Barrio del Diablo near the El Paso County Coliseum. Acosta began drawing at an early age. He studied art at Bowie High School under Octavia Magoffin Glasgow, a descendant of early settler James Magoffin.[25]

Although not a U.S. citizen, Acosta served in the army during World War II and was sent to Europe, where he visited as many museums and galleries as he could. After returning home, he became a citizen. His strong desire to be a serious artist led him enroll at Chouinard Art Institute (now Otis Parsons) in Los Angeles. Thereafter, he attended the College of Mines and studied under Urbici Soler, the Spanish sculptor who created the statue of *Christ Crucified* on Mount Cristo Rey overlooking El Paso where it meets the states of New Mexico and Chihuahua. Soler introduced Acosta to the renowned New Mexico artist Peter Hurd, who hired him as assistant on numerous mural projects including two commissions, one in Houston and another at Texas Tech University in Lubbock. Acosta prepared the plaster of marble dust and lime for Hurd and applied it to the wall. He also mixed paints and did some touch-up work. Three years in the making, the Tech mural was a pictorial tribute to the pioneers of West Texas. The sixteen-panel fresco was said to "commemorate those men and women who carved an empire from the plains."[26]

After his experiences in painting murals with Hurd, Acosta considered leaving El Paso to benefit his art career, but his mentor persuaded him to remain at home. As a result, his family, friends, and neighbors helped him build a studio behind the family home at 121 Hammett Street. It came to reflect his outgoing personality and was a showplace for his artistic works and the setting for legendary parties.

In 1958 Acosta painted his first solo mural in Logan, New Mexico. The 8-by-26-foot panel at the Casa Blanca Motel depicted the history of the state.[27] The Bank of Texas in Houston commissioned him in 1962 to paint six fresco murals, *Texas Under Six Flags*.[28] Later that year, he completed a seven-panel, 540-square-foot mural for the First National Bank of Las Cruces, New Mexico, illustrating the history of the Mesilla Valley.[29] The works were featured in *Life* magazine as a Southwest tourist attraction.[30]

Acosta also assisted in the development of numerous murals painted by local youth, among them *Aztlán* (1985) in the Rio Grande Apartments, 212 Lisbon Street, in South Central El Paso. It featured the Aztec gods Iztaccíhuatl and Popocatépetl. The

principal artist was Angel R. Zambrano, who was assisted by some thirty people ages twelve to twenty-five.[31] For unknown reasons, the mural was painted over by the Housing Authority in 1992. Acosta in 1988 painted *We the People*, which was installed in the waiting area of the Clínica La Fe in South El Paso. Acosta, whose achievements as an artist had brought national attention to El Paso, was murdered at his studio on 25 October 1989 at the age of sixty-eight.

José Cisneros had created illustrations for *The Spanish Heritage of the Southwest* in 1952. The author, Francis Fugate, and his wife asked him fifteen years later to paint one of the illustrations on the garage at their home. He spent six weekends on *Capriccio Espagnol, Siglo XVII* featuring a Spanish Colonial woman and two men. The Fugates said Cisneros did not create further murals because it was quite a chore for him. They were unable to preserve the work because the wall had not been properly prepared for it and they were unable to find a sealant to retard its peeling.[32] It was almost gone by the time the house was sold in 1993 after their deaths. A photograph of the mural appears in *José Cisneros, An Artist's Journey* by John O. West (El Paso: Texas Western Press, 1993).

El Paso and Its Murals in the 1970s

The completion of Interstate 10 in 1970 sliced the city in half from one end to the other.

That same year, a delegation of some thirty El Pasoans attended the Chicano Moratorium in Los Angeles, the first minority-sponsored demonstration against the Vietnam War. Thousands of people took part in the march in East Los Angeles. Organizers had sent representatives to El Paso and other key cities with substantial Chicano populations to encourage their participation.[33]

Pete Duarte was then director of the Trans-Century Project, which gathered information on health care needs in Segundo Barrio. The need for a clinic was pinpointed in 1969. Through a coalition of members of various social agencies and area residents, led by Enedina "Nina" Cordero, doctors began providing clinic services in one of the rooms at Los Siete Infiernos (The Seven Hells) tenement in Segundo Barrio. Later a board was formed and the process of developing Clínica La Fe was begun.[34]

In 1974-75 an effort by the city to eradicate the tenements in South El Paso was undertaken by Mayor Fred Hervey's administration. His program tore down ninety of the worst tenements and displaced eight hundred families before ending in January 1975 because of a shortage of low-income housing.[35]

These events in South El Paso coincided with the rise of the Chicano Movement, a period of political, social, and cultural activity which addressed inequalities in housing, education, and welfare and protested the disproportionately high number of Hispanic and other minority soldiers in Vietnam.[36]

Fueled by the creation of Clínica La Fe and the aftermath of the Moratorium, the enactment of the Comprehensive Employment Training Act (CETA) in 1973 to employ youth in the summers, and Hervey's move to break up the barrio, a new organization was created. La Campaña Pro La Preservación del Barrio was a Chicano organization started in 1974-75 whose purpose was "to stop the relocation and uprooting of the community and to preserve the sense of community which already existed there."[37]

In 1975 La Campaña submitted a grant for the creation of murals in South El Paso. Titled Los Murales del Barrio/The Murals of the Neighborhood, the project had as its goal the hiring of twenty-three people to paint murals under the supervision of professional artists Manuel Acosta, Ernesto P. Martínez, Mago Gándara, and Carlos Flores. The city approved the proposal with a budget of $21,200 to paint fourteen murals under the Department of Parks and Recreation.[38]

South El Paso in the mid-1970s also was the training ground for activists and community organizers, including a large number of VISTA volunteers who were assigned to work there. Among them were artists who sought to promote a consciousness of the era.

In an essay on murals of this period, Marcos Sánchez-Tranquilino observed:

> Striving to meet the needs of the Chicano community through the visual articulation of its newly constructed political positions, the painting of virtually thousands of Chicano murals throughout the Southwest and Midwest were instrumental in the demystification of popularly held notions of Mexican Americans as politically passive and lacking history as well as culture. Much of the work to be done in this arena meant the supplanting of negative images of broader-based and ethnically diverse American history. Muralists became important educators as they painted Chicano contributions to American society not included in textbooks. Through chicanismo, they also highlighted the ancient cultures of Mexico in order to show historical continuity and cultural legitimacy.[39]

The artists who painted murals in South El Paso in the mid-1970s seized the spirit of the Movimiento and began to visually reclaim their neighborhoods and culture after years of neglect. As they painted, the images translated their feelings of pride, identity, and empowerment to their communities.

One of these artists, Arturo "Tury" Avalos, who headed Los Muralistas del Barrio, was inspired by Los Tres Grandes, the Mexican trio of Diego Rivera, David Alfaro Siqueiros, and José Clemente Orozco. Under the sponsorship of La Campaña, Avalos and his crew (Pablo Schaffino, Gaby Ortega, and Pascual Ramírez) painted the Segundo Barrio in rectangular letters with a geometric Aztec-inspired design on the east wall of the presidios in the 500 block of Father Rahm avenue near Campbell street. The mural became a proud symbol for the barrio which was under the threat of urban development changes and where several blocks were slated to be razed. Los Muralistas went on to paint Avalos' version of the feathered serpent Quetzalcóatl on the side wall of Centro Legal at Paisano and Campbell streets. Of the murals painted by the group, that one has been best preserved because it was protected by several trees.

Avalos described the painting of murals as an opportunity to be constructive and to aid in the campaign against the city's effort to tear down the tenements. "People didn't realize what was happening then," he said. "Painting was a way of getting people together."[40]

According to Avalos, artists were encouraged to express the history of the barrio but eventually each person decided on his own imagery. Salvador Meléndrez and Manuel Arias painted a portrait of Ernesto Ché Guevara, the Cuban revolutionary leader, who became a symbol for the Chicano Movement, on the side of Duffy's Beverage Company in the 800 block of South Florence Street in South El Paso. The work was painted on the wall without the owner's permission. The artists, who were high school students, used paint left over from a previous project. The mural faces the lot where the First Tent City was created to protest the eradication of the tenements. The *Che Guevara* and *Segundo Barrio* murals were significant to the community because they inspired pride in identity. *Che Guevara* was repainted by Bowie High School MEChA members in 1994, under the direction of their sponsor, Oscar Lozano. He was a founder of La Campaña, which funded the painting of murals in Segundo Barrio in 1975.

In 1976 Carlos Rosas executed what was the largest local mural at the time, *Entelequia/Entelechy*, a 35-by-100-foot work on the rear wall of the El Paso Boys' Club. Sherwin-Williams Company had planned to have a large flag on the wall. Rosas approached the center about doing a mural instead. Using CETA funds, he and his stepfather Felipe Gallegos painted the mural in ninety days. The

work presents three faces which represent the determination to live, nature, and self-realization. The late Chicano poet Dr. Ricardo Sánchez defined Entelequia as "a philosophical notion that means the actualization of potential, the power or force within life itself, and the fuel for realizing humanity."[41] Unlike other murals being created at that time, *Entelequia/Entelechy* did not use Aztec motifs or designs. Rosas restored the mural in 1989.

During the 1976 Bicentennial celebration, Chicano artist Ernesto Pedregón Martínez painted *Meso-America*, his first mural in El Paso, in the Bowie High School cafeteria. An accomplished artist/illustrator, he raised the standards of mural making by incorporating specific Pre-Columbian motifs into his designs as a means of expressing the grandeur of Mexico's ancient cultures. By the time he completed *Meso-America*, he had created a body of work which was reflective of the Chicano community in El Paso and which later became associated with the Chicano Movement. One of his early paintings, *Si Se Puede*, a 1973 tribute to the United Farm Workers' struggle, was included in the "Chicano Art: Resistance and Affirmation, 1965-85 (CARA)" exhibition organized at the University of California at Los Angeles in 1990 by Chicano art historians and artists from throughout the United States.

In 1977, Martínez painted *Congressional Medal of Honor Winners* inside the Veterans' Affairs Building at 5919 Brook Hollow Drive. The 8-by-28-foot mural took eight months to complete and was dedicated on 24 October 1977.[42] The portraits were of Ambrosio Guillén, William Deane Hawkins, and Benito Martínez against a spectacular full combat background. His attention to details of clothing and artillery were also characteristic of his later murals. In El Paso he is known primarily for his military subjects.

Two large murals were painted in the neighborhood called Chihuahuita, part of what used to be the First Ward of South El Paso. One titled *Chuco, Tejas* was done by Salvador Meléndrez, Manuel Arias, and Victor Cordero, assisted by Victor Sánchez and Eddie Aguirre, in 1975 under La Campaña. The other, *Untitled or A Tribute to Joe Battle*, painted in 1978 and formerly known as *Lágrimas/Tears*, is in the 200 block of Seventh Avenue. It was dedicated to Battle, then district director of the Texas Highway Department (now Department of Transportation). Alfredo "Freddie" Morales and other Chihuahuita artists produced the mural. Morales said an artist from Massachusetts, a VISTA volunteer known as "Mara," sketched the design. He said she left without finishing the mural, but painted her initials on it. At the time, Battle and his department had decided to construct the Border Highway (Loop 375) through Chihuahuita. The mural was done to publicly display the people's disapproval of the state's plan which would destroy their neighborhood. Artist Manuel G. Acosta provided advice on materials. Rich in detail, the painting deteriorated after years of exposure to the elements. In 1991 the Junior League of El Paso Los Murales Project funded its restoration.

Mago Gándara, the first woman muralist in El Paso, began work on *Time and Sand*, a sand-cast mosaic, in 1975. She and ten classes of her El Paso Community College students developed it over a three-year period. She and Ernesto P. Martínez taught Chicano art courses at the college in the early 1970s. The two-story, 34-by-30-foot mural was installed at the new Valle Verde campus in September 1978. Cast in sections, each weighing five hundred pounds, the mural was composed of sand, glass, acrylic, resin, and plastic. *Time and Sand* was also an engineering feat. Cranes were needed to raise it in order to secure it to the wall with specially designed triangular frame bolts. Gándara says the piece is about "the evolution of humankind from diversions of self and society, represented by split and violent machine-like forms, toward a new compassion and integration, symbolized by the vaulting ecstatic forms."[43]

Community Works, 1980 to 1990

Mural production in El Paso took a different course during the 1980s with the relocation of skilled artists who had worked in larger cities. They included Felipe Adame, who had worked in San Diego's Chicano Park, and Carlos Callejo, who had done murals at Estrada Courts in East Los Angeles and was among those who assisted Judith F. Baca in the *Great Wall of Los Angeles*, a mural depicting the history of the city. The decade also saw murals by artists who continue to produce them today. The 1980s can be best characterized as a mural renaissance.

The expertise of the experienced artists introduced another dimension to sponsorship of works. Instead of being financed by the artists, they gained agency support. Our documentation project, undertaken in 1988, assisted in the identification of works, the classification of bodies of work by separate artists, and recognition of the artists themselves. Through the combined efforts of the Junior League of El Paso's Los Murales Project and the promotion of murals in the local press, the work moved from the "fringe" to an accepted and respected art form.

The end of the 1970s and the early 1980s saw the involvement of various Chicano gangs in mural efforts with the help of agencies and individual sponsors. Among supporters of these endeavors were Aliviane, a local drug rehabilitation agency; the City of El Paso Gang Intervention Department under John Estrada; the city's Arts Resources Department; St. Anne's Center under Nicolás Domínguez; and individuals such as then City Rep. Alicia Chacón, artists Manuel G. Acosta and Mago Gándara, and community workers such as Carmen Félix, Salvador "Chava" Balcorta, Chevo Quiroga, Salvador Valdez, and Greg Villaseñor.

Villaseñor, while working in the 1970s as an education counselor for the Community Drug Abuse and Education Center (Aliviane), directed the creation of two murals. He had been active in painting murals in local schools from 1966 to 1969. In 1973 he directed the painting of a 30-by-60-foot work on the east wall of the San Juan Gym. It was destroyed when an addition was built.

Quiroga, who had been with the city's Gang Intervention Department, joined the Aliviane staff in 1981. He was asked by several gang members to assist in the creation of new murals. Gangs, although often viewed as negative, have conducted beneficial activities as their mural involvement indicates.

Aliviane and the Arts Resources Department funded *Santo Niño de Atocha* at the Marmolejo Apartments in East El Paso. The principal artist, Angel Romero, sketched the initial design with the help of Manuel G. Acosta. Quiroga said fifteen youth from the neighborhood helped. Alicia Chacón helped acquire funding, and support also came from Katherine Brennand, chairperson of Aliviane. A play, *Chuco 80*, was written by youth inspired by the mural. It was performed at Chamizal National Monument, El Paso Community College Transmountain Campus, and the Civic Center.

Santo Niño de Atocha, honoring the patron saint of travelers and children, is located in the rear of the Marmolejo housing complex and is not visible to traffic. This mural and others developed by Villaseñor, Valdez, and Quiroga, represent team efforts by community workers, a social agency, and a city funding source to help youth.

In the fall of 1982, Quiroga was approached by the Chicano Pride gang from the Kennedy Apartments off Zaragosa road in the Lower Valley. The twenty youth wanted to paint two murals at the complex on the west wall of the Jane Briscoe Day Care Center at 447 South Schutz Circle. The first would be Our Lady of Guadalupe with the Ysleta Mission and the second would be of the Aztec gods Iztaccíhuatl and Popocatéptl.

According to Quiroga, the Kennedy Apartments emblem, in large stylized letters, was painted on the handball court by someone known as El Pecas/Freckles in one afternoon.[44] "People talk about muralists who have been to college—we've got guys in the community that can do much more than [someone with a degree]," he said. Rudy Mendoza and Juan Martínez were also involved in the Kennedy work. Quiroga said that time and time again, untrained artists have demonstrated their vast ability to create beautiful works. The Virgin of Guadalupe at the Fatherless territory on Seville street was painted by a man who came from the penitentiary, he explained. "He did that in one day."[45]

Aliviane and the Arts Resources Department funded the two Kennedy projects. Quiroga said Alicia Chacón was the main force behind the financing of community murals he undertook.

Quiroga was contacted by members of Varrio Indio Viejo (VIV) for a mural at a handball court near Presa Elementary School in the summer of 1982. Salvador "Chava" Valdez, a teacher at Ysleta Middle School, assisted, with about ten youth working with oil-based paint. Again Aliviane and Alicia Chacón acquired the funds.

Quiroga and Valdez helped youth paint *El Hombre Aguila/The Eagle Man* at Middle Drain handball court, a City Parks and Recreation Department facility in the Lower Valley. Quiroga said overhead projectors were used to show the image on the wall for sketching. Like many community murals, this one started by the youth simply picking up brushes and painting. Permission was not asked of the city department; an employee noticed the work and called Aliviane and Quiroga. As a result, Quiroga said the department gave him a contract stipulating that the mural should be completed.

Youth at Varrio López Maravilla (VLM) in South Central El Paso asked Quiroga in 1982-83 for his help in painting a mural on the wall of the old Summit Fashions building on Colfax street. According to Quiroga, someone from the López Mara gang in Los Angeles tried to expand their territory into El Paso; their efforts failed, but the name remained.

Community artists are often known by nickname only. "Santos," "El Smiley," and "El Robe" painted the mural on Colfax street but left some of the faces incomplete. The mural was of the Virgin of Guadalupe towering over a red brick wall. Above the wall were painted two young men and a young girl dressed in Chicano Chuco style. A rose, symbol from prison iconography, signified tenderness and love. A *ramfla* (automobile) zoomed from the left corner, and on the right side a cobweb representing entrapment hovered over a fallen body on the street. The iconography as a whole was largely taken from symbols, motifs, and drawings which make up a body of images used by prison artists.[46] Later a former inmate finished painting the faces to complete the mural. Joe Shamaley and Jim Viola of Viola Sportswear paid five hundred dollars for the mural.

By 1984 Quiroga was no longer with Aliviane. Members of the López Maravilla gang called El Paso's Gang Intervention office for assistance in obtaining permission to restore the mural in July, 1988. By then the building had been sold. Chevo Quiroga tried to facilitate the restoration, but the new owner did not grant permission and the proposal was dropped. As of 1995, only the upper portion of the Virgin was visible, with graffiti on the lower half.

Bowie High School art teacher Gaspar Enríquez assisted youth at the Rubén Salazar Apartments, 311 South Eucalyptus Street, in 1985-86 in the painting of *Christ Looking Over El Paso/Cd. Juárez*. He was first contacted by the Housing Authority to do the work. Controversy was stirred when the Thunderbirds gang painted their motif on the mountain in the mural. Housing officials told them to remove the five-inch symbol but they did not do so.

Enríquez's students also have painted sports murals in the women's gymnasium at Bowie High School. More recently, colorful spray can murals have been done at the schools' handball courts. Numerous murals throughout the campus attest to this instructor's use of the genre to train his students in creative works.

In May 1988 Enríquez assisted youth at the Salazar Apartments in painting a mural at Building 2 as a tribute to Enedina "Nina" Sánchez Cordero, founder of Clínica La Fe. The design was the idea of Rosendo Montes, who then worked as a VISTA volunteer with the Department of Gang Intervention. A scroll is pictured on which is written a poem by Juan Contreras, son of Cordero, with a mountain range, clouds, and a portrait of the subject air brushed on plywood. The size is 18 by 24 feet. The work was restored in 1991 with a grant from the Junior League. Students assisting in the restoration were Dino Cano, Rubén Arias, René Sánchez, and Victor Perches.[47]

Artist Felipe Adame painted more than a dozen works in El Paso beginning in 1980. The most popular are his Vírgenes de Guadalupe. He also assisted Kofu gang members in South El Paso with a mural on the second story of their tenement building at Florence and Eighth streets near the Armijo Center. According to Jan Wilson, the design was from an emblem on jackets worn by Kofu members.[48]

Adame's 1981 Virgen near the Lincoln Cultural Arts Center was painted on a freeway pillar under an Interstate 10 interchange known as the Spaghetti Bowl. The location is near the corner of Durazno and Uva streets. The image was reproduced on the poster for a 1989 city-wide celebration of Our Lady of Guadalupe. Adame said he sought to create El Paso's version of San Diego's Chicano Park there, but was deterred by authorities. An unfinished 8-by-4-foot image of a revolutionary figure was also painted in 1981 on a freeway pillar—a lone vestige of Adame's attempt to create El Paso's version of San Diego's Chicano Park.

Adame in 1982 painted *Iztaccíhuatl, Mujer Blanca, Leyenda de los Volcanes,* taken from a painting by Mexican artist Jesús Helguera (see Appendix D), inside the Armijo Recreation Center at 710 East Seventh Avenue in South El Paso. He was assisted by Elizabeth Joyce, Raul Macías, Nacho Guerrero, and Jesús "Machido" Hernández. They used a perforated paper technique to transfer the mural to the wall. The wall was plastered by Ignacio Guerrero, Nacho's father.

That same year, Adame painted *Dale Gas* (give it gas) at Gator's Grocery in South El Paso. It pictured a zoot suiter with El Paso's skyline in the background.[49] The 30-foot mural, which no longer exists, was near the corner of Sixth avenue and the alley west of Cotton street.

La Virgen de Guadalupe y Juan Diego, painted by Adame in 1982-83 at the Salazar Apartments Building 10, was done at the request of the Thunderbirds and the Cornejo family. It took six months to complete and was financed by Adame, who sold square-foot blocks to the League of United Latin American Citizens (LULAC), Ruidoso Grocery, and numerous other sponsors. The mural was restored by the artist and neighborhood youth in 1991 with a $5,000 stipend from the Junior League's Los Murales Project.

He began working with youth from Varrio Quinta Street (VQS) at Father Rahm (former Fifth) avenue and Campbell street in 1985, in an effort to deter the use of spray inhalants in the area. The resulting mural, 26 feet high by 22 feet long, displays the Aztec gods Iztaccíhuatl and Popocatépetl. The name of the group reflects the use of the street term for "barrio" as "varrio," also found in the names of several other groups. In 1985 Adame also painted a mural in Chihuahuita on the garage of Lico Zubia in memory of his son, Florentino Zubia, Jr., "Nuni," who had died in a motorcycle accident in 1980.[50] Zubia asked Adame to paint a scene from the film *Easy Rider*. A pickup truck is shown emerging from a snow-covered area, driving toward a beach with palm trees.

Adame's murals reflect the Chicano fascination with Helguera's style of work which is in most cases culturally acceptable for the public at large. In his murals, Adame used various versions of the Mexican artist's work to convey to his audience a sense of Chicano muralism. In his paintings of the Virgin, he centered on one of the most respected images of the culture.

Local artists who had not developed a funding infrastructure in the 1980s became skilled at raising monies for their projects. The arrival of Adame and Callejo signaled the need for a mechanism to raise public funds for the creation of works.

In 1987 Callejo was approached by David Romo, then director of the Southside Educational Center, about painting his first commissioned mural in the city on the north wall of the center at 800 San Francisco Avenue. A youth crew would be provided through the Upper Rio Grande Private Industry Council (PIC). Coincidentally, the same wall had sported an early Chicano mural dating from 1981. That work had deteriorated and had been painted over. It featured the faces of a family, a prevalent theme in early Chicano murals.[51] It was located near two others from the 1970s at El Paso and Fourth streets, one of a revolutionary figure standing in front of the United Farm Workers' emblem atop a sun and the other displaying three Mayan faces.[52]

Kids on the Moon took Callejo six weeks to paint. The PIC youth researched issues of concern to the barrio. The mural implied that, while we have the capacity as a civilization to put man on the moon, children go to bed hungry at night. The building was sold in 1992 and the mural was destroyed. The new owners first painted footwear labels on the upper portion, then cut out part of the wall to install a garage door. Finally, they painted the wall dark brown. Although the mural was a source of great community pride, it was located in a commercial area where the public may not have been moved to protest its removal.

Under joint funding by the Chicano AIDS Coalition, Clínica La Fe, and PIC, Callejo in 1988 painted a mural depicting AIDS issues at Sixth and Ochoa streets behind the clinic. Controversy was sparked by the inclusion of the nude figure of a woman inside a whirling tornado, to show that women were susceptible to the virus. Upon seeing this image, PIC officials were reluctant to let youth work on the mural and several were reassigned to the Salazar Apartments mural. Several of them, however, continued to work with Callejo. They included Rosendo Montes, Jaime Valencia, Fili Medina, Jaime Baca, and Salvador "Chava" Alvarez.

With Archie Moreno and César Galván, Callejo supervised the painting of a memorial to slain journalist Rubén Salazar at the Salazar Apartments Building 31, Cypress and Eucalyptus streets. The housing complex was named in honor of Salazar, a former El Pasoan who became a noted journalist in Los Angeles. He was killed by a police tear gas canister fired into the Silver Dollar Cafe in East L.A. after the Chicano Moratorium in 1970. Salazar became a martyr for the Movimiento.[53]

In 1989 Callejo created a mural at Socorro High School, 10150 Alameda Avenue, based on a painting by Marta Arat. *Dance, a Universal Art Form* shows dancers amid waves of color characteristic of Arat's work, which has appeared on countless community and national posters.[54] Callejo was assisted by Alejandro Martel and Antonio Mercado. The sponsors were the Socorro Independent School District and Rosa Guerrero's Folklórico dance company.

The El Paso Arts Resources Department and La Fe Clinic in the winter of 1989 sponsored Callejo's *El Chuco y Que/El Paso So What* in the 700 block of South Virginia street. The Junior League of El Paso began its Los Murales Project with a contribution of $500. Raymundo "Rocky" Avila, who had helped with the AIDS mural, also worked on this one as did Antonio Mercado, Manuel Arrellano, and Frank Mata. It reflects how the international world stereotypically views the state of Texas as cowboy country, a stereotype that El Paso does not necessarily fit into. According to Callejo, "We are much more than just cowboys. We are a unique blend of cultures." El Chuco is a Chicano slang term for El Paso.

During Christmas vacation of 1981, Lupe Casillas-Lowenberg and her Gadsden High School students painted *The Apparition of the Virgin of Guadalupe* on an exterior side wall of San Martín de Porras Catholic Church, 5805 McNutt Road, in Sunland Park, New Mexico. The mural of the Virgin, a popular Chicano image, became a symbol for the community of Sunland Park. Residents built a fence around it to deter damage or graffiti. Gloria Irigoyen, one of the artist's students, and her family helped secure the wall for the project. The design they created was applied to the cinder block using paint donated by Hanley Paint Company. Irigoyen's father provided the scaffolding. The Big 8 Supermarket, then on Doniphan drive, donated fruit and drinks and townspeople provided lunch

for the team. The mural was completed in three weeks. Roberto Salas, a former student of the artist, worked with the group to further develop designs which they painted at the handball courts and dugout in Sunland Park.

Mexico City artist Manuel Anzaldo Meneses, Carlos Callejo, Eva María Kutschied, and others with the Cholos of Ciudad Juárez painted *Todos Somos Illegales/We Are All Illegal Aliens* in early July 1987 on the banks of the Mexican side of the Rio Grande under the Santa Fe Street Bridge. Anzaldo Meneses organized artists of the two cities to create the mural, measuring more than 20 by 200 feet. Participants were invited to express their views about immigration issues facing both nations. Anzaldo's goal was to show the need to break down man-made barriers which in his view constitute the myth of the border. He also wanted to paint the expanse of the border between El Paso and Ciudad Juárez. The murals were painted without permission.

Todos Somos Illegales/We Are All Aliens was based on a bumper sticker produced by the now defunct League of Immigration for Border Rights Education (LIBRE) group created by Debbie Nathan and others. More river murals followed in subsequent years including one supporting U. S. Trade with Cuba in 1993. In May 1988 Anzaldo and artists from both sides of the border painted *Todos Somos Américanos/We Are All Americans* on the banks of the river under the same bridge in Ciudad Juárez. He returned to the area to execute other works in May 1989. He, Rafael Martínez, and six other artists painted a huge mural of Quetzalcoatl with the words *El Puente Negro* (the black bridge, referring to a railroad bridge commonly used to gain illegal entry into the United States).[55]

An announcement in the *El Paso Times* of 2 May 1990 invited local artists to take part in a mural paint-in on the river banks under the Paso del Norte Bridge on the Mexican side, in celebration of the May Day international workers' holiday. Each participant was asked to contribute five dollars for paints and brushes. In the early 1990s Anzaldo returned to Ciudad Juárez from Mexico City in order to restore old murals and create new ones. Now, in the mid-1990s, anonymous artists continue to produce their own immigration murals on the river in the spirit of Anzaldo.

Carlos Rosas returned to El Paso in 1989 with the intention of restoring his thirteen-year-old *Entelequia* mural at the El Paso Boys' Club. With the help of intermediaries, an agreement was reached between Rosas and the club's board of directors.[56] Given Paint Company donated materials and a thousand dollars was raised from private donors for the three-month project. In a complete make-over of the mural, he radically changed it and added contemporary imagery and color.

Following that work, Rosas raised funds to paint a mural in homage to artist Manuel Acosta, who had died in 1989. With help from local business people, he painted the 12-by-84-foot *God Is Mexican/Tribute to Manuel G. Acosta*, facing the Border Highway, in March 1990.

Murals in the 1990s

The creation of murals in El Paso took a more focused route in the 1990s with the establishing of a major funding source. Also there were two major commissions: one for $150,000 awarded to Carlos Callejo in 1990 and the other from the General Services Administration Art-in-Architecture program for the El Paso Federal Building, awarded to Los Angeles Chicano artist John Valadez. These major commissions also helped to raise artistic and communal standards regarding murals, their placement, and their importance to the city.

Fifteen years earlier, in 1975, La Campaña Pro la Preservación del Barrio had initiated Los Murales del Barrio which painted murals in Segundo Barrio.

In 1990 the Junior League of El Paso established its Los Murales Project as a means for continuing the creation of murals in the city. Historically Junior Leagues across the country identify community service projects needing support. They provide funds to implement the endeavor, then withdraw as it becomes self-supporting. The League also sought to recognize artists who had created earlier work almost in isolation.[57]

Artist Carlos Callejo invited Dr. Tim Drescher, nationally known author and publisher/editor of *Community Murals* magazine, to speak with Junior League members about the proposed project in the fall of 1989. Drescher encouraged the group to formulate policies on awarding commissions, especially to community-based muralists, which would allow them freedom of expression.[58]

Junior League member Anna Salas-Porras Walcutt wrote the original proposal for the governing body. Gallery owner Adair Margo served as the first chairperson of Los Murales. The League awarded the first five thousand dollars in commissions to artists with the promise that they could paint what they wanted.[59] Beth Vann served as 1991-92 chairperson, succeeded by Michele McCown (1992-93) and Beth Ford (1993-94). Cynthia W. Farah was a sustaining advisor to the committees.

To date the Junior League has spent $151,000 in the creation of murals in El Paso: $20,000 in 1990-91, $32,000 in 1991-92, $18,000 in 1992-93, and $18,000 in 1993-94. The 1994-95 budget was $33,000 with Julie Delgado as chairperson; in 1995-96, $10,000 under Tanya Schwartz. Additional funds have been allocated to the project by the Texas Commission for the Arts, the City of El Paso Arts Resources Department, Texas Commerce Bank, Mexican-American Bar Association, Women's Bar Association, Diocesan Migrant and Refugee Service, and individuals including Nate and Estele Goldman and Greg Acuña.

Other cities have expressed interest in projects similar to Los Murales. In April 1994, Tyler, Texas, invited Callejo to work with youth there in producing a mural based on the city's history on a downtown wall.

The creation of murals in El Paso has built bridges between groups who had been traditionally divided by class and economics. The creation and patronage of works drew interest throughout the city. Murals are now seen as tourism attractions and sources of community pride. In acknowledging the need for funds to create them, the Junior League took the lead in filling the void.

Based on our documentation, a color brochure, "Los Murales: Guide and Maps to the Murals of El Paso," was published by the Junior League in 1992 to help direct viewers to some of the major murals in the city.[60] The first printing of 10,000 was so popular, a second printing of 10,000 was initiated. Subsequent reprints have been sponsored by corporate groups. The guide, which has been sent throughout the world, was distributed free of charge.

Major Commissions

Chicano artist John Valadez was among artists chosen in 1988 by the General Services Administration's Art-in-Architecture Program to execute two major works, one in the new El Paso Federal Building, 700 East San Antonio Avenue, and the other at the Ysleta Border Station, Building A, 797 South Zaragosa Road at the International Boundary. Slides of his work were submitted to the GSA by the Saxon-Lee Gallery in Los Angeles at the request of former El Paso Museum of Art curator Kevin Donovan.

Valadez visited El Paso from 1989 to 1993 to study the city, collecting images for possible use in his murals. *A Day in El Paso del Norte*, a 9-by-50-foot mural on canvas in oil and acrylics, was installed inside the Federal Building in December 1993. It reflects the history of El Paso and its people, with the downtown area as a stage on which past and present images are interwoven in a panoramic snapshot of the city.

The Coming of Rain, which the artist termed a "rural agricultural" landscape, gives a panoramic view of a field after irrigation, with an abandoned adobe house in the center. Billowing clouds appear in the distance, while a ghost-like stagecoach hovers in the clouds above. Valadez included a handmade Tarahumara Indian plow in the lower right side of the 6-by-9-foot oil on canvas mural which was installed 19 April 1994 at the border station. The dedication of both works was held 13 September 1994.

With the announcement of a $150,000 commission to Carlos Callejo in 1990, a clear picture emerged of the level of sophistication towards public art in El Paso. This commission for the new El Paso County Courthouse was the largest for a mural to any one artist in the city's history, and also signaled the commitment on the part of local agencies to support mural production.

Other Commissions in the 1990s

Carlos Rosas in November 1990 painted *Sacred Family*, a 10-by-10-foot mural in front of Clínica La Fe depicting a man, a woman, and a child. It resembles a Chicano poster, "La Familia," printed by AMATL Publications, Inc., and signed "Chinas, 62."

The following year, Rosas was commissioned by the Junior League of El Paso to paint a 19-by-29-foot mural at the David L. Carrasco Job Corps building. It honored Carrasco, the award-winning director of the center, who died 16 October 1990. The mural at 11155 Gateway West, in East El Paso, cost five thousand dollars and employed youth from the center. Rosas illustrated the subject's life, his family, and his career achievements.[61] It was restored in 1996.

Rosas painted a mural in 1991 for artist Ho Baron on his garage on Altura avenue in the Manhattan Heights Historical District in exchange for occupying a basement apartment. It depicted an Olmec head and other Pre-Columbian motifs in bright bold colors characteristic of the artist's style.[62]

Several of Baron's neighbors protested the painting of the mural without prior permission from the city's Landmarks Commission, a requirement of the historic district.[63] The question went to the City Council on 17 September 1991, after a poll of the commission had been eight to six to allow the mural to remain. Baron, assisted by activist and writer Rober Chávez, who lived in the neighborhood, had acquired 397 signatures in favor of the mural in a door-to-door campaign. Opponents took the view that Baron had violated the city ordinance requiring permission for such changes in the district. The council vote was a tie, broken by Mayor Bill Tilney to allow Baron to keep the mural.

On 12 April 1994, Carlos Rossas (he added an "s" to his surname to honor Picasso who had double "s" in his name) dedicated *The Children First/Los Niños Primero* to record the contributions of people of Segundo Barrio and to recognize past students of Aoy School.[64] Rossas also painted other images and buildings symbolic of youth and beauty, hopes and dreams of the Mexican culture. He incorporated Jesús Helguera's Cuauhtémoc into the work. The mural he considered his most serious to date was funded by the Aoy Alumni Association and Ramiro Guzmán. Felipe Gallegos, Jr., assisted in the painting. State Sen. Peggy Rosson and Richard Romo,

representing U.S. Rep. Ron Coleman, presented Rossas flags that had been flown over the state capitol and the national capitol as gifts for the school.

The "Mexican Preparatory School" that grew into Aoy had been opened as a private free school in 1887 by Olivas Villanueva Aoy, who was born in Valencia, Spain, in 1833. It was taken into the El Paso Independent School District in 1891.

In 1991 Callejo was asked by the Junior League to paint a mural for Superior Solutions, Inc., at 2001 Magoffin Avenue. Already committed to other projects, he suggested Mario Colin. Using ladders and working mostly after hours, Colin and his crew completed a spectacular mural that wrapped around the entire building. *Hispanic Heritage and Homelessness* is at the corner of Magoffin and Eucalyptus streets in Central El Paso. The wall facing Magoffin features a tapestry of images of Mexican history, religion, education, family, and ancient cultures. A large representation of the Virgen de Guadalupe against her brightly colored aureole dominates the picture. Two colossal heads from the Olmec culture of La Venta, Tabasco, and two children reading books complete this section. A portrait of a family is shown against a colorful weaving. Other images from Mexican culture are a folklórico dancer, a revolutionary on horseback, and the Pyramid of the Sun. The outstretched arm of an Aztec warrior is found at the far right, against a stellar background.

The issue of homelessness merited the artist's attention on the wall facing Eucalyptus street. It was not part of his original proposal.[65] This separate mural shows sleeping children huddled together. The artist almost lost the commission because of his commitment to this subject.

This first mural by Colin was very powerful with imagery representative of the Mexican heritage. It has been reproduced numerous times in local newspapers because of its articulation of history and traditions of the Mexican-American community. Colin was among local muralists who were featured in a video, *Walls That Speak*, produced by Jim Klaes in 1994 and sponsored by the El Paso Hispanic Chamber of Commerce and Los Murales. *Hispanic Heritage* was painted over in 1996.

In 1991 El Paso-born, San Diego-based artist Roberto Salas painted *Las Cosas de la Vida/The Things of Life* in Sunland Park on the handball court of the sports field in Elena's Memorial Park. A past member of the Border Arts Workshop/Teller de Arte Fronterizo (BAW/TAF), he used stylized graphic representations of New Mexican and Mexican images in squares similar to the Mexican game of *lotería*. The images deal with various aspects of life, religion, and identity. He was assisted by David Anderson, Svenja Sliwka, Gene Flores, and Carlos Madrigal. Salas has painted murals in San Diego, Los Angeles, Houston, and Central America.

Mago Gándara in February 1993 was commissioned by the Junior League to create a mosaic mural at Douglass Elementary School on Eucalyptus street. The work features a flowing image of a woman in bright mosaic tile, glass, and other materials. *La Niña Cósmica* is a spectacular mural which changes as the sun makes its way across the sky. One of few women creating murals in El Paso, Gándara is the only one currently working in the painstaking mosaic process.

Ernesto P. Martínez in 1995 executed an updated version of the *Congressional Medal of Honor Recipients* inside the Veterans Administration Building in the Health Care Center next to William Beaumont Army Medical Center. It depicts Hiroshi H. Mayamura, William Deane Hawkins, Joseph C. Rodríguez, Roy P. Venavídez, Raymond G. Murphy, Benito Martínez, and Ambrosio Guillén. The two-panel canvas painting was commissioned by the Department of Veteran Affairs. The health center opened in October 1995.

CHAPTER 2

INTERVIEWS

The documentation of El Paso's murals has been sporadic and not widely disseminated. The purpose of this book is to consolidate information available on these murals and to allow the muralists to tell their own stories.

The interviews presented here allow artists to offer their personal perspectives on their lives, their artistic vision, and development of their work.

Prior to conducting these interviews, I had met and worked with most of the artists. All sessions were conducted in English except for Carlos Flores' which was in Spanish. The text has been organized in narrative format with the questions deleted to make the text more readable.

All but two of the artists were able to read the transcripts before publication. Felipe Adame could not be located and Manuel G. Acosta died in 1989.

Ernesto Pedregón Martínez
Interviewed by Mike Juárez
Martínez Residence, El Paso
21 November 1992

Most of my work has been out of town, and the media in the past focused mainly on the late Manuel Acosta. In addition, I have stepped on too many people's toes with my paintings. I was not accepted in the mainstream art area in El Paso. For many years I was the lone activist in art.

I remember in the sixties, the seventies, I used to exhibit my Chicano art in the El Paso Civic Center. It offended many people because Chicano art was not readily accepted. I was considered somewhat of a rebel. For many years I was the only Chicano artist here.

The only opportunity I received to exhibit my work was through MEChA (Movimiento Estudiantil Chicano de Aztlán at UTEP]. I used to exhibit a lot at the Corbett Center [at New Mexico State University in Las Cruces]. The military always gave me exhibits. I was also able to exhibit at the Chamizal National Memorial. Of course the El Paso Museum of Art was out of the question.

I was born in South El Paso. My birthplace was a house on La Calle Quinta [Fifth Street], which is now Father Rahm Street. I was born at Quinta/Fifth and Oregon streets. I was born in one of those presidios on February 26, 1926. They used to have an *escuelita* [little school] there through the Sacred Heart [Catholic Church] nuns. From there I went to Aoy [Elementary] School, then to Cathedral [High School]. Outside of that, that's my total education.

I come from very, very humble beginnings. The only pride in our family, prior to me, was that my uncle, my father's brother, was a priest in Mexico. He was executed in front of a firing squad during the persecution. They caught him saying mass. They took him outside and executed him.[66]

My father was a tailor. I'm the youngest of seven children. We were very, very poor and we lived in the barrios around the Calle Oregon, across from Sacred Heart Church. I could never afford art lessons or anything of that nature. I copied the work by the masters and read as much as I could about art. As far as I can recall, I've been painting since I was in kindergarten.

I would draw or sketch anything I could from an early age. My work was admired in kindergarten. It was hung on the walls although it was strictly pencil. At Aoy School, I didn't do many drawings, but I used to keep a box of sketches under my bed. When I went to war, I didn't paint. After the war, I met my wife Mary. She was the one who encouraged me to start painting again. Nobody thought I would someday venture entirely into the field of art. I got married. I had to support my family and, since I was totally unknown, I had to pursue other endeavors. I got a job with Fort Bliss in electronics. At Fort Bliss, there were always occasions when they needed a sketch. That's when my artistic ability started to get noticed. Little by little, I left electronics and started working in commercial art. I eventually became an illustrator for the army.

I painted many easel paintings and would read anything I could on art. Through my job, I experimented with all kinds of media and different sizes of work. Eventually I started dabbling in acrylic. I love acrylics. Almost everything I painted from then on was in acrylics. By that time, I was approaching forty-eight years old and I was totally unknown. I didn't have any exhibits—nothing, completely nothing in art.

All my life I had great admiration for Mexico, so I had also acquired quite an extensive knowledge of Mexican anthropology. I was very familiar with the Mexican muralists. When I was in my twenties, before I got married, I loved the art of bullfighting/*tauromaquia*, so I got deeply involved in bullfighting to the point I took part in several *festivales* where I actually used to fight bulls for charity.

I guess it was the movement, the beautiful coloring of bullfighting, the *trajes de luces* [suits of lights] and the works of Ruano Llopis. Ruano Llopis is possibly Spain's greatest bullfight artist. I used to copy a lot of his work and I used to copy a lot of El Greco's work. So I acquired the coloring of Llopis and Jesús Helguera from Mexico. Helguera was the artist who painted for the cigars de México, the one who painted *La Leyenda de los Volcanes/The Legend of the Volcanos* [see Appendix D]. The combination of Helguera with Ruano Llopis, together with the sadness of the melancholic skies of El Greco and Michelangelo, gave me the movement. Before I knew it, I had a combination of all these masters which developed into my particular style of painting.

As I told you, I had a great quantity of bullfight paintings. And I had a large amount of paintings of *campesinos*, Mexico and humble people, *la gente, la pobreza*, the market and *el barrio*. I must have had between sixty and eighty paintings. I had known Dr. Ricardo Sánchez [poet and Chicano activist] for a long time. He saw my work and at this time he was deeply involved in El Movimiento. He came to the house. They did interviews, checked my work out, and little by little they started giving me the

exposure. Bert Salazar, who was writing for the *El Paso Herald-Post,* started writing a few articles. Little by little, I was absorbed into the Movimiento because of the nature of my work.

Before long they were claiming these paintings as belonging to the Movimiento—*la gente,* to La Raza. And again through Ricardo Sánchez, I was introduced to a lot of these students at UTEP. At that time they were part of MEChA. MEChA was very instrumental in giving me my first ever one-man show. I was forty-eight years old. The one-man show was presented in the Centennial Museum at UTEP.

Surprisingly, this art was considered more of a rebel kind of art. We opened the exhibit on a Sunday afternoon. By all accounts, it was supposed to be a flop—nobody should have attended. Yet that day, we set a record. The attendance reminds me of CARA [Chicano Art: Resistance and Affirmation], because supposedly it was a very unpopular art; yet, there were over three hundred people in attendance. From then on, I was invited to exhibit at the University of New Mexico, the University of Colorado in Boulder, and so on. I started getting invitations for exhibits and interviews, papers, and this and that—it was almost instantaneous. From then on, I was committed to El Movimiento.

I had done paintings of El Segundo Barrio. I wanted to preserve them. I have a painting of Segundo Barrio. I had a painting of the little cars, the *ramflitas* that existed at the time. So it was just something that happened. I was there and I guess we crossed [encountered the Chicano Movement] at the right time. From then on, I got to meet and became an intimate friend of Reies López Tijerina, one of the leaders of the Movimiento. I got to be part of it and I attended the conferences. It was in the nature of my paintings.

The first mural that I did, was the Bowie mural, *Meso-America.* I was approached by Candelario Mena with the idea that the Bowie Boosters wanted a mural of mine in the city because I had never done one here in El Paso. So the Bicentennial was rapidly approaching and they thought Bowie would be a nice place to do one. I don't know how much trouble it was to acquire the permission of the school board, but the Bowie Boosters went through it and they got the permission and the wall, and I started painting that mural.

Needless to say that I was thrown out of Bowie a couple of times because the teachers there were not in agreement with me— one day almost physically I got thrown out; they wanted to suspend the making of that mural. But then I called back Mr. Mena and he got hold of the principal. They had a big meeting and discussed the issue. Anyway, I was never bothered again. I was free to

complete the mural, but like I say, at that time there were almost no activists or no Chicano artists in this area. There were Mexican-American artists, but no artists as rebellious, I guess. So I believe that I was almost by myself in El Paso.

You know I really shouldn't say this, but a lot of things were promised if I did the mural. None of it came about. I just did it and donated it to the city as a gift to the city. I never got a penny for it. But it's something that the kids appreciate and they like it. They like to have it there.

The second one – I painted *The Resurrection* at St. Joseph's Church in Houston. This church is roughly one hundred to one hundred and fifty years old and it is also in the Sixth Ward, something comparable to the Second Ward in El Paso. Father [Samuel] Rosales, whom I knew, had taken it over. I had known Father Rosales previously here in El Paso because I was his scoutmaster. I used to fly in from El Paso to Houston every Friday. I did this for almost eight months. I would go and paint during the weekend and come back late Monday or Sunday and work the rest of the week at Fort Bliss. This is how the mural came about. Two weeks ago they informed me that the mural at St. Joseph had been destroyed. Somehow water had run down in it. It destroyed the whole roof. I don't think they have been able to get additional funds to restore it.

At the Vet Center I painted another mural. That was my first commissioned mural. It was commissioned by the new UVO, which is the United Veterans Organization. The new clinic in El Paso for the veterans had opened up, so on the verge of opening they wanted something to commemorate and officially to honor the heroes who had died from El Paso. By heroes, I mean the ones who have received the Congressional Medal of Honor. We found out that Ambrosio Guillén, William Deane Hawkins, and Benito Martínez of Fort Hancock had given their lives in the wars. They had been awarded the Congressional Medal of Honor. I thought it was a good tribute to them. In 1993 or '94 William Beaumont Army Medical Center is going to relocate. The mural will probably be destroyed. I have talked to some people and they said the mural can be taken off the wall; it is painted directly on the wall. But they figure it will run beyond $25,000.

I did two more murals. I was commissioned by the State of New Mexico. This was under a competition for national art. I was commissioned to do two murals for the State of New Mexico. They are located in the VA Center in Truth or Consequences, in the hospital. That's roughly the extent of my murals.

This is the latest one, the one which was commissioned by the Junior League. That was done to commemorate the victims of the Gulf War. That was painted at Fort Bliss inside Stout Gym. For the record, I think whoever said that I was glorifying the war in this

mural has a yellow streak down his back. And I can repeat it as many times as needed. This is my personal feeling. I feel very strongly about it because I am a veteran. I fought in the war, in Europe, in one of the most famous divisions, the 104th "Timberwolf" Infantry Division.

Funding and the money available is always good to have. Artists are human and they have to have food to eat. They have needs. They need materials. They need paints—their brushes. I think that if an organization like the Junior League provides that funding, even if it's in small amounts, they're doing a tremendous thing because you can create, but if you don't have the money to buy canvas or you don't have the money to throw away, like when I was painting, I was actually throwing the money away that I used to paint—I was taking it away from my family because I needed to put food in their mouths, in my children, my wife, pay for rent, pay for gasoline—and a lot of times I would do without to go out and buy a tube of paint or a canvas to paint on.

Unless you have a patron, you cannot really develop the art to any great length. It's always been proven over and over throughout the ages like Lorenzo el Magnífico from Italy.[67] He provided the funds, the means, the opportunity for many of the world's greatest artists to flourish—one of them Michelangelo. And [José] Vasconcelos from Mexico, he provided the funds for the *murales* to be born—for the giants of Mexican muralism, Siqueiros, Orozco, Rivera. I think that you have to fund the artists.[68]

And like any artist, any human being, I think that it's great to have your art appreciated, but it's better to have somebody appreciate it by giving you money. Unfortunately, they think that the artist is there to paint just for a little bone that they throw at him, that his work is not worth anything. You call an electrician, you call a carpenter, he charges you hundreds of dollars and you gladly pay him. But you call an artist to do some work for you and unfortunately, most of the time, they like that artist to do it free. The poor guy has to eat. He has to have the encouragement of going forward.

I have several dream commissions. I move just as easy in the mural field as I do in the easel art field. I'm not getting any younger. I'm approaching my seventies very rapidly. It's becoming harder and harder for me to climb up there or paint down on the ground or what have you. I think eventually I might start moving more towards easel art, but I still have dreams of painting maybe three or four more murals.

Most of my life I've been either not getting paid or getting paid very little and having to fight every Tom, Dick, and Harry to get my commission paid. Like every artist, I have dreams. I dream that maybe someday I could sell my paintings for good money. Maybe before I'm gone, I'd like to do maybe one or two more murals and leave the field to the younger artists that are coming up.

That's another thing—you have artists and you have muralists and then you have artists and muralists combined. If you open the field to just muralists, what happens to these guys that don't paint murals? It seems to me like we're ignoring them. We also have many good artists. For one reason or another they don't want to tackle the task of painting murals, but we shouldn't forget about them. We should help them.

Mago Orona Gándara
Interviewed by Mike Juárez
Douglass Elementary School, El Paso
9 June 1993

Ah, *hijo!* So, you want me to talk about murals? Could I talk about just my work and my ideas? That interests me more. Who cares where I went to school? *Ya no importa*/It doesn't matter anymore. About 1965, I had wanted to do a mural so badly and there was no money and no commissions. At that time, I had been away from teaching so long, and I was raising a family and lo and behold, I got a teacher's retirement check. So with that money, I bought wood panels, pressed wood and frames, and I made twelve panels, four by six feet each. That would be a section which would make it possible for me to handle. And I decided to commission myself to paint a mural.

At that time also, I had gone on a trip to Mexico and seen the great masters, not for a long study, but briefly. I had seen Orozco, Siqueiros, a little bit of Diego Rivera. But Orozco and Siqueiros blew my mind, at the boldness of their movement and their shapes—there was no fear, and that was very inspirational to me.

Also at that time, I was going through a big change, of trying to break away from the terrible frightening sickness of Catholicism, under which I had been brought up and educated, into a humanistic view of life, of God and creation within humanity instead of this awful fear that I had suffered from as a little girl. So I'd actually had a nervous breakdown—part of that guilt was part of the breakdown—so I wanted to free myself. And the way to free myself was to paint a mural.

I had heard Beethoven's *Missa Solemnis* and then the credo that was said in the Catholic church at that time was a very strict credo; it's freer now. I heard Beethoven's "Credo" in his *Missa Solemnis* and it was absolute architectural humanity. It just flipped my brain, and I began to see hope for this oppressive religion to a humanistic way of life that would lead to salvation not only in the next world, but certainly salvation in this world. With all that in mind, I dedicated [myself] to life drawing for a year. Drawing life, drawing people in action, students in high school wrestling, pole vaulting, anything until I felt I was ready.

When I thought I was ready, I found an old theater—this was in California—it was empty. It was a basement of a theater and it was abandoned. So with the money I received from my teacher's retirement, I rented it for twenty-five dollars for the summer. I was very excited because it was big enough to carry my tall panels. This was my first real mural.

I stretched the panels out, four by six feet, ten or twelve of them, forty-eight feet, and they were all primed and ready. I had done all my drawing head-on. I had done a pre-sketch in watercolor, but I didn't do a graph. When I got in the room, I got so scared I couldn't stand it. I ran out. It scared me half to death to see those white panels. So I said, this would never do. In the meantime, I had to have someone take care of my babies while I came out to do this.

All I had then was acrylic house paint. I don't think then in California, the stores yet carried acrylic artist paints. So I had my colors laid out in great big gallon jugs and a lot of brushes, and I dipped my brush into the violet, kind of a pale violet, and I just got it and swung it all over the panels and said okay they're ruined now. Now I can start painting. That's the way I did it; I was scared to death. From then I just began with my brush to block it out, to sketch the figures, to feel their movement, to feel their love and their care and their arching desire for life, the praise to woman and the belief in a god, a creator who's part of humanity and not looking around to punish us. And the whole mural came out that way. It was slow. I still have it. I'm very proud of it.

The figures are left sketchy. I don't like things that are finished to a frozen degree. In my opinion, very few artists can do a figure finished and still retain the gesture of it. I prefer to retain the gesture. That's one of my trademarks. I love movement. I love gesture and I will not go beyond to the infinitesimal detail because to me, it destroys the spontaneity of the original work. Color has the same feeling. So it was not only a religious credo but it came to be my first one. And of course, it wasn't for anyone. I still have it stacked around the house; now and then I take it out. It's good. I think it's pretty good.

After that, I was so inspired by the Beethoven. I don't play it when I'm doing work. I hear his architecture. He, to me, is a master architect. He did spaces, he did something back then that is little done today. He just stops in the middle of the thing and leaves a space. You think the thing is over with, but it's a space, wonderful, imagine in that century! So I did the next thing from the "Credo," which is a mass in the Latin which is called the "Agnus Dei" or the "Lamb of God." In this case, it was a merciful God I was seeking and I did. I think it's the best mural I've ever done, it's nine panels, four by six but turned sideways in rows, three by three by three.

At that time in California, there were tremendous areas of acreage being repaired, but in my opinion destroyed by these huge, huge earth movers which looked like great dinosaurs. I was inspired to draw them. Instead of drawing the human figure, I drew the human machine. I went to a car dump, but it was a machine dump, and I sat on the wheels and crawled inside them, and I drew them until I was ready.

The other mural, *Credo* (1965), has muted tones, this [one was painted] in brilliant acrylic. By this time, artist acrylic was in. I did the same technique. I hung the panels, no graphing, no tracing, a lot of pre-study. I left the impulse of whatever I wanted to say, not say but discover and carry me. Unfortunately, I had an accident and it broke, but I'm going to try and repair it.

I painted the work after the *Credo*. It might have been 1965, '66, '67, maybe three years after the *Credo*. It takes me a year or two to prepare myself for a work. Now, it's a little different; I prepare myself with all my previous experience that I draw into my new work. But then I was, after all, a beginner. It's a very bold work, very musical, very good, real brilliant.

By that time I moved from California to here and had to ship all that stuff here. It drags around. I got my original stuff from Chicago and sat on my stuff to bring them. Now, I do them on a wall so I don't have to keep them. By this time, I decided to be single and no longer married, although I had three children [of my] five babies; the other two were on their own.

So I heard through another artist—we're such allies to one another if we will, if we don't fight with envy and bigotry and don't put each other down, it's very dangerous. But if we help each other, we can all grow and still be individuals. One artist said to me, "Mago, they have a grant at [El Paso] Community College, a National Endowment, I've forgotten what they called it, and they need a zany project." I said, well, I've got one. So I walked in bold as brass and I said I had an idea. They didn't think I would ever do it. They said good, write it down so we can get a grant. I wrote it down and they got the grant. They didn't know what I was doing. They had no idea, thank God or they would have never let me do it.

I had this huge, huge mural [*Time and Sand*, 1978] that I was inspired to do in the sand, in the desert, because at that time the college was at the Fort Bliss [Logan Heights] campus and all I had was sand. I asked what do I do with sand? Well, wet the sand and what I'll do is carve in it. I drew my designs. This time I still didn't do graphs or tracing. I found in the garbage can, where they had carpets, big rolls of brown paper, so I went to the community college, which was just barracks, and on one Sunday, there was no room because the mural was so big, I taped that brown paper to the street and just got a big stick and started to draw it. Right there. Now I look back and I'm aghast at my boldness.

I was like a blind person. It was so big, I couldn't see it, but I felt it. So after I drew them, I cut them out. These were individualized shapes. I had taken a big leap. After all, I'd been studying contemporary machinery, going to the future to take computerized ideas, but not really, that's later. So I decided to trace these shapes in the sand. I wanted them to be as if a computer had taken our basic human emotions, all of our universe, and made them into shapes.

That was my idea. I was taking the first step away from the direct human figure. And I introduced it to Chicano art at Community College as a course. They still didn't think I was going to do it. It was only when I met with the architect—he came to the field and saw what the students and I had begun to do out there—that he really liked it. And he told the president then, who was Dr. [Alfredo] De los Santos, who was by that time burned, ousted, and who knows what, the political turmoil. Murals are always involved in political turmoil and in revolution and change, even the innocent ones.

But I have the letter, where the architect David Hilles told Dr. De los Santos, "This mural should be in the new school." They were building a brand new campus on the Valle Verde. So with that encouragement, we went on to cast those pieces. They were huge!

At that time, I didn't know about light-weight materials, so I cast it with armatures that the auto shop did for me, then an artist friend of mine from California who's a sculptor but who's a physics genius, helped me design the armatures so they would completely support the system. From there we started to get more and more encouraged. This took three years. And each class, like the Holy Grail, they handed down this idea and they [the administrators] still didn't believe I was going to do it.

They said, "Who's that crazy lady playing in the sand with the students? Kick her out!" I have the diaries the students wrote.[69] I have complete [records] of that thing. There it is, dumped in a closet in my house. They [local archivists] don't seem to want it, but there it is. When the college was ready, the architect had left the door open where this was to be vaulted and bolted onto the wall. He had left a double-thick wall to carry the work.

At that moment when we were going to get ready to move the mural from the sand at Fort Bliss to the Valle Verde campus, I got a telephone call and head of maintenance said, "Mago, we don't want your mural, we have chairs, desks, and we've got a lot of business to do." Which didn't make me feel real good after three years of hard work and love and caring, courage and failure and rebuilding. We built that mural three times before it came out right, and it's huge.

Somehow the spirits take care of me, God takes care of me or this infinite creator or this power of creation—anything we want to call it—and always appears as a guide to me. At this time, there was a man from San Francisco, a little short guy who looked like a hippie, but an older man, not a young kid. He became the liaison between the architects and the school. So they said, go talk to him. So I made an appointment and I had my scale. The students helped me with the scale, made from little pieces of sandpaper; it's very beautiful and he looked at it. I saw this skinny man with a bunch of beads and I said, now what? He just looked at it; I was very discouraged at this point. I figured it was lost. He just looked at it. He said, "Mago, it's going to go up."

So he went and he did the fighting for me. He went to maintenance and he said, "This thing is going up, get out of the way!" So we got big truck beds and filled them with sand. I had to direct this thing. I had to make the idea myself. With the help of eight to ten men at a time, we had to lift each shape and put it on the sand bed and bring it to the campus across town and unload them, stack them up and get them prepared for the wall. That took three or four or five trips. It was tremendous. It's one of the most awesome things I've ever witnessed and I don't know to this day how I had the guts to do it.

The mural began to go up. The sculptor from California offered to direct the hoisting of the mural, and he invented some incredible brackets to support the weight in the back. I had invented some tubes to go through the work. We were just going to bolt it, but he invented some brackets. It's still up. It's fantastically strong. Everyone said, "It's going to break, it's going to fall, she's crazy, it's no good." All these things to cheer you up. We got the mural up. I directed it. We traced where we wanted the shapes and we would adjust it and when it was up, my friend had left and I was sitting on my porch exhausted, and I was sitting there one evening and I had the most horrible feeling. I got violently ill and I didn't know why. At that time, without me knowing it, a committee got together without the president of the college and said they wanted the mural down, that it was no good. You can imagine! Well, it was maintenance who had seen me work on this, me and the students, that said, "We won't take it down, we know what it's taken to hang it, it's too heavy. We know what she's done, so we won't help you take it down." So it was saved. And it's there today and it is magnificent, just magnificent.

The man who wanted the mural down made me sign a contract that I could not ask for any money for that mural which is ridiculous because I'd been paid $265 a month because I was teaching. I was starving, literally hungry. They made me write that contract. He left. He got kicked out—he was an evil person. Muralism always becomes a contest between good and evil. I don't know why. In my case, it's very true. We're like a spiritual force, out in the open; we scare people.

But they didn't even want to have an opening. When they were going to inaugurate the school I said, "Hey, these students did this and they should be informed and they should be honored." They were supposed to get in touch with them; they didn't. They had some kind of an opening. They said Mago is here, she did the mural. There was no real tribute, no honor.

Years later, I was teaching a course at the Universidad Autónoma de Ciudad Juárez through International Programs at El Paso Community College. They told me to bring my students from the college for a luncheon. So I did. And see how things work in relayed time, Einstein time. I was just sitting there and in come these catered trays. I didn't know what this was, but they were

honoring me and the mural. In Spanish, the man said, "!*Este no es un mural, es un muralazo!*/This is not just a mural, but a great mural!"

It took me almost six years (1982) to have someone recognize the enormity of this work and what it is and its presence. To this day they [the college] have not allowed for the diaries to be presented, for the maquette to be presented, for the explanation for the public. They ignore it. You can go to Stanford and get thousands of dollars for archive material and here they won't even take it. Maybe I'll send it to Stanford. Maybe they'll be interested, so I can get a good hunk of money, if they're foolish enough to skip over it.

After *Time and Sand*, I received a commission to do a mural on the adobe wall that was created by Mac Caldwell [in 1980 at the southeast corner of Paisano and Piedras]. They were building the Solar Energy Building [now the Environmental Center]. I always choose my walls. They tell me to do a wall, I go choose it. I won't just take any wall, the wall has to talk to me and this wall was magnificent because it looked like a human form.

So I designed and executed a mural [*Señor Sol*, 1982-83], and this time instead of just imbedding pieces of glass in sand, I went the next step and began to use any found material. The budget was very low for materials, so I used glass, tiles, seashells, pottery, whatever, and I made a large single figure. This was a new step for me. Instead of a lot of figures, I wanted one individual figure who had the power, or which could intercept the power, to transfer goodness of divinity, beauty, because usually it is the individual who is courageous, it is not the mass of people. I'd like to pay tribute to the individual. That was a new step for me; I'd progressed.

From there, I'm doing this mural [*La Niña Cósmica*, 1993]; it's right in the middle of a school with little children. Little innuendoes with the administrators; I wanted to do an apprenticeship program, but they would punish the students. Instead of letting them be in my class so they could get better, they would punish them for some other thing and take them out of the class.

But all this is progress; it takes time. Now they're beginning to understand. Again a mural just explodes with its ideas, with its very size. But here again, I've got another step this time—I had enough money for materials so I decided to challenge myself to do glass, tile, and mosaic. So here you see it Mike, it's in progress and it's succeeding. It's very kinetic and energetic and it's a theme of a Niña Cósmica, a young girl more or less the age of the children in this school taking within her all the culture which is ours: the Pre-Columbian culture, the moon, the sun, the war between the planets, the war between good and evil and of the courage of certain powers to burst forth with goodness. We certainly need it with the present drama which is unfolding with the Chicano environment and our Chicano culture. Our whole way is either going to be magnificent or we're going to start off killing each other and destroying one another.

So she's here to remind us, to remind us that we're beyond that, that we have great infinite powers and that we're very beautiful, and I also do it because I like it. There's a lot of philosophy to it but I did intend to do it on this wall and I did intend to do it so it would communicate to the children.

So that's it. *Ya no quiero hablar, ya apágale.* [I don't want to talk further, turn the tape recorder off.]

Lupe Casillas-Lowenberg
Interviewed by Mike Juárez
NAFTA Trade Center, downtown El Paso
20 June 1993

The mural at Sunland Park [*The Apparition of the Virgen de Guadalupe*, 1981] evolved from a class at Gadsden [High School] in Anthony, New Mexico. They wanted to do a community project. The most talented kids seemed to be living in Sunland Park. Gloria Irigoyen, a student at that time, talked to the church about the project. Her mother worked at the [San Martín de Porras Catholic] church. They lived there [in Sunland Park] and it was a real strong community. I told them we could paint a mural if we got a wall. We asked everyone in the community what they wanted on the wall and of course everyone wanted Our Lady of Guadalupe. The design was created by the students, Roberto Salas, and myself. We all worked on it, including Bobby Salas, who happened to be in town. He became my assistant and a valuable role model for the students. I did the faces of Juan Diego and the Blessed Mother. Nine years later I repainted her face. We had about fifteen kids. We did it over the Christmas vacation in 1981.

The wall was in good shape because it was cinder block. We cleaned up the wall, patched holes. We didn't have that much money, but we applied primer and sealer to the wall. The paint was donated by Hanley Paint. We used acryenamels, a polyvine sealer, and primer. It was weatherproof. The paint was guaranteed for fifty years. It was all water soluble. We used Mr. Irigoyen's scaffolding. The people from the Big 8 on Doniphan drive donated fruit to us. The people living around there made burritos for us. It was freezing cold. It took us about two or three weeks to complete, working every day, from six in the morning to late at night. We created more designs and Bobby and the students painted the handball courts, but that was after he had worked with me. He had not ever created murals. He was very good, he was great, because he would be there, *mucho ánimo* [enthusiastic] for the group, but it was more of a collective, group project than an individual one.

Again with my students, we painted original designs inside a restaurant. The paintings included Native American designs and again we worked with the best materials, with the best students, and created these murals. Every summer for the migrant program, we painted murals with the little children. We would paint four-by-four panels. We would illustrate stories that they wrote. We would

also create huge murals at Sunland Park Elementary. We did one of *La Leyenda de los Volcanes*. It was a masterpiece. They were portable murals because we would travel to the schools and tell the stories with the murals.

Even though the kids were Catholic, the kids never knew the story of Our Lady of Guadalupe, so they learned about the organization of the church and the workings of the church. The fence [around the mural] was put up about five years ago; it's very, very strange. It used to be that you could drive up to the mural at night and shine the lights on it and pretty soon someone would come out to see what you were doing because that's how protective they were about the mural.

I've always been involved with the kids in real learning situations, which is why murals are great. At Coronado High School, we had a core of students who created portable murals for stories we read. One of my past students created a business in Dallas called Sticks and Stones and Ice Cream Cones, a very unusual name. She travels all over the world creating murals and that's something she learned in high school. I've always been involved with large works on masonite or large stretched canvases. Everywhere I've worked, I've produced murals. They were created for the schools, the children, and their communities.

I used to have a studio at the former Falstaff Brewery [now the Brewhouse] and another one downtown. I lived in the old firemen's quarters in a little wooden house upstairs. I'm for the students, for teaching the community and expanding on the awareness of art. I'll work with anybody and with everybody. Creating art is dynamic participation; one is not just a passive spectator. When one creates art, there is an awareness of the environment—it is emotion, spatial and spiritual action involving an audience or community. What is important is the relationship between the two, the interaction of each other at every phase of the piece.

I believe that art was created by God to enable us to use both sides of the brain and communicate with the higher self, to be linked with the creative force, and to continue the process of creation, not destruction, to give us joy in our daily lives. I didn't take on the creation of more murals because there was never really any funding. I had to provide everything. I had to research the wall, prepare the wall, work with kids, teach them. I was young and I had my children who I couldn't leave. Often they participated in my projects at the time. I had to have a full-time job so I could support my family, and then I loved teaching. I was limited to the circumstances of my life. Now I have no regrets. I have the freedom. I'm still young and healthy and can create murals. [I have influenced numerous individuals who have gone on to paint murals.] There's Becky Bencomo, Susie Kratzer Davidoff, Karla Fausto, Hal Marcus, Irene Soto—I could go on and on with kids who are still creating work in the arts, but they all started with me at Coronado High. Many of them helped me when I was a teacher at El Paso High. I feel that if I can teach somebody well and if they

can go out and teach someone else, then I know that they have learned it. Now my dreams are coming true. Now I can paint a mural and I can do it by myself or with my students of the community.

The reason I think women haven't been involved in the area is that there hasn't been any training. I wasn't trained at UTEP. We had three hours of Mexican art history from a professor who had never been in Mexico. Luckily my parents took me to Mexico on their summers and allowed me to work with muralists refurbishing their works. In Guadalajara, I assisted the muralists in small details in either mixing paint or assisting them in general. I also learned how to do sculpture by apprenticing myself to Militón Salas, a stone carver. I learned how to carve on stone. Whatever they would allow me to work on, I would do and I would keep myself very humble. I would ride the buses to the sites. I would eat what they ate. I attended the University of Guadalajara in the summers and I did work there.

When my children were young, I would leave them with a baby-sitter and I would enroll in drawing classes. There wasn't a formal plan. If it hadn't been that God has been good to me and that my parents came from Mexico and exposed us to our culture, I would not have developed my work. Our parents took us everywhere in Mexico: every ocean, every lake, every park, every museum, every shrine, and every church—we just lived off of that, it just fed our spirits. We learned about the history of Mexico through the murals of the Mexican Revolution. And my parents took great pride and joy in teaching us the history of Mexico.

I'm a mother, a teacher, a member of the community. What can I do to make the community better, more exciting and more meaningful and a place where the kids can appreciate? I've been involved in numerous projects outside of the community that I never got paid for, but my kids learned a lot and I was able to share my skills. I feel that part of me is at Sunland [Park]. Part of me is at Mesquite, part at San Miguel [New Mexico]. Part of me is with every student, and every student is in me. I don't have any complaints. As far as [being a] woman [and painting murals], it's hard because it is hard to move scaffolding. It's scary to be up on a very high scaffolding; you have to be in very good physical shape to be able to take the wear and tear. The physical limitations are serious.

I feel bad for Mago [Gándara] because I think she has not had the best working conditions. She has chosen to work with a very difficult and time-consuming media. I appreciate her. I love her. And I've learned a lot from her but I've said to myself: that's not the way I'm going to do my work. I like the art room, studios, and some walls. Mago works differently than I do, but I think she's great! Another example of an exceptional artist is Ysela O'Malley, who was also an influence on many of El Paso's artists.

In the creation of the mural for the Unite El Paso Congress [*Unite El Paso*, 1993], I worked with Melvin Moore, a local architect.[70] He designed a black-and-white sketch and we added the color. It was in good proportion considering they wanted it to be 25 by 50 feet. Had they given me at least a month, maybe I would have painted [a better] mural. They gave us four days to paint a 15-by-25-foot mural, which was actually a fine arts piece.

I took the kids to look around the buildings [at the El Paso Civic Center] so they could get an impression of the immensity of the place and the feeling of the atmosphere that place creates. We had photographs and a gridded drawing to scale. I taught my assistant, Rosa Salazar, how to select the palette of colors we would be working with. I couldn't take everyone. Normally, I would take the whole group because they need to know where to go and take stuff, how much materials cost, and why you use some products and not others. I picked the color scheme, figured out how many square feet a gallon covers, and so on.

When you work with students, you don't work with the cheapest materials, you work with the most expensive or the best materials, because if you make a mistake you can go back and change it; it won't tear on you, it won't fall apart. That's what we did. Some of them had never painted. My computer [graphics] students were the ones who came through on this one. One student had mixed paints before. I also had one student who had done stage work, but had not created murals. We didn't even have a place where we could stand it up because the first two days we worked on it without having it stretched.

We worked in the Ysleta High School auditorium. I worked three nights and four days, but the kids were so enthusiastic that they were on time every single day and at night they didn't want to quit. They actually put in more hours than they thought. Everyone thought we wouldn't finish in time, but I told the kids, "I have experience and I can tell you how much time it will take me to do one panel." We also had no water and no air conditioning because it gets turned off after the school closes. The kids found out that it's not all glamorous to be an artist.

I don't have any doubts about myself as an art teacher, as an artist, because I know I can do the best job and I can teach people how to do the best job and now I am in a position in my life where my dreams are coming true, and that's beautiful. And these dreams can come true in El Paso. I didn't want to go elsewhere. I liked it here. I liked raising my kids here. I hope that everything I've created which lasts, my great-grandchildren can see.

What I'm doing is going to be done correctly. I did take a class in commercial paints. I actually belonged to a painters' union and I taught there. I don't know of too many artists who have put themselves through that. I learned the chemical composition of paints and how to intermix them and so on. I'm teaching people who are working with me to do it correctly. It's combining the

technology with the traditional approach to creating a mural, the social message, the context of the piece, *todo esto*, and I'm lucky I can teach all this. I get the community involved because I'm working with kids from different parts of town. They're working together and loving it. They don't see the kid from Coronado [High School] as [being] a snob; he's a hard worker. And the kid from Coronado sees that the student from the Lower Valley might have long hair and be dark, but he's a fabulous artist and he's so smart and they like the same music. To me, a mural almost represents a time in life. It's my life, sharing my life with them and they with me—a community life. And this is how one develops a sense of community.

It's like the French philosopher who said, "If you give me a fish, I'll eat for a day. If you teach me how to fish, I'll eat for a lifetime." And that's what I'm after. The art world puts pressures on artists; it's only a judgment in material wealth or a reward for the artist, but the real wealth is how the artist integrates with the integrated whole, within self, morals, ethics, and vocation. Those of us working in the community work together for the "greater good," *para hacer el bien.*

I am content when I think about my life as a mother-artist-teacher and a member of my community. I know that I am blessed to have worked with everyone God has placed in my path. I can't speak for others, but I've had an ideal life. My children and I experienced life together with my students, my schools, and my community. My imagery is rooted in those experiences, manifesting in creative responses of being. My hands are not empty and I am still striving for more and better works. My long-term goal is to achieve excellence.

Today we are in the middle of major paradigm shifts, changes where we'll have to align ourselves in more creative ways of healing within our culture. I agree with what Charlene Spretnah wrote in an essay titled "Re-weaving the World," where she says we need to work for ecopeace, ecojustice, ecoeconomics, ecopolitics, ecoeducation, ecophilosophy, ecotheology....We need to heal. We need to be in balance.

Art plays a pivotal role in that healing. It soothes us; it gives us opportunities to experience new things, to grow and to become whole again. Art fulfills that balance and makes us whole. Yet we can't meet wholeness alone. We need to reach that wholeness together. Only when we work together, will we be using art to *hacer el bien.*

Felipe Adame
Interviewed by Cynthia Farah, Mike Juárez, and Mona Padilla-Juárez
Clínica La Fe, El Paso
13 July 1989

I'm different in the sense that I don't consider the works I've done being my own. All the projects that I've painted in El Paso, with the exception of two, have been community projects where a group of people were involved in getting the project completed. It was true I was the artist who painted the mural, yet it was a community as a whole who worked on the project. So I want to emphasize, every mural that I've painted has been a community effort. It was the community that chose the theme, the artist, and the site itself—that's the philosophy I have.

I painted my first mural in El Paso in 1981. I've painted murals in California, in Colorado, Montana, Kansas, Washington, D.C., Mexico. I consider murals which I have painted as a means to preserve a culture, to retain heritage, and to value the community-organized effort behind a work of art.

I painted murals at the Armijo Recreation Center. These projects were initiated by the Thunderbirds, [the Armijo] Senior Citizens group, and Junior Robles, the director of the Armijo Center. Robles invited me [to the project]. [The City Department of] Parks and Recreation [supplied the] wall. We received donations from individuals in the community and businesses.

I have the original paper sketch. It was taken from a calendar by Jesús Helguera [see Appendix D]. I have it right here. I simply took that and copied it on the wall. I drew it to scale on paper. I transferred it from the paper, perforated the paper, and transferred it onto the wall. It was a brick wall, and we needed materials to make it a smooth surface. The Thunderbirds,[71] who would hang around the corner, found one of their fathers to plaster the wall. He was an expert plasterer. Even though he had arthritis, even though he was retired, [Ignacio Guerrero] literally came out from his bed and taught us how to plaster the wall. He taught us how to prepare the cement, the sand, the gesso, and prepare it for a mural. The ladies from the Senior Nutrition Program held raffles and sold ceramics [to benefit the project]. They even fed the artists and the youths [painting] the mural. It was a real collective effort.

The Aoy School teachers would bring their elementary grades into the center when we were painting the mural. We would tell the kids the legend behind the mural. Later, the kids would come back with their own little drawings and their own little stories.

We still see those kids, who're now in the eighth or seventh grade. They still remember the experience of having been involved in the process of creating the mural. The painting of that mural took approximately twelve weeks. It was around the clock. It was a non-stop project. It was myself, Elizabeth Joyce, Raul Macillas, Nacho Guerrero, and Jesús "Chuy" Hernández, Machido.

The beauty of creating the mural was that the project was not funded by the city. It was not funded by the Parks and Recreation Department. We didn't get any funding from any established agency. We appealed to the [City of El Paso] Arts Resources. We appealed to the [El Paso] Arts Alliance. We received real small donations like twenty dollars, thirty dollars, but nothing substantial. Everybody worked on it. Nobody got paid for it. Community support is necessary. In San Diego there's a Chicano Arts Council, [which is] involved in the [production of] murals. It's a collective effort. They pay for the program development and for the proposals. The artist does not have to contend with any of those activities, only with the subject matter. In El Paso, we don't have that unified effort.

I would say that the [El Paso City] Council, whatever you would want to call it, would form a support group. My understanding was that the [El Paso] Arts Alliance was designed for that purpose.[72] That's what I thought when I was first introduced to the Arts Alliance, that they were going to form a coalition. It's been so difficult to obtain anything from them in terms of community efforts. I've begged at their meetings. I've submitted proposals and never have I received any kind of endorsement nor any kind of support—but yet when I'm unveiling a mural they seem to take part in the unveiling.

I also painted the *Cuauhtémoc* (1981-92) on a historical building on Eighth and Santa Fe streets [formerly Villalva's Grocery].[73] That wall had a mural which was painted by a fourteen-year-old kid who painted the story of Pancho Villa and President Taft. The community asked me to update it. I started with the Aztec culture. It was going to move from the Aztec to the Spanish, to the Indians, [and then to] the evolution of [other] historical figures. But I was left alone because everyone I appealed to said, "Another mural? That's all you want to do. You just want to get your name up on the wall." So I said, "You know what? Forget it!" I just left it at that.

I painted the Virgen at the Salazar Projects [*La Virgen de Guadalupe con Juan Diego*, 1983, restored in 1991] after we completed the Armijo mural. In 1982 the Cornejo family got the Housing Department [Authority] to plaster the wall. They were the very first committee to get permission from the Housing Department to let them paint a mural in El Paso. The Thunderbirds also were involved in the project. In fact, the Salazar Housing Committee, which was already organized, recruited me for the project. I made myself an instrument of the community. I don't charge for my murals—because it's a collective effort. The committee said, "We want

Felipe Adame to paint a Virgen of Guadalupe." At that time I was doing a painting of the Virgen of Guadalupe for the Church of Our Lady of Guadalupe on Alabama [street].

I painted that theme because they wanted a painting of Juan Diego and the roses. Many people got involved in the creation of the mural. Every day I would have five new young people come around to help me paint. They would stay on for a couple of days, then a new group would replace them. It was a very beautiful evolution, where almost everyone in the community got a chance to put a little bit into the mural.

A sixty-two-year-old lady got up at five o'clock in the morning so no one would see that she was working on the mural. She would get up with me when it was still dark in the morning, and paint one of the roses. Towards five o'clock in the afternoon, a little girl about four years old would come out and work on the mural, just for a few minutes, then she would leave. But the majority of the kids who worked on it were thirteen-, fourteen-, and sixteen-year-olds who were just willing to get involved. We financed the mural by dividing the wall into square feet and we got a sponsor for each square foot.

The League of United Latin American Citizens (LULAC) bought a big portion of it. Ruidoso Grocery Store bought a big portion of it. Each day we would get three or four sponsors, thirty or forty dollars, and it would go towards the wall—and that's the way the mural was financed. It didn't cost the community any money. To this day, people still think I made a lot of money off of it. That mural took about six months to complete.

We started painting the mural in the spring of 1983 and finished during the fall of that same year. Bobby Adauto, the director of the Lincoln Cultural Arts Center, offered me the park and the pillars. [He wanted me to paint] murals similar to [those found in] Chicano Park in San Diego. The Virgin of Guadalupe [*La Virgen de Guadalupe with Roses*, 1981] is there because the community wanted it there. At one point [in history] there was a church they [used to call] El Santuario located there. It was a historical rock church made up of volcanic block rock.

When the [Texas] Highway Department built the Spaghetti Bowl [a freeway interchange], they tore up that section of the community. The city made a promise to the community that, even though they couldn't have the church anymore, they could still hold mass in the Lincoln Center. I guess the guiding force of God led me to that pillar. I didn't know at that [location, there had been a] church. All I knew is I had a very strong desire to paint the image there. On the other side [of the highway pillar], I was going to paint a Jesus [Christ].

I was going to [continue to] paint the whole revolutionary figures [*Emiliano Zapata*, 1981] [under the Spaghetti Bowl], but that's as far as I got. But the city has done nothing to cover up these works. They go to cover up the graffiti, but they don't cover up these works. I don't understand that. Now that I have a little bit of color, I'm considering going back out and finishing my work. Even the steel company—they let me borrow scaffolding with stairways. They were willing to commit. The Easy Electric Company and the Triangle Electric Supply Company—they all made a donation. I have plans and designs for the pillars. I envision a lot of young people of all ages working on a pillar at a time. Each school in the community can have a pillar. Each group in the community can have a pillar. It's a beautiful place. The arts are found there.

I also left a mural inside there [Lincoln Cultural Arts Center], too, Bambi, in one of the daycare rooms downstairs, a beautiful Bambi with a butterfly on its tail and Thumper and *como se llama ese* [what's his name], Flower. The ladies from the daycare center asked me to paint it.

The one [*Iztaccíhuatl and Popocatépetl*, 1987] that I'm working on at Campbell [street], that's an oil enamel. Everything is oil enamel. It's expensive. This is when a group approaches the artist rather than the artist or the community painter approaches a group. The group came and recruited me. Quinta [Fifth] Street. Varrio Quinta Street (VQS). That corner is very famous for spray and inhalants. One of the ideas we had as muralists was to promote positive activities rather than criticize their negative actions, by involving them in constructive work rather than criticizing the negative or lack of activity. What we saw there for years were the "spooks" as they used to call them. They would wear these long leather coats and inhale spray. And they would sometimes paint their faces—silver. At night they would look like a ghost; so they were called spooks.

I kept telling them not to spray their lungs, but to spray the wall. I told them every time they wanted to work with me on that wall, they had to be straight and sober. It's good to come down and say "Hey brother look at me, I'm clean! I haven't done spray in over two days." You get up on the wall with them. You may affect them or may not, but it's an effort. And the mural is an instrument to communicate with them. I have another work in Chihuahuita, on Canal street. Nico's. That mural [*Easy Rider/In Memory of Nuni*, 1985] was done in memorial to his son, who was killed while riding his motorcycle.

The mural on Fifth and Campbell [VQS] was painted with oil enamels. That one, I have been financing it myself. I have received a donation from We the People, three hundred dollars. It's been the only donation I have received. It was through the Renaissance 400. It was a campaign to celebrate the two-hundred-year anniversary of the [U.S.] Constitution. That mural originated because Albert Gómez, they call him "Spider," got photographed because he has an emblem of a Madonna on his back, tattooed.

The police had come out with a statement a week before saying that there was nothing that the police department could do about gangs – that they tried all avenues to change them. It was a real negative article on the gangs of South El Paso. Albert Gómez had raised the issue and had said, "Hey, we're not all bad. Some of us are doing something good."

When I read that article, I met him and he approached me with two of his partners, El Cuate and El Sobeck, since I had done work with the Thunderbirds, Los Mestizos, and everybody else in the community. "Why can't you do one with us?" So I said, this is the opportunity I have been waiting for—to keep these young men from spraying onto the wall. So without them knowing it, I was doing free-lance social work. And that's when the clinic [Clínica La Fe] recruited me to come and work for them.

I also painted the *Dale Gas* (1982). It was a play on the gas company. First, we had painted it on the pipes because there's a Chicano expression that says *dale gas* [get in the car, let's take off]. Or somebody wants to get it on with you, "Dale gas!" So what we did, the Zoot Suit is saying, "*Dale gas.*" But in a sense, we're trying to get the gas company to give us the gas. So, it's a juxtaposition. The owner of the store [Arturo García] wanted a zoot suiter and his car and the El Paso and Juárez skyline.

We painted that mural when the movie [*Zoot Suit*] was coming around to El Paso. We also painted works in memory of the young men who have been killed in gang wars. Across the street there are eight thunderbirds [in 1981] that were painted as tombstones on the sidewalk. We painted La Virgen de Guadalupe [on La Corona Grocery], *a ver* [to see] if she would bring us peace.

The *Aztec Calendar* (1981) was painted by Jesús Hernández, "Machido." He's disappeared, too. It's been a year and a half that he's disappeared. His son was drowned at Armijo Center. Then a few years back his little baby son fell into one of those ditches in the street. They were digging out the sewer lines, and he got killed—a lot of tragedies. He's been one of the muralists here in Segundo Barrio. He also worked on the Madonna [*La Virgen de Guadalupe* at La Corona Grocery]. I have another mural in Canutillo. It has covered wagons crossing the Rio Grande. It's located on the side of the Harris Western Wear Store. I painted it in 1981, *también* [too] with acrylic. That was just a historical mural because that's what happened in Canutillo. Canutillo used to be a lake, a swamp. You could only cross [the Rio Grande] at a specific time of the season.

The handball court *Thunderbirds, El Chuco, Tejas* was painted by them [the Thunderbirds] in 1981. The *Virgen de Guadalupe* (1981) was done in memory of the Thunderbirds who have died, in a way maybe to make a peace with the neighborhood. Every year they have a mass and an offering. It's nice. It's like an outdoor church during the day of Our Lady of Guadalupe, December twelfth.

I have another mural inside the Bear's Kitchen [the bear is Bowie High School's mascot; Bear's Kitchen was across the street from the school]. You've seen the bears, *qué no* [haven't you] inside? It's a seafood place now on the corner of Sixth and Cotton [streets]. There are two big bears [painted] on the whole wall.

I met [José Antonio] Burciaga in Washington, D.C., in 1971. He was doing illustrations for a number of companies. We got together in his basement in Arlington, Virginia, and we came up with a painting together. We used every medium we could think of. And after we finished the painting, I don't know what we did with it. I think we folded it up into little squares and wrapped it up and mailed it to someone.

In his work at Stanford, he painted a Jesus being disrobed before he was placed on the cross. It was a replica of an original masterpiece by an artist in the fifteenth century. He did it with a collage of cutouts of magazines. When you would look at the collage, you would think it was just like the original. But *hijo, ese* [incredible]!

I also had murals at El Cerezo Restaurant at Mesa and Missouri streets. When the restaurant closed down, the owner was able to buy back the paintings from the bank, all for two thousand dollars. He [John Salpas] has them in a garage. I have some slides of the work. Those were done specifically for the first El Paso Street Festival. That was my contribution to the Arts Alliance. They were decorating the lobby of the Civic Center—when they had the big cake [Four Centuries '81 celebration]. It was an incident where Rob Hankins invited me to bring the paintings in for an exhibit as a contribution from the community. But the other artists, they didn't see that as a contribution. They saw it as an artist who was getting a free exhibit. And I hadn't paid for the space, like they had. They couldn't separate [out] the fact that I was a non-profit community artist, simply contributing to the festival. What they saw is why should we pay and he not pay? So, in addition to that, I was doing portraits in front of the murals and making money. So they objected about that, too.

They had me removed from the Civic Center under guard because he got the order that he was supposed to remove me. And I said, "If you remove me, I go with everything!" And I took all my paintings and put them outside. And I put up a sign saying, "These murals have been evicted by the Arts Alliance!" Rob Hankins came out and said, "I didn't mean for your paintings to be escorted." I asked, "How can I leave the premises and leave my work there?" [State Rep.] Paul Moreno saw what was happening, [City Rep.] Jim Scherr saw what was happening, and they said, "This is crazy!" So in a minute, the issue got resolved and they put me back. But ever since then, I don't think the Arts Alliance has wanted to associate themselves with me. And I don't blame them because I'm very critical of how easy it is for a group to solicit money for the arts and retain so much for administrative costs.

Several of my paintings also burned down at Sal's II—the club which used to be on Alameda [avenue]. I had left my paintings there as collateral for a loan I received from the owner to travel to Corpus Christi to exhibit. When I returned, the place had burned down. All my paintings had been burned up, too. It was like ten years of work up in smoke. I never received any compensation because they were uninsured.

I also have two paintings at Guadalupe Catholic Church on Alabama [street]. Another mural, *The Adoration of the Magi*, is 14-feet by 7-feet; another at the Hong Kong Restaurant, 6-by-6 feet, is comprised of one hundred birds.

I love to paint.

Carlos E. Flores
Interviewed by Mike Juárez
Chamizal National Memorial, El Paso
9 March 1994

Well, I was born in Chihuahua. They brought me to Ciudad Juárez before I was a year old. I grew up and went to grade school in Ciudad Juárez. The place where I grew up was in downtown Juárez, along the railroad tracks across from the [Alberto Balderas] bullring. That was my home. In the bunch I ran around with at that time, the idea was to survive one way or another. Most of us kids were motivated to accomplish something in life.

It was predictable: you could choose between being a bullfighter, a boxer, or a singer. Almost all my buddies back then ended up becoming bullfighters, boxers, or singers. Thank God I was lucky enough—it *was* luck—to see the works of [Antonio] Berumen [Sandoval] when he was still just painting a few murals there at the Río Bravo Hotel. [He also painted murals at the Hotel Continental in El Salón Azteca in Ciudad Juárez.] I was still pretty young and was attending grade school. Those murals were painted back in the forties or fifties.

Jesús Helguera was important because he became the most popular artist. The works of Diego Rivera weren't very well received by people because he was more sophisticated. He was more historical, more didactic, more of a teacher. Helguera's art was for the people; I'm sure he had classical training in his art, because his compositions are all typically classical.

They're Indians standing there like Greeks, you know? The composition is really well done. But his Indians are finely crafted, well worked. Their anatomy is carefully done. And there were the illustrations of legends reproduced every year in some calendars that were given out free to people by the El Aguila cigarette company. Those calendars were very popular for many years in Mexico. And other popular painters, the ones who were painting murals and commercial stuff for businesses, got a lot of material from there. Even one of the first murals—not the very earliest, but one of many that were around here in El Paso besides those of Tom Lea, Jr. and other painters—in my opinion are more illustrative than mural.

They're very illustrative of history. But Lea is a good illustrator. [José] Cisneros also paints that type of art, and very well. Here in Armijo [Center], Felipe Adame did a copy of an Helguera painting, and it was a fine copy. Really well done. It's the only one of its kind I've seen.

Later, in Mexico, Berumen began to make some magnificent copies, much better than the ones here, at the Río Bravo Hotel, which have survived to this day. There they are; you can go take a look at them, you know. If they're not visible it's because they put up a laundry, or who knows what it was. That's what they did: they covered it up and made divisions. They covered up the marvelous reproductions of those paintings. There's one titled *The Abduction,* where a guy is carrying a girl off into the night in his arms. He's just stolen her away on his horse and everything—what a romantic concept. But it's painted so well, really well.

Berumen inspired me to paint, because actually I've always drawn. I can't even remember when I started to draw. I recall when I was in elementary school, in kindergarten, sometimes the teacher would send me to the blackboard and have me sketch maps of Mexico. Later, when I was in the upper grades—third, fourth, fifth, sixth grade—I was always drawing maps in the classrooms. I knew them by heart. I remember how ever since kindergarten I started to draw what I saw: bullfighters.

Back then, down in Mexico City or here in Ciudad Juárez, times were good because the war was going on. There were a lot of soldiers [from Fort Bliss] in Juárez, so the bullring was full. It would fill up beginning on Saturdays, when the people from El Paso would start to come here to Juárez for a good time. Juárez was like a big town, not a city yet. Downtown only extended as far as Constitución street, and that was the end of downtown. And over there was Altamirano street, and where it stopped was the edge of Juárez. And then the railroad just up to the station. And coming in from out that direction, the Río Grande. But I remember it well: the bullfighters didn't even arrive in cars or any kind of vehicle—they just went to a hotel called the Hotel San Carlos, which was over there on Juárez avenue.

From there they would walk to the ring with all the picadores, the banderilleros, and their whole team. They'd go on foot to the bullring like clockwork, with the crowd of young people cheering them on and everything. And I was a part of that young crowd, because I sometimes sold banderillas. I'd sell cushions, too. They let me into the bullring. That's the environment I first grew up in.

Well, as I was saying, I always drew. I slowly began to draw all those images, and they're still vivid in my mind, so I can start drawing them at any time. I can bring them back again. After that, I was in grade school and started to see Berumen's work and started to get really interested in how he mixed colors, the way he handled his composition. I didn't exactly understand how he started out on the blank wall, because you couldn't see any sketched outlines on it. He probably just went along doing one part after

another based on what he saw. But he probably did have something sketched out because it always came out right, and there wasn't any distortion to speak of. Those paintings are still there. They're really well done. From that point on, I devoted myself exclusively to painting, and I've been painting ever since.

The first chance I had to really study with a painting teacher was when they offered some classes in Public School 29, where I graduated from. They were night classes. Several teachers began to give classes there. Once again I was lucky and came across some books about painting, like Leonardo da Vinci's. I carried that book around in my pocket as though it were my Bible. I had that book on me everywhere I went, and a sketch pad too. Because that's what Leonardo said: that you had to draw everything you saw. When I got a little older and was in junior high, when I got out of junior high, I started to do more work, but still not professionally. I was working at a lumber mill called Kilometer Five, where they would bring in raw lumber from the forest. My job was to keep count of the lumber and prepare the tally sheets for shipping it here to the United States. All the good wood came through here. I had a lot of time to draw and would always have my stack of papers with me. I began to draw the workers. That's where I learned all I could about the human anatomy in motion.

I would draw the workers. I did thousands of sketches. Besides that, I drew everything else following the precepts of Leonardo in his book. Everything that I would find—like stones—I'd put in, change it around, take hold of the papers, hold them up like this and try to get all the nuances I could see—with birds, with everything I found. Even lizards, anything I could find, because back then we were out in the desert. The Kilometer Five was on the outskirts of Juárez. I put my first paintings in an exhibition they held in Juárez, the "Book Exhibition" there at the edge of the city on the highway.

Then, after that, my family came here to the United States. Right after I came to the U.S., the next year I had to go to Korea, in the fifties. When I was in the army they made me a military engineer. So my job was to make drawings for portable hospitals, and the like. That was my job, but at the same time, deep inside, I was feeling the urge to paint, because I was always painting. I was always doing sketches of the soldiers and stuff. I had thousands of drawings like that when I got out of the army. The only thing is, in time they gradually became lost. But when I returned to the States I just couldn't stand it any longer and I went back to Mexico. As soon as I got back, I left my duffle bag here with my mom and I took off for Mexico City.

There I entered the Academy of San Carlos, but just as an auditor, not a regular student. I studied with maestro Luis Nishizawa, who continues to be a close friend. I think he's one of the greatest landscape artists that Mexico has had in the past thirty years.

He put together everything that was left of Dr. Atl [Gerardo Murillo] and his ideas of how to paint Mexican landscapes.[74] That, and he also put together things by José María Velasco and Velasco's landscapes, which were still very academic. From the landscapes of Dr. Atl he did an about face and was very modern, but sometimes his technique failed him because he was one of those Renaissance types who tried to invent colors and everything, so sometimes his colors didn't come out right.

Then maestro Nishizawa became sort of a bridge between those two tendencies, and his painting for the past twenty-five to thirty years has been devoted exclusively to landscapes and to completely modern, even abstract work. And like a good Japanese—even though he was born in Mexico and everything, his father was Japanese—he's got that thing where he's very studied and very methodical. So for me his work is among the best there is today in Mexico, because he's got the technique.

I studied with maestro Ignacio Asúnsolo, who taught me sculpture, and I learned a great deal from him, because maestro Asúnsolo was responsible for shaping most of the sculptors in Mexico today—the professional, the good sculptors. He's a real pro, from head to toe. Maestro Asúnsolo is from Chihuahua too—that's the thing—because there have been a lot of very talented people from Chihuahua, like Siqueiros, who gained such recognition worldwide. Unfortunately, in Chihuahua they aren't given the credit that they should have received. For example, there isn't a single mural done by Siqueiros in Chihuahua. There are murals by other artists, though, like Aaron Piña Mora and Alberto Carlos, who are both friends of mine as well.[75]

I left there in 1969. I left because things got pretty tough with the student movement. At that time many of my friends were students there at San Carlos, and I was already an adult.

So, politically it was a hard time in Mexico for students, because the student movement was getting under way, until the massacre that happened. That was at the time the Olympics came to Mexico City. I was involved in all those movements. Then once, when I returned home, the lady from the building there told me, "Look, you'd better not go into your house." So I asked her, "Why not?" I wasn't expecting anything. And she told me, "It looks like the police are there."

So I said OK, what can I do? I'll just leave, it's all right. I came back to the States. Here at UTEP I studied with all the teachers who were there in the seventies: [Loren Gene] Janzen in engraving, Sally Bishop, and the others I don't even remember. I studied engraving, ceramics, everything, because everything interested me. I was even interested in doing something that I still have in mind: doing ceramic murals using ceramic techniques.

I was also fortunate to have contact with David Alfaro Siqueiros, who was also born in Chihuahua. In his later periods he tried to combine sculpture with painting. In the last work he did on a mural, he tried this combination and to a certain degree accomplished it in the *Poliforom*. That made a very big impression on me, and I would like to do it again here.

A mural is not really just a big painting. The mural is another medium: composition must be done differently, and light must be taken very much into account, as must the space in front of the wall. The architecture of the building must be borne in mind so that the two things won't clash, and at the same time you've got to try to make it as free as possible. Try to get the architecture not to do anything for you but just to help you and give greater emphasis. I got a group of guys together and we did a mural there at UTEP, which was really the first one at that time, and later they painted others.

That mural [*Pollution*] was painted in '73. When I was doing that mural some guys from here in the Second Ward went to ask me what they could use, what colors and all. I gave them all the information, and they did some murals that were the first in the Second Ward [La Campaña murals]. I was one of the advisors on that project.

The theme of the mural was pollution and what could be done to solve it. In other words, I put it basically in terms of creation, in terms of religion, and in terms of science. From the religious point of view, there were Adam and Eve nude. That's the reason they erased it later. And that mural was there for about ten years. It measured about eight to ten feet high and about thirty feet long. The name, I think, was *Pollution*, or something like that. It was acrylic on marble dust, and the whole combination I did for that.

After that, I did easel painting almost exclusively, because here in El Paso there wasn't yet—and still isn't—enough of a response to the needs of mural painting. Mural painting is something very special and requires support from the government and even more from the private sector. People aren't very accustomed to seeing murals here.

After that, I worked for three years with an association that provided work to school children during their vacation time. The PIC, that's it, the Private Industry Council. I did three murals with them. I didn't really like the way they ended up, because unfortunately they had to use kids who often didn't know how to draw and then set them the task of finishing a mural in less than a month.

I also worked for Ballet El Paso for nearly ten years. They still call me when they need me. I did all the work on the ballet, the sets, along with Mr. [Albert] Ronke of UTEP. Sometimes he had the idea for the design, and I would do it, and I did the painting at the same time.

I painted one thing at the Brewhouse, where I lived. I painted at the end of a little hallway, where there's a guy from Budweiser or some beer—because it used to be a brewery there[76]—a guy with a big belly. But it was just a favor. There's still really no art there.

The mural in the Chamizal [*Nuestra Herencia/Our Heritage* (1992)] was something where it was a combination of my need to find a place to paint a mural and the need to paint a mural at that moment. That mural had been assigned to somebody else to do, but apparently that person was going to do something simpler. He was going to use elementary school kids, first or second graders no less. It would probably have been something very nice, you know? But it was going to be smaller. He was thinking of something smaller.

After that I was looking for a place. Originally, the plans that I made were to scale, and it was going to be done at the Civic Center, at the entrance and at the sides of the Civic Center. But the city seemed to be putting me off and stalling. They told me we had to wait for up to two years, and nobody wanted to take responsibility to give the go-ahead and get the thing going. So for that reason, we looked elsewhere. And right when we were looking, this person who was going to do the mural told them that if they wanted, they could look for somebody else, and we went to see the space.

I spoke to [Bill] Sontag [superintendent of the Chamizal National Memorial]. He's the one in charge here, and we came to the conclusion that the space really was ideal, because it was inclusive. I made it twice the size it was going to be, because I needed more space in order to get everything I needed in there.

So basically the mural attempts at first to focus on what El Paso is, after so many years and everything, apart from the image people have of the Southwest, which is really a myth. Because that only lasted twenty years in U.S. history. But it's been sold to the people for centuries. And those myths never existed, stories of gunfighters and everything, right? They shot at each other like anywhere else. They shot from their hiding places and got rid of their enemies just that easily. They didn't stand up in broad daylight with their guns at their sides and all that. That's just a myth, isn't it. That never happened.

But it's a nice myth, and so people have believed it and especially because John Wayne and all those other famous guys did it. I mean, when I've traveled around the world—I went to Japan and I've been lots of places, like Spain, and elsewhere—and people hear about the United States, the first thing they talk about is the Southwest, and those people think it really existed. They think the wagons are still rolling, you know? So for me it's something of a joke. But it also has its tragic side, because it hasn't allowed the real

history of the Southwest to be told, with all its scars and bruises, all the good and bad times it has had. It's prettier to live the myth than to live reality, huh?

So that has kept many of the things we left from having their name. But in this case, I had put all that into the mural. I had the scientific part, the movement after the death of [John F.] Kennedy, and NASA. I had the things peculiar to this region—music and dance—and a lot more than what was in the project. And I brought one project and created another.

I presented them to Sontag and said, "Look, these will work, because it's basically the same thing. It's a celebration of our region. All I have to change is a few aspects of it." I wanted to put in the three main representatives of the American, who should really be called the North American. Not American, because we're all Americans, all of us. But they've stolen the name from us. That's really the way it is. The U.S. has taken the name for itself, as though they were the only Americans. Actually, we're all from the American continent. Whether North, Central, or South, we're all Americans. So, to divide it up somehow, I put the Negro, the American American [the "white"], and the Indian (the latter from all regions here in the U.S.). Because there are Indians here in the southern, central, and northern sections of the country.

So I put them in just as symbols—the Anglo, the Indian, and the Negro. Sontag asked me why didn't I put in a famous female singer I had heard of but I wasn't really sure what she had done in her life. He helped me to understand who she was. He suggested I paint in the face of Marian Anderson instead of that of the Negro. Anderson was the singer who was involved with the black movement here [before] Martin Luther King and others.

For a time she was the only one to hold up the flag of the Negro here in the United States. And she had never been recognized. And some horrible things happened to her, like she wasn't allowed to stay in a hotel right here in El Paso. They didn't let her stay there because she was black.

But aside from that, I divided the first mural into that and then the second mural with the eagle of the United States also in the first mural, and I naturally have my beliefs about the right and the left in the U.S. and how they work, and I've seen how they do things. As for me, I'm liberal and proud of it. So I put the eagle's talons with the arrows and everything on the right, the objects of war. And I put the olive branch on the left. Because for me the left always offers greater opportunity, even though they might not be from here in this country. Although I've felt like an American from this country for many years, because I went to Korea and everything, and what better proof can you give a country than offering your life for it?

So, in the second mural I also put in the Indian as a principal figure, as the origin, and then I put the Spaniard on the other side, and the result of the two is that we are all Mexicans, the only difference being that in Mexico we kicked the invader out and sent him packing back to Europe. That is, after taking from him many things that have always been positive for all Mexicans, like religion and culture, and the Spanish language.

And for us Spain is a second mother. Spain is more than just family because of the culture it gave us. So that's why I put the three representatives. Then I added the Voladores de Papantla, because for me they represent something that was here before the arrival of the Spaniards in Mexico. They represent the union of man and heaven. The flutist is communicating with the gods of the heavens and is passing the message on to the four compass points as the Voladores de Papantla descend until they reach the ground and in turn pass on the message to the people.

So that was my motivation to include this as a symbol. Then, on the other side, the focal point is Kennedy, because he was the first one with the vision to realize that the mixup over the Chamizal, with the river changing its course every year and all that, could be resolved peacefully for the good of both countries. And he had the vision to accomplish it. And at the same time he had the vision to see the possibilities of space flight and NASA. That's where there's a nude figure there trying to reach the stars, because that's it, it represents that aspect. And then there's the god Tláloc, the representation of the god of water in Mexico. The problem was exactly that: the waters changing their course.

And then there are other things taken from the folklore of Mexico and also of the U.S. Southwest. There are the dancers, "Tex-Mex," as they call them, dancers and music created in these areas. The Tigua Indians' dance of the eagle and all that, and the first churches they built, primitive and everything, but they are also representative of this region.

So that's basically it—a celebration, you might say, of what we have here, which could still be expanded a great deal. But in this case I was limited by space. The space ran out. I actually had eight months to complete the mural.

I forgot to mention that Cortés is there too, and not as a conquistador in the mural but as a man, as a human being. And this is his first defeat at the hands of the Indians. He's crying beside a tree on the evening of the Noche Triste. With Marina—who was called Marina because she was from the sea, doña Marina, La Malinche—there to one side. Then there are the priests, who gave so much to the Indians. They gave them protection, culture, many things. And they often saved them from horrible exploitation at that time on the part of the Spaniards.

That's basically what the whole mural is. I took advantage of the wall's original texture and just added a base coat of acrylic to prime it. It's mostly industrial acrylic base, because that's the kind that's most resistant to sun and rain, so it's really stood up well. On the small scale I used a higher quality paint for touch-ups, for the little things. However, this doesn't hold up too well against the sunshine and rain, so not too much of it can be used. But it's basically that kind of paint, which is the best thing there is right now for mural painting.

There's one thing I'd like to stress. The vast majority of murals have been done under very difficult circumstances, and I know this from experience. So I know that the guys who have painted murals here in El Paso have done so under adverse conditions, where they've lacked materials, and most of them have been paid very poorly, just as I was. There isn't much money; it's very scarce. And then, the muralist movement here in El Paso has been sidetracked because they're not united yet. Everybody has a different idea: one does this, another does that, and everything's scattered all around, the way I see it. In the same way that ideas are scattered, so is knowledge about how to put them into practice. Many mistakes are made in the area of mural painting technique. Sometimes this is due to the fact that some of the murals are no longer in existence. The paint has come off because it wasn't properly applied. Even though the idea may have been quite original and the painter very talented, his technique was defective and so naturally some of these murals have been lost. Some painting has been done even with paint from a can for painting furniture; I've used them all. So it would be very desirable to create a library, you might say, where one could learn exclusively how to paint murals, where the necessary information would be available to everyone about the correct way to paint murals so that they will last for many years, because a lot of effort is required to accomplish this. A lot of personal effort. Some really magnificent ideas I've seen in murals here have suffered because of faulty technique, or because there wasn't enough money to carry out the projects.

So most painters here who want to do murals are in a position to do it well, especially in the future. But needless to say, there are some who have a long way to go. They have a lot to learn as muralists. They have the mistaken impression that doing a mural is like doing a big painting, and it's not like that, you see? But there aren't very many of those, and they're not even worth mentioning.

Here in the barrio, murals are the result of the desperate desire to exist, to say, "Here I am. Pay attention to me. I live. I exist." This is also the explanation—at first, but not now—for the large quantity of graffiti that we see. Because it too wanted to say, "Here I am. My name is Raúl, my name is Manuel, my name is whatever." Now graffiti has become something else. Graffiti has never been an art and never will be. But the impulse that moves kids to mark up walls is essentially the same as that of the artist who wishes to be something, to stand out.

Unfortunately, it has become bastardized, and now it's a criminal offense, because when you look at graffiti it's as if you were looking into the minds of the ones who paint it: the confusion, the muddle, the blot, the unclear thinking, the ignorance.

It's mostly about violence. It's a violence that shouldn't exist, because they're taking a part or they're believing they own this or that property just because they scrawl their name on it, and that's plain stupid. The victims of all this violence are ourselves, the Mexicans, which is the biggest stupidity of all.

So you see, I detest the muddle that exists in the minds of some and which leads them to produce graffiti. Because graffiti doesn't tell you anything. It just says that this barrio doesn't like the other one, then they write over each other's markings and that's all it says. It doesn't bring anything aesthetic, it doesn't tell you anything you didn't already know about the ones who are doing it.

More than anything, the graffiti in Ciudad Juárez and in other places around Mexico comes from the need to copy. The United States is very powerful and, whether we like it or not, transmits images through television and music.

Well, it's time for me to go now and leave my fleas somewhere else.

Gaspar Enríquez
Interviewed by Mike Juárez
Mi Casa Gallery, San Elizario, Texas
September 1994

I was born in El Paso, Texas, in Segundo Barrio. It's ironic that I was born and raised in Segundo Barrio and after a few years, I returned to teach and work there. I attended school in proximity to where I now teach, at Beall Elementary and Jefferson High School.

I cannot say that any one individual influenced me to become an artist when I was growing up. There were, however, many incidents which helped me fulfill my destiny of becoming an artist, but I cannot think of anything specific. In elementary school there was one teacher who gave me encouragement to pursue the arts. And Mel Casas [a nationally-known Chicano artist from San Antonio], who's gone on to become a successful artist, lived in the same apartment complex where I lived. He used to take us to his classes, where I saw his work. My high school classes were a big turn off and I didn't learn much there. I didn't get any guidance. I didn't have any role models nor see art as a viable career.

It wasn't until several years later while working in California that I decided to pursue art as a career. I had always liked drawing and as a child in California I had visited galleries and museums. What really aided me in pursuing an arts career was my wife's support and encouragement. A paint box she gave me started me on my journey in the arts and it hasn't stopped ever since. My father had been somewhat of an artist but he worked as a mechanic to earn a living and support us.

The neighborhood where I teach and where I grew up has been the source of my work. It still maintains a lot of influence in my images. My work is a reflection of my environment and my experiences there. The neighborhood has not changed much from the time I lived in it. The neighborhood history keeps repeating itself with each passing generation. One of my pieces deals with this kind of generational attitude of the past repeating itself. When my [Bowie High School] students create designs to paint murals on the walls, they paint some of the same images which were painted years ago, with the same concerns we had at the time we were growing up in this neighborhood. I still use some of these images and symbols in my work but in a different context. My work is a product of my environment—its past, present, and future.

My involvement in mural making has been more one of being a consultant, coordinator, and educator for works produced. Students whom I've assisted have created their own designs. I assisted them with composition and the elements of art, such as color, etc., but essentially they executed their own works. All the murals I've supervised, whether at Bowie High School or in the community, have been painted in this manner. In 1994, I designed and painted a mural with the assistance of several talented high school and college students in Socorro, Texas. I hope they will pass their experiences to others and keep muralism alive.

My easel work deals with *mi gente* [my people]. I paint people and attitudes. My metal work [*Mi Familia Series*], which was featured in the past CARA exhibit, deals with heritage and culture, and personal memories. My mural work deals with a wide spectrum of images and symbolism. My public art work is based on issues and concerns of the theme and the time. Since [the work] is public, there are compromises an artist makes.

I think quality is an important issue in the creation of works. A well-executed mural makes a positive impression on people no matter what the content is. If muralism is to be supported, it must be of quality. It must impress its audience, the people who see it. You can't give paint and a wall to individuals without any kind of instruction and expect quality work. They need education, experience, and guidance. Los Murales and programs which support the production of murals in El Paso should be commended for their efforts in resuscitating muralism in El Paso. We also owe thanks to individuals like you and Cynthia Farah who continue to document and write about murals. As for the [City of El Paso] Arts Resources [Department], sometimes they have other priorities.

We started painting murals at Bowie High School in the late 1970s. Joe Olivas, then art instructor, and his students painted the first murals at the school. Then Ernesto P. Martínez painted *Meso-America* in the cafeteria in 1976. The other murals have been painted by students, too many names to mention here, but their names appear on their works. We continue to paint murals every school year and we will continue to paint them until the interest for murals fades—which may not be any time soon.

Like I stated, we've had a tendency [in Chicano culture] to repeat the past in the neighborhood. As long as there is oppression, prejudice, injustice, greed, and poverty living conditions in local neighborhoods, there will be murals. There are enough causes and concerns in our culture to keep muralism alive for a long time. Our hunger for self-awareness and self-esteem keeps us looking back to see where we are, where we came from, and where we're going. In reaching our roots, we can begin to reinforce our pride, self-esteem, and our future. This is why the images that are painted keep reappearing in our community murals. Our culture transcends time and it needs to survive, if even on walls, before our people assimilate, if they do.

Carlos Callejo
Interviewed by Mike Juárez
Callejo Studio, Canutillo, Texas
2 June 1993

I was born in El Paso and raised in Ciudad Juárez, Chihuahua, from about four to nine years of age. I was born in 1951 in San José Clinic in El Segundo [Second Ward], which is now the Annunciation House [a refugee house]. In November or October of 1987, I was hired as a social worker by Clínica La Fe. David Romo [who started the Southside Education Center] approached me [about painting a mural]. I was doing the mural that we were doing. He came up to us. The Bridge [Gallery] thing [*Cuantos Hermanos (Han Muerto)/How Many Brothers Have Died (Crossing the River)*, 1987]. I [started the project] two weeks late. They had started fixing up the alleys, remember?

We had about eighteen kids work on the mural. I pretty much had my regular kids. I like to get youth involved in the overall process of the mural painting and not just on the painting of the wall. In that particular mural the kids were involved in setting the theme. Before beginning the project, I gave the kids an assignment, to think about something to paint and not to restrict themselves to the immediate area, just to the barrio, but to think nationally and universally. They came back with positive suggestions, a lot of concerns like nuclear war and such issues.

What stood out the most was a theme by this young lady who had just graduated from Bowie—she came out with the idea that even though technology has advanced in the world, there are still many children dying of malnutrition. That's how we came up with the concept, but of course, we didn't want to insult anybody with negative imagery, starving children. Instead we presented humanity as children playing on the moon or having control of technology, the moon representing technology.

The mural was painted over and it hurts because I didn't consider it one of my pieces but one belonging to the community. The kids had major input in it. When I started painting murals [in Los Angeles] it used to be quite prestigious to have one of your murals whitewashed. Work would have been whitewashed if you had made enough of an impact to cause such an action. But *Kids on the Moon* belonged to the kids, not to me. From there I started working at [Clínica] La Fe. That was in the summer of 1988. I assisted

in the design of the mural [*Memorial to Rubén Salazar*, 1988, Salazar Housing Complex, Building 31, 1000 Cypress Avenue]. But [the kids] painted it all. I didn't have not one brush or pencil mark on that work. The kids guided the design.

We were working with two groups of kids. One group was hired through the summer youth employment program through the Private Industry Council [PIC] and the other was a group of kids from the Segundo [Barrio] who were recruited to participate in an educational program on AIDS. This program took kids and taught them how to deal with peer pressure, kids teaching teens instead of adults teaching kids. It was more of a peer approach. It was also an opportunity to teach on a nontraditional basis.

It was a threefold project. The kids were divided into three groups. One group worked on a video [of public service announcements]; another group created a theater piece which toured throughout the El Paso and Ysleta school districts. They created a piece for kids on the dangers of AIDS. The third group, which I coordinated, was the mural project, which also depicted the dangers of AIDS.

That was in 1988. The AIDS mural (1988) [800 block of Sixth Avenue] was geared towards high-risk out-of-school youth using non-traditional methods of education such as a mural to teach the dangers of AIDS, using the tornado [in the center] as a symbol of the AIDS virus, people surrounding the mural engaging in high-risk behavior. The far left corner of the mural shows people seeking shelter, but through community efforts and unity we might be able to defeat this phenomenon of AIDS. The other side of the mural we find ostriches hiding themselves in the ground, representing the politicians. Many medical experts believe that if it wasn't for the politicians hiding their heads in the ground, this epidemic would not have grown to these proportions.

After the AIDS mural, I painted the San Miguel mural, which was funded by the Doña Ana Arts Council. They originally approached me because they had obtained some funds for the project. They had other artists in mind. They were thinking of sponsoring three different projects with three different artists. They wanted a mural on the San Miguel [New Mexico] Community Center, but the artist had never done one. I went to give a presentation to the people at the center; that was it. Eventually the [other] artist pulled out and they called me to see if I was interested. I was, but it was very limited in money. Again, this was a summer project. The kids were taking some art courses. Juan Lucero was teaching the kids how to do the grid system. After they learned the grid system, they decided to do the mural. We set up a meeting with some of the elders and had them tell us stories of what the valley represented to them. Based on those stories, the kids were able to come up with the concepts. We had kids from all ages. The youngest kid was eight years old and the oldest was eighteen. We had kids from elementary, middle, to high school.

The rural kids were not proud of coming from a heritage of farm workers, but after doing that mural they developed a pride [in that heritage]. In that mural you see two farm workers holding up the world, because if it wasn't for farm workers, we wouldn't have any food on our tables. So the kids began to see farm workers in a different light. Murals tend to serve multiple purposes. One is to fill in gaps. At San Miguel it helped to fill in the gap between ages because it was the elders talking to the youngsters about the history of San Miguel.

The project began in November, 1988. The kids were paid while they were being taught, but they worked on the mural largely on a volunteer basis. The San Miguel mural took more time to complete because we only worked on weekends. The project continued into late winter. There weren't any funds towards the preservation of the mural. That's why the blue is fading, because we bought the paint in Ciudad Juárez. We didn't have money to buy paint. We also painted on wood. The wood was not prepared. Then the rains came in and they put some water resistant coating on the wood, and that made it worse because it started cracking the whole thing.

In 1989, when Dr. Tim Drescher was in the area for a mural conference in Las Cruces, he went to talk to Los Murales at my invitation. He was making politically motivated comments. There were a lot of artists there—Carlos Rosas, Felipe Adame, I was there, some people from Los Murales, Adair Margo was there. He gave them some ideas in terms of formulating some policy to make it a fair process for applying. Some of the things they adopted, others they didn't. But it wasn't written in stone. That's how Los Murales got started.

I don't think those policies the community advisory committee proposed were formally implemented. There is nothing formal about it, even the applying to do murals. On the projects I've done they usually come and hit me up. But they are very specific in terms of working with kids. Once I turned in the contract after I finished the mural. In some ways it's good because it keeps the bureaucracy at bay and you get more things accomplished. Eventually it will be good.

I created the mural in the Salvation Army [*Story Book Characters*, 1989, 4300 Paisano Drive]. I created a mural for Socorro High School [*Dance, a Universal Art Form/Tribute to Rosa Guerrero*, 1989]. Rosa Guerrero contacted me and wanted a mural with the theme of dance. That's when Marta Arat had just created the design for the poster titled *Dance Is a Universal Art Form*. They were very impressed with that design and they asked me if I could do that design on a mural. I said sure and I welcomed the opportunity simply because I liked the idea of doing a collaborative project. One artist does the design and the other paints the mural. Mrs. Arat was invited to the opening for the work. She was happy. It's her design. She was approached before me doing it. Everything was handled through Rosa.

I just told Cindy [Farah] that in the Los Murales brochures and the credits, I get mentioned about three times—which is quite a bit. And one of the first ones mentioned is *El Chuco y Que*, they basically didn't help on that. I was helping them structure and develop their program, and I wanted them to start building a track record, so I let them help me with the dedication.

They [Los Murales] provided the refreshments and the parachutes for the unveiling and that kind of stuff, so they could get credit. But now they are taking credit for more than that; they should explain their involvement. It was no more than a few hundred dollars. That one shouldn't be counted but it's one of the first ones. *El Chuco y Que* was sponsored by the ARD [City of El Paso Arts Resources Department] and the Clínica La Fe in late '89. It was the first time John Valadez had visited El Paso. It was winter and I remember I was painting the mural with gloves and a hat and it snowed.

I also painted and donated a mural to Canutillo Middle School. I painted two other murals on canvas for both the 1992 and 1993 installation banquets for the El Paso Hispanic Chamber of Commerce. The first one was when actor Eddie Olmos came and spoke and the second one was when actor Anthony Quinn spoke.

Threshold to Knowledge was the title for the first banquet mural. It's 20 by 11 feet. We had to paint it in a factory because it didn't fit here in my studio. That was a year and a half ago. The mural painted for the second banquet was 20 feet by 9 1/2 feet. I also painted a mural for Greg Acuña, who owns Superior Solutions, last year titled *Labors of Cotton*. *Labors* is 5 1/2 by 16 feet.

Then I painted the [Juvenile] Detention Center mural [*Choose Your Destiny*, 1993], which took a little bit of diplomacy. Basically, I interviewed the kids and, based on the stories of the detainees, I resolved the idea, even though there were some objections; there was some compromise. I did change some stuff, and other things I did not change. I told them I couldn't change because they were the ideas from the kids, and I didn't feel it was my jurisdiction to change them. Eventually they went for it. The staff was very supportive and helpful, much to my surprise, merely because of the type of center that it is. Funding came from the Junior League and the Juvenile Probation Department. We had about thirty kids from the center work on the mural in rotating shifts.

I think I've developed a particular style. The more work I do, the more the work becomes distinct, just for murals. In my easel work and studio work, it varies because I think of myself as being very versatile in styles. In terms of murals, I'm beginning to develop a distinctive style, and it's a process of refinement. I'm at the stage where I think I'd like to do something else. I'm at the stage of doing different work and incorporating other styles. The easel work has more refinement. The subject matter is more subdued. It's not as dramatic. The viewer has to form his own conclusions in some ways. In contrast, the imagery and symbolism in my murals is easily understood, whereas my easel painting is more subliminal.

The [El Paso County] Courthouse mural [*Our History*] is basically historical. In the imagery, I was basically confronted with the dilemma that the space is not large. In order for murals to have a big impact, they have to show big images. If I'd paint only large images, they would take up the majority of the space and I'd take a lot of space away from the historical elements which I've planned in the piece. I had to decide whether I was going to create an aesthetic piece versus a mural presenting historical information. I had to make a compromise. I had to go through a process of elimination on the historical imagery. I asked myself what I could do without. There was still an abundance of information, so I had to reduce the imagery. In order to get everything across, I worked out the design and the concept in a form that is kind of a collage. But it still works. There is a lot of flow, a lot of movement, and there is still a planned motive behind the work—everything fits in the right places, even though it looks like a collage. I chose to create a collage of imagery because the walls have shadows from the frame that is holding up the glass in the atrium. The shadows from the frame are constantly moving.

I foresee that a lot more people are going to get involved. I just went to an opening yesterday where there were nothing but youth from high schools at a mural unveiling [*Murals at the Mall,* sponsored by Arts Resources and the Junior League]. I foresee more artists getting involved. They're in the making. They're going to bring new styles and forms. I think the main influence locally has been either from El Paso artists or different periods in El Paso—very distinctive to the area. I see that changing. I also see a lot more support. Right now, we're in a height, we're moving up. I see that support and interest leveling off because people are going to say, "Oh, a mural again?" Saturation. So that's why I encourage innovative works, not just in the style but also in the media. Maybe some wall reliefs. Maybe like my idea I'm proposing of putting an oval mirror into one of my murals. People become part of the piece because they see themselves in the mirror. That kind of a thing. Doing some imagery where you take some photographs which are outside of the wall, so there's an exchange. There's a physical exchange. All these things are coming. But at this point I do not want to encourage the newcomers to pursue this because we still need to grow out of this stage. We need to refine our style. We need to take it more seriously. We need to take it to the highest level in terms of quality, and then we move on.

Works are valid on their own rights. I think it's a sensitive matter. I would say that we just leave it up to the individual. If the individual doesn't create a mural which is good enough, he will not be called again. Whether the artist needs to produce these works either for self-expression or for monetary purpose, setting higher standards for work is inevitable. When I say higher standards of work, I mean the development of the artist's standard of work. Jan Wilson [researcher of Segundo Barrio murals] does have a point;

I've always pondered on the issue of quality. I encourage any newcomer to create work, no matter at what level his/her work may be—it's still valid. The more you do, the more you grow.

It's very hard to judge. The quality of murals as "art" has been questioned more often than their authenticity of expression. This skepticism is in part natural because murals are [a relatively] recent phenomenon, diverse, scattered, only semi-permanent and of variable quality. It is in fact hard to gain enough of an overview to judge. At the same time, some of this critical silence represents social prejudice and ignorance of the aesthetics of murals. Too often, the spokesmen of the official "art world" conveniently stereotype murals as folklore, as protest art, and as minority art, poor art for poor people, in order to dismiss them from serious consideration.

Murals, however, are not only protest or simply large paintings on walls; they are paintings binded [*sic*] into architecture; public art conceived in a given space; art rooted in a specific human context. Murals are art that speaks about social concerns and issues. They are an art form in their own right, and serious criticism and major commissions are long overdue.

You cannot just take it into the streets. There is a difference between art for art's sake and art which is rooted in the human contemporary social context. You need to take it into the communities and the context—because the roots of murals speak about the dignity of the people, about the struggles, the needs, and the celebrations of traditions and the dignity of our culture.

There may not be places to find the material, but sometimes you can find enough to begin to piece the history together. You can see the ignorance, the lack of interest to tell these stories, especially for our areas. The reason I think it's important to El Paso—and in a way it sounds a little bit exaggerated—this nation owes a lot to El Paso. A lot of things have emerged from this area and there has been no credit given. People have just taken it for granted. Every time I go into the different archives, I see things that have been important, especially when they say we have a lack of identity. That's bullshit.

I wrote an artist's statement for a past commission which I'd like to include in this interview. In the sixties I was caught up in the energies of the streets and it seems I've never been able to leave them. During these times, I found myself thinking a lot like other minority artists of the times, thinking that for the most part our traditional funding sources and our academic art institutions were not supportive and had little relevancy towards cultural or community-related art projects, as such; we became dependent on our own resources, ourselves, and our own communities. These resources became and still are my main inspiration for the subject matter in our art which speaks about history and culture, traditions and celebrations, needs and struggles, people's dignity and aspirations

and projects—a vision of a future free from war and exploitation. I have produced art using a variety of art media, but for the most part my success and recognition have been through mural painting.

Murals can be a great way of reaching thousands upon thousands of people, since they are located in public places, accessible to everyone. They are a wonderful form to educate and inspire. Murals tend to fill a need for honest communication between all people on a non-verbal level. Muralists often communicate ideas which often get neglected by our politicians and media or newspapers, ideas which need to be explored in the public's eye. I particularly see murals as much more than decorations. While murals do add color to a neighborhood, this is not my or our main objective. In my view, those muralists who are most effective use color and form not as end products but as tools for conveying a specific subject matter. This subject matter is expressed by means of symbolism, easily understood by the general audience rather than a private audience in personal symbols to be interpreted only by a few or esoteric. Murals that truly speak for a community and the social concerns are a real inspiration, both as a model for the artist and as a monument to the struggles and aspirations as a community.

Manuel Gregorio Acosta
Interviewed by Cynthia Farah and Mike Juárez
Acosta Studio, 366 Buena Vista Street, El Paso
27 May 1988

There's one [a mural] on Lisbon [street]. It was done through the efforts of Aliviane [drug rehabilitation agency]. Some of the city representatives were there when we had the unveiling. It was painted by the kids at the complex. The theme is from the poster by Helguera [see Appendix D]. Are you familiar with the famous Jesús Helguera of Mexico with all his beautiful Indians and legends? All of a sudden, they were all copying him: the warrior with the maiden fainting down. They painted this theme on the mural. I told them do something else—don't copy, but it [mural painting] was too new for them.

So they copied it—kind of badly, but an effort is an effort. I helped where I could. No one besides them put a hand on it. They did it themselves. So you can catch up on that. There's another mural on Carolina [drive], north of Alameda. It's another housing complex. I don't know its title, but I went to see them while they were painting it. Chevo Quiroga can guide you to at least four that I know that they've done together. You may ask Alicia Chacón, because [as city representative] she got involved in some of them. She always attended the receptions and the unveilings. And of course, you've probably caught up with all the murals in South El Paso.

There's a terrible one off the freeway and Stanton [*Cuantos Hermanos (Han Muerto)/How Many Brothers Have Died Crossing the River*, 1987]. They vacated the building and let several artists go at it. It's a messy thing. This one has no organization whatsoever. Inside, at the Cerezo Restaurant, which is now closed, there were two murals by Felipe Adame [based on Jesús Helguera's *La Leyenda de los Volcanes* series]. They were on the walls. I don't know what happened to them. I think the building is still there. They used to have good food there. I don't know why they closed. That's all I can think of.

I started on the mural for [*Centro Familiar Clínica*] La Fe [*We the People,* 1988] in March, I believe. I had beaucoup photographs of all the processes! Yeah, I'm thinking that beforehand if something would be done, I would have the documents and photographs, which I took myself. All in color. There are lots of them in sequences. So eventually if someone were to put together the thing as it began from the sketches to the people posing and all of that, szss! Photographs!

When they told me we have a little wall there and even less money, well, I said, South El Paso. I went to see the wall, a

challenge, and I thought say, this is one time that I can really put my thoughts together of where I lived, where I've always been getting my inspiration—South El Paso. I said, why don't I put it all in this mural. They said, "We have historical people." So I put some of them in and I painted my nephews and nieces and what have you. No one section has given any more or any less. I had the grocer, the soldier, my grandmother, and then a banquet table which shows the joy of being born and raised [in Segundo Barrio] with the traditions which we all brought from Mexico; they're represented on the banquet table—the food, the fruit, the flowers, the happiness—it's all there! That was my chance to really put my own feelings [into the mural]. I included *pan dulce* [Mexican sweet bread] here. My little dog Pati was in it; he's a big dog now.

When you look at it you'll see little bits of—and I played a dirty trick on all these people. I asked them, have you really looked? Yeah, we looked everywhere! But there's a mouse peeking somewhere in the mural! They said, "We haven't seen it." But I'm not going to tell anyone ever!

I did the mural [in my studio]. Many people saw and came and went. Many, many, many. I had two pieces of masonite, sixteen feet long and about four feet wide pieced together at the bottom. I added a wooden frame. I worked on it, on the scaffolding, cables, pots and pans, and finished. Then we moved it over here [pointing to the end of his studio] so James Dean, a photographer from the [El Paso Natural] Gas Company—could photograph it because he had to space this way to get all of it in.

So here's the one good perfect photograph of the mural because over here, he couldn't get back. It was easy; we just moved the whole armature with about two cases of beer, baloney sandwiches, but we got it there and it was photographed. Then we moved it over there on weekends [to Clínica La Fe] because people are sick all the time; that's something about a clinic.

I went in several times in there and somebody would feel my pulse and I'd say, "Hey, I'm still warm!"

There are always lines for everything. So they sit there and they contemplate and of course that's the idea, so it helps. I put joy in it, no depressing thought whatsoever because I knew where it was going to be. And it's peaceful, it shares a comfort. And no one waits more than twenty minutes. They have a sign which reads, "If you wait more than twenty minutes, you tell the manager." It's a beautiful operation. So the mural just adds to it. If you have a chance, photograph it.

I'll have a contest when I'm about ninety years old, and if no one has done any graffiti on the mural—it's amazing that they have respected the mural. At first, it was like everything. They walked in. They didn't see it! It's true, they walked in like nothing. So Dr. Domingo Reyes, he got so mad, "Why is it people just come in?" They were about to lean on it. Finally, they began to see it, so I'm very proud of it.

Mario Colin
Interviewed by Mike Juárez
Memorial Park, El Paso
17 September 1994

I'm a local artist from El Paso. I was born in Ciudad Juárez but I've lived here since I was three years old. We used to live by Findley and Piedras Streets [in Central El Paso] but we eventually moved to the Five Points area where I attended Houston School. From there I attended Austin and Bowie high schools. I've been interested in art ever since I was a kid. In school, I liked to draw. When I graduated from high school, I needed to make money so I did construction work for about ten years. I thought I was going to be a carpenter the rest of my life. Carpentry is creative, too, and satisfying. When I was twenty-seven years old I thought I could actually sell some of my art work. I wanted something to do when I was an old man, so I decided I was going to be an artist and I've been doing it ever since. It's been a good eight years now.

I first met you at the Bridge Gallery. I had just arrived in town. I didn't know any other artists. I didn't know any techniques; my artwork was very raw. I was working with number two pencils and drawing on just any old piece of paper. I learned a lot by being at the Bridge Gallery. I decided to become a volunteer because I needed some art space, and Gallery Director Al [Harris] gave me the chance to meet a lot of artists and ask them a lot of questions. I didn't study to be an artist. I learned many techniques by asking and observing other artists.

The "Works on Paper" exhibit sponsored by the Juntos Arts Association in 1987 [at the Arts Resources City Hall Gallery] was my first art show. I had never been in an art exhibit before then. In fact, you invited me to show. That was great! It was the first time I presented my work. I received a lot of positive feedback from it. From then on people started to take notice and I was invited to show in other exhibits with professional artists. At that time I still considered myself an amateur. I had never really sold too much of my work then.

I met Chuck Zavala from the "Works on Paper" exhibit. Joan Shepack, who was also in the exhibit, encouraged her husband Dr. John Shepack [El Paso Community College president] to help me enroll in art studies at the college. They provided me with a scholarship to attend a summer semester. Philip Behymer was one of my teachers. He influenced me and taught me a lot of

techniques which would have taken years to learn by myself. I already had my style. I started learning about painting and painting murals there. Through photographer Rigoberto de la Mora I met artist Chuck Zavala.

A friend of mine owned the store at Piedras and Sacramento streets [Esparza's Grocery]. He wanted me to paint the Virgen of Guadalupe with both the Mexican and American flags behind it. I told him I would do the Virgen, but that I didn't want to get political [and paint the flags]. I had already painted a mural at El Paso Community College but I still didn't know that much about painting murals.

In 1988 we painted [the mural at Community College's Valle Verde campus] in the computer room; it's titled *Visually Processed Data*. The mural was painted on three walls, [to depict] the past, present, and future of computers. That was the first time I painted a mural that large. Thereafter, I painted the *Virgen de Guadalupe*. I needed some help. I didn't really know how to go about it just yet. Chuck Zavala, who was good with colors and had gone to school and knew the technical stuff, helped me. I thought we were going to draw it out but Chuck took the paint out the very first day and started painting. That was a trip to me because I was more timid. We just attacked the wall. The first day we started the mural, we got something out and then we began detailing it. It was bringing out the best in both of us. Chuck's colors were coming out and my painting technique and then we drew roses around it. Boy, you know, people's mothers who never talked to me before, who thought I was some kind of hoodlum or something, all of a sudden they were nice to me, like I did good or something good for the community.

We painted the mural in September 1989. It took us about a week to finish it and that's because we were slacking off. We worked one day and then skipped a couple of days. Right after we finished the mural in November 1989, Chuck died. He died of cancer. By that time the mural was a shrine. It would freak me out because people would go by there *y se persinaban* [they would bless themselves]. It was strange to me, we were painting, then all of a sudden *se aparece la Virgen* [the Virgin appears]. *Se persinaban*.

The person who owns the land, Mr. Raul Meza, commissioned the grotto to be built by the Ortiz brothers from the Lower Valley. They built it and then the priest came and blessed it. The store changed owners and the new owners installed a light so you could see it at nighttime. The shrine got bigger and bigger. Now people put flowers there and they throw pennies at the Virgen. It's become a neighborhood shrine—it's a real good feeling. It's holding up pretty good. This is how I got introduced to painting murals. At first I was drawing mainly in pencil, trying to do photo realism, but I really wanted to paint murals.

For the commission for the mural at Eucalyptus and Magoffin Streets [*Hispanic Heritage and Homelessness*], they originally wanted Carlos Callejo to paint it but he was too busy. They wanted him to paint it but he asked me if I wanted to apply for it.

He introduced me to the owner. I showed him some of my pencil work and designs. I showed him my Virgen and he seemed to like my work. At the time I was being interviewed, it helped that the owner received a telephone call from his wife saying she was pregnant, so he was totally happy. He told me, "You got the job!" right then but we still had to go through Los Murales because they were going to pay half of the money to paint it. I was paid five thousand dollars to paint it. Five thousand for everything. I gave it away! Five thousand included the paint, scaffolding, and everything else. Five thousand dollars. They received their money's worth.

I began painting the mural in 1990. I had to submit a design. They wanted the design in color but for me presenting a color design stifles the creative process. With a line drawing, I feel I have the freedom to create more of what I want. They wanted a color cartoon for the mural. That was all part of the deal.

I also had another drawing which I had drawn about the homeless five years prior, which I wanted to include as a part of the mural. I had received a lot of positive feedback on this drawing. People liked it and I had always thought about making it into a mural and I thought this was my big chance to do it. I proposed it to them but they [Los Murales] thought it was a negative image. They thought it wasn't going to fit because on the other side I had positive images about the Chicano experience, religion, the family and history, the arts and music, and on the other side I had the homeless.

They were pretty much two different murals [one titled *Homelessness,* facing Eucalyptus Street, and the other titled *Hispanic Heritage,* facing Magoffin Avenue, and tied together by a geometric design].

It took us, my friends and I, six months. Sometimes I would take about a week off. At first we lacked the scaffolding. In fact, the Magoffin side was done on ladders, with a ladder jack and a board across it. We would put it on top of my friend's car, Greg García. We would use his car every night when the traffic on that street would die down because that neighborhood is busy and there were many trucks going in and out of the building. We had to fight the environment to paint the mural. It was like trying to study outside and read a book in a corner of a busy street. We had to concentrate and at the same time we had all these things going on around us. We'd go in the evenings and work about four to five hours and that would be it. Greg García, Chilo Meza, Raul Meza, they're brothers, and Ernesto Ruiz also helped me paint the mural. Greg knew a little bit about art but the other guys didn't. They just decided they would be part of it. I didn't even have money to pay them because my funding was so limited.

I had gone around, not so much in that neighborhood, but I had asked my friends for their opinions. I also looked into myself because I'm part of the experience myself. I thought what would be nice for the people. I was thinking mostly about the kids

who are going to grow up there. I wanted to paint positive images for the kids, to give them self-esteem and pride as to who they are. That was my basic goal.

I used acrylics—Nova's [NovaColor] to paint the mural, Nova paints from California.[77] Carlos [Callejo] was the one who set me up with the paint. I spared no expense. I spent a lot of money on the paints. This paint is real rubbery and it expands and contracts with the heat and the cold. They're really durable paints. It has been three years now and the paint is holding up. The colors are still there. The mural receives sun all day.

The community response to the mural was great! A lot of people tell me that that's their favorite mural. When I was painting the mural, it was the people who kept me going. A lot of times I would think, wow, what did I get myself into? I'll never make it. It was a big wall. Then somebody would cruise by and honk their horn and give me a thumbs up and that would just make my day. Then there are always the critics.

The only problem I had while working on the mural was that I really didn't have any place to store my paint and equipment, so I wound up storing it on the roof. The funding was very low. At the time, it was the biggest mural in El Paso per square foot, even bigger than Carlos Rosa's *Entelequia*. My mural is a couple thousand more feet than his. It took all the money that I had to finish the mural. The best thing that came out of it was that my work was finally exposed. I've done many other works but I'm known for painting that mural. It's funny, like I told you earlier, Greg's [Acuña's] wife was pregnant when I received the commission and when we had the mural unveiling, the baby had already been born.

Since then I've painted mostly portraits, murals for restaurants, signs when I have to, but nothing major. I'm still hoping to get another large commission. The mural at Magoffin and Eucalyptus is still the biggest project I have worked on. I just painted a mural for Cappetto's [Italian] Restaurant and one for the Old West Steakhouse [and Pub] and other Virgen de Guadalupes for individuals. I'm always being asked to paint Virgen de Guadalupes. I painted one for Santa Lucía Church and a lot of religious murals in people's backyards.

There's definitely room for more murals in El Paso. Murals seem to be popular right now. I think people need to relate to their surroundings just like muralists need to paint what people accept. If they don't like the mural, they are going to mess it up. My work is a reflection of the time and the people. Murals are for everybody. My studio work is different from my mural work. My studio work is more self-centered, while my mural work is public art. We should keep improving the quality of our work. A lot of people equate murals with street art, but it is fine art in its own right. Many people think murals are projects for kids to do in the summer to keep

them off the streets, but murals should have quality from quality artists. To me murals are not recreational. We need to improve our standards. John Valadez just set a standard for every muralist in El Paso with the work he created for the Federal Building [*A Day in El Paso Del Norte*, 1990-93]. That's awesome. I'd like to get that good some day!

John Valadez
Interviewed by Mike Juárez and Mona Padilla Juárez
Juárez Residence, El Paso
15 May 1993

I think I realized at a point I wanted to stay away from some of the clichés of nostalgic El Paso, where you see the same photographs. There were the conquistadors, the Mexican era, the border split, the trade routes, Pancho Villa, and you see the same images repeated—which is good, but I wanted to show how it's all mixed up in the city now. The mural commissions are in two buildings. The one in the Federal Building [*A Day in El Paso Del Norte*] is a cross-section of the people. For the Ysleta crossing [*The Coming of Rain*], I wanted to show the rural-agricultural aspects of the region, whereas in the downtown mural, you have the sense of two mountain ranges, the Franklins and the Juárez mountains, but looking at historic downtown to find the clues of the area. [I was] trying to make it different yet still show the conquistador or the Indian, and Anglo settler, the Spanish rancher, the American farmer; you know, the struggle between the ranchers and the farmers—that was a big battle.

The design of the mural was left up to me. I think there was a little bit of concern when I showed the drawing to the committee. I wanted the reflection of history in the store window and in the mirrors, the train and the Guadalupe church [of Juárez] I wanted to put in more, but I didn't want to crowd it with the reflections. Instead of loading it up with all kinds of stuff which you can do, historical little images, you can still put them in there. I'm still trying to put [varying elements] in there—bits of archeological stuff, even some tourist stuff like those Indian mandalas. Just small things that all add up to the area [and the familiarity] that people are used to growing up [with] here.

I decided to work in my studio because of my family; it would have been good to have painted it here, but I would have had to rent a studio and live here for a couple of years. It was a little bit too much for me to do. If I was single, I probably would have done it, but with a family, it's hard. They gave me two and a half years to do it, but it's going to take three. This is not three years of painting but three years [for] the research, drawing, building and stretching the canvas, sizing it, gessoing it, [and] putting the sketch down.

I had five and a half months to do the sketch. I had to learn about the area and draw it in five months. It's just not enough time. So I used some of the time to refine the drawing and add small things. And I like the idea that things are mixed up, that my conquistador is not historically correct—stuff like that. I'm attracted to the downtown scene. I'm attracted to that area right by the toll crossing. I want the mural to be a little more uplifting, where [in] the other [studio] work I question values, morality, class, and [different] kinds of things, perceptions. The mural [*A Day in El Paso Del Norte*] is a cross-section of the community and the hopes are the children—the kids running down the street.

The idea was that children leave El Paso; there's only so much opportunity, so they end up in different parts of the country. But it seems to be that—it's good to see after I've done the research—when the children get educated and they leave, they come back. A lot of them come back. It's good to see. Maybe that's why the political climate is stirring up some here now, because the young troublemakers come back and, you know. I won't mention any names. Which is good to see, and it seems that, since I've started the research and done the painting, I have an idea and people will judge the painting.

What I've seen is a really nice boom in the sense of place from people. Maybe it always was there in the three years that I have been coming and going. But I see a bit of a change, even in that small mural catalog ["Junior League Mural Guide"] and even within the last years, since I've been back. It really opened up. It helped to open up opportunities for the artists here. When I first started the project I was reluctant because I wouldn't want anybody coming from out of town and doing a major project; of course, in Los Angeles, it would be different, we're always competing, but in El Paso? There are only so many opportunities.

I was honored to be picked, and I realize it's a big responsibility to do what I do. I'm from LA, so that's why I used that downtown area. For the border crossing [*The Coming of Rain*], it's much more challenging for me because I never do those landscapes. I don't know anything about the agricultural [landscape and images], and I'm still learning, I'm still trying to figure out that one. I've done kind of a pencil sketch, but the important thing is showing where the river benefitted the desert region here. And as I drove down yesterday, I drove a little down past Fabens along Farm Road 20 and I saw it! I was so excited to simply see it—on one side of me was where the river sediment didn't go there was sand and shrub and on the other side the farm—and there it was right there and I guess this Farm Road 20 is kind of on the edge in certain parts where the desert begins and where the ground is fertile. Real simple things like that are real exciting to me because I realize while looking at it, there it is—the line between the river and the desert! It's so beautiful, and even where the irrigation ditch goes right along the crops, and when the one guy opens up the irrigation ditch and it

floods. For somebody from the city, it's very exciting! You read about it, try to imagine it and then you see it—the battle between the cattlemen and the sheepmen and all that.

There are definite themes artists paint. The Chicano, Mexican-American on this side, that history, what does that mean? I see that as different. And that's really among the artists themselves because the general population—we kind of live in our own little world. We exchange information and ideas and issues, but the general public, I think they see it as "You know the artists are really starting to paint and do things," and it helps in the area here, in the city and even in the county. It's got to be good and where it's influenced from the whole idea of going to LA, I think that's kind of turning a corner now because there's not as much opportunity in LA as people seem to think.

Even though the job market is tight here, it's tight everywhere. But here, people that come back, they can effect change. That's what I find exciting. You know you guys can really effect change here, where in LA we just get swallowed up, so many issues and it's just so complex. Change is slower or compromised.

There is a tendency to put [Chicano mural painting] in this camp or to put it in that camp. I'm under the impression that it's better not to wait for the appropriate heading for us to show our work. I think it's still debatable, and you go in there under whatever label, and the work challenges you. Are you articulate to explain it, or does the work explain it? It's what you say, as compared to what you paint. There's visual expression and articulation, and there's vocal and sometimes, especially with conceptual and abstract art, the work is okay but it's what they say about it. What people are responding to, sometimes the rhetoric is more important than the work. You ask yourself, "What is that?" And when you hear what they are talking about it you say, "Oh, I see." They may see it that way but it's not necessarily that way when you first see it. It's based on people's impressions and also on who's your audience. All these kinds of questions.

Among us that's the debate—among the art world. We're [as social artists] always being slighted, so we're always being sensitive to a lot of things. But sometimes I think we have to step back, because we're being a little bit too sensitive, but that's okay. That's the way I am because in LA, I hear the debates and the political battles of just the aesthetics, because we come from working class sensibilities of aesthetics and stuff, and the institutional kind of work from the upper classes has to do with art for its own sake. We're challenging that. And there's going to be a backlash. They don't want to see it. We get somewhat of a support. We go through

the government and community sponsorship and support which becomes a filter. We have to watch the content and even the market.

It's [the work] in danger of being depoliticized, but that's always proved wrong, it's sometimes proved wrong. Like the mural [*Choose Your Destiny,* 1993] that Carlos [Callejo] did inside the [Enrique Peña] Juvenile Detention Center—it's a very strong piece. You couldn't put that just anywhere. I went in there with him and I photographed it. It's in the gymnasium. It's got this one pile of vice and corruption, needles and knives and guns and somebody in the bars, and death on top of it. And they're sort of melting all this corruption and vice into bricks for the future and the judge, and this is inside this place for these kids, the kids who are busted for various things, including murder, you know. We're always trying to show them enlightenment and sort of a pie in the sky. It's sort of like a monster piled up, in a certain metaphor, that's the way it is. And you're reminded of it and there's a sense of hope in another direction coming from a different viewpoint instead of trying to deny it or ignore it and telling the kids, "Just forget about it."

[The public will not see it] unless they photograph it and run it in the paper. They'll say, what's this stuff? You're showing this to these kids! It's real strong. What I'm saying is that your content need not always be compromised. I want to make my mural [in the Federal Building] uplifting. I want people to see themselves and identify or have some sense of the city, without seeing all the—you see some of the same clichés and stereotypes of the history that still needs to be investigated. You see it, but it's real different. You'll see in it a little bit more of how we take it into our lives. That's what the mural is: it's like a stage, downtown and then the landscape, and I've put us in it and how we interreact, to include a bit of the cross-section of the area.

Even with the conquistador guy, he's probably a National Park Service ranger and he's probably riding a quarter horse and not the original horses the Spaniards brought. And the saddle is different, but that's the way we really are. When I took the project on, I realized there was a big responsibility for the project because I'm not really from here. But then when my mother told me that we were from here, it was almost kind of spiritual. On my father's side, I also have cousins in Ciudad Juárez. I don't know them. I don't know who they are. So my family from both sides of the border are from here. They've lived here from the turn of the century to the twenties. They were rural and poor. They went west, first to Phoenix and then to Los Angeles before World War II. When my mother told me this part of our family history, it made me feel better. It helped me connect even more.

When I went down there [to San Elizario], during one of their festivals, I got all nostalgic. I thought, what if I had been raised here? Would I be so different? Maybe not. But I'd be more at peace because I really like the land. It's very solitary. I guess I just have a solitary spirit. There's something inside of me that gets real comfortable when I'm there—it's very spiritual.

[Our history] is a big secret. It's very uplifting when we hear it. It's very subversive for us to learn our history because our identity has always been in question. We are not like the Anglo and yet they've sort of tricked us into wanting to aspire to be like them. I think we're part of the generation that starts to question that, if not totally reject it. I don't think we should totally reject it because we have to live in their society.

We can't turn back time. But we need to learn their history, their perspective, like going to the history museum. It's all Fort Bliss. It's all the soldiers. Remember, I saw those telescopes [there]. El Paso was the rifle scope capital of the country. Everything has a reason. I saw a whole case of rifle scopes and I asked, what are they doing exhibiting rifle scopes? Then I realized those rifle scopes were donated by one of the wealthy families in El Paso so that their family name is preserved. They're in a museum and what they did as a family. And the Mexicanos, most of that history is on the Ciudad Juárez side, I realized just from talking to the woman from the museum. So there's still a split. That's why I asked her if there is any sharing of information [between the two].

There's still this undercurrent of animosity, and now with free trade, I think it's still in question if it's going to go. There's still this animosity, like the Americans again are trying to key into the Second World. There's research to be done.

We just don't matter quite as much. That's the fact. Because they had to take our land. They had to take what we had. We had to sell it to them or they just up and killed us and took it. We still live from that legacy. It's still relevant. But we became the children. We became educated and started learning about this history and we give them pressure. We give their children pressure.

[Our history] is not part of the curriculum. [We've] got to fight for it, that's just it. That's why they don't do it. It makes us angry. We feel cheated and we feel discarded. It's all this institutional racism where they took everything and it's only been recently. The wound is still open. It's still there. It's only happened within the turn of the century—like ninety years ago [within the last two generations].

For example, we can look at the [period between] 1910 to 1920, [and see] how the Mexican Revolution affected the border regions. Mexicans were using the Revolution as a means to justify kicking out the Anglos and taking everything from them. And that's when the Texas Rangers came in and up and down the border and slaughtered innocent people to create terror, so the insurrectionists could be turned in. They [the United States] didn't believe it was a conspiracy created by the people themselves because they had such a low opinion of us as a people. "They can't possibly be doing this as an organized movement."

[All through our school life, we've been told we can't do certain things, we] let them tell us that, [but] don't tell yourself that. It was kind of reverse for me. When I was getting out of college, I tried to get a factory job and they wouldn't hire me. I couldn't find a job. It was my personality. I looked like a real troubled kid, and I wasn't, that was just the way I was raised. So I couldn't find a job. I applied at the Ford Motor Company and at the Santa Fe Railroad. I was going to be a salesman, but I couldn't do that. So that's why I went back to school.

It was through luck I went to California State University at Long Beach. There were two of us. We both went, we filled out the papers. I was scared, but I decided to do it. And I realized what kind of education I did not have when I tried to take notes. That gets back to why our children don't learn the border history, maybe because some of the Anglos fear that they did something wrong—for them to take the land and to prosper. I see the development along the border, the machinery, tractors, nice homes—that's our legacy.

It [the teaching of Mexican and Chicano history] is necessary because it gives people a sense of placement, of identity, of a continuum of who we are. Because already the younger generation doesn't know who César Chávez was or what the farm labor struggles were about. And why the struggles evolved.

When you teach the history, you also have to teach what to do with the anger because there's going to be some anger. I was very angry, but I was in my twenties. But a young kid who still identifies himself with the anger and sees reverse racism—that all has to be part of the course. It's very controversial.

We have to channel the anger, not get rid of it. Once again, it's trying to stop being a sinner. And what is sin? I know it sounds a little off, but it's the same kind of thing to change your life—it's hard. It is a natural human emotion, and anger motivates us not just to self-destruct but to change. And that's subversive.

Even wanting to teach that history, how horrible that history is, is necessary, because we didn't migrate east from the south. We were here. We still are here. We weren't defeated. We were kicked around a bit, massacred and denied the connection to the land, but we're still here. The boundaries were imposed.

[Gang warfare is a reflection of] American culture. That's where it comes from. It's competition perverted. In certain forms, it is the perversion of the American competitive spirit. People compete against each other. With us, it's mixed in with the low self-esteem and the identity of not being Anglo, the identity of not being that "superior" race, fighting over turf that is not even yours.

It's also fashion—it's total perversion. It's the latest style, the thing to do. No matter how aghast we are with what happens with our children, there's a bit of excitement people don't want to mention. People don't talk that it's exciting.

On the news once in awhile, I've seen how someone witnessed this terrible thing and they're smiling as they're saying it. It's so wild. They get a high out of it. And those things we never talk about—those undercurrents. It makes life exciting for the kids, to be challenged and know that you may die today or your friend will die tomorrow.

You're more connected to life instead of the idealism of staying in school and persevering and struggling with your books and it will pay off. They see that it won't necessarily pay off, there's no opportunity. Without articulating it, they see it. Kids are sharp. They see beyond what we see. The more you learn, the more clouded it gets, but at a certain level—it's real clear.

Appendix A: Listing of Murals

This section provides a comprehensive list of murals painted in the El Paso vicinity in a format suggested by Dr. Tim Drescher. The groupings begin in the Upper Valley, then proceed to West El Paso, the University of Texas at El Paso, Downtown, Chihuahuita, South El Paso and along the Rio Grande, then to Central and South Central El Paso, the Northeast and East areas, and finally the Lower Valley. Interstate 10, which runs diagonally through the city, is used as a north/south orientation.

Information is given in the following order:[78]

> Title. An asterisk (*) indicates that the mural no longer exists.
> Address (if known)
> Year painted (if known)
> Size (height precedes width; sizes may be approximate)
> Artist(s)
> Funding source

Upper Valley

1. Untitled
 Concilio Campesino
 San Miguel, New Mexico, on Highway 28
 1988
 8' x 120' (various sizes)
 Carlos Callejo and students
 Doña Ana Arts Council

2. Untitled
 Gadsden Junior High School
 Anthony, New Mexico
 1993
 8' x 120'
 Carlos Callejo and students of the school
 Junior League of El Paso Los Murales Project

3. *Camino Real*
 5024 Doniphan, exterior wall of Studio W
 1996
 8' x 38'
 Mauricio Mora
 Lucchese Boots

4. *Covered Wagons Crossing the Rio Grande*
 Harris Western Wear Store
 7002 Doniphan Drive, Canutillo, Texas
 1981
 8' x 16'
 Felipe Adame
 Harris Western West

5. *The Apparition of the Virgen de Guadalupe*
San Martín de Porras Catholic Church
Sunland Park, New Mexico
1981
12' x 30'
Sunland Park students supervised by Lupe Casillas-Lowenberg
Sunland Park community

6. *New Mexico Sun Over Cristo Rey*
Handball court of Elena's Memorial Park
Off 5860 McNutt Road, Sunland Park, New Mexico
1981
12' x 32'
Roberto Salas

7. *Las Cosas de la Vida/The Things of Life* (on the back cover of
this book)
Handball court at Elena's Memorial Park
Sunland Park, New Mexico
1991
12' x 32'
Roberto Salas, assisted by David Anderson, Svenja Sliwka,
Gene Flores, and Carlos Madrigal
Gift from Salas to Sunland Park
(Salas also painted and installed twenty-five 18" x 27"
minimurals using the concept of cones, a prevalent theme in
his work. Several were placed on bus benches in El Paso, and
included *La Virgen de Guadalupe* at La Corona Grocery, 900
South Ochoa Street, and a bus bench on Paisano Drive
between Raynolds Tobin Place and Washington Park.)

8. *La Calavera*
Smeltertown/Calavera neighborhood off San Marcos Street
1991
8' x 8'
Roberto Salas
Commissioned by *mayordomo*/leader of neighborhood

9. *Western Scene*
Billy Crews Restaurant
1200 Country Club Road
1993
L. B. Porter

10. *Jesus Christ*
Sandoval Sports Club
Sandoval Aztecs
Sandoval Apartments
5353 Ridge Street
1986
Jesus Christ, 12' x 12' based on drawing by David Carreon's
girlfriend, partially funded by Jimmy Goldman
Sandoval Sports Club and *Sandoval Aztecs* each 4' x 8'
Robert Jones, Enrique Sterdivan, and Chilo "El Kiki" Pero
Aliviane

11. *Untitled
La Hacienda Cafe
1720 West Paisano Drive
1958
4' x 8'
Rosendo Villa
Painted over when the building changed ownership in the
early 1990s. The building is on the National Register of
Historic Places.

West El Paso

12. *Grateful Dead*
 4747 Emory Road, garage of private residence
 1991
 8' x 144' (aerosol)
 José "Match" Fernández

13. *My Toys*
 10265 Crenshaw Drive, garage of private residence
 1990
 8' x 26' (aerosol)
 José "Match" Fernández

14. *A Celebration of Women*
 Junior League of El Paso offices
 520 Thunderbird Drive
 1994
 8' x 48'
 Ysleta High School students supervised by Lupe
 Casillas-Lowenberg
 Los Murales

15. *Murals on the Mall*
 Sunland Park Mall, second floor
 1993
 Two murals, each 8' x 12'
 Bowie High School students José Quiroz, Victor Nevares,
 Daniel Castro, Alfonso Carrasco, Magdalena "Maggie" Ibarra,
 and Adriana Acevedo supervised by Gaspar Enríquez and
 Peggy Denny; and El Paso Technical Center students Jorge
 Cisneros, José Juárez, Jr., and Carlos Legarda supervised by
 Bonnie Lyons-Cohen.
 El Paso Arts Resources Department, El Paso Independent
 School District, Sunland Park Mall, and Los Murales

16. *El Paso Historical Scene*
 Jewish Community Center
 405 Wallenburg Drive
 1994
 4' x 8'
 Carlos Rosas
 Jewish Community Center

17. *Old West Gunfighters*
 Old West Steakhouse and Pub
 Peppertree Square, 5411 North Mesa Street
 1994
 8' x 24'
 Mario Colin

18. Untitled
 4798 North Mesa and Castellano Streets
 Kokopelli and other desert motifs on walls facing Mesa
 1995
 Paul Zeitz with apprentices Justin Fritz and "Daivid"
 Los Murales and Homestead House

19. *Hands That Heal*
 Providence Memorial Hospital, Oncology Unit
 1993
 4' x 8'
 Ysleta High School students supervised by Lupe
 Casillas-Lowenberg

20. *Capriccio Espagnol, Siglo XVII*
 Garage of home at 2800 North Kansas Street
 1967
 8' x 12'
 José Cisneros
 The late Mr. and Mrs. Francis Fugate

21. Untitled
 Diocesan Migrant and Refugee Center, 1117 North Stanton
 Street
 1994
 7' x 8' on canvas
 Xavier Reyes
 Diocesan Migrant and Refugee Center

22. *The Space Cowboy Without the Cowboy*
 Wall of "Turtle House" in Sunset Heights
 516 Corto Street
 1975, restored 1978
 4' x 10' on retaining wall; 6'5" x 6'5" porch
 Mark E. Regalado, graphic arts instructor at El Paso
 Community College
 Bobby Perel

University of Texas at El Paso

23. *Coronado*
 El Paso Centennial Museum
 1945; restored 1981 by Robert Massey
 5' x 10'
 Salvador López

24. *Miners Inside Mine*
 Centennial Museum, third floor
 1936
 4' x 28'
 Emilio Cahero
 Public Works Program of the Works Progress Administration
 (A second mural was painted over.)

25. *Mining*
 Metallurgy
 Holliday Hall
 1936; painted over in 1960s
 Two murals, each 14' x 120'
 Emilio Cahero
 Public Works Program of Works Progress Administration

26. *Pollution or Ecology*
 Fox Fine Arts Complex, second floor
 1973; painted over in mid-1980s
 9' x 60'
 Carlos Enrique Flores

27. *Myths of Maturity*
 Library second floor
 1991
 8' x 20' on masonite panels
 UTEP Summer Youth Program '91: Monika Acevedo, Rubén
 Arias, Irene Martínez, Robert Soto, and Germán Llerena,
 directed by Rudy Roybal
 Los Murales

28. *Gang Violence*
 Education Building, third floor
 1992
 6'5" x 14' on two sections of canvas
 UTEP Summer Youth Program '92: Sergio Cabada, Juan
 Gaytán, Liliana Rodríguez, Adrian López, Carlos Hernández,
 and group leader María Elena Sánchez
 Los Murales

29. *Encounter*
Computer Science Building (formerly Old Geology)
1993
8' x 16' on wood panels
UTEP Summer Youth Program high school students
supervised by Rubén Verdu
Los Murales

30. New Mexico Scenes
Education Building, second floor
1971
Two masonite panels, each 5' x 10'
Peter Hurd

Downtown El Paso

31. *Si Me Matan, Resucitaré en Mi Pueblo*
Casa Vides, 325 Leon Street
1992-93
6' x 30'
Patricia Malcolm
Casa Vides
(The mural symbolizes thousands who died in violence in
Central America. Casa Vides is named in honor of Gabriel
and Estela Vides who were killed in El Salvador.)

32. *Antidiscrimination in the Workplace*
El Paso Saddleblanket
601 North Oregon Street, rear exterior wall
1992-93
18' x 36'
Ethan Houser
Diocesan Migrant and Refugee Services Center through grant
from the Department of Justice

33. **Leyenda de los Volcanes*
El Cerezo Restaurant
1981
Two portable works, 7' x 12' each; present location unknown
Felipe Adame

34. *Untitled
Exterior wood panels, north side of former Guynes Printing
building facing Interstate 10 on Missouri Avenue
1987
4' x 4' (various)
Amy Dalzell

35. **Cuantos Hermanos (Han Muerto)/How Many Brothers Have Died
(Crossing the River)*
1987
10' x 120'
Former Guynes Printing building, North Stanton and
Missouri streets
Manuel Anzaldo Meneses, Carlos Callejo, Mike Juárez, and
Eva María Kutscheid

36. *Untitled
South wall of former Guynes Printing building razed in 1988
1987
14' x 24'
Morgan Pennypacker, assisted by Vickie Trego Hill, Lee Byrd,
and Julie Zimet. (Pennypacker painted an anti-war
manifesto.)

37. *Desert Scene* (mosaic)
 Former El Paso Savings and Loan
 517 North Kansas Street
 9' x 18'
 William Kolliker

38. *Dixieland*
 Former Louisiana Kitchen (now Las Tías Restaurant)
 beer garden
 508 North Stanton Street
 1989
 18' x 24'
 Gene K. Wilson

39. *Downtown El Paso, Early 1900s*
 Mills Building exterior, Main drive at Oregon Street
 1981
 24' x 32'
 Irene Soto, Dawn Hinesley, Susan Troxell, and Lauren
 McSweeney
 El Paso Electric Co. for 4 Centuries '81

40 * *The History of Money*
 Former State National Motorbank near San Antonio and
 Oregon streets
 1957
 6.5' x 56' mosaic
 Robert Massey with Paul Tetzner
 (One of the largest mosaic murals in the U.S. at the time of
 completion)

41. *Netherlands scene
 Inside Mills Restaurant (then next to Plaza Theater)
 1952
 8' x 16'
 Arturo Arias

42. *Our History*
 El Paso County Courthouse
 500 East San Antonio Avenue, third floor
 1993-95
 15' x 126'
 Carlos Callejo
 County of El Paso

43. *A Day in El Paso del Norte*
 Federal Building
 700 East San Antonio Avenue
 1990-93
 9' x 50' on canvas in ten sections
 John Valadez[79]
 General Services Administration Art-in-Architecture Program

44. *Unite El Paso* (portable mural)
 Displayed 19 June at Unite El Paso Community Congress
 El Paso Civic Center
 1993
 12' x 12' portable mural
 Ysleta High School students supervised by Lupe
 Casillas Lowenberg
 Unite El Paso and Hanley Paints

45. *Modes of Transportation*
 Inside Union Depot
 700 West San Francisco Avenue
 1983
 John Downey
 Sun Metro

46. Diorama murals (various)
 Americana Museum-Southwestern Museum of Cultural
 History
 Civic Center Plaza
 Various dates
 Bill Kwiecinski

47. *Four Nudes and Cartoon Character*
 Realm Nightclub (former Newberry's)
 201 North Stanton Street
 1996
 10' x 28'
 Gregorio García from design by Damon Sacks

48. **Bicentennial Celebration*
 Near corner of Stanton and Mills streets
 1976
 14' x 48'
 Sandi Casillas and students of St. Clement's Episcopal
 Parish School

49. *Pass of the North*
 United States Courthouse
 511 East San Antonio Avenue
 1937-38; restored and cleaned by General Services
 Administration, 1987
 11' x 54'
 Tom Lea, Jr.
 U.S. Treasury Department, Section of Fine Arts

50. *Southwest*
 El Paso Public Library
 501 North Oregon Street
 1956
 5.5' x 20'
 Tom Lea, Jr., assisted by his wife Sarah

51. *Two Bullfighters*
 Newberry's
 Stanton and Overland streets, second floor
 1985
 12' x 12'
 J. Contreras

Chihuahuita

52. *Easy Rider/In Memory of Nuni*
 Garage door, 502 Canal Road
 1985
 8' x 12'
 Felipe Adame
 (Painted as a birthday present for Florentino "Lico" Subia,
 father of Nuni Subia, who was killed in an accident in 1980.)

53. *Chuco, Tejas*
300 block of Canal Road
1975, restored 1991
12' x 24'
Salvador Meléndrez, Manuel Arias, and Victor Cordero,
assisted by Victor Sánchez and Eddie Aguirre

54. *History of the Santa Fe Railroad*
Chihuahuita Community Center
417 Charles Road
1992
10' x 30'
David Alemán with students from the David Carrasco Job
Corps Center, instructors Miguel Carrasco and José Silva, and
students of the Center Sergio Saenz and Raymundo Terrazas,
using research materials provided by Fred Morales
Los Murales Project

55. *Grandfather and His Nephew (Fausto Priego and
Florencio Gallardo)*
466 Charles Road
1959
6' x 6'
Ramiro Limón Martínez

56. *Religious scene with Dove
*Fairy
Between Chihuahuita and Eighth streets
1978
Ramiro Limón Martínez

57. *Untitled or A Tribute to Joe Battle or Lágrimas*
200 block of Montestruc, formerly West Seventh Avenue
1978
12' x 24'
Freddie Morales, Mara (full name unknown), and other
Chihuahuita residents
Proyecto Bello/Beautification Project under Project Bravo
Southside

58. *The Meeting of the Presidents: Porfirio Díaz and William
Howard Taft*
Villalva's Grocery, south exterior wall
915 South Santa Fe Street
1970 or earlier; now painted over
8' x 8'
R. M. Licón
(Recorded meeting of the presidents in 1909 and presence of
Pancho Villa's troops in Ciudad Juárez in 1914.)

59. *Cuauhtémoc*
Villalva's Grocery, south exterior wall
915 South Santa Fe Street
1981-82
8' x 8'
Felipe Adame

90

Second Ward/Segundo Barrio

60. *Quetzalcoatl*
Centro Legal side wall
400 block, South Campbell street
1975
10' x 24'
Arturo "Tury" Avalos, Gaby Ortega, Pablo Schaffino,
and Pascual Ramírez (Los Muralistas del Barrio)
La Campaña Pro la Preservacíon del Barrio

61. *Native Americans*
Alamo School
500 South Hills Street
1981-82
6' x 12'
Students from classes 6A, 6B, 5A, and 5B

62. *La Fe: Mantenganla/La Fe: Support It*
Centro de Salud Familiar Clínica La Fe
608 South St. Vrain Street
1994
8.5' x 10' collage of murals on canvas
Mauricio Olague

63. *We the People*
Centro de Salud Familiar Clínica La Fe
700 South Ochoa Street
1988
5.5' x 16'
Manuel G. Acosta

64. *Sacred Family or Tribute to the Chicano Family*
Centro de Salud Familiar Clínica La Fe facade
700 South Ochoa Street
1990
10' x 10'
Carlos Rosas, assisted by Felipe Gallegos

65. *Health and Technology*
Centro de Salud Familiar Clínica La Fe
700 South Ochoa Street
1985
8' x 24'
Jorge Becerra, Joel Castro, Jaime Chávez, Lisa Contreras, Lily
De La Rosa, Miguel Guillén, Gilbert Montes, César Chávez,
and Angie Ulloa, supervised by Joe Olivas
Upper Rio Grande Private Industry Council

66. *Conquistador with Friar*
Southside Senior Citizens Center
600 South Ochoa Street
1981
8' x 24'
Santiago González, assisted by Danny Téllez and
Gabriel García
Paint donated by Given Paint Co.

67. *El Chuco/Cd. Juárez*
Sacred Heart Gym
610 South Oregon Street
1993
12' x 24'
Magda García, assisted by Martín Cortez
(In celebration of Sacred Heart Church centennial)

68. *Emiliano Zapata*
 Sacred Heart Gym exterior wall
 610 South Oregon Street
 Mid-1970s
 8' x 16'
 Carlos Rosas

69. *Our Lady of Fátima*
 Sacred Heart Church
 602 South Oregon Street
 1995-96
 8' x 16'
 Carlos Callejo

70. *Tezcatlipoca* (mural on plywood)
 Centro Chicano exterior
 718 South Mesa Street
 1987 (temporary)
 8' x 14'
 Heriberto "Eddie" Godina, Lalo Sánchez, and Henry González

71. *La Campaña: History of the Housing Struggle in El Segundo*
 Mesa and Father Rahm streets
 1977-79; painted over in early 1990s
 12' x 12'
 Jesús Rodríguez
 La Campaña Pro La Preservación del Barrio.

72. Kofu gang mural
 Tenement second story
 Florence and Eighth streets behind Armijo Center
 1981
 8' x 8'
 Felipe Adame

73. *La Virgen de Guadalupe*
 La Corona Grocery
 900 South Ochoa Street
 1981; restored, 1991
 12' x 12'
 Felipe Adame, assisted by Jesús "Machido" Hernández
 Restoration sponsored by Los Murales

74. *Aztec Calendar*
 Housing complex under first set of stairs
 Seventh and Ochoa streets
 1981
 6' x 6'
 Jesús "Machido" Hernández

75. *Entelequia/Entelechy*
 Boys' Club of El Paso exterior west wall
 801 South Florence Street
 1976; restored, 1989
 18' x 120'
 Carlos Rosas, assisted by Felipe Gallegos
 Comprehensive Employment Training Act (CETA) Summer
 Youth Project; restoration by private donors through Juntos
 Art Association

76. *Iztaccihuatl, Mujer Blanca, Leyenda de los Volcanes*
 Armijo Recreation Center
 710 East Seventh Avenue
 1981-82
 Felipe Adame, assisted by Elizabeth Joyce, Raul Macías, Nacho
 Guerrero, and Jesús "Machido" Hernández

77. *Ché Guevara*
 800 block of Florence between Seventh and Sixth avenues
 1975; restored by Bowie High School MEChA, 1994
 18' x 12'
 Salvador Meléndrez and Manuel Arias
 La Campaña Pro La Preservación del Barrio as part of the
 1975 Los Murales del Barrio Project

78. *Dale Gas/El Pachuco
 Gator's Grocery
 Sixth Avenue and alley off Cotton Street
 1982
 8' x 30'
 Felipe Adame

79. *Iztaccíhuatl and Popocatépetl*
 600 block of South Campbell Street
 1987
 26' x 22'
 Felipe Adame, Varrio Quinta Street (VQS) members, and
 others
 Partially funded by "We the People" committee; 1991
 restoration under Los Murales Project grant

80. *Segundo Barrio*
 500 block of Father Rahm Avenue
 1975
 24' x 22'
 Arturo "Tury" Avalos, Gaby Ortega, Pablo Schaffino, and
 Pascual Ramírez (Los Muralistas del Barrio)
 La Campaña Pro La Preservación del Barrio

81. *Education Is the Future*
 Roosevelt Elementary School cafeteria
 616 Father Rahm Avenue
 1995
 8' x 16' on plywood mounted on the wall
 Four Bowie High School students and four Roosevelt School
 students supervised by Gaspar Enríquez
 Los Murales Project, Safe 2000, Silva's Supermarket, Hanley
 Paint Manufacturing Co., El Paso Electric Co., El Paso
 Natural Gas Hispanic Engineers, and Nancy Lara

82. *La Virgen de Guadalupe
 Tula Irrobalí Park (Alamito Park)
 Tays and Fifth streets
 1978-79
 18' x 24'
 Arturo Avalos, Pablo Schaffino, and Gaby Ortega
 Coordinated by Aliviane
 (The handball court was later demolished to deter drug
 activity.)

83. *Aztec Calendar
 Tula Irrobalí Park (Alamito Park)
 Tays and Fifth streets
 1986
 12' x 18'
 Luis Anchondo, Poli Cisneros, and neighborhood youth
 Coordinated by Aliviane
 (Handball court later demolished.)

84. *Houchen Bus*
Houchen Community Center
609 Tays Street
1992
Bus painted by Ernesto Pedregón Martínez

85. *Kids on the Moon*
Southside Educational Center
100 block of Fourth Avenue
1987; painted over in 1992
16' x 76'
Carlos Callejo with students of the Upper Rio Grande Private
Industry Council (PIC) Summer Youth Employment Program

86. *Untitled
Wall in 200 block of Fourth Avenue near El Paso Street
1975
8' x 14'
Luis Pérez
(Three faces represented the transformation of a Chicano.)

87. *Untitled
Old Sylvania building across from Rainbo Bakery
Fifth and Stanton streets, northwest corner
1975
9' x 24'
Arturo "Tury" Morales, Pascual Ramírez, Jr., and Pablo
Schaffino
(The mural, featuring a geometric codex-like border with a
central figure with protruding tongue, was used on the cover
of a Chicano Studies brochure for the University of Texas at
El Paso.)

88. *Chicanos Unidos Del 2nd*
Fourth Avenue between El Paso and Oregon streets next to
Los Cuatro Hermanos Restaurant
1975 or earlier
12' x 12'
Artists unknown
(Mexican flag and two hands shaking; photo appeared in *El
Poder de la Luz* [November 1975] published by Chicano Power
and Light, Inc.)

89. *Revolutionary with Thunderbird* (probably Zapata)
200 block of Fourth Avenue near El Paso Street
Early 1970s
8' x 14'
Artist(s) unknown, probably under La Campaña

90. *Aztlán Sin Fronteras*
100 block of Fourth Avenue
1975 or earlier
16' x 76'
Artist(s) unknown, probably under La Campaña
(Carlos Callejo painted *Kids on the Moon* over the deteriorated
mural in 1987.)

91. *AIDS*
800 block of Sixth Avenue
1988
18' x 75'
Carlos Callejo and youth from Upper Rio Grande Private
Industry Council (PIC) and Chicano AIDS Coalition
PIC Summer Youth Employment Program and Chicano AIDS
Coalition

92. *El Chuco y Qué/El Paso So What?*
Pepe's Grocery
700 block of South Virginia Street
1991
16' x 24'
Carlos Callejo, assisted by Alejandro Martel, Raymundo
"Rocky" Avila, Antonio Mercado, Manuel Arellano, and Frank
Mata
City of El Paso Arts Resources Department and Clínica La Fe;
reception sponsored by Los Murales
("El Chuco" is a Chicano slang term for El Paso.)

93. *The Children First/Primero Los Niños*
Aoy Elementary School cafeteria
901 South Campbell Street
1994
12' x 48'
Carlos Rosas
Aoy Alumni Association

94. *Discover the Secrets of the Universe Through Your Library*
Armijo Branch, El Paso Public Library
620 East Seventh Avenue
1994
Two walls, one 20' x 124' and the other 17' x 24'
Carlos Callejo
El Paso Public Library, City of El Paso Community
Development Department, and Los Murales

95. *Memorial to Manuel G. Acosta or God Is Mexican*
Border highway at South Campbell Street
1990
12' x 84'
Carlos Rosas
Silva's Market

96. *Guardian Angel*
Guillén Housing Complex
1100 block of Ninth Avenue
1988
24' x 24'
Joe Isais, Alex Castro, Mario Barrozo, Jorge Aparicio, Alfredo
Carmona, and Carlos Lugo
El Paso Housing Authority

97. Guillén Junior High murals
900 South Cotton Street
1986
Two murals, each 3' x 110'
Estela Briones, Martin Cano, Tony Cordero, Fermín Montes,
Gilbert Montes, Angie Ulloa, and Nelli Oporto supervised by
José Olivas
St. Anne's Center with PIC funding

98. Zavala Elementary School cafeteria
51 North Hammett Street
1986
18' x 36'
Estela Briones, Martin Cano, Tony Cordero, Fermín Montero,
Gilbert Montes, Angie Ulloa, and Nelli Porto supervised
by José Olivas
St. Anne's Center with PIC funding

99. *Legacy of Fire* or *Firehouse Mural*
131 South Cotton Street
1995
7' x 250'
Lance Hunter with volunteers: Liliana Calleros, Victor Cano, Joe Hinojosa, Juan Soto, Vincent E. Kitch, Lilia Peña, Raul Palomo, Ed Saucedo, and Michael Ross, with special help from Eloise López Price
El Paso Arts Resources, Los Murales, and City Rep. Raymond Telles

International Boundary/Rio Grande

100. *Todos Somos Ilegales/We Are All Illegals*
Ciudad Juárez side of Rio Grande canal near Stanton Street bridge
1987
18' x 36'
Manuel Anzaldo Meneses and Los Artistas de la Frontera
LIBRE and artists from both sides of the border

101. *Todos Somos Americanos/We Are All Americans*
Ciudad Juárez side of Rio Grande canal near Stanton Street bridge
1988
18' x 36'
Manuel Anzaldo Meneses and Los Artistas de la Frontera
LIBRE and artists from both sides of the border

102. *El Puente Negro*
Ciudad Juárez side of Rio Grande canal near Avenida Lerdo bridge
1989
18' x 36'
Manuel Anzaldo Meneses, Rafael Martínez, and Los Artistas de la Frontera
LIBRE and artists from both sides of the border

103. *Untitled
Immigration and Naturalization Service facility, Stanton Street bridge
1981
7' x 29.5'
Ruthie Loewenstein and Patty Freeman

104. *Mural Postcards
El Paso side of Bridge of the Americas
1981
6.6' x 36.8' on sheet metal bolted to wall
Paul H. Ramírez, Susan Troxell, Rene Garrison, Linda Joens, Irene Soto, and Lauren McSweeney
Junior League of El Paso arts task force and El Paso Arts Resources Department, stemming from a workshop led by Sarah and John Fishbone; in celebration of 4 Centuries '81 (The same group painted two 5.5' x 10' postcards on stretched canvas, which were unveiled and signed by El Paso and Juárez mayors in the Museo de Arte e Historia [INBA] in Ciudad Juárez, then were mailed to the presidents of the two countries.)

105. *La Virgen de Tepeyac*
Wall surrounding Mago Gándara's studio in Ciudad Juárez
1995
6' x 60'
Mago Orona Gándara

Central El Paso, North of I-10

106. *Stop the Killing*
Pershing Theater
2905 Pershing Drive
1989-95
8' x 24'
First mural painted by José "Match" Fernández, assisted by
Frank Molina. Later murals by other community aerosol
artists known as Chas, Graves, Dave, War, Skew, and Grafix.
Los Murales

107. *La Virgen de Guadalupe*
Esparza's Grocery
2901 1/2 North Piedras Street
1989
8' x 8'
Mario Colin and Charles "Chuck" Zavala
Esparza's Grocery

108. *Meso-American Olmec*
Garage door of residence
Aurora and Piedras streets
1991
8' x 18'
Carlos Rosas
Ho Baron

109. *Save the Planet*
Railroad overpass
Altura avenue near Pershing Drive
1992
12' x 24'
Austin High School students Nidela, Jorge, and Chris Macias
supervised by Tony Márquez
Southwestern Bell Partners-in-Education Program[80]

110. Vignettes depicting U.S./Mexico border life
Basement game room, home of Dieter Selbach
4601 Cumberland Circle
1935
Tom Lea, Jr.
Dorrance D. Roderick (owner of the home at the time)

111. *Religious mural
Wall at Jefferson and Copia streets
1991
8' x 12'
Jaime and Elena "Mari" Carrillo

112. *Los Paisanos/Five Points Block Party*
West wall of Planned Parenthood
2817 East Yandell Boulevard
1985
8' x 60'
Gene K. Wilson
Restored in 1994 under the direction of the artist's sister, Jan
Wilson; lead artist Mario Colin, assisted by Rigoberto de la
Mora, Gregorio García, Mago Gándara, David and Mary
Nakabayashi, and Linda Wilcox, with other participants: Raul
Meza, Dale McLaughlin, Carol Wortner, Raul Meza, Jr.,
Cynthia Meza, Roland Gilham, John Ríos, Ana Cristina, Ho
Baron, Jacob Roberts, Derrick Sánchez, Rosie García, Judy

Polwort, Mckenzie Rhren, Paul and Connie Haeder, Henry Cruz, Fred Albin, Gabriel Enríquez, Jr., Sylvia Barraza, Richard and Manny Enríquez, Paul Hoylen of Deming, New Mexico, and two others known as Oatley and Chris.

113. *Portrait of Gene K. Wilson*
West wall of Planned Parenthood next to Wilson's mural
2817 East Yandell Boulevard
1994
8' x 12'
José "Match" Fernández

South Central El Paso, South of I-10

114. Beall Elementary School cafeteria
320 South Piedras Street
1987
PIC students supervised by Joe Olivas
St. Anne's Center

115. *Jesus Christ on Cross and La Virgen de Guadalupe*
EZ Mart (formerly KIMA Grocery)
401 South Piedras Street (mural faces Palm street)
Each mural 12' x 12'
Year and artist unknown

116. *La Virgen de Guadalupe*
Tays Place Apartments
Olive Avenue
1987
18' x 18'
Los 14, the 14s

117. *Sports TNT*
Handball court at Tays Place housing complex
Cypress and Nixon streets
1990
16' x 16'
Youth of the housing complex supervised by Ray Davis

118. *Hispanic Heritage* and *Homelessness*
Superior Solutions, 2001 Magoffin Avenue
1990-91
18' x 120'
Mario Colin, assisted by Gregorio García, Raul Meza, Chilo Meza, and Ernie Ruiz
Industrial Stone Washing, Inc., and Los Murales

119. *Labors of Cotton*
Superior Solutions, Inc., inside
2001 Magoffin Avenue
1992
6' x 16'
Carlos Callejo
Superior Solutions

120. Untitled
Superior Solutions, Inc.
2001 Magoffin Avenue
1993
16' x 20'
Raymundo "Rocky" Avila
Superior Solutions, Inc., and Greg Acuña

121. *La Virgen de Guadalupe con Juan Diego/Offering of the Flowers*
Salazar Apartments Building 10
1000 Cypress Avenue at 300 South Eucalyptus Street
1981-83
24' x 24'
Felipe Adame, assisted by Jesús "Machido" Hernández and community residents
1991 restoration under Los Murales

122. *Memorial to Rubén Salazar*
Salazar Apartments Building 31
1000 Cypress Avenue
1988
24' x 24'
Alejandro Martel, Luis Alamo, Manny Flores, Norma Antunes, Annette D. Flores, Ramiro Peña, José Barrios, Armando Estrada, Douglas Moran, Manuel Guzmán, and Luis Sustaita, supervised by Archie Moreno, César Galván, and Carlos Callejo
Upper Rio Grande Private Industry Council (PIC) Summer Youth Employment Program

123. *Christ Looking Over El Paso/Cd. Juárez*
Salazar Housing Complex
311 South Eucalyptus Street
1985-86
24' x 24'
Youth from the apartments including Gabriel Ontiveros (main artist), Rosendo Montes, George Quiñones, and two young men known as "El Corn" and "Paquita," supervised by Gaspar Enríquez
Housing Authority of El Paso

124. *Tribute to Enedina "Nina" Sánchez Cordero*
Salazar Apartments, Building 2
300 South Eucalyptus Street
1991
18' x 24'
Painted under supervision of Gaspar Enríquez
El Paso Housing Authority; 1991 restoration under Los Murales
(Cordero was honored as founder of the Clínica La Fe in South El Paso.)

125. *La Niña Cósmica*
Douglass Elementary School
101 South Eucalyptus Street
1993
12' x 72' mosaic
Mago Orona Gándara, assisted by Rocio and Edgar Domínguez
Junior League of El Paso and SAFE 2000

Bowie High School, 801 South San Marcial Street

126. *Bear Mascot*
On elevator between buildings
1986
16' x 12'
Bowie students, supervised by Gaspar Enríquez
Bowie High School

127. Sports murals
Handball courts and inside girls' gymnasium
12' x 12' (various)
Painted each year by art students, supervised by Gaspar Enríquez

128. *Offering*
Library
1978
8' x 18'
Students Ray Cervera, Raul Espinoza, Raul Ruiz, Ferris
Meléndrez, Hector H. Trejo, Luis Ramírez, and Antonio
Cordero, supervised by Joe Olivas

129. *History of El Paso*
Cafeteria south wall
1978
8' x 30'
Students Ray Cervera, Raul Espinoza, Raul Ruiz, Ferris
Meléndrez, Hector H. Trego, Luis Ramirez, and Antonio
Cordero, supervised by Joe Olivas

130. *Meso-America*
Cafeteria
1975
8' x 30'
Ernesto Pedregón Martínez; bicentennial gift to the city
Bowie Boosters

South Central El Paso, South of I-10

131. *Heroes of Mexico: Miguel Hidalgo, Emiliano Zapata, Pancho
Villa, and Benito Juárez* (on the cover of this book)
St. Anne's Community Center cafeteria
600 South Piedras Street
1985
20' x 20'
Robert Paredes, Elizabeth Juárez, Michael De La Cruz, Anna
Reza, and Oscar Hernández, supervised by Joe Olivas

St. Anne's Center with funding from Upper Rio Grande
Private Industry Council (PIC)

132. *La Familia*
St. Anne's Community Center administrative offices
600 South Piedras Street
1987
7' x 12.7' and 7' x 9' on two walls
Oscar Hernández, Elizabeth Juárez, Robert Paredes, Michael
De La Cruz, and Ana Reza, supervised by Joe Olivas
St. Anne's Center with funding from PIC

133. *Señor Sol*
800 South Piedras Street
1982-83, restored in 1992
12' x 48' mosaic
Mago Orona Gándara
City of El Paso Arts Resources Department and Los Murales
Project. Restoration funds from City Rep. Jesús Terrazas

134. *Nuestra Herencia/Our Heritage*
Chamizal National Memorial
800 South San Marcial Street
1992
18' x 120'
Carlos Enrique Flores
Gift to Chamizal National Memorial and City of El Paso from
Junior League of El Paso Los Murales Project

135. *Aztec Ball Players*
Delta Recreation Center
4625 Delta Drive
1983
12' x 120'
El Paso Community College students, supervised
by Philip Behymer
El Paso Community College

136. *Iwo Jima*
Segura McDonald Post Veterans of Foreign Wars
3930 Findley Avenue
1966
8' x 9'7"
Manuel H. Acosta (not to be confused with Manuel G.
Acosta)

137. *Mujer Obrera/Working Woman*
Thomason Hospital, stairway behind first floor elevators
4815 Alameda Avenue
1990
8' x 8' on plywood
Carlos Rosas

138. *75th Anniversary, 1915-1990*
Thomason Hospital cafeteria, basement level
4815 Alameda Avenue
1989
4' x 200'
Rubén Olvera and Ricardo Ramírez Armendáriz

139. *Emiliano Zapata*
Alamo Plumbing
Collingsworth and Alameda streets
1980
12' x 12'
Ismael Facío and employees of John Valenzuela as a
present for attorney Mark Howell
Alamo Plumbing

140. **Aztlán*
Rio Grande Apartments
212 Lisbon Street
1985; later painted over
24' x 24'
Angel R. Zambrano and neighborhood youth, coordinated
by Aliviane and supervised by Manuel G. Acosta
City of El Paso

141. *Tribute to Abraham Lincoln*
Lincoln Cultural Arts Center, second floor
4001 Durazno Avenue
1984
8' x 12' on two facing walls
Carlos Enrique Flores, assisted by Ernesto Montero, René R.
Huerta, Victor Alarcón, and Martín Chavarín
Upper Rio Grande Private Industry Council Summer Youth
Employment Program

142. *Amistad/Friendship*
Lincoln Cultural Arts Center, first floor
4001 Durazno Avenue
1985
Carlos Enrique Flores, assisted by Fermín Montes, Manuel
Guzmán, Ana Ramos, Flaviano Ortiz, Fernando Galván,
Carlos Casillas, and Enrique Flores, contracted by City Parks
and Recreation Department
Upper Rio Grande PIC Summer Youth Employment Program

143. *La Virgen de Guadalupe with Roses*
4001 Durazno Avenue
1981
12' x 8'
Felipe Adame

144. *Emiliano Zapata*
Underpass called the Spaghetti Bowl
1981
4' x 8'
Felipe Adame

145. *Revolution*
Forti's Mexican Elder
321 Chelsea Street
1992
4' x 17'
Pedro J. Aybar
Forti's

146. *Boxers*
San Juan Recreation Center boxing arena
5628 Webster Avenue
1985
12' x 24'
Carlos Enrique Flores, assisted by Fermín Montero, Manuel
Guzmán, Flaviano Ortiz, Ana Ramos, Fernando Galván, and
Carlos Casillas
City Parks and Recreation Department

147. **La Virgen de Guadalupe*
Wall near corner of Seville and Sambrano streets
1982-83
8' x 9'
Artist known as Memin's Uncle and the Presence Car Club
Aliviane

148. **La Virgen de Guadalupe*
Former Summit Fashions building
220 Colfax Street
1982-83
10' x 20'
Artists known as Santos, El Smiley, and El Robe, coordinated
by Chevo Quiroga of Aliviane
Joe Shamaley sponsored in part
(Only the head of the Virgin remains.)

149. **Quetzalcoatl*
Handball courts at Ascarate Park
1982
18' x 24'
Artist unknown
El Paso County Sheriff's Department

150. *La Virgen de Guadalupe*
Sherman Apartments handball court
4528 Blanco Avenue
1988
14' x 18'
Artist known as Bobadillo and others

151. *Aztec Designs*
Sherman Apartments
4528 Blanco Avenue
8' x 18'
Date and artists unknown

152. *Storybook Characters*
Salvation Army
4300 Paisano Drive
1989
9' x 36'
Carlos Callejo
Los Murales

153. *Choose Your Destiny*
Enrique H. Peña Juvenile Detention Center
6400 Delta Drive
1993
18' x 30'
Carlos Callejo and youth at the center
Los Murales Project and Juvenile Probation Department

East Central El Paso, North of I-10

154. *History of Air Transportation*
El Paso International Airport
6701 Convair Drive
1984
6.6' x 34'
Chris Steven Meister

155. *Congressional Medal of Honor Recipients*
Veterans Affairs Building
5919 Brook Hollow Drive
1977
8' x 28'
Ernesto Pedregón Martínez
United American Veterans Organization of El Paso

156. *SER Mural*
SER administrative offices
4838 Montana Avenue
1987
9.6' x 30'
Joel Castro, Lily De La Rosa, Angie Ulloa, Jorge Becerra, César Sánchez, Jaime Chávez, Lisa Contreras, Gilbert Montes, Miguel Guillén, and Ernesto Armijo, supervised by Joe Olivas
Upper Rio Grande Private Industry Council

Northeast El Paso

157. Diorama murals (various)
Wilderness Park Museum
2000 Woodrow Bean Trans-Mountain Road
1974-76
Mario Parra, Sam Herrera, and Mago Orona Gándara,
supervised by William Rakocy

158. *Homage to César Chávez*
Texas Employment Commission
5735 Will Ruth Avenue
1994
12' x 36'
Student artists in COMPADRES program
Texas Employment Commission
(The mural raised controversy because a Mexican flag was
painted alongside the U.S. flag.)

159. *A Myriad of Faces*
Northeast YWCA
9135 Stahala Drive
1995
9' x 800' in three sections
Lupe Casillas-Lowenberg and students from area high schools
Los Murales and Northeast YWCA

160. *Tribute to Desert Storm*
Stout Gymnasium, inside
Forrest Road, Fort Bliss
1991
12' x 55'
Ernesto Pedregón Martínez
Los Murales

161. *Congressional Medal of Honor Recipients*
Department of Veterans Affairs Health Care Center
5001 North Piedras Street
1995
6' x 20'
Ernesto Pedregón Martínez
Department of Veterans Affairs

162. *In Memory of Jerry Sánchez III*
Skyline Optimists Park
5050 Yvette Drive
1992
8' x 14'
Freddie Ramírez, Chris Calanche, and Cristy Ruiz

163. *Universal Peace*
4317 Dyer Street
1992
8' x 16'
José "Match" Fernández

164. *Franklin Mountains*
Ace Drive-in Grocery No. 2
5828 Quail Avenue
1993
8' x 24'
Parkland High School Art Extension Group, supervised
by Eva Kutscheid
(Murals on two sides of building, one sunrise, the other
moonrise)

East El Paso, North of I-10

165. *Class of 2000*
El Paso Independent School District Central Office
6531 Boeing Drive
1995
5' x 6.5'
Burges High School students: John Martínez, Andy Pérez, Ricardo Rivera, Paul Martínez, Adam Rosas, Calvin Griffin, and Ben Natera; and El Paso High School students: Luz Castro, Alex Márquez, Norma Orozco, Francisco Marez, Ana Montelongo, Theron Nicholson, Jon'l Johnson, Jesús Soto, and Eduardo Rodríguez, supervised by Leilani Calzada and Scotti Burns (Burges) and Debbie Hartman (El Paso High)

166. *UTEP Athletics
Former Gardenschwartz Sports store
8900 Viscount Boulevard
1987
Gene K. Wilson

167. *Selva Tropical*
Ysleta Independent School District
Cultural Fine Arts Center, second floor
9600 Sims Street
1994
9' x 47'
Visiting student artists from Tabasco, Mexico: Emilio Uriel Hernández García, Isabel Morales García, René German Maldonado, Eleazar Hernández Arias, and Hector García Salvador, under the direction of Miami artist Leandro Soto

168. *Folklórico Dancers*
Ysleta Independent School District
Cultural Fine Arts Center, second floor
9600 Sims Street
1994
9' x 26'
Emilio Quiroz
Ysleta ISD

169. *Southwest Wildlife*
Bowl El Paso
11144 Pellicano Drive
1995
6' x 240'
Tobi Jo Varnell

170. *German Traditions*
Gunther's Edelweiss Restaurant, interior and exterior
11055 Gateway West
Dieter Sebastian

171. *Tribute to David L. Carrasco*
David L. Carrasco Job Corps Center
11155 Gateway West
1991
24' x 28'
Students from the center: David Velasquez, Victor Villegas, Stephan Whelpdale, and Barbie Jiménez, supervised by Carlos Rosas
Los Murales and Job Corps

172. Diorama murals (various)
 El Paso Museum of History
 12901 Gateway west
 1974-76
 Mario Parra and Sam Herrera, supervised by William Rakocy

Southeast El Paso

173. *La Virgen de Guadalupe
 6700 Sambrano Street
 1982-83 (wall demolished in late 1980s)
 7' x 8'
 Artist known as Memin's Uncle and Presence Car Club

Lower East El Paso, South of I-10

174. *Time and Sand*
 El Paso Community College Valle Verde Campus
 Library Resource Center cafeteria east wall
 919 Hunter Road
 1975-78
 30' x 34' sand cast mosaic
 Mago Gándara and her students from the college's original
 Logan Heights Campus

175. *Visually Processed Data*
 El Paso Community College Valle Verde Campus
 Academic Computer Center Room S-108
 919 Hunter Road
 1988
 9' x 46'
 EPCC students: Freddy Archuleta, Mario Colin, Arturo Del
 Hierro, Juan Enríquez, Frank Escobar, Alan Grau, Efrén
 Molina, Sr., Simón Nájera, Hyank Ok, Jesús Parra, Juan

Santos, and Don Valdiviezo, supervised by Anna Patalano

176. *African Spirit of Jazz: Dedicated to James De Cracker*
 and *Ysleta Mission*
 El Paso Community College Valle Verde Campus
 Handball court
 919 Hunter Road
 1993 and 1994
 16' x 21' each mural
 EPCC students, supervised by Steve Beck

177. *Together Then, Together Again*
 El Paso Community College Valle Verde Campus
 919 Hunter Road
 1995
 4' x 16' portable mural, tribute to Vietnam veterans
 EPCC students: Shannon McDonnell, Mitsumasa Overstreet,
 Ricardo Quiñonez, Fernando Ramírez, Mayela Soto, Manuel
 Ybarra, and José Leon, supervised by Steve Beck

178. *Lotería: La Sirena, La Calaca, La Palma, La Mano, El Aguacate*
 El Paso Community College Valle Verde Campus
 Water tank, northeast corner of campus
 919 Hunter Road
 1995-96
 30' x 12' diameter
 EPCC students: Shannon McDonnell, Mitsumasa Overstreet,
 Ricardo Quiñonez, Fernando Ramírez, Mayela Soto, Manuel
 Ybarra, and José Leon, supervised by Steve Beck

179. *Adam and Eve at the Rio Grande*
El Paso Community College Valle Verde Campus
Library Resource Center first floor
919 Hunter Road
1985
5.5' x 42'
Mexico City artist Pedro Medina, assisted by EPCC students:
L. Carrasco, S. Diaz, M. Gonzales, A. Herrera, J. Herrera, A. Lozano, G. Ramos, and E. Rodríguez

180. *Futuristic City*
El Paso Community College Valle Verde Campus
Walkway
919 Hunter Road
1985
13' x 71'
Mexico City artist Pedro Medina

Lower Valley

181. *Untitled (Southwestern theme)
Carolina Community Center handball court
563 North Carolina Drive
1988
24' x 24'
Magda García and students in Private Industry Council Summer Youth Employment Program

182. *El Santo Niño de Atocha*
Marmolejo Apartments
600 North Carolina Drive
1984
22' x 32'
Angel Romero, principal artist, and neighborhood youth, supervised by Manuel G. Acosta
Aliviane and City of El Paso

183. *Guardian Angel*
Marmolejo Apartments
600 North Carolina Drive
1993
22' x 26.5'
Manuel Ponce and youth from the apartments
Los Murales

184. *In Memory of Andrea Hensley, 1978-1993*
Wall facing street at car wash
8230 North Loop Road near Lomaland Drive
1994
8' x 18'
Ricardo Vega, assisted by Tony Medina, Mario Muñoz, Chris Porras, and Cindy Pacheco
(Andrea Hensley, daughter of David Hensley, was a student at Hanks High School when she died in an accident.)

185. *Mural de Senecú*
Ysleta Independent School District Entrepreneur Center
8455 Alameda Avenue, exterior wall behind building
1996
800 square feet, three panels each 11' x 16'
Lupe Casillas-Lowenberg and students with assistance from
Enrique Escobar
Ysleta ISD

186. *Stages of Life*
Julián Téllez Senior Citizens Center inside
8908 Old County Road
1985
8'8" x 15'10"
Pedro Medina
El Paso Arts Resources Department

187. *Tigua Pueblo, Mission Ysleta*
Tigua Indian Reservation
119 South Old Pueblo Road
1988
13' x 35'
Felipe Adame
Tigua Indian Reservation

188. *The Coming of Rain*
Immigration and Naturalization Service
Ysleta Border Station Building A
797 South Zaragosa Road
1994
7' x 9'
John Valadez
General Services Administration Art-in-Architecture Program

189. *Images of Unity*
Q-Mart, 10005 Alameda Avenue
1993
16' x 18'
Students from Socorro Middle School and Socorro High
School, supervised by Jan Deragisch
Q-Mart and City of Socorro

190. *Eagle Pride* and *La Virgen de Guadalupe*
Ramon Arevalo's repair shop, 12700 Socorro Road (Farm Road
258) and Convento del Paseo
1994
Two walls facing corner, one 10' x 60' and one 10' x 36'
Willie Alvarez, Nancy Alvarado, Robert Chavira, Antonio
Flores, Rene Gonzalez, Jaime Lopez, Christina Lujan, Victor
Macias, Ricky Maese, Jose Martínez, José Medina, Ruben
Morales, Carlos Nava, James Ortiz, Jose Rangel, Raul Rendon,
Jesús Reyna, Eric Rocha, Rodrigo Rojo, Cesar Soto, Lorenzo
Tellez, Miguel Torres, Angel Urbina, Daniel Valadez, David
Valdez, Luis Varela, Xavier Vega, Adriana Zuniga, Brian
Zuniga, Ana Zuniga, and Elizabeth Zuniga, supervised by
Francisco Borrego
Los Murales

191. *Azteca: El Hombre Aguila*
Handball court in area known as Middle Drain at Varrio Indio
Viejo near Presa Elementary School
1982
24' x 24'
Community youth, supervised by Salvador "Chava" Valdez
and organized by Chevo Quiroga
Aliviane

192. *La Virgen de Guadalupe with Ysleta Mission*
Kennedy Apartments Main Building
447 South Schutz Drive
1988
13' x 24'
Members of Varrio Chicano Pride supervised by Salvador
"Chava" Valdez and organized by Chevo Quiroga
Aliviane

193. *Aztec Gods Iztaccíhuatl and Popocatépetl*
Kennedy Apartments Main Building
447 South Schutz Drive
1982
13' x 12'
Rudy Mendoza, Juan Martínez, Oscar Martínez, and members
of Varrio Chicano Pride, supervised by Salvador "Chava"
Valdez and organized by Chevo Quiroga
Aliviane

194. Sports mural
Pavo Real Recreation Center exterior
9301 Alameda Avenue
1988
13' x 19'
Alberto Chávez, Marta Medina, and Richard Reinhardt,
supervised by Arnulfo Torres

195. *Conquistador*
Del Valle High School
950 Bordeaux Drive
1992
10' x 48'
Adrian Ramírez and Danny Hernández, assisted by Gaspar
Enríquez

196. *Dance, A Universal Art Form/Tribute to Rosa Guerrero*
Socorro Center for the Performing Arts, inside
10150 Alameda Avenue, Socorro, Texas
1989
12' x 36'
Carlos Callejo, assisted by Alejandro Martel and Antonio
Mercado, using image from painting by Marta Arat
Los Murales

197. *The History of the Mission Valley*
Grain silo next to Horizon Big Eight supermarket
Horizon Boulevard and North Loop Road
1994
24' x 18' diameter
Gaspar Enríquez, assisted by Mauricio Olague, Donna
Haynes, Alfonso Valenzuela, Diana Corral, Steve Salazar,
Ernie Muñoz, and Mariam López
Big Eight and Junior League of El Paso Los Murales Project

Appendix B: School Murals

Aside from those already listed, additional murals in schools are worth mentioning because of the proliferation of interest in this art form which has existed in El Paso for many years.

Two high school libraries have paintings by Audley Dean Nicols (1886-1941), a local professional artist. Not long after Austin High School opened in 1930, he created a mural of a mountain scene.

In 1925 he was commissioned by the First National Bank of El Paso to paint a mural of the city skyline as seen from Montana and Trowbridge streets, measuring four by sixteen feet. Seth Orndorff acquired the painting after the bank closed in 1931 and two years later presented it to El Paso High School.

Bowie High School has an abundance of murals throughout its campus, painted by local artists and students. The tradition was started by Ernesto P. Martínez in 1975. Thereafter, José Olivas, art instructor, continued the painting of murals with his students. Gaspar Enríquez and his students have maintained the tradition, producing sports murals in the women's gymnasium and more recently expanding to spray can murals on the handball courts. These works are prime examples of how talented instructors can work creatively and productively in teaching this art form.

Two murals were painted in the cafeteria of Ysleta High School in 1976-77 under the supervision of art teacher Richard Holguín. In 1981 he oversaw the creation of a 9-by-120-foot mural dedicated to learning outside the Write Place on the second floor. Students were allowed to paint popular images of the time. Another mural, executed in the math building in 1990, was painted over during renovation in 1992.

Students at Alamo Elementary School in South El Paso in 1981 produced a small mural in the courtyard, a southwestern scene with Pueblo Indians.

In 1991 students at Austin High School depicted their school against the Franklin Mountains on the second floor of the main building. Participants included: Jesús Alva, Frank Camacho, Victor Carreón, John Castañeda, Jay Guerra, Zandra Fierro, Adriel Lozano, Frank Rodríguez, Ben "GeJoe" Rodríguez, John Pacheco, Pete Santiago, Ron Winkelman, Edgar Rodríguez, Jethro Armijo, Eva Richie, and Louis Martínez. Other murals at the school have followed.

Art teacher/artist Armando Villalobos and one of his students in 1992 painted a shuttle launch mural in the gymnasium at Irvin High School in Northeast El Paso. Numerous other student works also adorn the campus, showing various versions of the rocket mascot.

María Natividad, artist and art educator, and several of her students from Del Norte Elementary School in May 1993 painted a 5-by-15-foot work titled *Celebrate American History*. The free-standing acrylic on wood mural illustrates various historic documents—the Constitution, the Bill of Rights, the Chamizal Treaty—plus the American flag, U.S. maps, and cutouts of children. The artists, aged eleven and twelve, were Gabriel Macias, Andy Castillo, Fide Rivera, Alex Gallardo, George Hernández, David González, and Antonio Alcantar. The work was displayed at the Chamizal National Memorial from June to September 1993.

During the summer of 1993, Hanks High School art teacher Al Díaz and his students painted a 20-by-90-foot mural in the cafeteria titled *Visions of Time, What We Were, Are and Will Be*. Those involved were Sandra Alba, Xochitl Araujo, Greg Berglund, Jennifer Brehm, José Bustillos, Erick Estrada, Jesús Luna, Michelle Montoya, and Richard Vega. Art teachers Teri Yasger and Díaz supervised the project.

Emilio Quiroz, artist and assistant principal at Scotsdale Elementary School, in 1994 painted various murals. Two ocean scenes are in the cafeteria, one 7.5-by-35 feet and the other 9-by-17 feet. To add another dimension to the space, school architects

designed waves of hanging fabric for a deep-sea effect. Quiroz was assisted by students Veronica Loy, Ruby Quiroz, and Cristina V. Ramírez. In 1995 he completed desert scenes for the library.

The Parkland High School Arts Extension Group, under the supervision of Eva Kutscheid, painted two murals depicting the Franklin Mountains on two sides of the Ace Drive-in Grocery on Quail Avenue (159 in Appendix A) in 1993. The following year, they created murals on the walls of several portable classrooms, then completed others in the Northeast community, including six on multicultural themes at Nations-Tobin Park.

Steve Beck, artist/teacher, and his students at El Paso Community College worked from September to December 1993 on a 15-by-30-foot mural on a handball court on the Valle Verde Campus (171, Appendix A). The east wall painting is dedicated to longtime college employee James De Cracker, a jazz fan. It depicts the African spirit of jazz, with three small children peering at a group of musicians representing the misunderstanding of jazz, contemplation and appreciation of the music, and the poverty and cultural deprivation of contemporary society. The west wall, executed from September to December 1994, shows Our Lady of Mount Carmel Church of Ysleta, the oldest mission in Texas. The work is in shades of black, white, and blue to resist discoloration in harsh sunlight, and was also designed to ward off radiated heat from adjacent blacktop which would have faded the paint.

During the summer of 1994, Roberto Dozal, assisted by fellow teacher Porfirio Garza, painted an 8-by-24-foot mural at Eastwood Middle School. The untitled work presents six panels, each with a theme: "the city," "technology," "the future," "land," "sea," and air." Dozal, an accomplished artist, took two weeks to complete the work.

The Junior League of El Paso in 1994 sponsored "Murals on the Trolleys." The project invited students from selected schools in the El Paso, Ysleta, and Socorro school districts and the David L. Carrasco Job Corps Center to paint murals for the El Paso-Juarez Trolley Co. Burges High School participants included: Eric Aguilar, Omar Contreras, Dario Farina, Kati Hammukaiman, Ben Matera, Vanessa Pacheco, David Rojas, Adam Rosas, Claudia Sepúlveda, and Paul Villia, with their art teachers, Ethel Burns and Leilani Calzada. Student Sergio Saenz and his teachers, Miguel D. Carrasco and José Silva, represented the Job Corps Center. From Hanks High School were Steve García, Jesús Luna, Jr., Rosa Erica Martínez, Rosa L. Pérez, Robert Reyes, Tiffany M. Tomberlin, and Gene White, with art teachers Al Diaz, Bruce Lee, and Teri Yasger. Socorro High students taking part were Adrian Arellano, Diana Corral, Nancy Escamilla, Sinai Flores, José Luis Girón, Claudia Hernández, Robbie Jones, and Miriam López with their teacher, Dolores Dueñez.

The preceding account is not meant to encompass all mural activity in area schools, but demonstrates the widespread interest in this field. Local districts recently were compiling lists of all murals in their schools. It is safe to say, mural activity in El Paso area schools will continue into the next century.

Appendix C: Other Murals

In addition to the murals listed in Appendix A and Appendix B, several others deserve mention in the interest of local history and of the prominence of the artists.

T. J. Kittilsen

1917: *Col. Alexander W. Doniphan at El Paso, Cabeza de Vaca trading with a Manso Indian, Meeting of Mexican President Benito Juárez and Gen. James H. Carleton of the California Rifles, Apache Indians attacking a Stagecoach West of El Paso, Coronado Seeking the Seven Cities of Cíbola,* and *Arrival of a Pioneer Caravan at the Juan María Ponce de León Ranch,* and two others

Eight murals on canvas by T. J. Kittilsen hung in the El Paso County Courthouse for forty years before being removed in 1957 during renovation of the building. The lobby area where they had hung was redesigned and no longer had space for them. They were based on themes suggested by Maj. R. F. Burges.

Six of them are now in the collection of the El Paso Museum of Art.

Edward Holslag

1922: *The Buffalo, The Indians, The Pioneer, In the Beginning, The Ysleta Mission, The Burro, The Round Up, The Smelter, The Rio Grande,* and *The Mountains*

James G. McNary, president of the First National Bank of El Paso, in 1922 commissioned Edward Holslag of Chicago to paint a series of ten panels, each about 6-by-10 feet, for the bank, based on drawings by Mrs. McNary. When the paintings were completed, the bank published a booklet, *Southwestern Milestones,* with poems by local author Owen P. White, to accompany photographs of the paintings. After the bank closed in 1931, the murals were acquired by the family of Lee Orndorff, who had been a bank director.

During the 1950s one of the murals was displayed in the Student Union Building at the University of Texas at El Paso. Two others were loaned to El Paso International Airport by heirs of the Lee Orndorff Estate where they may be seen at the base of the escalators.

Aldo Lazzarini

1949: *El Paso del Norte/The Pass of the North*

The 26-by-7-foot mural by Lazzarini, a native of Milan, Italy, was unveiled in the Grill Room of Hotel Paso del Norte in March 1949. The artist had studied in Italy and in Paris before coming to the United States in the 1920s. He painted numerous murals for hotels and steamship companies. This one was on canvas attached to the wall by a special adhesive. It is pictured in a booklet about the hotel (now the Camino Real), "Under the Dome—Footsteps Through History" (1989).

Hal Marcus

These oil on canvas works are in the collection of the artist:

1975: *My World, My Life, My Friends*

1988: *El Mercado,* assisted by Fernando Flores, Sergio Villanueva, Paul Seitz, and Susi Davidoff

1990: *Avenida Juárez*

1992: *Plaza de los Lagartos/El Paso Navidad,* assisted by Fernando Flores and Sergio Villanueva

1993: *El Paso Gracias a Dios*

1994: *Children of the Sun*

1995: *Peace Corps*

Marcus draws on his Arab-Judaic heritage and the El Paso community in his work. He attended Coronado High School, where he studied art with Lupe Casillas-Lowenberg.

Bassel Wolfe

Three murals on canvas, each approximately 5'5" x 7'5" were executed in 1990, 1992, and 1996 for Jaxon's Restaurant, 1135 Airway Boulevard, with the theme *The History of El Paso*. The sponsor was Jack Maxon.

Wolfe has taught life-drawing in San Francisco and drawing and design at the University of Texas at El Paso. He has won numerous awards for his art work and is represented in collections in the Orient, Europe, and North America.

Appendix D: Jesús Helguera

Jesús Helguera's paintings have long been the inspiration of Chicano and Mexican artists. They became known largely through calendar reproductions. His imagery, tied to the legends of Mexico, helped celebrate the country's heritage and identity; therefore, it is no accident that when new muralists began looking for subjects other than the Virgin of Guadalupe, they turned to Helguera's works. His imagery has also influenced contemporary Chicano artists such as sculptor Luis Jiménez in his *Southwest Pieta*, a stylized fiberglass version of one of Helguera's most famous subjects.

The artist was born 28 May 1910 in Chihuahua, Mexico.[81] Thirty days later his family moved to Mexico City. He was baptized at San Cosme Church as Jesús Enrique Emilio de la Helguera Espinosa. When he was two years old, the family relocated to Córdova, Veracruz.

At the age of seven, he left his family to go to Spain, where his artistic skills were awakened in elementary school.[82] He was nine when he was put in charge of his art class and painted murals of the adventures of Don Quijote. He also illustrated history lessons and maps without problems with scale.[83]

After his elementary studies, he went to live with his grandparents in Madrid. At fourteen he enrolled in La Academia de Bellas Artes de San Fernando. He received a scholarship to become a landscape painter in the Spanish governor's residence in the province of Segovia. An exhibition prize enabled him to study at the Alhambra in Granada. Helguera went on to win numerous other honors, including a Círculo de Bellas Artes award. He studied in Spain with Cecilio Plá, Moreno Carbonero, Manuel Benedicto, and Julio Romero de Torres. He was a frequent visitor to the Prado Museum in Madrid.[84]

After his studies, Helguera was hired by Editorial Araluce de Barcelona to illustrate such collections as *Los Grandes Hechos, Los Grandes Hombres, Páginas Brillantes de la Historia, Colección Folklórica Seleccionada de Todas las Razas y de Todos los Pueblos*, and the magazine *Estampas y Blanco y Negro* and other publications.

When he began teaching at the Instituto Miguel de Unamuno de Bilbao in San Fernando, he was dubbed "the child" by his peers. He went on to influence many students and to develop recognition in Spain. In Granada he met and married his wife, Julia González Llanos, a native of Madrid, who became the model and inspiration for many of his paintings. Their children were Fernando and María Luisa.

During the Spanish Civil War, Helguera and his family faced hardships because he could not earn substantial wages. Additionally, his brothers, Luis Felipe and Fernando, had health problems as a result of near starvation. Helguera returned to Mexico at the time Gen. Lázaro Cárdenas was repatriating citizens.

His son-in-law, Ismael Popoca Salas, quoted in a 1985 exhibit catalog, described Helguera's return: "With fifty cents in his pocket, he arrived in Mexico City and took up temporary residence in a hotel in front of San Lázaro station. He visited the office of the magazine *Sucesos Para Todos* and presented his drawings and letters of recommendation. The proprietors did not believe that such a young man could be the artist of such works, so they assigned him to create an illustration to hand in the next day. The young Helguera went back to his hotel and by candlelight created his work. The next day he returned to the magazine and was hired on the spot."

On weekends, he traveled throughout the country and studied Mexican history and culture. This research would become the basis for his paintings of Pre-Columbian and Colonial Mexican images. Many of his works were influenced by the state of Veracruz. Knowing his work would be reproduced through offset printing, the artist used bright colors. During this period, many of his paintings appeared on calendars that drew a large audience.

Towards the end of 1940, Helguera developed his famous *Leyenda de los Volcanes* based on Aztec mythology. This series was acquired by the publishing house of LITOLEOSA, which from 1941

into the 1980s introduced it to millions of Mexican households.[85]

La Leyenda de los Volcanes is a Nahua myth which concerns Izcozauhqui, the son of Tonatiuh the Sun, and Coyolxauhqui, daughter of Metztli, the Moon, who fell in love and were punished by the gods for visiting earth. Both were enchanted by earth, but Coyolxauhqui fell ill and died. Izcozauhqui, with his immense love for her, remained at her side. The gods were moved by his devotion and, in order for them to spend eternity together, the two were changed into rock and covered with snow. The legend continues, "In the Nahuatl tongue she is called Iztaccíhuatl, meaning the woman of snow or the sleeping woman; he is called Popocatépetl, the smoking mountain."[86]

Volcanes has been seen by millions of people throughout the world and has been copied by many artisans in ceramics, stone, metal, and mixed media.

Helguera died 4 December 1971 at the age of sixty-one in Mexico City. In 1985 El Instituto Nacional de Bellas Artes sponsored an exhibition of twenty-six of his paintings from the Cía. Cigarrera La Moderna at the Palace of Bellas Artes. The exhibit ran from 21 November to 26 January 1986, then traveled to Chihuahua City, Tijuana, Monterrey, San Antonio, and León, Guanajuato.[87]

Miguel "Mike" Juárez, Jr., is a cultural arts historian and native El Pasoan. He received a B.A. degree in journalism from the University of Texas at El Paso in 1985 and took graduate studies in arts administration and Chicano research studies at California State University at Dominguez Hills and museum studies at California State University at Long Beach. With fellow artist Paul H. Ramírez, he organized "Juntos 1985, 1st Hispanic Art Exhibition," which led to the formation of the Juntos Art Association. He has coordinated dozens of community art exhibits and readings. From 1985 to 1989, he served on the Texas Regional Planning Committee for Chicano Art: Resistance and Affirmation (CARA). His poetry, prose, art work, and photography have appeared in numerous publications in Texas and California. Juárez has taught art history at the Instituto Tecnológico y de Estudios Superiores de Monterrey (ITESM) in Ciudad Juárez as a visiting scholar through the El Paso Community College International Studies Program. Juárez is a member of the Southwest Oral History Association (SOHA) and is a member of the Committee on Multiculturality of the national Oral History Association (OHA).

Cynthia Weber Farah, photographer and author, has a B.A. degree in communications from Stanford University and an M.A. in literature from UTEP. Her book of portraits of southwestern authors, *Literature and Landscape: Writers of the Southwest*, won the C. L. Sonnichsen Award from Texas Western Press and a Southwest Book Award from the Border Regional Library Association. A member of the City of El Paso Arts Resources Department Advisory Board since 1987, she also was on the board of the Texas Committee for the Humanities and the advisory council of the Harry Ransom Humanities Research Center at the University of Texas at Austin. In 1991 she received the Conquistador Award, highest honor presented by the City of El Paso, for her contribution to the arts, and in 1992 she was inducted into the El Paso Women's Hall of Fame. Currently she is the director of the film studies program at the University of Texas at El Paso.

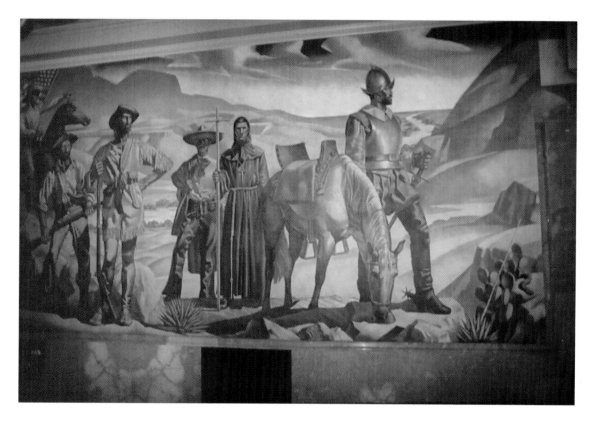

Pass of the North (1937-38)
Tom Lea, Jr.
United States Courthouse, downtown El Paso
(Appendix A, no. 49)

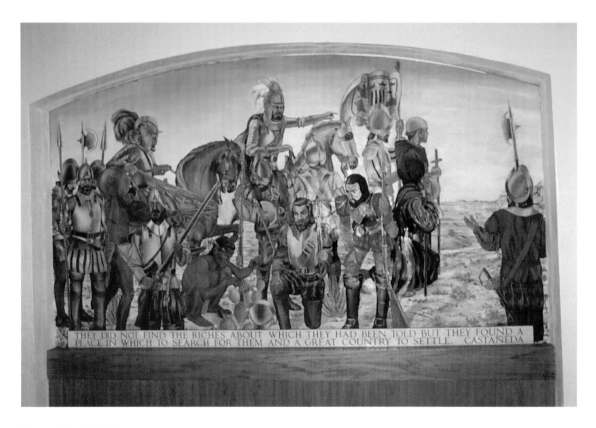

Coronado (1945)
Salvador López
El Paso Centennial Museum, University of Texas at El Paso
(no. 23)

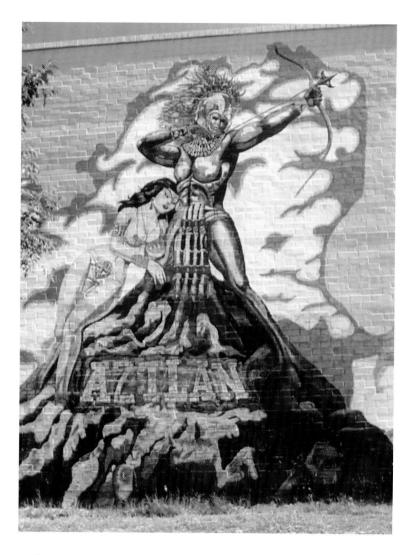

Aztlán (1985)
Supervised by Manuel G. Acosta
Rio Grande Housing Complex, 212 Lisbon Street
(no. 140)

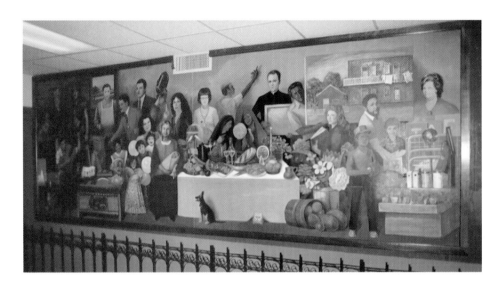

We the People (1988)
Manuel G. Acosta
Centro de Salud Familiar Clínica La Fe
(no. 63)

Capriccio Espagnol, Siglo XVII (1967)*
José Cisneros
Former Francis Fugate home,
North Kansas Street
(no. 20)

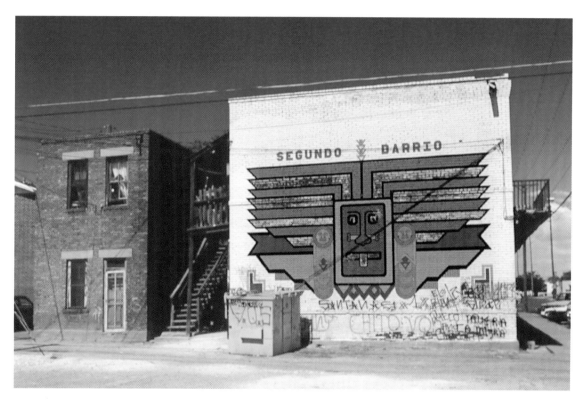

Segundo Barrio (1975)
Los Muralistas del Barrio
500 block Father Rahm Avenue
(no. 80)

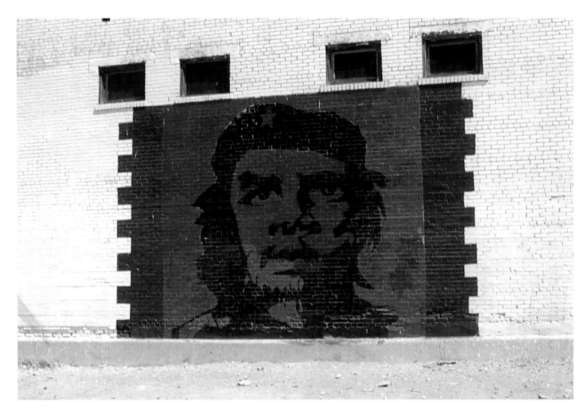

Ché Guevara (1976)
Salvador Meléndez, Manuel Arias; restored by Bowie High School MEChA in 1994
Duffy's Draft Beverage Co., Florence Street between Sixth and Seventh avenues
(no. 77)

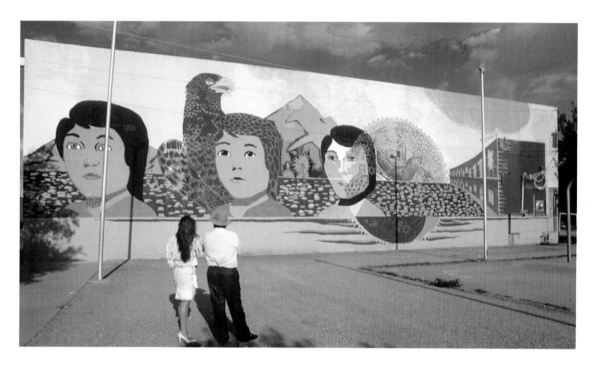

Entelequia (1976)
Carlos Rosas assisted by Felipe Gallegos
El Paso Boys Club, 801 South Florence Street
(no. 75)

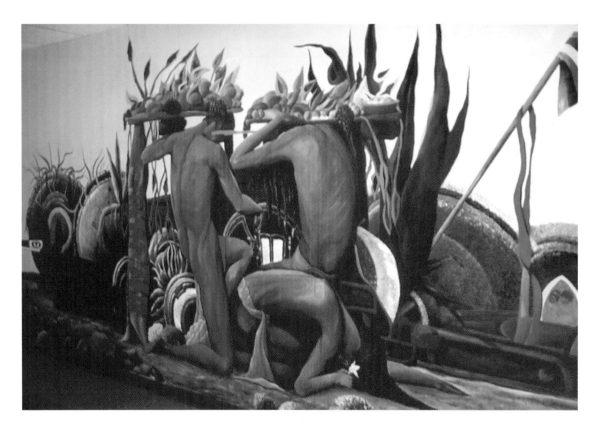

Offering (1978)
Supervised by Joe Olivas
Bowie High Scool Library, 801 South Marcial Street
(no. 128)

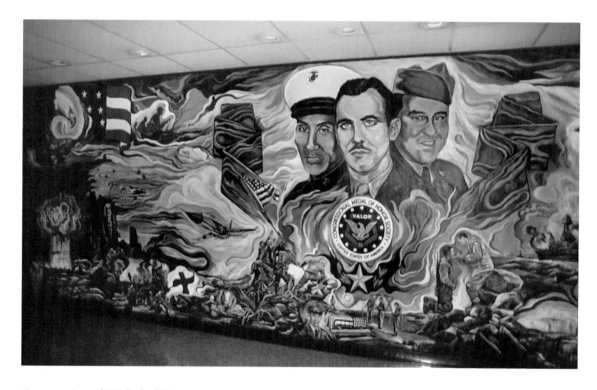

Congressional Medal of Honor Recipients (1977)*
Ernesto P. Martínez
Veterans Affairs Building, 5919 Brook Hollow Drive
(no. 155)

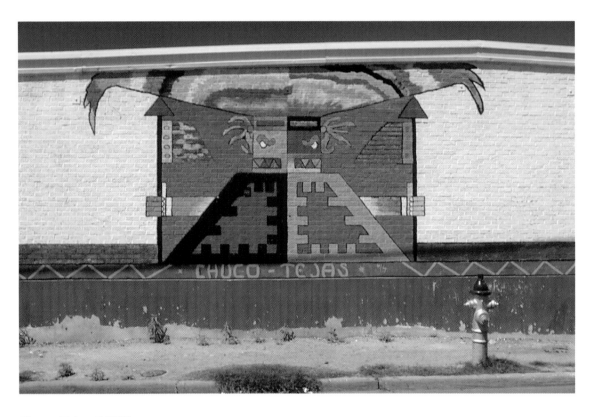

Chuco, Tejas (1975)
Salvador Meléndez, Manuel Arias, Victor Cordero and others
Canal Road, Chihuahuita
(no. 53)

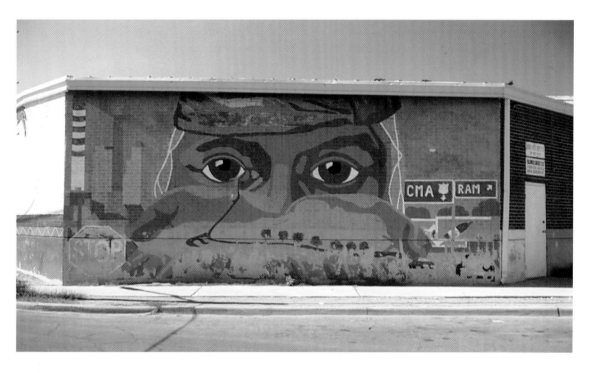

Tribute to Joe Battle or *Lágrimas* (1978)
Chihuahuita residents
200 block of Montestruc
(no. 57)

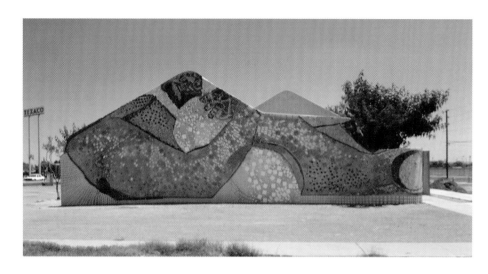

Señor Sol (1982-83), restored in 1992
Mago Orona Gándara
800 South Piedras Street
(no. 133)

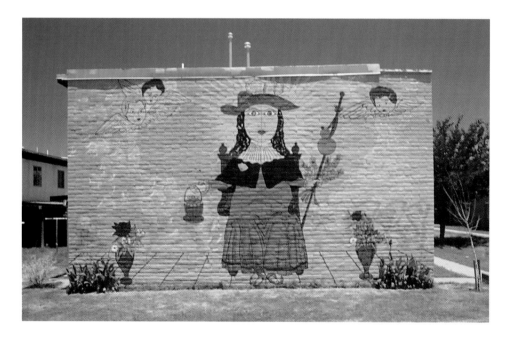

El Santo Niño de Atocha (1984)
Angel Romero, and youth,
supervised by Manuel G. Acosta
Marmolejo Apartments
(no. 182)

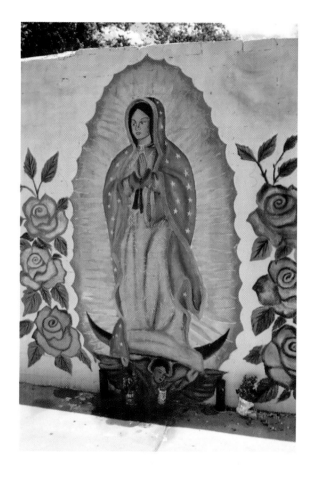

La Virgen de Guadalupe (1982-83)*
Artist known as Memin's Uncle
and the Presence Car Club
Sambrano and Seville streets
(no. 147)

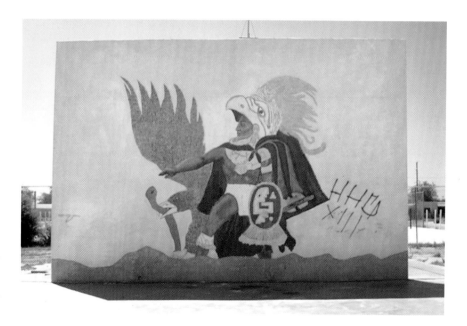

Azteca: El Hombre Aguila (1982)*
Supervised by Salvador Valdez
Middle Drain handball court
(no. 191)

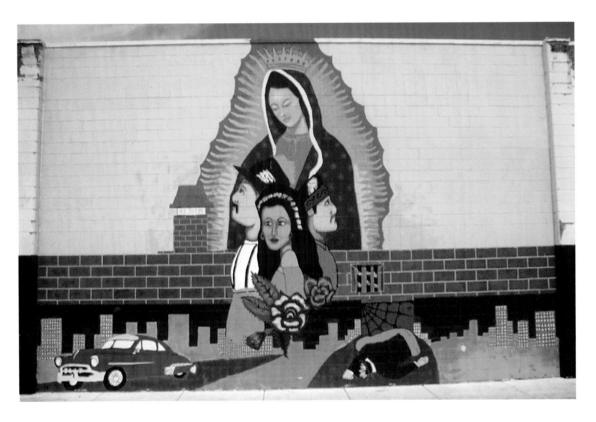

La Virgen de Guadalupe (1982-83)*
Varrio López Maravilla
220 Colfax Street
(no. 182)

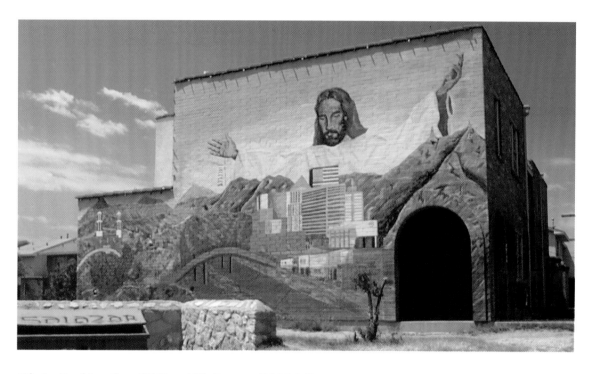

Christ Looking Over El Paso/Cд. Juárez (1985-86)
Supervised by Gaspar Enríquez
Salazar Housing Complex
(no. 123)

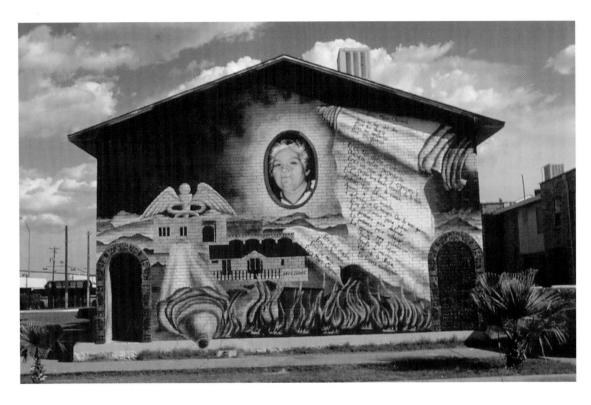

Tribute to Enedina "Nina" Sánchez Cordero (1991)
Supervised by Gaspar Enríquez
Salazar Housing Complex, Building 2
(no. 124)

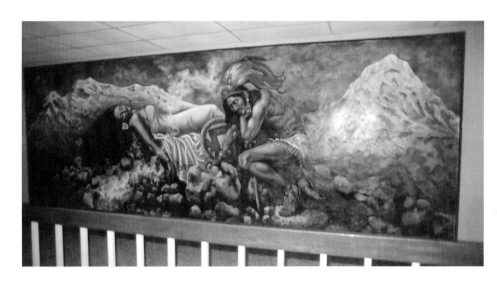

Iztaccihuatl, Mujer Blanca,
Leyenda de los Volcanes (1981-82)
Felipe Adame and others
Armijo Recreational Center,
710 East Seventh Street
(no. 76)

Dale Gas/El Pachuco (1982)*
Felipe Adame
Former Gator's Grocery,
South El Paso near Sixth Avenue
(no. 78)

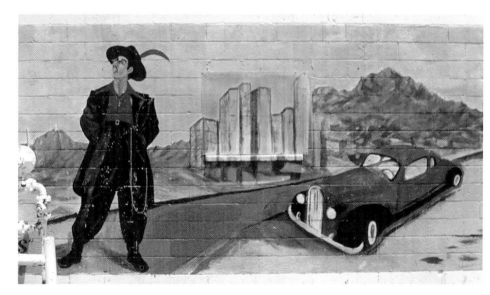

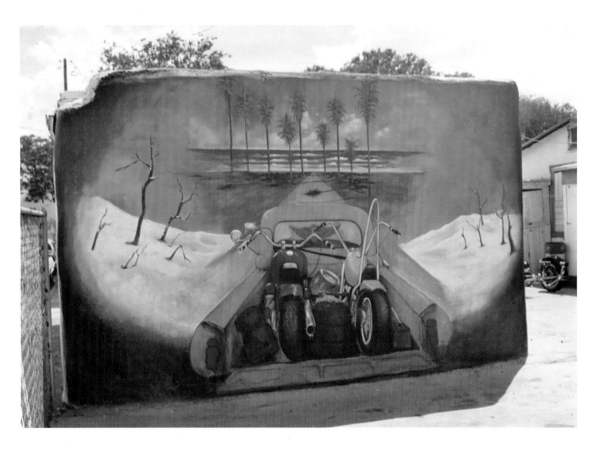

Easy Rider/In Memory of Nuni (1985)
Felipe Adame
Lico Zubia's garage, Chihuahuita
(no. 52)

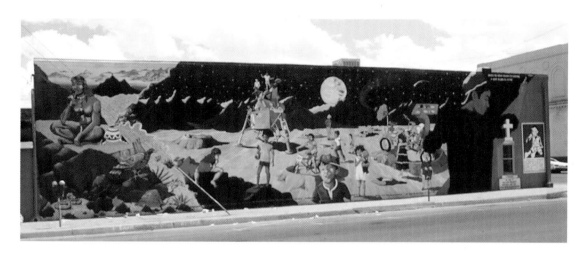

Kids on the Moon (1987)*
Carlos Callejo with students from the Upper Rio Grande Private Industry Council (PIC)
Former Southside Education Center
Fourth and Santa Fe streets
(no. 85)

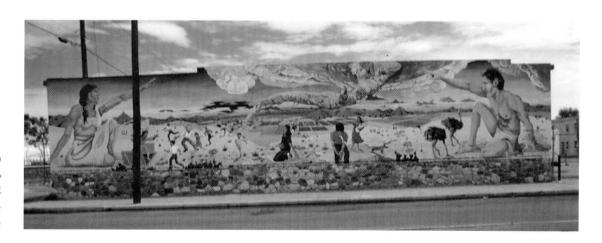

AIDS (1988)
Carlos Callejo
and youth from PIC
800 block of Sixth Avenue
(no. 91)

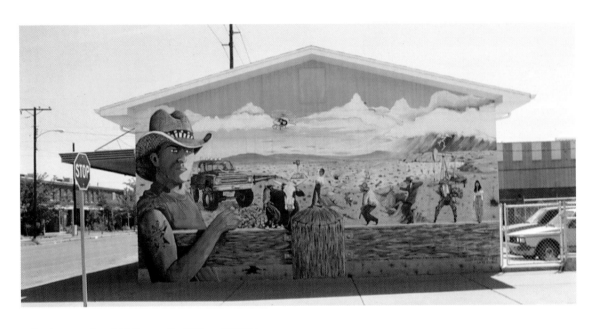

El Chuco y Qué/El Paso, So What (1991)
Carlos Callejo and others
Pepe's Grocery, Virginia and Father Rahm streets
(no. 92)

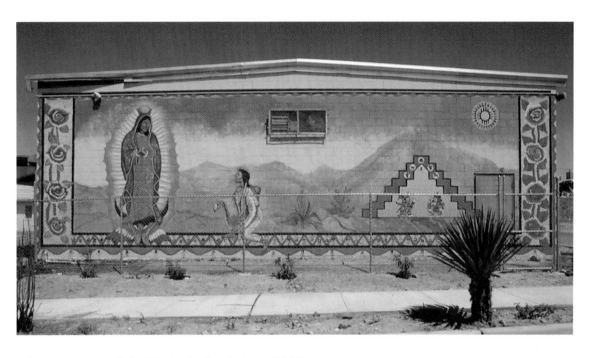

The Apparition of the Virgin de Guadalupe (1981)
Supervised by Lupe Casillas-Lowenberg
San Martín de Porras Church, Sunland Park, N.M.
(no. 5)

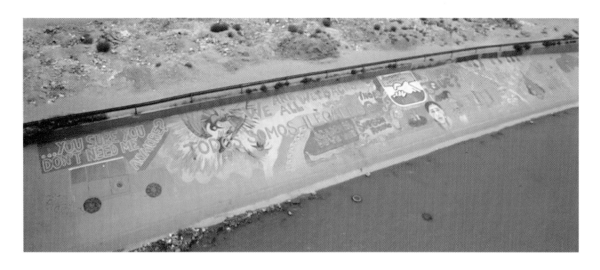

Todos Somos Ilegales/We Are All Illegals (1987)*
Manuel Anzaldo-Meneses and Los Artistas de la Frontera
Banks of the Rio Grande, U.S./Mexico border
(no. 100)

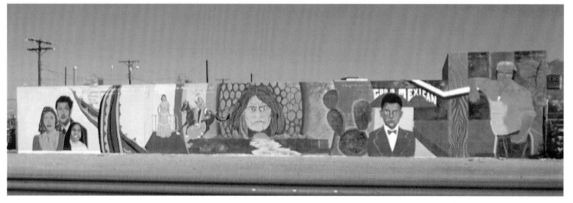

Memorial to Manuel G. Acosta (1990)
Carlos Rosas
Border Highway at South Campbell Street
(no. 95)

Tribute to David L. Carrasco (1991)
Supervised by Carlos Rosas
David Carrasco Job Corps Center, 11155 Gateway West
(no. 171)

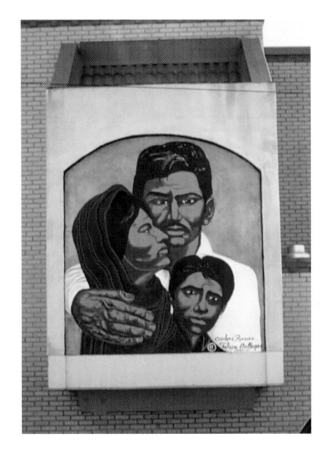

Sacred Family (1990)
Carlos Rosas, assisted by Felipe Gallegos
Clínica La Fe, 700 South Ochoa Street
(no. 64)

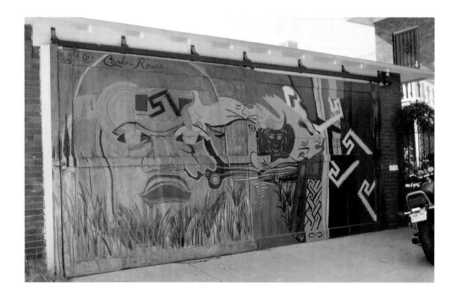

Meso-American Olmec (1991)
Carlos Rosas
Private garage, Aurora and Piedras streets
(no. 108)

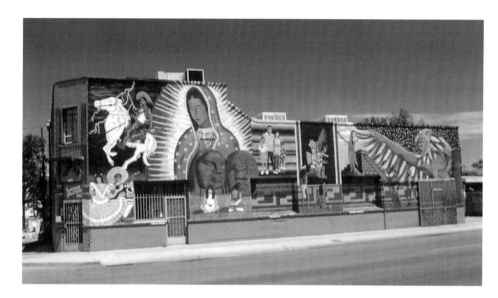

Hispanic Hertage (1992)*
Mario Colin
Superior Solutions,
Magoffin and Eucalyptus streets
(no. 118)

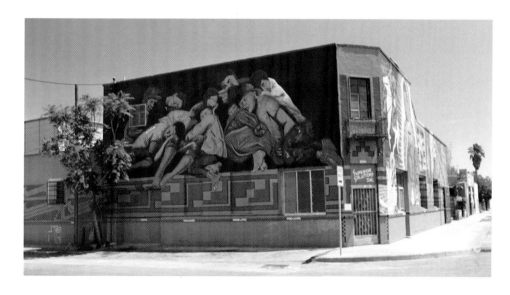

Homelessness (1992)*
Mario Colin and others
Superior Solutions,
Magoffin and Eucalyptus streets
(no. 118)

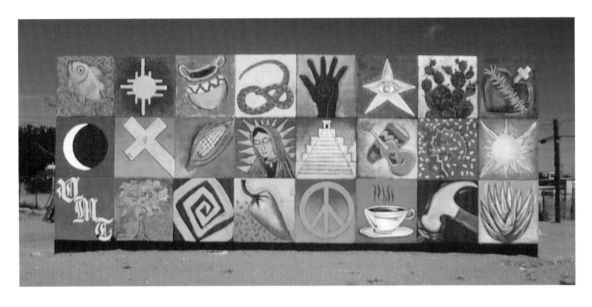

Las Cosas de la Vida/The Things of Life (1991)
Roberto Salas and others
Elena's Memorial Park, Sunland Park, N.M.
(no. 7)

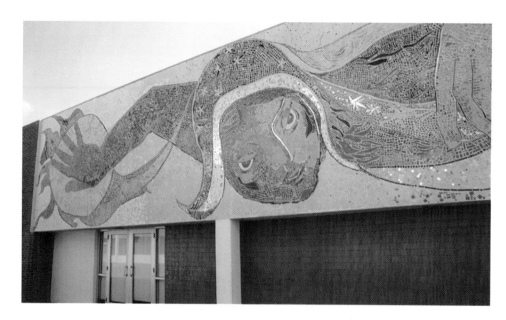

La Niña Cósmica (1993)
Mago Orona Gándara
Douglass School,
101 South Eucalyptus Street
(no. 125)

Nuestra Herencia/ Our Heritage (1992)
Carlos E. Flores
Chamizal National Memorial
800 South San Marcial Street
(no. 134)

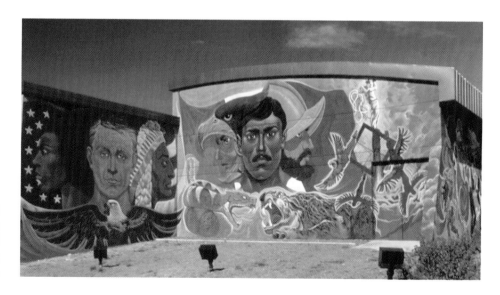

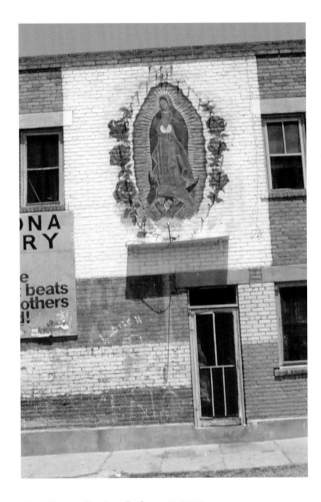

La Virgen de Guadalupe (1981)
Felipe Adame, assisted by Jesús Hernandez
La Corona Grocery,
Seventh and South Ochoa streets
(no. 73)

La Virgen de Guadalupe (1989)
Mario Colin and Chuck Zavala
Esparza's Grocery, 2901 1/2 North Piedras Street
(no. 107)

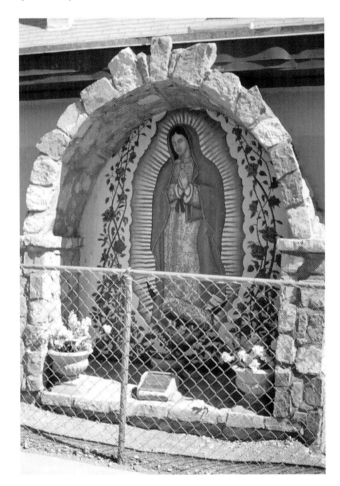

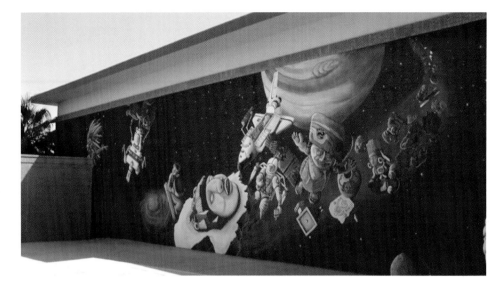

*Discover the Secrets of the Universe
Through Your Library* (1994)
Carlos Callejo
Armijo Branch Library,
620 East Seventh Avenue
(no. 94)

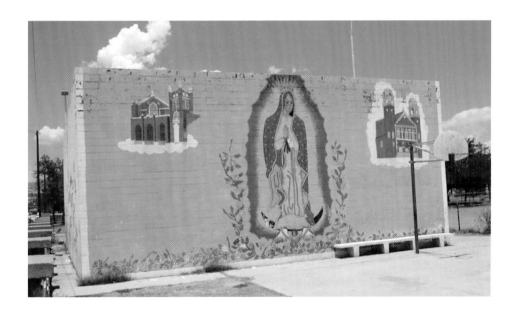

La Virgen de Guadalupe (1978-79)*
Arturo Avalos and others
Tula Irrobalí Park (Alamito Park),
Tays and Fifth streets
(no. 82)

Stages of Life (1985)
Pedro Medina
Julián Téllez Senior Citizens Center,
8908 Old County Road
(no. 186)

Myths of Maturity (1991)
Rudy Roybal and the
Summer Youth Program
University of Texas at El Paso
(no. 27)

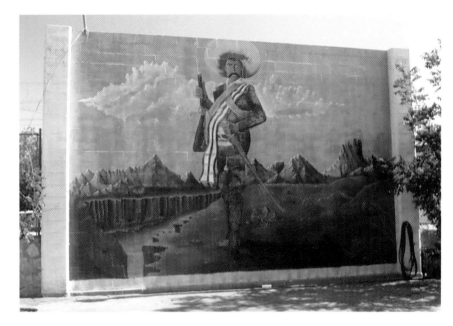

Emiliano Zapata (1980)
Ismael Facío
Alamo Plumbing,
Collingsworth and Alameda streets
(no. 139)

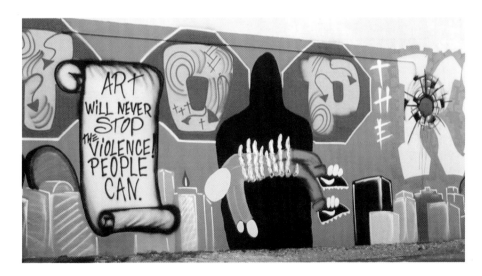

Stop the Killing (1989-95)*
José "Match" Fernandez,
assisted by Frank Molina
Pershing Theater, Pershing at Piedras streets
(no. 106)

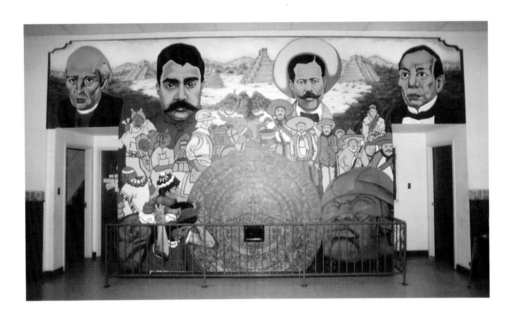

Heroes of Mexico: Miguel Hidalgo, Emiliano Zapata,
Pancho Villa, and Benito Juárez (1987)
José Olivas and Summer PIC program students
St. Anne's Center, 600 South Piedras Street
(no. 131)

*= mural beyond repair or painted over

Colores en los muros del desierto: Los murales de El Paso

por Miguel Juárez

Fotografías de Cynthia Weber Farah

Prólogo de José Antonio Burciaga

Traducción al español de Richard Ford

PREFACIO

Este libro es el resultado del trabajo de campo que realizamos Cynthia Weber Farah y yo durante el verano de 1988 para documentar los murales de El Paso.[1] Mis primeras pláticas sobre este trabajo las sostuve, hacia finales de los ochentas, con el bibliotecario César Caballero y la artista Marta Arat en Freddy's Cafe, un local en la calle El Paso frecuentado por personas interesadas en los asuntos de la comunidad. Yo quería realizar investigaciones acerca de los murales de El Paso, y Farah tenía el mismo deseo. Caballero y Arat sugirieron que trabajáramos juntos. Los frutos de esta colaboración podrán apreciarse en las páginas que siguen.

Farah había empezado a fotografiar murales en el sur de El Paso en 1979. Pudo captar así las imágenes de varias obras en Chihuahuita y el Segundo Barrio que más adelante desaparecerían, al quedar recubiertos estos muros de pintura nueva.

El interés que tengo en documentar la pintura mural floreció a partir de haber buscado, en 1986, obras que presentar ante el Texas Regional Steering Committee [Comité Directivo Regional del Estado de Texas] para ser incluidas en la exhibición intitulada "Arte Chicano: Resistencia y Afirmación, 1965-85" (CARA, por sus siglas en inglés). A consecuencia de mi experiencia en el Comité de Selección de CARA y de haber visto diapositivas de murales en otras ciudades de Texas, comencé a explorar la historia del arte chicano en El Paso, y en especial el movimiento muralista.

Nuestra búsqueda inicial en archivos locales produjo una sola colección de diapositivas, localizada en la biblioteca de la Universidad de Texas en El Paso. Se trataba de un conjunto de fotografías de murales del Segundo Barrio. Nos asombró el hecho de que no se hubiera emprendido antes un esfuerzo más abarcador para documentar los murales.

Hasta la fecha, mediante la documentación fotográfica llevada a cabo durante nuestro trabajo de campo, se ha logrado reunir más de dos mil diapositivas. Asimismo, las entrevistas con artistas nos han deparado una magnífica colección de materiales históricos primarios. Farah siguió fotografiando obras nuevamente realizadas y eventos relacionados con la creación de murales, mientras yo salí de la ciudad entre 1989 y 1991 para realizar estudios de posgrado. Me mantenía al corriente de los últimos acontecimientos mediante frecuentes visitas y llamadas telefónicas. Nunca perdimos de vista nuestro objetivo, el de incorporar algún día los resultados de nuestras investigaciones en un libro. Iniciamos nuestra búsqueda de obras sin contar con normas formales, bajo los auspicios de la Asociación de Arte Juntos. El punto de partida del proyecto era nuestro deseo sincero de perpetuar un aspecto único de las artes en

El Paso. Por otra parte, Farah y yo nos complementábamos mutuamente en nuestros esfuerzos, y teníamos acceso cada uno a un grupo de personas diferente. Nos acercamos a los artistas y activistas con el espíritu de compartir el proyecto.

Tan pronto como hicimos saber nuestras metas a los líderes de la comunidad, éstos se dieron a la tarea de ayudarnos. Entre las personas clave que empezaron a contribuir inmediatamente a nuestra labor están Salvador "Chava" Balcorta, John Estrada, Chevo Quiroga, Nicolás Domínguez y los artistas entrevistados en este libro.

La gran calidad de las fotografías de Farah – como documentos y como obras de arte por derecho propio – es evidente. Yo opté por entrevistar a los muralistas y hacer que ellos explicaran sus obras dentro de la tradición oral descrita por el historiador Mario T. García, tradición más cercana en forma y fondo al testimonio latinoamericano.[2] Creí que los artistas mismos eran quienes mejor podían interpretar sus propias obras, dar sus definiciones del arte mural y resumir sus propias carreras artísticas.

Una parte de la información presentada aquí forma la base de una guía de pinturas murales que escribió por Al Harris, director del Centro de Arte Contemporáneo Bridge, con motivo de la exhibición intitulada "Expresión directa" en 1988. Luego, en 1990, la Junior League of El Paso utilizó nuestra información para producir una guía de los murales de El Paso, un folleto de veinte páginas y a cuatro colores, tamaño sobre, que se encuentra actualmente en su tercera edición, con más de 30,000 copias en inglés y español. En diciembre de 1994, la Junior League publicó también un calendario a todo color en el que aparecen trece murales. Estos calendarios eran obsequiados a quienes asistieron a la 21 Feria de Navidad patrocinada por este organismo.

En 1975, el fotógrafo paseño Bruce Berman comenzó a documentar los murales de El Paso y el arte de neón, consistente este último en la obra comercial de Luis Jiménez, Sr., padre del célebre escultor Luis Jiménez, Jr. En 1976, el fotógrafo Terrence Moore, de Tucson, fotografió los murales del Segundo Barrio. Su foto de *Tribute to Joe Battle*, en Chihuahuita, aparece en la cubierta de *On the Border*, de Tom Miller (Tucson: University of Arizona Press, 1985).

Debido a la índole efímera de los murales, varias de las obras aquí documentadas fueron destruidas después de que iniciamos este proyecto. Sobreviven únicamente en fotografías y en los recuerdos de la comunidad. Este es un proceso que se desarrolla en forma continua y que todos debemos reverenciar: documentar y fomentar la conciencia de los murales en nuestra comunidad, ayudar a preservarlos, reconocer a sus creadores y, por último, celebrar el simple hecho de su existencia.

MIGUEL "MIKE" JUAREZ

RECONOCIMIENTOS

Este libro se viene preparando desde hace ocho años. Numerosos individuos e instituciones han contribuido para que su publicación sea una realidad.

Ante todo, quisiera agradecer a Cynthia Weber Farah su incansable labor y su generosa dedicación a este proyecto. Deseo agradecerle el haber proporcionado tan excelentes fotografías, muchas de las cuales constituyen la única constancia que nos queda de ciertos murales. A ella le quiero dar las gracias también por su apoyo durante los tiempos de bonanza y de tempestad y por estar de acuerdo en no estar de acuerdo. Debo expresar asimismo mi gratitud a César Caballero y a Marta Arat, que insistieron en que Farah y yo trabajásemos juntos en este proyecto que tanta falta hacía.

Nos sentimos muy afortunados en contar con un Prólogo del fallecido José Antonio Burciaga. Nuestro dilema para encontrar la voz justa para principiar este texto quedó resuelto cuando él aceptó escribir su penetrante ensayo como artista, historiador y paseño.

Gracias, además, a muchos estudiosos y activistas de la comunidad que en un principio compartieron su información con nosotros, entre ellos: Salvador "Chava" Balcorta, Juan Contreras, el Dr. James M. Day, Nicolás Domínguez, Pete Duarte, John Estrada, Carmen Félix, los finados Sr. y Sra. Francis Fugate, Arturo "Tury" Morales y Chevo Quiroga. Un agradecimiento especial al artista Steve Beck por proveer información sobre el artista mexicano Pedro Medina; a Mary Sarber, de la Biblioteca Pública de El Paso; a Claudia Rivers y Juan Sandoval, de la biblioteca de UTEP, por permitirnos el acceso a las colecciones; y a Stephen Vollmer, curador, y Prince McKenzie, subcurador, del Museo de Arte de El Paso, por la información sobre los murales de T. J. Kittilsen. Deseo agradecer también a Rosario G. Holguín el habernos facilitado información sobre su difunto tío, Jesús Helguera.

Numerosos artistas compartieron con nosotros sus pensamientos, historias y datos sobre sus obras: el finado Manuel Acosta, Felipe Adame, Marta Arat, Manuel Arias, Arturo "Tury" Avalos, Carlos Callejo, Gaspar Enríquez, Carlos Flores, Mago Orona Gándara, Ernesto Martínez, Manuel Anzaldo Meneses, José Olivas, Carlos Rosas, John Valadez y Salvador Valdez.

Entre las instituciones, departamentos y organismos que apoyaron la creación de esta obra queremos agradecer de manera especial a las personas siguientes: el Dr. Samuel Schmidt, ex director del Centro de Estudios Interamericanos y Fronterizos de UTEP, por una subvención y el uso de su equipo, además de su orientación general en cuanto a la preparación del manuscrito; Teresa

Nevárez, antes adscrita al mismo Centro, por leer las pruebas de la entrevista preliminar con Carlos E. Flores en español; el Dr. Howard Campbell por editar las entrevistas y ofrecer sugerencias con respecto al manuscrito; y el Dr. Dennis Bixler-Márquez, por su ayuda en la preparación del manuscrito.

Amerita mención especial Marcia Daudistel, directora adjunta de Texas Western Press, por resucitar el presente proyecto en innumerables ocasiones. Nuestras más expresivas gracias también a Nancy Hamilton, por su habilidad como editora y sus recuerdos de acontecimientos y personajes históricos. Gracias además a los integrantes del consejo editorial de Texas Western Press, que autorizaron la publicación de este libro, y, por último, a la presidenta Diana Natalicio por creer en este proyecto.

El Dr. Timothy Drescher editó el borrador final, excepto las entrevistas, y sus sugerencias han permitido que la obra se viera realizada en su forma final. Gracias por su compromiso, sus palabras de aliento y sus consejos.

Tres amigos me inspiraron a seguir este proyecto pero no alcanzaron a vivir para ver el resultado final: Alberto Bonilla, José Antonio Parra y Ruth S. Ortego. Otras personas que han influido sobre mi trabajo en las artes incluyen los paseños Michael Mills, David R. Fleet, Andrés Mares, Trish Winstead y Adolfo Zavala, los artistas neoyorquinos Paul H. Ramírez y Barbara Postelnek; el artista y administrador de arte Joe Bastida Rodríguez (de San José), el Dr. Miguel Domínguez (de la Universidad Estatal de California en Dominguez Hills), Gloria E. Alvarez, Ann Brace, Barbara Carrasco, Yreina D. Cervántiz, Harry Gamboa Jr., Mia Kuwada, Gilbert "Magu" Luján (todos de Los Angeles), el escritor Stephen Thralls Vessels (de Santa Barbara, Calif.) y el curador Patricio Chávez (de San Diego).

Merece reconocimiento asimismo el Dr. Richard Ford por haber hecho la magnífica traducción del texto al español y de la entrevista con Carlos Flores del español al inglés. Y por supuesto, un agradecimiento a John Downey por su diseño del producto final.

Quisiera agradecer de manera especial a mi esposa, Mona Padilla-Juárez, quien nos acompañaba a Cynthia Farah y a mí mientras documentábamos la historia mural de El Paso y quien ha sido la persona que más apoyo me ha brindado en esta empresa. Finalmente, tanto Cynthia Farah como yo deseamos expresar agradecimiento a nuestras familias, que nos han acompañado a lo largo de este extraordinario viaje de descubrimiento de los murales de El Paso.

MIGUEL JUAREZ

Prólogo

Colores en los muros del desierto

Olvídese usted por un momento de los "murales" y piense en los miles de muros dispersos por todo el pueblo desértico de El Paso. Piense en éstos simplemente como lo que son: barreras, baluartes, defensas, partes de complejos habitacionales y de edificios, que sirven para impedir a la gente la entrada o la salida, muros construidos para proteger a las personas o la propiedad. La definición principal de mural, en el diccionario, es "relativo a un muro"; la palabra se deriva del latín *murus*, en francés *mur*.

A lo largo de la historia, los grandes muros han logrado su propósito de proteger, y además, de dividir. Desde las moradas cavernarias de nuestros antepasados prehistóricos hasta la monumental Muralla de la China, el antiguo Muro de Berlín, los centenares de murallas que rodeaban los antiguos poblados, castillos, conventos, monasterios, catedrales, haciendas e incluso la famosa Cortina de Tortillas, los muros han cumplido bien con sus objetivos principales: proteger y aislar de la intemperie y de la gente. Pero desde tiempos prehistóricos la sociedad se ha resistido a vivir con lo que ha parecido poco natural, un búnker. Los muros desnudos servían para recordarnos la intención de quienes los habían construido.

Existieron en una época modelos arquitectónicos ideales, desde la capital azteca de Tenochtitlan, una enorme ciudad lacustre con su sistema de calles rectilíneas, hasta las ciudades renacentistas de Venecia y Florencia, con su arquitectura ornamentada y triunfal. Las ciudades de Tenochtitlan, Venecia y Florencia reflejaban una preocupación social común y un compromiso con la estética de la planificación arquitectónica que embellecían, definían y potenciaban sus respectivas sociedades, como una Torre de Babel o una Utopía.

Esta puede llamarse la función social del espacio arquitectónico, pero hoy en día la planificación urbana en una sociedad capitalista y consumista se ha distanciado completamente del concepto original de una arquitectura ideal al servicio de la organización social, o de una estructura social ideal al servicio de la arquitectura.

Llega la Revolución Mexicana, una insurrección que reformó el alma de México y cuyas cenizas estéticas siguen esparciéndose, cayendo a lo largo y más allá de sus fronteras al sur y al norte.

En 1919, David Alfaro Siqueiros y Diego Rivera se encontraron en Europa y observaron los cambios que ocurrían en las artes plásticas. Sus impresiones de las grandes capitales europeas debieron ser numerosas y profundas, incluyendo las semejanzas entre ciertas manifestaciones de la arquitectura colonial mexicana y la arquitectura europea.

Rivera y Siqueiros hicieron contacto con la forma antigua del muralismo, una forma de arte colectiva que había desaparecido ya casi por completo. En un discurso ante un grupo de artistas, Siqueiros dijo: "Hacia finales del Renacimiento la burguesía, o el embrión de la burguesía, con su concepto del individualismo y la propiedad privada, había sacado al arte de las catedrales y de los centros públicos, embolsillándoselo y llevándoselo a su propia casa. Se dio el arte privado: los paisajes, los retratos y las naturalezas muertas; y de la misma manera, paulatinamente, se fueron desarrollando otras corrientes unilaterales, llegando por fin al abstraccionismo y el 'tachisme'. Los 'nuevos mecenas del arte' no tenían el menor deseo de exhibir en sus casas sangrientas escenas religiosas, descensos de la cruz o Vírgenes bañadas en lágrimas. No les hacía falta nada de esto. Querían más bien la felicidad, la tranquilidad, algo que correspondiera a la euforia que ellos mismos experimentaban."

Bajo la dirección visionaria de José Vasconcelos, filósofo y Secretario de Educación después de la Revolución, se instituyó un programa muralista nacional. Y del caos inicial nació una forma artística que se convirtió en netamente mexicana. Ponderemos por un momento el ultraje y la indignación que sintieron los depuestos porfiristas y la aristocracia ante una pandilla de talentosos artistas mexicanos que comenzaron a pintar murales sobre las paredes de los palacios – el Palacio de Bellas Artes en la Ciudad de México, el Palacio Nacional y otras paredes nacionales – murales que captaban la verdadera historia e imagen de México.

En su evolución, el muralismo mexicano fue transformándose en ciencia. El concepto de lo "folklórico" fue atacado como un "nacionalismo falso". Los murales encerraban una importancia y una significación más profunda. Sólo al retratar y dar validez a un pueblo dentro de su ambiente natural y sociopolítico se podía apreciar también el conocimiento mayor de un pueblo universal. Shakespeare había escrito *Hamlet* en inglés, Cervantes compuso el *Quijote* en español, y Nezahualcóyotl había hecho hermosas poesías en náhuatl. Del mismo modo que estas obras no eran folklóricas, tampoco lo serían los murales.

Para comenzar a apreciar los murales de El Paso es necesario regresar a la Revolución Mexicana, que transformó una estética eurocéntrica en una estética indígena más realista. Por muy fundamental que parezca, resulta imprescindible reconocer los propósitos social, político y ambiental de los muros y cómo los artistas los redefinen para crear un punto de referencia más humano, realista y estético donde vivir.

No por casualidad, azar o ironía es El Paso el lugar de nacimiento, la cuna de tanta historia y cultura chicana. El Paso ha sido siempre punto de entrada y salida entre el país viejo y el país nuevo, entre el Viejo México y Nuevo México. Sirva de ejemplo la siguiente relación histórica:

El 20 de abril de 1598, la expedición conquistadora de Juan de Oñate llegó a las orillas del río Bravo, cerca de lo que hoy es El Paso. Atormentados por la sed y el agotamiento, los expedicionarios descansaban y recuperaban sus fuerzas. Esto sucedía veintidós años antes de que arribaran los Peregrinos a Plymouth Rock. Diez días más tarde, Jueves de Ascensión, celebraron el hecho con una misa solemne. Juan de Oñate tomó posesión de la tierra a nombre de Su Majestad Católica Felipe II y bautizó este territorio con el nombre Reino de Nuevo México. El capitán Marcos Farfán de los Godos presentó una comedia, una pieza teatral que él había escrito, y esta función viene a ser la primera representación de una obra teatral en los Estados Unidos. Una figura especialmente interesante es la esposa de don Juan de Oñate, hija de Hernán Cortés. Como biznieta de Moctezuma, era descendiente de los dos grandes jefes que se habían peleado y fusionado para crear una nueva raza de mexicanos y chicanos.

La primera Acción de Gracias hecha por gente de raza blanca en lo que hoy es Estados Unidos la ofrecieron estos hispanos. La primera representación teatral en este país la dieron estos mismos conquistadores ese mismo día. No se nos olvide que la gente autóctona de esta región ha realizado siempre el rito de dar gracias a diario, y su propio teatro de la realidad es representada por medio de estos ritos de acción de gracias.

Desde hace siglos, El Paso ha sido un oasis dentro del enorme desierto chihuahuense, la puerta que conduce al México nuevo. A lo largo de los últimos dos siglos, la situación geográfica de El Paso ha sido de gran importancia estratégica, ya que su ubicación en el sur de la zona central del vasto desierto del sudoeste lo convertía en un punto donde paraban y se reabastecían de combustible autobuses, trenes y aviones. Los artistas y músicos que viajaban hacia el oeste, provenientes del este y del sur, encontraban aquí un clima y un público amenos. Ciudad Juárez les brindaba la oportunidad de entrar en otra cultura, otro mundo, para luego seguir su camino hacia el este o el oeste. Durante la época de la Ley Seca en Estados Unidos, Ciudad Juárez se convirtió en un oasis para tomadores y músicos, artistas y bohemios.

La influencia inmediata y conjunta que ejercieron Juárez y El Paso sobre los artistas mexicanos y chicanos ha impactado a ambas naciones. Algunos de los talentos más creadores de México son de Juárez: Juan Gabriel reconoce a las estaciones de radio de El Paso como una influencia; y Germán Valdez, mejor conocido como Tin Tan, adoptó la figura del pachuco paseño, con su *zoot suit,* su

caló y su actitud especial, para convertirse en estrella del cine mexicano. En Tijuana, otra ciudad hermana fronteriza, Carlos Santana comenzó a mezclar los sonidos mexicanos con la incipiente música rock afroamericana y angloamericana.

El impacto de los artistas chicanos de El Paso en toda la Unión Americana ha sido impresionante. Artistas como Luis Jiménez, John Valadez, Manuel G. Acosta, Mago Orona Gándara, Carlos Callejo, José Cisneros, Felipe Adame, Lupe Casillas-Lowenberg, Arturo Avalos, Carlos Rosas, Ernesto P. Martínez, Gaspar Enríquez, Joe Olivas y muchos otros forman parte de un grupo de artistas mucho más nutrido que han alimentado e inspirado a otros muralistas en urbes más grandes como Los Angeles y Chicago. De igual importancia son los artistas angloamericanos que sintieron el fuerte influjo de la cultura mexicana en El Paso y Juárez: entre ellos se destaca Tom Lea, Jr., seguido por otras lumbreras, tales como el profesor Robert Massey y, más recientemente, Hal Marcus.

La frontera, como divisoria política entre dos países, ha existido únicamente durante este siglo. Y así, El Paso se ha convertido en la isla Ellis del Sudoeste. Pero como faltaba la Estatua de la Libertad, el único punto de orientación de que disponía el nuevo inmigrante eran los altos edificios con muros que se elevan hacia el cielo.

El mexicano recién internado echaba raíces justo tras la puerta del país, en la zona sur de El Paso, conocida también como el Segundo Barrio. Tan cerca de México, resulta paradójico que este sector no se haya convertido en el Primer Barrio.[3] Mientras los aristócratas mexicanos expulsados y exiliados radicaban en los vecindarios residenciales más lujosos de El Paso y el Sudoeste, los mexicanos más pobres arraigaban en el Segundo Barrio, no para ser asimilados, sino para transculturarse y formar una cultura nueva.

Resulta muy natural, nada insólito, el hecho de que comenzaran a aparecer graffiti en los muros del sur de El Paso, mucho antes de que el Movimiento Chicano diera lugar a los murales chicanos. Los graffiti, como los murales, constituían expresiones, aseveraciones, declaraciones, exposiciones, voces que se desahogaban hablando del sentido de pertenecer, de la identidad propia y la integridad; placas, como matrículas de los carros, que certificaban, convalidaban y ratificaban la existencia de un pueblo atrapado por un torrente extranjero. La contraseña c/s, con safos, fue acuñada como legítimo *copyright* mexicano, un imprimátur o maleficio sobre cualquiera que desdeñara la afirmación que la acompañaba.

Si los graffiti bautizaron los muros, entonces los murales llegaron a ser la confirmación cultural. Los murales forman parte de nuestras herencias culturales europea y mesoamericana, pero expresan además una necesidad real y legítima de retornar a un ambiente urbano más humano y estético, de un plan arquitectónico para realzar, definir y potenciar nuestra existencia urbana, nuestra juventud, nuestro futuro en la Utopía, la Torre de Babel, Aztlán, la tierra reconquistada mediante la cultura: los colores en los muros del desierto.

JOSE ANTONIO BURCIAGA

A la memoria de
José Antonio Burciaga
†7 de octubre de 1996

El paseño José Antonio Burciaga fue un autor chicano reconocido en todo Estados Unidos, un ensayista, poeta, humorista y muralista con una gran firmeza de voluntad, y miembro fundador de Culture Clash. Después de graduarse de la Universidad de Texas en El Paso, asistió a la Escuela de Arte Corcoran y al Instituto de Arte de San Francisco. Su libro de poesías *Undocumented Love* fue el ganador de un importante premio, el Before Columbus American Book Award.

También fue autor de *Weedee People; Drink Cultura: Chicanismo* y *Spilling the Beans/Lotería Chicana*. Poco antes fallecer, estaba a punto de terminar su próximo libro, intitulado *The Temple Gang*. Burciaga fue también columnista con la red periodística Hispanic Link News Service durante la década de los ochentas.

Como artista, participó en muchas exhibiciones y creó numerosos dibujos y pinturas, muchos de los cuales aparecen en posters y en tarjetas de felicitación. En la Universidad Stanford, se desempeñó como asesor en la Casa Zapata, una residencia para estudiantes latinos, e invitó a varios artistas chicanos a que pintaran murales en este edificio.

En 1985, ingresó al Salón de la Fama de los Escritores Paseños, un organismo patrocinado por el periódico *El Paso Herald-Post*, y fue conferenciante de honor en el Primer Festival de Voces de la Frontera, celebrado como una de las festividades de conmemoración del primer centenario de la Biblioteca Pœblica de El Paso.

Además de sus muchos logros, la labor de Burciaga y su amor por El Paso y por la Raza eran notorios y muy respetados. Era amado por muchas personas que lo echan de menos. Le sobreviven su esposa Cecilia, sus hijos José Antonio y Rebecca Burciaga de Carmel, California, y la familia de su hermana Margarita Burciaga en El Paso.

MIGUEL JUAREZ
CYNTHIA WEBER FARAH

CAPITULO 1

INTRODUCCION

El Paso del Norte y del Sur

La geografía nos proporciona un contexto para el desarrollo de los murales en El Paso del Norte/The Pass of the North. El paso lo fue abriendo el río Bravo a través del extremo sur de las Montañas Rocallosas, y fue durante siglos la puerta por la que pasaban tribus de nómadas que recorrían el continente. Antes de la llegada de los exploradores españoles, era el hogar de los indios suma y manso.

En 1536, Alvar Núñez Cabeza de Vaca y tres compañeros, tras naufragar frente a la costa del golfo, cruzaron Texas a pie y atravesaron el río Bravo al sur del Paso del Norte. Al arribar a la Ciudad de México, Cabeza de Vaca habló a los españoles de las legendarias riquezas del norte, inspirando así otras expediciones de exploración.

El primer grupo de españoles que llegó al Paso viajando hacia el norte fue encabezado por tres franciscanos: fray Agustín Rodríguez, fray Francisco López y fray Juan de Santa María, en 1581. En 1598, los españoles decidieron colonizar lo que hoy es Nuevo México y mandaron a Juan de Oñate a la cabeza de 400 hombres con sus familias y algunas cabezas de ganado. Llegaron al valle el 20 de abril, fecha en la cual Oñate reclamó para España la cuenca del río Bravo. Hubo una ceremonia de acción de gracias, que antedata la de Plymouth por veintidós años.

Un grupo de franciscanos dirigido por fray García de San Francisco y Zúñiga fundó, en lo que hoy es Ciudad Juárez, una colonia alrededor de una misión construida para los indios manso en 1659. La iglesia, que lleva el nombre de Nuestra Señora de Guadalupe, se encuentra todavía en este sitio.

A consecuencia de la rebelión de los indios pueblo, en el norte de Nuevo México en 1680, numerosos españoles y algunos indios pueblo se desplazaron hacia el sur, refugiándose en el Paso. A lo largo del río surgió una cadena de pueblitos, y cuando los españoles regresaron al norte, los grupos de tiguas y piros decidieron quedarse en la región de El Paso. La misión de Ysleta, de los tiguas, fue la primera fundada en Texas, y la construcción de la misión de Socorro empezó poco después. En 1691 se erigieron edificios

permanentes en ambos lugares. Un tercer pueblo, San Elizario, nació justo al sur de Socorro, en 1780, cuando fue trasladado a este sitio un presidio español. Su iglesia, aunque llamada con frecuencia misión, era en realidad una capilla militar.

El gobierno de los españoles duró hasta 1821, año en que México ganó su independencia. En 1827, le fue concedida a Juan María Ponce de León una encomienda de quinientos acres al norte del río, donde él construyó una casa y sembró cultivos en lo que hoy es el centro de El Paso.[4] El Paso se convirtió en apeadero para los mercaderes que transitaban por el camino entre la Ciudad de México y Santa Fe.

Las hostilidades entre tejanos y mexicanos provocaron que Texas declarara su independencia de México en 1836 y se fundara la República de Texas.[5] El conflicto continuó con la guerra entre México y Estados Unidos, de 1846 a 1848, que terminó con un tratado que establecía que a partir de entonces el río Bravo constituiría la frontera internacional. Una de las importantes batallas de esta guerra se libró cerca de El Paso, y poco después el coronel Alexander Doniphan condujo sus tropas a Chihuahua.[6]

A raíz de la guerra, Ponce de León vendió su terreno a un mercader norteamericano llamado Benjamin Franklin Coons, cuyo segundo nombre fue aplicado al pueblo y a las montañas cercanas. En 1849, las primeras tropas norteamericanas enviadas a esta zona establecieron un puesto avanzado para proteger a los ciudadanos de los ataques de los apaches. Ya para 1850, se habían establecido tres propiedades de especial importancia para lo que más adelante sería El Paso: la casa de adobe del mercader James Magoffin, originario de Santa Fe, el rancho de Hugh Stephenson y un molino de harina construido sobre los rabiones del río Bravo por Simeon Hart, hoy el restaurante La Hacienda.[7] El plano hecho por Anson Mills en 1859 daba al lugar el nombre de El Paso. El nombre del poblado mexicano de El Paso del Norte sería cambiado en 1888 por el de Ciudad Juárez.

La presencia de las tropas militares hizo que El Paso se convirtiera en un destino predilecto de los viajeros que iban de norte a sur, pero la población no creció mucho hasta que llegó el ferrocarril en 1881. Vino primero la empresa ferrocarrilera Southern Pacific, y la población de El Paso se duplicó; luego llegaron la línea de Santa Fe y, al año siguiente, la Texas and Pacific. Por último, el Mexican Central Railroad, un trayecto de 1,224 millas patrocinado por un conjunto de inversionistas de Boston, fue construido de la Ciudad de México a El Paso, con lo cual éste se convirtió en una encrucijada fronteriza de capital importancia para el comercio entre México y Estados Unidos.[8]

Casi de la noche a la mañana el poblado, vinculado ahora con diversos puntos de México y Estados Unidos, se vio transformado en una pujante ciudad. Los periódicos *El Paso Times* y *El Paso Herald* hicieron su aparición en 1881 y siguen en existencia hasta el día de hoy. Al final de la década, la población ascendía a 10,000 habitatantes y llegaban más personas todos los días.[9]

Durante los siguientes veinte años, el ferrocarril ayudaba a traer los materiales que hacían falta para construir la infraestructura de la ciudad. Durante este período se pavimentaron las calles, y urbanistas desarrollaban barrios residenciales a cierta distancia de la zona céntrica. Para el año 1900, la población ascendía a 15,000. A partir de 1890, y durante los primeros años del nuevo siglo, se establecieron las iglesias que se convertirían luego en monumentos históricos.[10]

Después de 1910 se construyeron muchos de los edificios más importantes de la ciudad, al tiempo que Francisco I. Madero, con su Plan de San Luis Potosí, encendía la llama de la Revolución Mexicana. El estado de Chihuahua, que colindaba con Texas, era clave en el conflicto porque allí siguió creciendo el movimiento rebelde aun después de que el presidente Porfirio Díaz lo había sofocado en otras partes de México. La Revolución llegó a un punto culminante cuando los revolucionarios se apoderaron de Ciudad Juárez, a finales de la primavera de 1911. En contravención a las órdenes de Madero, Pascual Orozco capitaneó el ataque para capturar Ciudad Juárez, el baluarte del norte, los días 8 y 9 de mayo. Muchos paseños contemplaron los hechos desde las azoteas de sus casas.[11]

A consecuencia de la Revolución en México, que duró diez años, miles de personas entraron en los Estados Unidos por medio del ferrocarril. En su libro *Occupied America: A History of Chicanos* (New York: Harper & Row, 1988), el historiador Rodolfo Acuña señala:

> Hay que recalcar la enorme importancia del ferrocarril. Al igual que en el Sudoeste americano, los ferrocarriles unificaron el interior de la región y vincularon al país con los Estados Unidos. Aceleraron el crecimiento industrial y agrícola de la nación y estimularon la afluencia de capital a la economía, incrementando la posibilidad del comercio y la explotación de los recursos mexicanos. El declive del ruralismo y el desarraigo de los recursos del campesino mexicano constituirían un factor crucial en la migración a los Estados Unidos.[12]

Los miles de familias mexicanas que acudieron a El Paso crearon una red informal que facilitó la venida de todavía más gente al Sudoeste. Muchos mexicanos se instalaban en el sur de El Paso, el área más cercana a la frontera, y permanecían allí hasta poder reanudar la marcha hacia otros estados del oeste en busca de nuevos horizontes. Otros se quedaban en El Paso, aguardando el día cuando pudiesen retornar a la patria, a México.

Durante esta época, El Paso se convirtió en un centro de reclutamiento de mano de obra barata para las industrias de las regiones norte y central de la Unión Americana. Muchos de los *presidios* (casas de vecindad) del sur de El Paso fueron construidos para hospedar a estos *enganchados* (trabajadores traídos a la frontera en tren).[13]

Mientras la afluencia de los trabajadores migratorios atestaba el Segundo Barrio, los ciudadanos mexicanos más prósperos radicaban en los barrios que rodeaban el centro de la ciudad, como Sunset Heights. Pero la vida en el Segundo Barrio distaba mucho de ser deprimente. La gente sacaba provecho de su situación y creó una comunidad social viable. Individuos emprendedores construían sus propias tiendas y se apoyaban mutuamente durante los tiempos de necesidad. Las familias mexicanas trajeron consigo su fuerte sentido de unidad y tradición. Para muchas de ellas, el haber llegado al Paso significaba comenzar de nuevo.

Después de la Revolución, el pueblo que contaba hacía setenta años con una población de 700 almas era ya, a finales de los años veintes, una pujante ciudad de 102,000 habitantes, con su propio sistema de transporte colectivo y ciertas ventajas como parques municipales y calles pavimentadas.

Gracias a la Works Progress Administration, que proporcionó durante los años treintas los fondos para la contratación de obreros para mejorar la infraestructura urbana, la ciudad continuó su desarrollo y expansión. Se pavimentaron calles, se construyeron instalaciones y alcantarillado para los residentes de la zona sur, y una suma considerable se destinó a patrocinar la pintura de murales en la localidad.

Posteriormente, en 1963, un acontecimiento de resonancia internacional, el Tratado del Chamizal, dirimió una disputa entre México y Estados Unidos sobre un terreno, conflicto que había durado ya un siglo. La frontera internacional entre El Paso y Ciudad Juárez se modificó cambiando el cauce del río, y así se le devolvió a México una parte de su territorio.

Como hemos observado en el desarrollo de estos dos países que comparten una sola frontera, los constantes acontecimientos históricos, políticos y sociales que han impactado tanto a Estados Unidos como a México han provocado conflictos y cambios en ambas naciones. Estos acontecimientos, y las tensiones a que dieron lugar, fueron dando la pauta para los artistas que han producido murales en El Paso. La historia de la región, incluyendo las Revoluciones tejana y mexicana, frecuentes escaramuzas fronterizas, la afluencia de refugiados y las tensiones raciales entre los angloamericanos y los inmigrantes mexicanos, vendrían a constituir el enfoque del Movimiento – un movimiento de afirmación cultural, social y política en que participan los méxicoamericanos de los Estados Unidos.

Los primeros murales en El Paso

Los primeros murales en El Paso fueron principalmente encargos oficiales auspiciados por los negocios y el gobierno (mediante los programas de la WPA de los treintas). Después de la Segunda Guerra Mundial, se seguía pintando murales en los comercios, especialmente los restaurantes. La doble significación de estas primeras obras es que representan ejemplos del arte público monumental expuestos a la vista de residentes de todas las clases, consagrándose así el mural como un medio digno de aprovecharse posteriormente, a partir de 1970, en expresiones originadas en la comunidad. Segundo, algunos de los primeros artistas, como Manuel G. Acosta, continuaron pintando murales como parte del movimiento comunitario de los setentas; su experiencia y sus conocimientos fueron aprovechados luego por los pintores más recientes.

Desde 1900 se habían pintado algunos murales para servir como escenarios en los teatros de variedades y como decoración en los salones y cantinas, pero no se habían comisionado obras públicas de importancia antes de 1917. Se exhibieron durante cuarenta años, en el vestíbulo de la Corte del Condado de El Paso, ocho murales de escenas históricas pintados por T. J. Kittilsen, pero estas obras fueron retiradas en 1956, cuando el edificio fue remodelado. De ellas, se encuentran actualmente seis en la colección del Museo de Arte de El Paso.

En 1922, James G. McNary, presidente del First National Bank, contrató a Edward Holslag, de Chicago, para pintar diez murales también basados en temas históricos. Dos de ellos están en exhibición ahora en el Aeropuerto Internacional de El Paso.[14]

A principios de la década de los treintas, la Works Progress Administration, creada por el New Deal de Roosevelt, dio los fondos necesarios para ofrecer capacitación y servicios de empleo a los residentes de la zona sur de El Paso, donde las mejoras incluían pavimentar las calles. Como sucedía en otras ciudades, escritores, artistas y artesanos desempleados encontraban trabajo por medio de una serie de programas federales de 1934 a 1943. El Federal Arts Project, que funcionó de 1935 a 1939, hizo posible que se pintaran varios murales en El Paso y sus alrededores.

En 1936, fue contratado Emilio Cahero, quien había pintado frescos en México y contaba con un equipo de asistentes, para pintar murales en Holliday Hall, en el recinto del Texas College of Mines (ahora la Universidad de Texas en El Paso). Intitulados *Minería* y *Metalurgia*, estos murales fueron las únicas obras pintadas utilizando acuarela y yeso bajo el patrocinio de la Works Project

Administration.[15] Los dos murales quedaron recubiertos de pintura cuando el edificio fue remodelado durante la década de los sesentas.

En 1935, Tom Lea, Jr. pintó viñetas murales sobre tres paredes de la sala de recreo en el sótano de la residencia de Dorrance D. Roderick, localizada en la calle Cumberland Circle #4801. Mary Olga Barnard las recuerda como "maravillosas obras de arte" en la casa de su finado abuelo.

Luego, en 1937-38, Lea pintó *Paso del Norte* en la Corte Federal. Cuando quedó concluido, el mural medía 11 por 54 pies y se arqueaba por encima de una puerta donde se pueden leer las palabras que expresan el tema de la obra: "O Paso del Norte—Se han ido ya los viejos gigantes—Nosotros, meros hombrecillos, habitamos donde otrora héroes pisaban la tierra inviolada". Lea ganó una competencia patrocinada por el Departamento de la Tesorería, división de Bellas Artes, en la que concursaban artistas de nueve estados.[16] Había sido ganador de otra competencia para pintar un mural, The Nesters, en la Oficina de Correos Benjamín Franklin, en Washington, D.C.

Lea estudió en el Instituto de Arte de Chicago con el muralista John Norton, de 1927 a 1933. Trabajó solo y en colaboración con Norton en varios proyectos en el área de Chicago antes de regresar al Sudoeste. Pintó otras obras en esta región y en otras ciudades de Texas. Asistido por su esposa, Sarah, pintó un mural al óleo sobre lienzo intitulado *Sudoeste*, en la pared interior de la Biblioteca Pública de El Paso en 1956. En 1994, fue homenajeado con una exhibición retrospectiva de sus obras en el Museo de Arte de El Paso, el El Paso Centennial Museum de UTEP y la galería Adair Margo.[17]

Uno de los primeros artistas mexicanos importantes fue José Aceves, nacido en Chihuahua, Chihuahua, el 14 de diciembre de 1909. El menor de ocho hijos, Aceves se mudó con su familia al Segundo Barrio y asistió a las escuelas San Jacinto y Alamo, donde hizo sus primeros estudios formales de arte. En 1938, Aceves fue contratado para pintar un mural para una oficina de correos en Borger, Texas. La obra, un lienzo que medía 4 por 9 pies, se intitulaba *Noticias de la gran ciudad* y representaba varios modos de transporte del Viejo Oeste: el Pony Express, la diligencia y la entrega del correo por avión. Se le dio un plazo de seis meses para terminar la obra y recibió un pago de 570 dólares.[18]

En noviembre de 1939, Aceves pintó otro óleo sobre lienzo, *McLennan buscando casa*, que medía 5 por 12 pies y estaba destinado a la oficina de correos de Mart, Texas. Patrocinado también por el Departamento de Bellas Artes, este mural mostraba una familia pionera de la región que atravesaba el gran llano.[19]

Durante la Segunda Guerra Mundial, Aceves se alistó en la Naval de los Estados Unidos, desempeñándose como ilustrador. Tras cumplir con el servicio militar, volvió a El Paso e ingresó en el Instituto Tecnológico de El Paso; posteriormente asistió al Instituto de Arte de Chicago. Uno de sus profesores en Chicago le insistía en que intentara pintar obras que reflejasen las condiciones sociales del Segundo Barrio, pero Aceves no triunfó, probablemente porque en aquella época no había suficiente demanda para este tipo de arte.[20] Las disparidades económicas y la escasez de oportunidades para mexicanos, sobre todo en las artes en El Paso, eran grandes; así, tal parece que Aceves tuvo un éxito limitado como pintor de caballete y como muralista. Pero destaca en nuestro estudio de murales porque fue uno de siete tejanos que lograron obtener subvenciones del gobierno para pintar murales en Texas a finales de los años treintas. También es posible que haya sido el primer artista de ascendencia mexicana en ser galardonado de esta forma. Falleció el 13 de agosto de 1968.[21]

Durante muchos años, Salvador López fue empleado como artista y técnico por el El Paso Centennial Museum del Texas College of Mines and Metallurgy (ahora UTEP). López preparaba vitrinas para dioramas y escenas de fondo para las exhibiciones y restauraba diversos objetos que se exhibían en el museo. En 1945, pintó un mural en la pared del vestíbulo, frente a la recepción, donde se representa a Coronado y un grupo de conquistadores reunidos en torno a un indígena norteamericano sentado en cuclillas, enseñándoles a los españoles cómo cosechar una tuna.

López murió de osteomielitis en Ciudad Juárez en 1945, poco después de cumplir los treinta años. Varios de los dioramas que él creó se encuentran todavía en el museo.[22]

En 1967, unas explosiones controladas, realizadas para ampliar un edificio cercano, hicieron que el mural de López se agrietara hasta tal grado que hubo que taparlo con triplay.[23,24] James M. Day, que ocupaba el cargo de director del museo en 1980, le ordenó a Tom O'Laughlin, el curador, que descubriera la obra. Al profesor de arte Robert Massey se le pidió que restaurara el mural, pintado originalmente en óleo y caseína sobre yeso. Massey y un ayudante pasaron dos meses tapando las grietas con yeso y efectuando una esmerada labor de restauración.

Manuel Gregorio Acosta, uno de los artistas más notables de El Paso, nació en 1921 en Adame, Chihuahua, a poca distancia de la capital del estado. Sus padres fueron Ramón P. Acosta y Concepción Sánchez de Acosta. La familia emigró a El Paso cuando el pequeño Manuel tenía un año y se instaló en el Barrio del Diablo, cerca del Coliseo del Condado. Acosta comenzó a dibujar desde joven; estudió arte en la preparatoria Bowie con la maestra Octavia Magoffin Glasgow, una descendiente de James Magoffin, uno de los primeros pobladores de la región.[25]

Aunque no era ciudadano estadounidense, Acosta sirvió en el ejército durante la Segunda Guerra Mundial y fue enviado a Europa, donde visitó todos los museos y galerías que pudo. Después de su regreso, se hizo ciudadano. Su intenso deseo de convertirse en artista serio lo llevó a matricularse en el Instituto Chouinard de Arte (ahora Otis Parsons), en Los Angeles. Posteriormente, asistió al College of Mines y estudió bajo Urbici Soler, el escultor español que creó la estatua del *Cristo crucificado* que corona el monte Cristo Rey, situado en el punto donde El Paso colinda con los estados de Nuevo México y Chihuahua. Soler presentó a Acosta al célebre artista nuevomexicano Peter Hurd, quien lo contrató como asistente en varios proyectos murales, incluyendo dos obras por encargo, una en Houston y otra en Texas Tech University, en la ciudad de Lubbock. Acosta preparaba el enlucido de cal y polvo de marfil y lo aplicaba al muro. También combinaba pinturas y hacía trabajos de retoque. El mural de Texas Tech, un homenaje a los pioneros del oeste de Texas, tardó tres años en terminarse. Esta obra, compuesta de dieciséis paneles, se supone que "conmemora a aquellos hombres y mujeres que sobre los cimientos de los llanos fundaron un imperio".[26]

Después de la experiencia que ganó pintando murales con Hurd, Acosta pensó en abandonar El Paso para favorecer su carrera artística, pero su mentor lo persuadió a que se quedara en casa. En consecuencia, sus familiares, amigos y vecinos lo ayudaron a construir un estudio detrás de la casa familiar, ubicada en la calle Hammett #121. En este estudio, que empezó a reflejar la personalidad extrovertida del artista, se exhibían sus obras de arte y se daban legendarias fiestas.

En 1958, Acosta pintó su primer mural trabajando a solas en Logan, Nuevo México. El panel, de 8 por 26 pies, en el motel Casa Blanca, representaba la historia del estado.[27] El Bank of Texas, en Houston, le encargó seis frescos murales, *Texas bajo seis banderas*.[28] En el mismo año, terminó un mural que consistía en siete paneles con una superficie de 540 pies cuadrados, por encargo del First National Bank of Las Cruces, New Mexico, ilustrando la historia del Valle de Mesilla.[29] Estas obras aparecieron en la revista *Life* como una atracción turística del Sudoeste.[30]

Acosta ayudó también en el desarrollo de numerosos murales pintados por jóvenes de la comunidad, entre los cuales se destaca *Aztlán* (1985) en los Apartamentos Rio Grande, calle Lisboa #212, en el sector centro-sur de El Paso. Aquí estaban representados los dioses aztecas Iztaccíhuatl y Popocatépetl. El pintor principal fue Angel R. Zambrano, asistido por unas treinta personas cuyas edades fluctuaban entre los doce y los veinticinco años.[31] Por razones que se desconocen, el mural quedó recubierto de pintura por orden de la Administración de Vivienda en 1992. En 1988, Acosta pintó *Nosotros, el pueblo*, que fue instalado en la sala de espera de la Clínica La Fe, en el sur de El Paso. Acosta, cuyos logros artísticos habían atraído la atención de toda la nación, fue asesinado en su estudio el 25 de octubre de 1989, a la edad de 68 años.

José Cisneros había hecho ilustraciones para *La herencia española del sudoeste* en 1952. Quince años después, el autor de este libro, Francis Fugate, y su esposa le pidieron a Cisneros que pintara una de las ilustraciones en la cochera de su casa. El artista dedicó seis fines de semana a la obra, intitulada *Capriccio espagnol, siglo XVII,* que retrataba a una mujer y dos hombres de la época colonial. Los Fugate han dicho que Cisneros no hizo otras pinturas murales porque le costaba mucho esfuerzo. No pudieron preservar la obra, puesto que el muro no había sido debidamente preparado y no encontraron un sellador para impedir que se desconchara la superficie.[32] No quedaba casi rastro de la obra en 1993, cuando se vendió la casa después de la muerte de sus dueños. Aparece una fotografía del mural en *José Cisneros, un recorrido artístico*, de John O. West (El Paso: Texas Western Press, 1993).

El Paso y sus murales en los setentas

Al quedar terminada, en 1970, la Carretera Interestatal 10 dividía la ciudad, de un extremo al otro, en dos mitades.

Ese mismo año, unos treinta paseños asistieron a la Moratoria Chicana en Los Angeles, la primera manifestación patrocinada por un grupo minoritario para protestar la Guerra de Vietnam. Miles de personas participaron en la marcha en el este de Los Angeles. Los organizadores habían mandado representantes a El Paso y otras ciudades importantes con una población chicana considerable para alentar su participación.[33]

Pete Duarte era entonces el director del Proyecto Trans-Century, un organismo que reunía información acerca de las necesidades de la gente del Segundo Barrio en lo que se refería a los servicios médicos. En 1969, se planteó la necesidad de una clínica. Mediante una coalición conformada por integrantes de varias agencias sociales y residentes de la localidad, encabezados por Enedina "Nina" Cordero, varios médicos empezaron a proporcionar servicios clínicos en uno de los salones de Los Siete Infiernos, una casa de vecindad en el Segundo Barrio. Más adelante, se constituyó una mesa directiva, y así dio inicio el proceso de desarrollo de la Clínica La Fe.[34]

En 1974-75, el gobierno municipal del entonces alcalde Fred Hervey inauguró un esfuerzo por erradicar las casas de vecindad en el sur de El Paso. Bajo Hervey, se derribaron 90 de los edificios que estaban en peores condiciones, desplazando a 800 familias antes de terminar el programa en enero de 1975, debido a la escasez de vivienda costeable.[35]

Estos acontecimientos en el sur de El Paso coincidieron con el auge del Movimiento Chicano, un período de actividad política, social y cultural que buscaba solucionar el problema de la desigualdad en la vivienda, la educación y los programas de

asistencia social y durante el cual se protestaba en contra de la cantidad desproporcionadamente alta de soldados hispanos y de otras minorías enviadas a Vietnam.[36]

Con el impulso creado por la Clínica La Fe y el período que siguió a la Moratoria, la promulgación en 1973 de la Ley de Capacitación Integral de Trabajadores, que daba empleo a jóvenes durante los veranos, y los esfuerzos de Hervey por desintegrar el barrio, se formó una organización nueva. La Campaña pro la Preservación del Barrio era un organismo chicano establecido en 1974-75 con el propósito de "poner fin al desplazamiento y al desarraigo de la comunidad y conservar el sentido de colectividad que ya existía en ella".[37]

En 1975, La Campaña solicitó un subsidio para crear murales en el sector sur de El Paso. El proyecto se llamaba Los Murales del Barrio/The Murals of the Neighborhood, y proponía que se contrataran 23 personas para pintar murales bajo la supervisión de los artistas profesionales Manuel Acosta, Ernesto P. Martínez, Mago Gándara y Carlos Flores. El municipio aprobó la propuesta con un presupuesto de 21,200 dólares para pintar 14 murales bajo la supervisión del Departamento de Parques y Recreación.[38]

A mediados de los setentas, el sur de El Paso era también el campo donde se entrenaban activistas y organizadores comunitarios, incluyendo un gran número de voluntarios de VISTA, que habían sido asignados a trabajar allí. Entre ellos estaban los artistas que buscaban fomentar una conciencia de la época.

En un ensayo sobre los murales de este período, Marcos Sánchez-Tranquilino escribe:

> En un afán de satisfacer las necesidades de la comunidad chicana mediante la visualización de sus nuevas posturas políticas, se pintaron miles de murales chicanos en todo el Sudoeste y Medio Oeste, y a este hecho se debe en gran parte la desmitificación del concepto popular del mexicoamericano como un ser político pasivo y carente de historia y de cultura. Para conseguir este fin se debía trabajar sobre todo para remplazar las imágenes negativas originadas en una visión de la historia norteamericana más amplia y de mayor diversidad étnica. Los muralistas se convertían en educadores, al aportar contribuciones pictóricas a la sociedad norteamericana que no fueron incluidas en los libros de texto. Mediante el chicanismo lograron, además, poner de relieve las antiguas culturas mexicanas, demostrando así una continuidad histórica y una legitimidad cultural.[39]

Los artistas que pintaron murales en el sur de El Paso a mediados de los setentas se contagiaron del espíritu del Movimiento y comenzaron a reclamar nuevamente sus barrios y su cultura, que durante tantos años ellos habían desatendido. Conforme pintaban, sus imágenes traducían sus sentimientos de orgullo, de identidad y de adquisición de poder a los integrantes de la comunidad.

Uno de estos artistas, Arturo "Tury" Avalos, líder de Los Muralistas del Barrio, sintió el influjo de Los Tres Grandes, el trío mexicano compuesto por Diego Rivera, David Alfaro Siqueiros y José Clemente Orozco. Patrocinados por La Campaña, Avalos y su equipo (Pablo Schaffino, Gaby Ortega y Pascual Ramírez) pintaron el Segundo Barrio en letras de molde rectangulares con un diseño geométrico de inspiración azteca sobre el muro este de los presidios en la cuadra 500 de la calle Father Rahm, casi esquina con la calle Campbell. El mural llegó a ser un símbolo del orgullo del barrio, que se encontraba bajo amenaza de sufrir las modificaciones de la urbanización y donde ya estaba programada la demolición de varias manzanas. Los Muralistas pintaron luego, en el muro lateral del Centro Legal ubicado en la esquina de las calles Paisano y Campbell, la serpiente emplumada Quetzalcóatl, en versión de Avalos. De todos los murales pintados por este grupo, éste es el que en mejores condiciones se ha conservado, ya que se hallaba protegido por varios árboles.

Avalos caracterizó la pintura mural como una oportunidad de ser constructivo y de ayudar en la campaña contra los esfuerzos del municipio por destruir las casas de vecindad. "La gente no se daba cuenta de lo que ocurría entonces", declara Avalos. "La pintura era un mecanismo para unir a las personas."[40]

Según Avalos, se alentaba a los artistas a que expresaran la historia del barrio, pero cada persona acabó por seleccionar sus propias imágenes. Salvador Meléndrez y Manuel Arias pintaron, sobre un muro lateral de Duffy's Beverage Company, en la cuadra 800 de la calle Florence en el sur de El Paso, un retrato de Ernesto Che Guevara, el líder revolucionario cubano, quien se convirtió en símbolo del Movimiento Chicano. La pintura se hizo sin el permiso del propietario. Los artistas, todavía estudiantes de preparatoria, utilizaron pintura que sobraba de un trabajo anterior. El mural da de frente al solar donde se estableció la primera Ciudad de Carpas para protestar la erradicación de las casas del barrio. Los murales *Che Guevara* y *Segundo Barrio* tenían especial significación para la comunidad porque infundían un gran orgullo de identidad. *Che Guevara* fue pintado nuevamente por los integrantes del grupo MEChA de la preparatoria Bowie en 1994, bajo la dirección de su consejero, Oscar Lozano, uno de los fundadores de La Campaña, organismo que sufragó los gastos de pintar murales en el Segundo Barrio en 1975.

En 1976, Carlos Rosas ejecutó lo que era a la sazón el mural más grande de la localidad, *Entelequia/Entelechy*, una obra de 35 por 100 pies pintada sobre el muro trasero del Boys' Club de El Paso. La compañía Sherwin-Williams tenía la intención de pintar una

gran bandera en el muro, pero Rosas pidió permiso al centro para pintar allí un mural. Utilizando fondos proporcionados por CETA, Rosas y su padrastro, Felipe Gallegos, realizaron el muro en 90 días. En la obra aparecen tres caras, que representan la determinación de vivir, la naturaleza y la autoactualización. El fallecido poeta chicano, Dr. Ricardo Sánchez, definió Entelequia como "la noción filosófica que significa la actualización de la potencialidad, el poder o la fuerza que existe dentro de la vida misma, y el combustible para que la humanidad se realice".[41] A diferencia de otros murales que se hacían en esa época, *Entelequia/Entelechy* no emplea motivos o diseños aztecas. Rosas restauró el mural en 1989.

Durante la celebración del bicentenario norteamericano de 1976, el artista chicano Ernesto Pedregón Martínez pintó *Mesoamérica*, su primer mural en El Paso, en la cafetería de la escuela preparatoria Bowie. Pedregón Martínez, un consumado pintor e ilustrador, elevó la calidad de la pintura mural al incorporar determinados motivos precolombinos en sus diseños para expresar la grandeza de las antiguas culturas mexicanas. Antes de dar cima a su *Mesoamérica*, había creado un conjunto de obras que reflejaban la comunidad chicana en El Paso y que posteriormente llegaron a identificarse con el Movimiento Chicano. Uno de sus primeros cuadros, *Sí se puede*, un homenaje que data de 1973 a la lucha del sindicato laboral United Farm Workers, fue exhibido en la exposición intitulada "Arte chicano: Resistencia y afirmación, 1965-85 (CARA)", celebrada en la Universidad de California en Los Angeles en 1990 y donde participaron historiadores y artistas chicanos de todo Estados Unidos.

En 1977, Martínez pintó *Receptores de la medalla de honor del Congreso* en el interior del Edificio de Asuntos para Veteranos, ubicado en el número 5919 de la calle Brook Hollow Drive. El mural, de 8 por 28 pies, tardó ocho meses en terminarse y fue dedicado el 24 de octubre de 1977.[42] Los retratos de Ambrosio Guillén, William Deane Hawkins y Benito Martínez aparecían en primer término, contra un fondo espectacular de intenso combate. La atención que dedica el artista a los detalles de la indumentaria y la artillería caracterizan también a sus obras posteriores. En El Paso se le conoce principalmente por sus temas militares.

Se pintaron dos grandes murales en el barrio llamado Chihuahuita, una parte de lo que antes era el Primer Barrio del sur de El Paso. Uno de ellos lleva por título *Chuco, Tejas* y fue pintado en 1975 por Salvador Meléndrez, Manuel Arias y Víctor Cordero, ayudados por Víctor Sánchez y Eddie Aguirre, con patrocinio de La Campaña. El otro, *Sin título, u homenaje a Joe Battle*, pintado en 1978 y conocido anteriormente como *Lágrimas/Tears*, se encuentra en la cuadra 200 de la Séptima Avenida. Estaba dedicado a Joe Battle, entonces director del Departamento de Carreteras del estado de Texas (ahora Departamento de Transporte). Alfredo "Freddie" Morales y otros artistas de Chihuahua realizaron el mural. Morales dijo que una artista de Massachusetts, una voluntaria de VISTA conocida como "Mara", dibujó el diseño. Dijo que ella se marchó sin terminar el mural pero que pintó en él sus iniciales. En ese

tiempo, Battle y su departamento habían decidido construir la Carretera Fronteriza (Loop 375) a través de Chihuahuita. El mural fue realizado como una demostración pública de la inconformidad de la gente con el plan del estado, que destruiría el barrio. El artista Manuel G. Acosta ofreció su asesoría en cuanto a los materiales. Aunque rico en detalles, el mural se deterioró tras años de haberse quedado expuesto a la intemperie. En 1991, el Proyecto Los Murales de la Junior League de El Paso financió su restauración.

Mago Gándara, la primera mujer muralista en El Paso, comenzó a trabajar en *Tiempo y arena*, un mosaico montado en arena, en 1975. Ella y los alumnos de diez cursos que impartía en el Colegio Comunitario de El Paso lo realizaron en el transcurso de tres años. Gándara y Ernesto P. Martínez enseñaban cursos de arte en este colegio a principios de los setentas. El mural, que abarcaba dos pisos y medía 34 por 30 pies, fue instalado en el flamante recinto Valle Verde en septiembre de 1978. Realizada en secciones, la obra era una verdadera hazaña de la ingeniería. Hubo que utilizar grúas para levantarla y fijarla en el muro con pernos triangulares especiales. Gándara dice que el tema de la obra es "la evolución de la especie humana desde diversiones del yo y la sociedad, representada por formas maquinales hendidas y violentas, hacia una nueva compasión e integración simbolizadas por formas afanosas en éxtasis".[43]

Obras de la comunidad, 1980 a 1990

Durante los ochentas, con la llegada de talentosos artistas que habían trabajado en otras ciudades, la producción de murales en El Paso tomó un nuevo rumbo. Entre ellos estaban Felipe Adame, que había trabajado en el Parque Chicano de San Diego, y Carlos Callejo, que había pintado murales en Estrada Courts, en el este de Los Angeles, y se contaba entre los artistas que ayudaron a Judith F. Baca a realizar el *Gran muro de Los Angeles*, un mural que representaba la historia de la ciudad. En esta década también nacieron murales pintados por artistas que siguen produciendo hoy en día. Los ochentas pueden caracterizarse definitivamente como un renacimiento del arte mural.

El dominio de su oficio que poseían estos experimentados artistas aportó una nueva dimensión al patrocinio de las obras. En lugar de financiar sus propias obras, los artistas recurrían al apoyo de diversas entidades. Nuestro proyecto de documentación, emprendido en 1988, ayudó a identificar obras, a clasificar grupos de obras realizadas por diferentes artistas y a obtener reconocimiento para los artistas mismos. Mediante los esfuerzos conjuntos del Proyecto Los Murales, de la Junior League de El Paso, y

la publicidad sobre los murales en los periódicos locales, esta labor salió de la marginalización y se convirtió en una forma artística aceptada y respetada.

A finales de los setentas y principios de los ochentas, empezaron a participar las pandillas chicanas en los proyectos murales, con subvenciones proporcionadas por diversos organismos y patrocinadores individuales. Entre las entidades que apoyaban estos proyectos estaban Aliviane, una agencia local de rehabilitación para personas farmacodependentes; el Departamento de Intervención en Asuntos de Pandillas, dirigido por John Estrada; el Departamento de Recursos Artísticos del municipio; el Centro St. Anne, dirigido por Nicolás Domínguez; y personas como la entonces regidora del Ayuntamiento Alicia Chacón, los artistas Manuel G. Acosta y Mago Gándara, e individuos activos en su comunidad como Carmen Félix, Salvador "Chava" Balcorta, Chevo Quiroga, Salvador Valdez y Greg Villaseñor.

Durante los setentas, mientras se desempeñaba como consejero para el Community Drug Abuse and Education Center (Aliviane), Villaseñor dirigió la creación de dos murales. Había tomado un papel activo en pintar murales en las escuelas de la localidad entre 1966 y 1969. En 1973, coordinó la realización de una obra de 30 por 60 pies en el muro este del Gimnasio San Juan. El mural quedó destruido cuando el edificio fue ampliado.

Quiroga, adscrito anteriormente al Departamento de Intervención en Asuntos de Pandillas, se afilió a Aliviane en 1981. Varios miembros de pandillas le pidieron que ayudara en la creación de nuevos murales. A pesar de la percepción negativa que existe sobre las pandillas, éstas pueden dedicarse a actividades benéficas, como lo indica su participación en la pintura mural.

Aliviane y el Departamento de Recursos Artísticos financiaron el *Santo Niño de Atocha* en los Apartamentos Marmolejo, en el sector este de El Paso. El artista principal, Angel Romero, dibujó el diseño inicial con la ayuda de Manuel G. Acosta. Quiroga dijo que contaron con la ayuda de quince jóvenes del barrio. Alicia Chacón ayudó a conseguir dinero y hubo apoyo también por parte de Katherine Brennand, presidenta de Aliviane. Una obra teatral, *Chuco 80,* fue escrita por unos jóvenes que tomaron su inspiración del mural. La pieza fue puesta en escena en el Parque Nacional del Chamizal, el recinto Transmountain del Colegio Comunitario de El Paso y el Centro Cívico.

Santo Niño de Atocha, en honor al santo patrón de los viajeros y los niños, se encuentra en la parte posterior del complejo habitacional Marmolejo, oculto a la vista de los transeúntes. Este mural y otros desarrollados por Villaseñor, Valdez y Quiroga representan esfuerzos conjuntos realizados por trabajadores comunitarios, un organismo social y una dependencia municipal en beneficio de la juventud.

En otoño de 1982, Quiroga fue contactado por miembros de la pandilla Chicano Pride, que vivían en los Apartamentos Kennedy cerca de la calle Zaragosa en el Valle Bajo. Los 20 jóvenes deseaban pintar allí dos murales en el muro oeste de la guardería infantil Jane Briscoe, ubicada en la calle South Schutz Circle #447. El primero sería de Nuestra Señora de Guadalupe con la Misión de Ysleta, y el segundo sería de los dioses aztecas Iztaccíhuatl y Popocatépetl.

Según Quiroga, el emblema de los Apartamentos Kennedy fue pintado en grandes letras estilizadas en la cancha de rebote (frontón de mano) por alguien conocido como El Pecas/Freckles en el espacio de una sola tarde.[44] "La gente habla de muralistas que han ido a la universidad, pero nosotros tenemos aquí en la comunidad muchachos que pueden hacer mucho más que [una persona con un título universitario]", dijo Quiroga. Rudy Mendoza y Juan Martínez también colaboraron en el trabajo de los apartamentos Kennedy. Quiroga dijo que en repetidas ocasiones los artistas sin estudios formales han demostrado su gran capacidad de crear obras hermosas. La Virgen de Guadalupe en el territorio de los Fatherless, en la calle Seville, fue pintada por un hombre que vino de la penitenciaría, explicó Quiroga, y agregó: "Lo hizo en un día."[45]

Los dos proyectos de los Apartamentos Kennedy fueron financiados por Aliviane y el Departamento de Recursos Artísticos. Quiroga dijo que Alicia Chacón había sido la fuerza motriz en la recaudación de los fondos necesarios para realizar los murales que él hizo en la comunidad.

Los miembros de Varrio Indio Viejo (VIV) se pusieron en contacto con Quiroga en el verano de 1982 para ver si hacían un mural en la cancha de rebote localizada cerca de la escuela primaria Presa. Salvador "Chava" Valdez, un maestro de la escuela intermedia Ysleta, colaboró en el esfuerzo con unos diez jóvenes que utilizaban pintura derivada de petróleo. De nuevo, Aliviane y Alicia Chacón adquirieron los fondos.

Quiroga y Valdez ayudaron a los jóvenes a pintar *El hombre águila/The Eagle Man* en la cancha de rebote Middle Drain, una instalación al cuidado del Departamento Municipal de Parques y Recreo en el Valle Bajo. Quiroga dijo que se utilizaron retroproyectores para mostrar la imagen en el muro al dibujarla. Como muchos otros murales comunitarios, éste se originó con el simple acto de empuñar los jóvenes sus brochas y comenzar a pintar. No se pidió permiso al departamento municipal; un empleado se fijó en la obra y llamó a Aliviane y Quiroga. Por esta razón, dijo Quiroga, el departamento le extendió un contrato con la condición de que se finalizara el mural.

Los jóvenes del Varrio López Maravilla (VLM), en el sector centro-sur de El Paso, le pidieron a Quiroga que los ayudara en 1982-83 a pintar un mural en el muro del viejo edificio de Summit Fashions, en la calle Colfax. De acuerdo con Quiroga, la pandilla

López Mara, de Los Angeles, había procurado extender su territorio para abarcar a El Paso, y aunque fracasó el intento, el nombre se quedó.

A los artistas comunitarios se les conoce con frecuencia sólo por su apodo. "Santos", "El Smiley" y "El Robe" pintaron el mural de la calle Colfax, pero dejaron algunos de los rostros sin concluir. El mural era de la Virgen de Guadalupe, cuya figura se elevaba por encima de un muro de ladrillo rojo. Encima del muro estaban pintados dos varones jóvenes y una muchacha vestidos al estilo chicano chuco. Una rosa, símbolo sacado de la iconografía carcelaria, significaba ternura y amor. Una *ranfla* (automóvil) salía disparada desde el extremo izquierdo, y a la derecha una telaraña, que simbolizaba el atrapamiento, flotaba sobre un cuerpo caído en la calle. La iconografía en su conjunto estaba tomada de símbolos, motivos y dibujos que componen la imaginería empleada por los artistas prisioneros en las cárceles.[46] Más tarde, un ex presidiario terminó de pintar las caras para dejar acabado el mural. Joe Shamaley y Jim Viola, de Viola Sportswear, pagaron 500 dólares por el mural.

En 1984, Quiroga ya no estaba afiliado con Aliviane. Los miembros de la pandilla López Maravilla llamaron a la oficina de Intervención en Asuntos de Pandillas para obtener permiso para restaurar el mural en julio de 1988, pero el edificio ya se había vendido. Chevo Quiroga intentó facilitar la restauración, pero el nuevo propietario no dio su permiso y se retiró la propuesta. En 1995, sólo era visible la parte superior de la imagen de la Virgen; en la mitad inferior había graffiti.

En 1985-86, un maestro de arte de la preparatoria Bowie, Gaspar Enríquez, ayudó a unos jóvenes de los Apartamentos Rubén Salazar, en la calle sur Eucalyptus #311, a pintar *Cristo vigilando a El Paso/Cd. Juárez.* La Administración de Vivienda le había propuesto primero el trabajo. Se suscitó una controversia cuando los integrantes de la pandilla Thunderbirds pintaron su emblema en la montaña del mural. Los administradores de Vivienda les dijeron que quitaran el símbolo, que medía cinco pulgadas, pero la orden no fue acatada.

Los alumnos de Enríquez han pintado además murales deportivos en el gimnasio de mujeres de la preparatoria Bowie. Más recientemente, se han hecho murales de mucho colorido utilizando pintura spray en las canchas de rebote de la escuela. Los numerosos murales que aparecen en varios puntos del campus dan fe del uso de este género artístico por parte del maestro para desarrollar la creatividad de sus estudiantes.

En mayo de 1988, Enríquez ayudó a unos jóvenes de los Apartamentos Salazar a pintar un mural en el Edificio 2, en homenaje a Enedina "Nina" Sánchez Cordero, fundadora de la Clínica La Fe. El diseño fue idea de Rosendo Montes, quien trabajaba entonces como voluntario de VISTA en el Departamento de Intervención en Asuntos de Pandillas. Aparece un pergamino sobre el cual

está escrito un poema de Juan Contreras, hijo de Sánchez Cordero, unas montañas y nubes y un retrato de la homenajeada aerografiado sobre triplay. El tamaño es de 18 por 24 pies. La obra fue restaurada en 1991 con una subvención de la Junior League. Los estudiantes que ayudaron en la restauración fueron Dino Cano, Rubén Arias, René Sánchez y Víctor Perches.[47]

El artista Felipe Adame pintó más de una docena de obras en El Paso a partir de 1980. Las más populares son sus Vírgenes de Guadalupe. También ayudó a miembros de la pandilla Kofu en el sur de El Paso a realizar un mural en el segundo piso del edificio donde viven, localizado en las calles Florence y Octava, cerca del Centro Armijo. Según Jan Wilson, el diseño proviene de un emblema que aparece en las chamarras usadas por la pandilla Kofu.[48]

En 1981, Adame pintó una Virgen cerca del Centro Cultural de Arte Lincoln, en un pilar que se encuentra debajo del "Tazón del Espagueti", un cruce de la Carretera Interestatal 10, cerca de la esquina de las calles Uva y Durazno. La imagen fue reproducida en 1989 en un poster, con motivo de una celebración de Nuestra Señora de Guadalupe, fiesta observada en toda la ciudad. Adame dijo que su intención era crear allí para El Paso una versión del Parque Chicano de San Diego, pero que las autoridades se lo impidieron. En 1981 se pintó en otro pilar de la autopista la imagen de una figura revolucionaria, de 8 por 4 pies, el único vestigio del intento por parte de Adame de crear una versión paseña del Parque Chicano de San Diego.

En 1982, en el interior del Centro de Recreación Armijo, ubicado en la Séptima Avenida #710, en el sur de El Paso, Adame pintó *Iztaccíhuatl, mujer blanca, leyenda de los volcanes*, tomado de una pintura del artista mexicano Jesús Helguera (véase el Apéndice D). Para ello fue asistido por Elizabeth Joyce, Raúl Macías, Nacho Guerrero y Jesús "Machido" Hernández y usaron la técnica del papel perforado para copiar la obra en la pared. La pared fue empastada por Ignacio Guerrero, padre de Nacho.

Ese mismo año, Adame pintó *Dale gas* en la tienda de abarrotes "Gator's" en el sur de El Paso. Este mural, que ya no existe, medía treinta pies y representaba un zoot suiter (pachuco) con el horizonte de El Paso en el fondo.[49] Se encontraba cerca de la esquina de la Sexta Avenida y el callejón que está al oeste de la calle Cotton.

A solicitud de los Thunderbirds y la familia Cornejo, entre 1982-83, Adame pintó *La virgen de Guadalupe y Juan Diego*, en el edificio 10 de los Apartamentos Salazar. Le tomó seis meses terminarlo y fue financiado por Adame, quien vendió el mural por pie cuadrado a la Liga de Ciudadanos Latinoamericanos Unidos (LULAC), a la tienda de abarrotes "Ruidoso" y a otros patrocinadores. El mural fue restaurado por el pintor y los jóvenes del barrio en 1991 con un estipendio de $5,000 procedentes del Proyecto Los Murales, auspiciado por la Junior League.

Adame comenzó a trabajar, en 1985, con jóvenes de la pandilla Varrio Quinto Street (VQS) entre la avenida Padre Rahm (antigua Quinta Avenida) y la calle Campbell, en un esfuerzo por impedir el uso de inhalantes o "spray" en el área. El resultado fue un mural de 26 pies de altura por 22 de largo, que muestra a los dioses aztecas Iztaccíhuatl y Popocatépetl. El nombre del grupo refleja el uso callejero del término "varrio" en vez de "barrio", usado también en los nombres de otros grupos. También en 1985, en Chihuahuita, Adame pintó un mural en la parte exterior del garaje de Lico Zubia, en memoria del hijo de éste, Florentino Zubia, Jr., "Nuni", quien había fallecido en un accidente de motocicleta en 1980.[50] Zubia solicitó a Adame pintar una escena de la película *Easy Rider*: en el mural se aprecia una camioneta pick-up que emerge de un área cubierta de nieve, el cual se dirige hacia una playa con palmeras.

Los murales de Adame reflejan la fascinación chicana con el estilo de las obras de Helguera, las cuales, en la mayoría de los casos, son aceptables culturalmente para el gran público. En sus murales, Adame utilizó diferentes versiones de la obra del artista mexicano para comunicar a su público el espíritu del muralismo chicano. En sus pinturas de la Virgen, se enfoca en una de las más respetadas imágenes de esta cultura.

Los artistas locales que no habían desarrollado durante los ochentas una infraestructura para conseguir financiamiento, aprendieron luego a reunir fondos para sus proyectos. El advenimiento de Adame y Callejo demostró la necesidad de un mecanismo para obtener fondos públicos para la creación de obras.

En 1987, el entonces director del Southside Educational Center, David Romo, contactó a Callejo para que pintara lo que sería su primer mural por encargo en la ciudad, en la pared norte del Centro, situado en el 800 de la avenida San Francisco. Un grupo de jóvenes contratado por el Upper Rio Grande Private Industry Council (PIC) trabajaría en el proyecto. Por casualidad, desde 1981 la misma pared ostentaba un mural chicano, que al deteriorarse fue borrado cubriéndolo con pintura. Esta obra representaba los rostros de una familia, tema predominante en los primeros murales chicanos.[51] Estaba situado en las calles El Paso y Cuarta, cerca de otros dos murales que databan de los setentas: uno de éstos representaba la imagen de un revolucionario de pie delante del emblema de los Trabajadores Agrícolas Unidos, superpuesto a un sol; el otro mostraba tres rostros mayas.[52]

Callejo tardó seis semanas en pintar *Muchachos en la luna*. Los jóvenes de PIC investigaron los asuntos de interés para el barrio. El mural sugería que, aunque tenemos la capacidad, como civilización, de colocar a un hombre en la luna, los niños se acuestan por la noche con hambre. El edificio fue vendido en 1992 y el mural fue destruido. Los nuevos propietarios primero pintaron etiquetas de calzado en la parte superior, y luego suprimieron una parte de la pared para instalar la puerta de un garaje.

Finalmente, pintaron el muro de café oscuro. Aunque era fuente de gran orgullo para la comunidad, el mural estaba en un área comercial, donde el público tal vez no haya sentido la necesidad de protestar por su remoción.

En 1988, bajo los auspicios de la Coalición Chicana contra el SIDA, la Clínica La Fe y PIC, Callejo pintó un mural representando temas relacionados con el SIDA entre las calles Sexta y Ochoa, detrás de la clínica. Estalló una controversia por la inclusión de la figura de una mujer desnuda dentro de un torbellino, para mostrar que las mujeres eran susceptibles de contraer el virus. Al ver esto, los administradores de PIC se mostraron renuentes a permitir que los jóvenes trabajaran en el mural, y varios de ellos fueron reasignados al mural de los Apartamentos Salazar. Muchos, sin embargo, continuaron trabajando con Callejo, incluidos Rosendo Montes, Jaime Valencia, Fili Medina, Jaime Baca y Salvador "Chava" Alvarez.

Con Archie Moreno y César Galván, Callejo supervisó la realización de un homenaje al asesinado periodista Rubén Salazar en el edificio 31 de los Apartamentos Salazar, entre las calles Cypress y Eucalyptus. El complejo habitacional lleva el nombre de Salazar, un ex paseño que ganó fama como periodista en Los Angeles y perdió la vida en 1970, cuando una bomba lacrimógena de la policía fue lanzada a un centro de negocios durante una manifestación chicana en contra de la guerra de Vietnam. Así, Salazar se convirtió en mártir del Movimiento.[53]

En 1989, Callejo creó un mural en la Preparatoria Socorro, en el 10150 de la avenida Alameda, basado en una pintura de Marta Arat. *La danza, una forma del arte universal*, muestra a danzantes en medio de olas de colores, un rasgo característico de las pinturas de Arat, las cuales han aparecido en incontables afiches en nuestra comunidad y la nación entera.[54] Callejo fue asistido por Alejandro Martel y Antonio Mercado. Los patrocinadores fueron el Distrito Escolar Independiente de Socorro y la compañía de danza folklórica de Rosa Guerrero.

En el verano de 1989, el Departamento de Recursos Artísticos de El Paso y la Clínica La Fe auspiciaron *El Chuco y Qué/El Paso So What*, de Callejo, en la cuadra 700 sur de la calle Virginia. La Junior League de El Paso comenzó su *Proyecto Los Murales* con una contribución de 500 dólares. Raymundo "Rocky" Avila, quien había colaborado en el mural del SIDA, trabajó aquí también, al igual que Antonio Mercado, Manuel Arrellano y Frank Mata. La obra proyecta el estereotipo de una tierra de vaqueros, como internacionalmente se concibe al estado de Texas, una imagen que no necesariamente le queda a El Paso. Según Callejo: "somos mucho más que simples vaqueros. Somos una mezcla cultural única". El Chuco es un nombre que designa, en el caló chicano, a El Paso.

En las vacaciones de Navidad de 1981, Lupe Casillas-Lowenberg y sus estudiantes de la Preparatoria Gadsden pintaron *La aparición de la Virgen de Guadalupe* en un lado de la pared exterior de la iglesia católica de San Martín de Porras, en McNutt Road #5805, Sunland Park, Nuevo Mexico. El mural de la virgen, una popular imagen chicana, ha sido un símbolo para la comunidad de Sunland Park. Los residentes construyeron una verja a su alrededor para protegerlo del vandalismo y del graffiti. Gloria Irigoyen – una de las alumnas de la artista – y su familia ayudaron a obtener permiso para usar la pared. El diseño que ellos crearon fue aplicado a la pared sin repello utilizando pintura donada por la compañía Hanley Paint. El padre de Irigoyen proveyó el andamiaje. El supermercado Big 8, ubicado entonces en Doniphan Drive, donó frutas y bebidas, y los pobladores brindaron el almuerzo para el equipo. El mural quedó terminado en tres semanas. Roberto Salas, un ex alumno del artista, trabajó con el grupo para desarrollar diseños que ellos pintaban en las canchas de rebote y en el diamante de béisbol de Sunland Park.

En los primeros días de julio de 1987, el artista de la Ciudad de México, Manuel Anzaldo Meneses, junto con Carlos Callejo, Eva María Kutschied y otros, con los Cholos de Ciudad Juárez, pintaron en las riberas del lado mexicano del Río Grande, bajo el puente de la calle Santa Fe, *Todos somos ilegales/We Are All Illegal Aliens*. Anzaldo Meneses organizó a los artistas de las dos ciudades para crear el mural, que mide más de 20 por 200 pies. Los participantes debían expresar sus puntos de vista sobre cuestiones de política migratoria que afectaban a ambas naciones. El objetivo de Anzaldo era mostrar la necesidad de romper las barreras artificiales creadas por el hombre, las cuales, según él, constituyen el mito de la frontera. Anzaldo también quería pintar la franja fronteriza entre El Paso y Ciudad Juárez. Los murales fueron pintados sin autorización.

Todos somos ilegales estaba inspirado en una calcomanía para vehículos producida por la ya desaparecida Liga de Inmigración para la Educación de los Derechos Fronterizos (LIBRE), grupo creado por Debbie Nathan y otros. En los años siguientes, se hicieron otros murales en la ribera, incluyendo uno en apoyo al comercio de los Estados Unidos con Cuba, en 1993. En mayo de 1988, Anzaldo y artistas de ambos lados de la frontera pintaron *Todos somos americanos* en la orilla del río, debajo del mismo puente, en Ciudad Juárez. Anzaldo regresó al área para ejecutar otras obras en mayo de 1989. El, Rafael Martínez y otros seis artistas pintaron un enorme mural de Quetzalcóatl con la leyenda *El puente negro*, título que alude al puente ferroviario usado con frecuencia para cruzar ilegalmente a los Estados Unidos.[55]

Un anuncio en el *Times* de El Paso del 2 de mayo de 1990 invitaba a los artistas locales a tomar parte en la realización de un mural a orillas del río, bajo el puente Paso del Norte, del lado mexicano, en conmemoración del Día Internacional de los Trabajadores. A cada participante se le solicitó la contribución de cinco dólares para adquirir pintura y brochas. A principios de los noventas,

Anzaldo regresó de México D.F. a Ciudad Juárez para restaurar los antiguos murales y crear otros nuevos. Ahora, a mediados de los noventas, con el espíritu de Anzaldo, artistas anónimos producen en el río sus propios murales sobre el tema de la inmigración.

Carlos Rosas regresó a El Paso en 1989 con la intención de restaurar su mural *Entelequia*, pintado trece años antes en el Boy's Club de El Paso. Con la ayuda de intermediarios se alcanzó un acuerdo entre Rosas y la directiva del Club.[56] La compañía Given Paint donó los materiales, y con fondos privados se reunieron mil dólares para la ejecución del proyecto, que duró tres meses. Rosas transformó totalmente el mural, haciendo cambios radicales y añadiendo colores e imágenes contemporáneos.

Posteriormente, Rosas reunió fondos para pintar un mural en homenaje al artista Manuel Acosta, muerto en 1989. En marzo de 1990, con ayuda de gentes de negocios locales, Acosta pintó, de cara a la carretera fronteriza, un mural de 12 por 84 pies intitulado *Dios es mexicano/Homenaje a Manuel Acosta*.

Murales en los noventas

En la década de los noventas, la creación de murales en El Paso empezó a seguir una ruta mejor delineada con el establecimiento de una importante fuente de recursos. También se contó con dos ingresos considerables: un encargo con valor de 150,000 dólares, adjudicado a Carlos Callejo en 1990, y otro auspiciado por la Administración de Servicios Generales del Programa de Arte y Arquitectura, para el Edificio Federal de El Paso, adjudicado al artista chicano de Los Angeles, John Valadez. Estos importantes encargos también ayudaron a elevar los estándares de apreciación artísticos y comunitarios hacia los murales y la ubicación e importancia de los mismos dentro de la ciudad.

Quince años antes, en 1975, la Campaña pro Preservación del Barrio había iniciado Los Murales del Barrio, que pintó murales en el Segundo Barrio.

En 1990, la Junior League de El Paso estableció su Proyecto Los Murales como un medio para continuar la creación de murales en la ciudad. Históricamente, las Junior Leagues a través del país identifican los proyectos de servicios comunitarios que requieren de apoyo. Las Ligas proveen los fondos iniciales, y posteriormente, cuando cada proyecto llega a ser autosuficiente, terminan su participación directa. La Liga también buscaba reconocer a los artistas que habían creado obras anteriores, aislados casi completamente unos de otros.[57]

El artista Carlos Callejo invitó al Dr. Tim Drescher, conocido nacionalmente como autor y editor de la revista *Community Murals*, para hablar con los miembros de la Junior League acerca del proyecto propuesto en el otoño de 1989. Drescher animó al grupo a elaborar normas para la adjudicación de encargos, especialmente a los muralistas de la comunidad, normas que fomentaran además la libertad de expresión entre dichos artistas.[58]

Ana Salas-Porras Walcutt, miembro de la Liga, redactó la propuesta original para la mesa directiva. Adair Margo, propietaria de una reconocida galería, se desempeñó como la primera presidenta de Los Murales. La Liga entregó los primeros cinco mil dólares en comisiones a los artistas, con la promesa de que ellos podrían pintar lo que quisieran.[59] Beth Vann fungió como presidenta en el período 1991-92; le siguieron Michele McCown (1992-93) y Beth Ford (1993-94). Cynthia W. Farah fue asesora permanente de los comités.

Hasta la fecha, la Junior League ha destinado 151,000 dólares a la creación de murales en El Paso: $20,000 en 1990-91, $32,000 en 1991-92, $18,000 en 1992-93 y $18,000 en 1993-94. El presupuesto de 1994-95, bajo la presidencia de Julie Delgado, fue de $33,000; en 1995-96, bajo Tanya Schwartz, fue de $10,000. Fondos adicionales para el proyecto han sido donados por la Comisión para las Artes del Estado de Texas, el Departamento de Recursos Artísticos de la Ciudad de El Paso, Texas Commerce Bank, la Barra de Abogados México-Americanos, la Barra de Abogadas, el Comité Migratorio y de Refugio Diocesano, así como por individuos como Nate y Estelle Goldman y Greg Acuña.

Otras ciudades han expresado interés en proyectos similares a los de Los Murales. En abril de 1994, Tyler, Texas invitó a Callejo a trabajar con jóvenes de la localidad en la producción de un mural sobre una pared de la zona céntrica, basado en la historia de la ciudad.

La creación de murales en El Paso ha tendido puentes entre grupos que habían permanecido tradicionalmente separados por razones de clase social y económica. La creación y el patrocinio de obras atrajeron el interés de personas de toda la ciudad. Los murales son vistos ahora como atracción turística y fuente de orgullo de la comunidad. Reconociendo la necesidad de reunir fondos para crear los murales, la Junior League tomó la delantera para llenar el vacío existente.

Un folleto en colores basado en nuestra documentación y titulado "Los Murales: Guía y Mapas de los Murales de El Paso", fue publicado en 1992 por la Junior League para ayudar a los visitantes a localizar algunos de los principales murales de la ciudad.[60] La

primera impresión de 10,000 ejemplares fue tan exitosa que de inmediato se ordenó un nuevo tiraje de otros 10,000. Las siguientes reimpresiones han sido financiadas por grupos corporativos. La guía, que ha circulado a través de todo el mundo, fue distribuida gratuitamente.

Encargos importantes

El pintor chicano John Valadez fue escogido entre otros artistas en 1988 por la Administración de Servicios Generales del Programa de Arte en Arquitectura para ejecutar dos obras importantes, ambas en la Ysleta Border Station, Edificio A, ubicada en la South Zaragoza Road #797, en el límite internacional. A solicitud del ex curador del Museo de Arte de El Paso, Kevin Donovan, transparencias de las obras de Valadez fueron sometidas a la GSA por la Galería Saxon-Lee de Los Angeles.

Valadez visitó El Paso de 1989 a 1993 para estudiar la ciudad, reuniendo imágenes para su posible uso en los murales. *Un día en El Paso del Norte*, mural en óleo y acrílico sobre un lienzo de 9 por 50 pies, fue instalado dentro del Edificio Federal en diciembre de 1993. La obra refleja la historia de El Paso y su gente, utilizando la zona céntrica de la ciudad como escenario en el cual se entretejen imágenes del presente y del pasado, formando una vista panorámica de la ciudad.

La llegada de la lluvia, que el artista llamó "paisaje agrícola rural", da una perspectiva panorámica de un campo después del riego, con una casa de adobe abandonada en medio. En la lejanía se asoman unos nubarrones, mientras una fantasmal diligencia flota por encima de ellas. Valadez incluye un arado tarahumara hecho a mano en el lado inferior derecho de este mural pintado al óleo sobre lienzo, que mide 6 por 9 pies, instalado el 19 de abril de 1994 en la estación fronteriza. La develación pública de ambas obras se celebró el 13 de septiembre de 1994.

Con el anuncio de la adjudicación de un encargo por valor de 150,000 dólares a Callejo en 1990, emergía un panorama claro del nivel de sofisticación del arte público en El Paso. Este encargo, para el nuevo edificio de la Corte del Condado de El Paso, era el más grande concedido a un solo artista y destinado a la realización de un mural en la historia de la ciudad; subrayaba además el compromiso por parte de los organismos locales de apoyar la producción de murales.

Otros encargos en los noventas

En noviembre de 1990, Carlos Rosas pintó, frente a la Clínica La Fe, *La sagrada familia*, un mural de 10 por 10 pies, en que se retrata a un hombre, una mujer y un niño. Se parece a un poster chicano, "La familia", impreso por Publicaciones AMATL, Inc., y firmado "Chinas 62".

Al año siguiente, Rosas fue comisionado por la Junior League de El Paso para pintar un mural de 19 por 29 pies en el edificio del Centro de Empleos David L. Carrasco, en homenaje al señor Carrasco, célebre director de este Centro, quien murió el 16 de octubre de 1990. El mural, ubicado en la calle Gateway West #11155, en el este de El Paso, costó 5,000 dólares y empleó a jóvenes del mismo Centro. En él, Rosas ilustró los temas de la vida, la familia y los éxitos de este extraordinario hombre.[61] El mural fue restaurado en 1996.

Rosas pintó un mural en 1991 para el artista Ho Baron, en el muro de su garaje en la avenida Altura, en el distrito histórico Alturas de Manhattan, a cambio del derecho a ocupar un apartamento en el sótano del edificio. Rosas pintó una cabeza olmeca y otros motivos precolombinos en llamativos y brillantes colores, el estilo característico del pintor.[62]

Algunos vecinos de Baron protestaron en contra de la ejecución de los murales sin antes conseguir el permiso de la Comisión de Sitios Históricos del municipio, un requisito para realizar reformas en este distrito histórico.[63] El asunto fue llevado al Concejo Municipal el 17 de septiembre de 1991, después de que una votación entre los comisionados arrojara ocho votos a favor y seis en contra de que el mural permaneciera en su sitio. Baron, asistido por el activista y escritor Robert Chávez, quien vivía en el barrio, había recogido 397 firmas a favor del mural en una campaña casa por casa. Sus oponentes fueron del criterio que Baron había violado el reglamento municipal que exigía solicitar permiso para llevar a cabo tales modificaciones en el distrito. La votación en el Concejo resultó en un empate, roto por el alcalde Bill Tilney, quien emitió su voto a favor de Baron para que el mural permaneciera intacto.

El 12 de abril de 1994 Carlos Rossas (él mismo añadió una "s" a su apellido en honor a Picasso, quien escribía su nombre con doble "s"), dedicó *The Children First/Los niños primero* para hacer constar las contribuciones de la gente del Segundo Barrio y reconocer a los antiguos estudiantes de la Escuela Aoy.[64] Rossas también pintó otras imágenes y edificios simbólicos de la juventud y la belleza y de las esperanzas y sueños de la cultura mexicana. El incorporó dentro de su obra el Cuauhtémoc de Jesús Helguera. Consideró que ese mural era su obra más seria en el momento en que fue inaugurado por la Asociación de Ex Alumnos de Aoy y Ramiro Guzmán.

Felipe Gallegos Jr. lo asistió en la realización del mural. La senadora del estado, Peggy Rosson, y Richard Romo, representante del Congresista de los Estados Unidos, Ron Coleman, presentaron a Rossas banderas que habían ondeado sobre los capitolios estatal y nacional como un obsequio para la escuela.

La "Escuela Preparatoria Mexicana", que devino en Escuela Aoy, había sido abierta en 1887 como escuela libre privada, por Olivas Villanueva Aoy, quien nació en Valencia, España, en 1833. Fue incorporada al Distrito Escolar Independiente de El Paso en 1891.

En 1991, Callejo fue nombrado por la Junior League para pintar un mural para Superior Solutions, Inc., ubicado en la avenida Magoffin #2001. Como ya se había comprometido a la realización de otros proyectos, Callejo propuso a Mario Colin. Utilizando escaleras de mano y trabajando horas extras, Colin y su equipo concluyeron un espectacular mural que abarca el edificio completo. *Herencia hispana y desamparo* se encuentra en la esquina de las calles Magoffin y Eucalyptus, en la zona central de El Paso. En el muro que corre por la calle Magoffin se aprecia un tapiz de imágenes de la historia, la religión, la educación, la familia y las antiguas culturas mexicanas. Una gran imagen de la Virgen de Guadalupe, rodeada de su aureola de brillante colorido, domina la pintura. Dos colosales cabezas de la cultura olmeca de La Venta (Tabasco) y dos niños leyendo libros completan esta sección del mural. Un retrato de una familia aparece contra el fondo de un tejido multicolor. Otras imágenes de la cultura mexicana son: un bailarín folklórico, un revolucionario a caballo y la Pirámide del Sol. El brazo extendido de un guerrero azteca se halla a la derecha contra un fondo estrellado.

El tema del desamparo mereció la atención del artista en el muro que corre por la calle Eucalyptus. Pero no formaba parte de su propuesta original.[65] Este mural separado muestra a niños durmiendo juntos y amontonados. El pintor casi pierde el encargo por el compromiso que sentía con este tema.

Este primer mural de Colin era muy poderoso, con imágenes representativas de la herencia mexicana. Ha sido reproducido muchas veces en periódicos locales por la exposición articulada que hace de las tradiciones y la historia de la comunidad mexico-americana. Colin fue uno de los muralistas locales que aparecieron en el video *Muros que hablan*, producido por Jim Klaes en 1994 y auspiciado por la Cámara de Comercio Hispana de El Paso y Los Murales. *Hispanic Heritage* desapareció cuando quedó recubierto de pintura en 1996.

En 1991, Roberto Salas, originario de El Paso y radicado en San Diego, pintó *Las cosas de la vida* en Sunland Park, en la cancha de rebote de los campos deportivos de Elena's Memorial Park. Un antiguo miembro del Border Arts Workshop/Taller de Arte

Fronterizo (BAW/TAF), Salas usó estilizadas representaciones gráficas de imágenes mexicanas y novomexicanas en cuadros similares a los del juego de la lotería mexicana. Las imágenes tratan de varios aspectos de la vida, la religión y la identidad. Fue asistido por David Anderson, Svenja Sliwka, Gene Flores y Carlos Madrigal. Salas ha pintado murales en San Diego, Los Angeles, Houston y América Central.

En febrero de 1993, Mago Gándara fue comisionada por la Junior League para crear un mural de mosaicos en la escuela primaria Douglass, en la calle Eucalyptus. La obra, que representa la fluida imagen de una mujer, está realizada en brillante mosaico de azulejos, vidrio y otros materiales. *La niña cósmica* es un mural espectacular que cambia según el recorrido del sol por el cielo. Gándara es una de las pocas mujeres que crean murales en El Paso y es actualmente la única que maneja la difícil técnica del mosaico.

En 1995, Ernesto P. Martínez ejecutó una versión actualizada de *Los receptores de la medalla de honor del Congreso* en el interior del Centro de Salud localizado en el Edificio de la Administración de Asuntos para Veteranos, contiguo al Centro Médico del Ejército William Beaumont. En la obra aparecen retratados Hiroshi H. Mayumara, William Deane Hawkins, Joseph C. Rodríguez, Roy P. Benavídez, Raymond G. Murphy, Benito Martínez y Ambrosio Guillén. Esta pintura, en lienzo de dos paneles, fue encargada por el Departamento de Asuntos para Veteranos. El centro de salud abrió en octubre de 1995.

CAPITULO 2

ENTREVISTAS

La documentación de los murales de El Paso ha sido esporádica y poco diseminada. El propósito de este libro es consolidar la información de que disponemos sobre estos murales y permitir que los muralistas cuenten sus propias historias.

En las entrevistas que aparecen a continuación, los artistas ofrecen sus propias perspectivas sobre su vida, su visión artística y el desarrollo de su obra.

Antes de hacer estas entrevistas, yo ya conocía a la mayoría de los artistas y había trabajado con ellos. Todas las sesiones fueron en inglés, excepto la de Carlos Flores, que fue en español. El texto ha sido estructurado en forma narrativa y se han suprimido las preguntas para que el texto se pueda leer con más facilidad.

Todos los artistas menos dos pudieron leer estas transcripciones antes de su publicación. No se pudo localizar a Felipe Adame, y Manuel G. Acosta falleció en 1989.

Ernesto Pedregón Martínez
Entrevistado por Mike Juárez
Residencia Martínez, El Paso
21 de noviembre de 1992

La mayor parte de mi trabajo la he hecho fuera de la ciudad, y los medios de comunicación se enfocaban anteriormente sobre todo en el fallecido Manuel Acosta. Además, le he pisado los callos a mucha gente con mis pinturas. No he sido aceptado dentro de la línea del arte predominante en el área de El Paso. Durante muchos años fui el único activista en el arte.

Recuerdo que en los sesentas, los setentas, exponía en el Centro Cívico de El Paso mi arte chicano y mucha gente se ofendía porque el arte chicano todavía no era plenamente aceptado. Se me consideraba algo así como un rebelde. Por muchos años fui el único artista chicano de la región.

La única oportunidad que tuve para exponer mi trabajo me la dieron a través de MEChA [Movimiento Estudiantil Chicano de Aztlán en UTEP]. También hice muchas exposiciones en el Centro Corbett [en la Universidad de Nuevo México en Las Cruces]. El ejército también me permitió montar algunas exposiciones. También tuve algunas en el Parque Nacional del Chamizal. Por supuesto que en el Museo de Arte de El Paso me era imposible hacer exposiciones.

Nací en el sur de El Paso, en una casa sobre la calle Quinta, que actualmente se llama calle Father Rahm. Nací el 26 de febrero de 1926, entre las calles Quinta y Oregon, en uno de esos presidios. Había una escuelita de monjas, allí por la Iglesia del Sagrado Corazón. De allí pasé a la Escuela [Primaria] Aoy y luego a la Catedral [secundaria y preparatoria]. Fuera de eso, no tengo más estudios.

Mis orígenes son muy, muy humildes. El único orgullo en la familia antes de mí fue mi tío. El era hermano de mi padre y era sacerdote en México. Fue ejecutado por un pelotón de fusilamiento durante la persecución. Lo agarraron oficiando misa, lo sacaron y lo ejecutaron.[66]

Mi padre era sastre. Yo fui el menor de siete hermanos. Eramos muy pobres, pobrísimos, y vivíamos en los barrios de los alrededores de la calle Oregon, enfrente de la Iglesia del Sagrado Corazón. Nunca pude tomar clases de arte ni nada por el estilo. Copiaba las obras de arte de los grandes maestros y leía todo lo que podía sobre arte. Creo que he pintado desde que estaba en el jardín de niños.

Desde temprana edad, dibujaba o hacía bosquejos de todo lo que podía. En el jardín de niños admiraban mi trabajo. Ponían los dibujos en las paredes aunque sólo fueran hechos a lápiz. En la Escuela Aoy, no hice muchos dibujos, pero tenía una caja llena de bocetos debajo de la cama. Cuando me fui a la guerra, no pinté nada. Cuando se acabó la guerra, conocí a Mary, mi esposa. Ella fue la que me animó a pintar otra vez. Nadie creía que algún día me metería completamente al mundo del arte. Como me casé y tenía que sostener a mi familia, y puesto que era totalmente desconocido, tuve que hacer otros trabajos. Conseguí un empleo en Fort Bliss en el campo de la electrónica. Allí, algunas veces necesitaban algún croquis. Fue entonces que mis habilidades artísticas se comenzaron a notar. Poco a poco fui dejando la electrónica y comencé a trabajar como artista comercial. Con el tiempo me convertí en ilustrador del ejército. Pintaba mucho en caballete y leía todo lo que caía en mis manos sobre arte. Por medio de mi trabajo hice experimentos con toda clase de técnicas y tamaños de pinturas. Luego comencé a experimentar con acrílico. Me encanta el acrílico. Casi todo lo que he pintado desde entonces ha sido en acrílico. Por aquel tiempo tenía casi cuarenta y ocho años y era completamente desconocido. No había hecho ninguna exposición—nada, absolutamente nada en cuestión de arte.

Toda mi vida tuve una gran admiración por México, así que había adquirido un extenso conocimiento de la antropología mexicana. Conocía muy bien a los muralistas mexicanos. Cuando tenía unos 25 años, antes de casarme, me fascinaba la tauromaquia, de manera que estaba muy involucrado con las corridas de toros. Tanto así que tomé parte en muchos festivales de caridad donde llegué a torear.

Yo creo que era el movimiento, el hermoso colorido de la Fiesta Brava, los trajes de luces y los trabajos de Ruano Llopis. Ruano Llopis es posiblemente el más grande de los artistas españoles de la tauromaquia. Yo copiaba mucho su trabajo y también las obras de El Greco. Así que adquirí el colorido de Llopis y del mexicano Jesús Helguera. Helguera era el artista que pintaba para las tabacaleras de México. El pintó "La Leyenda de los Volcanes" (véase el apéndice D). La combinación de Helguera con Ruano Llopis, junto con la tristeza de los melancólicos cielos de El Greco y Miguel Angel me dieron el movimiento. Antes de saberlo, ya tenía una combinación de todos estos maestros, lo que me llevó a desarrollar mi propio estilo.

Como le dije, tenía una gran cantidad de pinturas taurinas. También tenía muchísimos retratos de campesinos, México y la gente humilde, la pobreza, el mercado y el barrio. Debo haber tenido entre 60 y 80 pinturas. Había conocido al Dr. Ricardo Sánchez [poeta y activista chicano] desde hacía mucho tiempo. El vio mi trabajo. En ese tiempo él estaba muy involucrado en el Movimiento. Vino a la casa. Me hicieron entrevistas, observaron mi trabajo y poco a poco me fueron dando a conocer. Bert Salazar, que escribía

para el *Herald-Post* de El Paso, comenzó a escribir algunos artículos. Poco a poco el Movimiento me fue absorbiendo, debido a la naturaleza de mi trabajo.

Poco después, se consideraban mis pinturas pertenecientes al Movimiento, a la gente, a La Raza. Y nuevamente, por medio de Ricardo Sánchez, conocí a muchos estudiantes de UTEP. En ese tiempo, ellos eran parte de MEChA. MEChA me proporcionó los elementos materiales para que montara mi primera exposición. Yo tenía cuarenta y ocho años. Esta primera exposición se realizó en el Museo Centennial de UTEP.

Para mi sorpresa, este trabajo se consideró arte rebelde.

Abrimos la exposición un domingo por la tarde. Según todos los pronósticos, se suponía que sería todo un fracaso, que nadie habría de ir. Pero ese día se sentó un récord. La asistencia me recuerda a CARA (Arte Chicano: Resistencia y Afirmación), porque supuestamente era un arte muy impopular. Con todo, la asistencia fue de más de 300 personas. De ahí en adelante, me invitaron a exponer en la Universidad de Nuevo México, en la de Colorado en Boulder y otras. Comencé a recibir invitaciones para entrevistas, artículos y esto y lo otro. Todo fue casi instantáneo. De ese momento en adelante estuve comprometido con el Movimiento.

He hecho pinturas del Segundo Barrio. Tengo una pintura de carros chicos, las ranflitas que existían en ese tiempo. Así suceden las cosas. Yo estaba allí y creo que me topé con el Movimiento Chicano en el momento oportuno. Conocí y me hice íntimo amigo de Reies López Tijerina, uno de los líderes del Movimiento. Llegué a formar parte del Movimiento y asistía a las conferencias. Todo estaba en la naturaleza de mis pinturas.

El primer mural que pinté fue el de la Bowie, *Mesoamérica*. Candelario Mena me comentó que los Boosters de la Bowie querían un mural mío en la ciudad porque yo nunca había hecho ninguno aquí en El Paso. Como se acercaba la fecha del Bicentenario, pensaron que Bowie sería un buen lugar para hacerlo. No sé cuántos problemas hubo para obtener el permiso del patronato de la escuela, pero los Boosters de la Bowie superaron los obstáculos y consiguieron el permiso y el muro, y yo comencé a pintar el mural.

Ni que decir que me corrieron de Bowie un par de veces, porque los maestros no estaban de acuerdo conmigo—un día, por poco me echan físicamente. Lo que querían era suspender la pintura del mural. Entonces llamé otra vez al Sr. Mena y él se puso en contacto con el director. Hicieron una junta y discutieron el asunto. Total, ya no me volvieron a molestar.

No tuve ya problemas para terminar el mural, pero como ya dije, en ese tiempo casi no había activistas ni artistas chicanos en esta región. Había artistas méxico-americanos, pero no artistas tan rebeldes, creo yo. Así que me parece que yo era el único aquí en El Paso. Bueno, yo no debería decir esto, pero me prometieron muchas cosas si hacía el mural. No me cumplieron nada. Tan sólo lo pinté y lo doné a la ciudad, como regalo. Nunca me dieron un solo centavo por hacerlo. Sin embargo, es algo que los muchachos aprecian y les gusta. Les gusta tenerlo en su escuela.

El segundo mural que pinté, *La Resurrección*, fue en la Iglesia de San José en Houston. Esta iglesia tiene alrededor de 100 a 150 años y también está en el Sexto Barrio, algo así como el Segundo Barrio aquí en El Paso. El padre [Samuel] Rosales, a quien yo ya conocía, estaba a cargo de la iglesia. Yo había conocido al Padre Rosales aquí en El Paso porque yo era el jefe de sus exploradores (boyscouts). Durante casi ocho meses estuve volando de El Paso a Houston todos los viernes. Iba y pintaba todo el fin de semana, regresaba los lunes ya tarde o los domingos, y trabajaba el resto de la semana en Fort Bliss. Así es como el mural se realizó. Hace dos semanas me informaron que el mural de San José se había destruido. Por alguna causa, le había caído agua. Todo el techo quedó destruido. No creo que hayan podido conseguir fondos para restaurarlo.

En el Centro de los Veteranos pinté otro mural. Ese fue el primer trabajo que hice por encargo. El UVO, o sea la Organización de Veteranos Unidos, me lo encargó. Ya se había abierto la nueva clínica para los veteranos en El Paso, así que faltando poco para la apertura quisieron algo que conmemorara y honrara de forma oficial a los héroes de El Paso que habían muerto. Lo que quiero decir por héroes son aquéllos que han recibido la Medalla al Honor que otorga el Congreso. Nos encontramos con que Ambrosio Guillén, William Deane Hawkins y Benito Martínez, de Fort Hancock, habían perdido la vida en las guerras y se les había concedido la Medalla al Honor. Creo que fue un buen tributo para ellos. En 1993 o '94 el Centro Médico del Ejército William Beaumont será trasladado a otro lugar. Probablemente destruyan el mural. He hablado con algunas personas y ellos me dicen que el mural podría separarse de la pared, aunque está pintado directamente sobre ella. Creen, sin embargo, que costaría más de 25,000 dólares.

Pinté dos murales más, por encargo del estado de Nuevo México. Esto fue para una competencia nacional de arte. Yo fui el encargado de hacer los dos murales para el estado de Nuevo México. Están localizados en el Hospital del Centro de Administración para Asuntos de Veteranos, en el poblado de Truth or Consequences. Esos son más o menos los murales que he pintado.

Este es el último. En éste me comisionó la Junior League. Fue hecho para conmemorar a las víctimas de la Guerra del Golfo. Se pintó en Fort Bliss dentro del gimnasio Stout. Que conste, el que diga que estoy glorificando la guerra en este mural es un cobarde.

Y lo puedo repetir las veces que sea necesario. Este es mi sentimiento personal. Lo siento desde lo más profundo de mi ser, porque yo soy un ex combatiente. Luché en la guerra, en Europa, en una de las más famosas divisiones, la División de Infantería 104, la "Lobo Gris".

Siempre es bueno tener fondos y dinero disponibles. Los artistas somos humanos y tenemos que comer también. Tenemos necesidades, necesidades materiales. Necesitamos pinturas, pinceles. Creo que si una organización como la Junior League aporta esos fondos, aunque sea en pequeñas cantidades, estarán haciendo una cosa muy importante, porque puedes crear. Pero si no dispones de dinero para comprar los lienzos o no tienes dinero que despilfarrar—como cuando yo estaba pintando, en realidad estaba tirando el dinero que usaba para pintar; se lo estaba quitando a mi familia, porque yo tenía que darles de comer, a mi esposa, a mis hijos, pagar la renta, pagar la gasolina. Y muchas veces lo hacía en lugar de ir a comprar un tubo de pintura o un lienzo.

A menos que tengas un patrocinador, no puedes desarrollar gran cosa tu arte. Así ha sido siempre, a través de los tiempos. Como Lorenzo el Magnífico en Italia,[67] que proporcionó los fondos, los medios, las oportunidades para que florecieran muchos de los más grandes artistas del mundo—entre ellos Miguel Angel. También [José] Vasconcelos en México, quien facilitó los fondos para la realización de los murales, para los gigantes del muralismo mexicano: Siqueiros, Orozco, Rivera. Creo que hay que financiar a los artistas.[68]

Y como cualquier artista, cualquier ser humano, creo que es de suma importancia que se aprecie tu arte. Sin embargo, es mejor que aprecien tu arte apoyándote con dinero. Desafortunadamente, se cree que el artista está allí para pintar por cualquier cosa que le quieran aventar, que su trabajo no vale nada. Si llamas un electricista, un carpintero, te cobra cientos de dólares y tú gustosamente le pagas. Pero si llamas a un artista para que te haga un trabajo, desgraciadamente, la mayor parte del tiempo quieren que lo haga gratis. El pobre hombre tiene que comer. Tiene que tener el aliciente para seguir adelante.

Mi sueño dorado es realizar algunas obras por encargo. Me muevo tan fácilmente en el campo del mural como en la pintura de caballete. Se me está acabando el tiempo. Estoy llegando rápidamente a los setenta años, y cada vez me cuesta más trabajo subirme a los andamios o tener que pintar al ras del suelo, o lo que sea. Creo que con el tiempo tendré que dedicarme más a la pintura de caballete, pero todavía sueño con pintar tres o cuatro murales más. La mayor parte de mi vida he trabajado, ya sea sin paga o con muy mala paga. He tenido que luchar con cada Fulano, Zutano y Mengano para que me paguen mis comisiones. Como cualquier artista, tengo mis sueños. Sueño con que quizá algún día pueda vender mis pinturas a buen precio. Tal vez antes de la partida, me gustaría

pintar uno o dos murales y dejarles el campo libre a los nuevos artistas que van surgiendo. Eso es otra cosa: hay artistas y hay muralistas y además hay artistas y muralistas combinados. Si les abres el campo sólo a los muralistas ¿qué pasa con los pintores que no pintan murales? Me parece que es como si los estuviéramos ignorando. También tenemos muchos buenos artistas que por una u otra razón no quieren emprender la tarea de pintar murales, pero no los debemos olvidar. Debemos ayudarlos.

Mago Orona Gándara
Entrevistada por Mike Juárez
Escuela Primaria Douglass, El Paso
9 de junio de 1993

¡Ah, jijo! ¿Así que quieren que hable de murales? ¿Podría hablar solamente sobre mi trabajo y mis ideas? Eso me interesa más. ¿A quién le importa adónde fui a la escuela? Ya no importa. Alrededor de 1965, había yo deseado fervientemente pintar un mural, pero no había dinero ni comisiones. Hacía mucho que me había retirado de la enseñanza, y además estaba criando una familia y he aquí el resultado: un cheque de jubilación del magisterio. Bueno, con ese dinero compré paneles de madera, madera aglomerada y bastidores. Hice doce paneles de cuatro por seis pies cada uno. Las secciones de este tamaño serían fáciles de manejar. Así que decidí comisionarme a mí misma para pintar un mural.

En aquel tiempo, yo había hecho un viaje a México y había visto a los grandes maestros, no en un estudio a fondo, sino brevemente. Había visto a Orozco, a Siqueiros, un poco a Diego Rivera. Sin embargo, Orozco y Siqueiros me fascinaron por la audacia de sus formas y sus movimientos. Eran trazos audaces, hechos sin temor, y eso me inspiró mucho. En ese tiempo yo estaba experimentando un gran cambio: estaba tratando de romper con la terrible y amenazadora enfermedad del catolicismo, bajo el cual había sido criada y educada. Quería cambiar a una visión más humanista de la vida, de Dios y de la creación dentro de la humanidad, en lugar de este horrible miedo que había padecido desde pequeña. De modo que en realidad tuve un colapso nervioso, y mi sentimiento de culpabilidad fue parte del colapso. Así que quería liberarme a mí misma, y la forma de liberarme fue pintar un mural.

Yo había escuchado la *Missa Solemnis* de Beethoven y luego el Credo que se rezaba en la iglesia católica. En ese tiempo era un credo muy estricto; ahora es más liberal. Escuché el Credo de Beethoven en su *Missa Solemnis* y eso fue para mí una perfecta arquitectura de la humanidad. Su obra me apantalló y comencé a vislumbrar una esperanza para esta religión opresiva, hacia un sistema de vida más humano que nos llevaría a la salvación, no sólo en el otro mundo, sino seguramente la salvación en este mundo. Con todo eso en mente, me dediqué al dibujo de modelos durante un año. Dibujar modelos, dibujar a la gente en acción, estudiantes de preparatoria practicando lucha libre, salto de garrocha, cualquier cosa hasta que me sintiera preparada.

Cuando creí que estaba lista, me encontré un viejo teatro que estaba vacío—esto fue en California—y era el sótano de un teatro que había sido abandonado. Así que con el dinero que recibí por mi jubilación de maestra, lo renté por 25 dólares todo el verano. Estaba encantada porque era lo suficientemente grande para que cupieran mis paneles. Este realmente fue mi primer mural.

Coloqué 10 ó 12 paneles de cuatro por seis pies, como ya todos tenían el apresto. Había preparado mis bocetos con anterioridad. Hice un esbozo del proyecto a la acuarela, pero no hice ninguna cuadriculación. Cuando entré al cuarto sentí tanto miedo que no me pude quedar. Salí corriendo; me moría del miedo tan sólo de ver todos esos paneles blancos. Así que me dije: esto no va a funcionar. Mientras tanto, tenía que buscar a alguien que se hiciera cargo de mis niños para venir a hacer esto.

Lo único que tenía en ese entonces era pintura acrílica para casas. No creo que en ese tiempo en California hubiera en las tiendas pintura acrílica para artistas. Así, pues, tenía mis pinturas en grandes galones de plástico y un montón de pinceles. Entonces sumergí el pincel en el violeta, un violeta muy pálido. Embarré todos los paneles y dije: bueno, ahora sí ya los arruiné. Ya puedo comenzar a pintar. Es la forma en que lo hice. Estaba muerta de miedo. De ahí empecé a trazar con el pincel, a trazar las figuras, a sentir su movimiento, a sentir su amor y su inquietud y su deseo intenso de vivir, el elogio a la mujer y la fe en Dios, el Creador que es parte de la humanidad, no el Dios vengador que sólo busca castigarnos. Y el mural entero se fue realizando en esa forma. Lo hice muy despacio. Todavía lo tengo y estoy muy orgullosa de él.

Las figuras quedaron esbozadas. No me gustan las cosas terminadas hasta el grado de que se vean tiesas. En mi opinión, muy pocos artistas pueden terminar una figura y conseguir que retenga la expresividad de sus gestos. Yo prefiero retener el gesto. Ese es uno de mis rasgos distintivos. Me encanta el movimiento. Me fascinan los gestos y no me voy hasta el detalle infinitesimal porque, para mí, se destruye la espontaneidad del trabajo original. Tengo el mismo sentimiento respecto al color. Así que no sólo es un credo religioso, sino que llegó a ser primordial para mí. Y por supuesto, no fue para nadie más. Todavía tengo ese mural amontonado en la casa, y de vez en cuando lo saco. Es bueno. Creo que es bastante bueno.

Aparte de eso, estaba tan inspirada con Beethoven. No lo toco cuando estoy trabajando. Escucho su arquitectura. El, para mí, es un maestro de la arquitectura. Crea espacios. Hizo algo en aquel entonces que casi no se hace hoy en día. Se detiene en la mitad de algo y deja un espacio. Tú crees que la cosa ya se terminó, pero es un espacio. ¡Qué maravilla! ¡Imagínatelo en aquel siglo! Entonces pinté lo siguiente a partir del "Credo", que es una misa en latín y se llama "Agnus Dei" o "El Cordero de Dios". En este caso, yo andaba buscando un Dios de misericordia y así lo pinté. Creo que es el mejor mural que he hecho en mi vida. Se compone de nueve paneles, de cuatro por seis, pero puestos de lado en filas de tres por tres por tres.

Por aquel tiempo, en California, había unos terrenos que estaban reparando, pero en mi opinión, más bien los estaban destruyendo con esas enormes motoconformadoras que se veían como grandes dinosaurios. Me inspiró dibujarlas. En lugar de dibujar la figura humana, dibujé la máquina humana. Me fui a un deshuesadero de carros, pero en realidad era un depósito de maquinaria hecha chatarra. Me senté en las ruedas y me subí adentro de las máquinas. Los dibujé hasta que sentí que ya estaba lista.

El otro mural, *Credo* (1965), tiene tonos muy apagados; éste tiene acrílicos muy brillantes. En ese tiempo, el acrílico artístico estaba de moda. Lo hice con la misma técnica. Colgué los paneles, sin cuadriculaciones ni calcos. Eso sí, [ya había hecho] un montón de estudios previos. Reprimí el impulso de decir: yo no quería decir, sino descubrir y dejarme llevar. Desgraciadamente, tuve un accidente y se quebró, pero voy a tratar de repararlo.

Pinté la obra después del *Credo*. Debe haber sido 1965, '66, '67, tal vez tres años después del *Credo*. Me tomó un año o dos prepararme para el trabajo. Ahora es un poco diferente. Me preparo con toda la experiencia previa, incorporándola al nuevo trabajo. Pero entonces yo era, después de todo, una principiante. Es un trabajo muy audaz, muy musical, muy bueno, realmente brillante.

Por ese tiempo me mudé de California para acá y tuve que enviar todas aquellas cosas. Y allí anduvieron rodando. Conseguí todas mis cosas de Chicago y tuve que venir sentada en ellas para poder traérmelas. Ahora, pinto en las paredes para no tener que guardar las pinturas. Para este tiempo, decidí ya no estar casada, aunque tenía conmigo a tres de mis cinco hijos. Los otros dos vivían ya por su cuenta.

Me enteré por otro artista—seríamos tan grandes aliados si lo deseáramos, si no peleáramos con envidia e intolerancia y no nos echáramos unos a los otros, eso es muy peligroso; sin embargo, si nos ayudáramos unos a otros, podríamos todos crecer y a la vez, conservar la individualidad—, un artista me dijo: Mago, hay una subvención en el Colegio Comunitario de El Paso, una subvención a nivel nacional, no me acuerdo como lo llaman, y necesitan un proyecto desorbitado. Yo dije: Bueno, tengo uno. Así que me armé de valor y dije que tenía una idea. Nunca pensaron que lo haría. Dijeron, bueno póngalo por escrito para que podamos conseguir el subsidio. Lo puse por escrito y consiguieron el subsidio. No sabían lo que yo estaba haciendo, no tenían ni la más remota idea. Gracias a Dios, o nunca me hubieran dejado hacerlo.

Tuve también este enorme, monstruoso mural [*Tiempo y Arena*, 1978], para el que me inspiré en la arena del desierto, porque en ese tiempo el Colegio estaba en Fort Bliss [el campus de Logan Heights] y lo único que había era arena. Me preguntaba qué podría yo hacer con arena. Bueno, mojé la arena y lo que hice fue grabar en ella. Dibujé mis diseños. Tampoco esta vez hice cuadriculaciones ni calcos. Me encontré, en el depósito de la basura, donde había hasta alfombras, unos rollos enormes de papel estraza. Así que me fui

al Colegio Comunitario, que sólo eran barracas, y en un domingo me acabé el espacio, de tan grande que era el mural. Pegué el papel estraza en la calle, agarré un gran lápiz y comencé a dibujar, allí mismo. Ahora que lo veo en retrospectiva, me horroriza mi audacia.

Era como una ciega. El mural era tan grande que no podía verlo, sólo sentirlo. Así es que, después que hice los dibujos, los recorté. Eran formas individuales. Ya había yo dado un gran salto. Después de todo, había estado estudiando la maquinaria contemporánea. Había ido al futuro para tomar ideas computarizadas—bueno, en realidad no; eso fue después. Decidí trazar estas formas en la arena. Quería que fueran como si una computadora hubiera tomado nuestras emociones humanas más básicas, todo nuestro universo, y las hubiera transformado en formas.

Esa era mi idea. Estaba dando el primer paso para alejarme de la figura humana directa. Esta idea la introduje como un curso de Arte Chicano en el Colegio Comunitario. Todavía se pensaba que yo no la iba a hacer. Hasta que consulté con el arquitecto—vino al campus y observó lo que los muchachos y yo habíamos estado haciendo allí. A él realmente le gustó y le dijo al que era el presidente en aquel entonces, el Dr. [Alfredo] de los Santos, quien para ese tiempo ya estaba quemado, destituido, y quién sabe qué más. Había mucha agitación política. Los murales, aún los más inocentes, siempre están involucrados con la agitación política, con la revolución, con el cambio.

Sin embargo, tengo la carta donde el arquitecto David Hilles le dijo al Dr. de los Santos: "Este mural debe estar en la nueva escuela". Estaban construyendo un campus nuevo en Valle Verde. Con ese estímulo nos pusimos a vaciar aquellas piezas. ¡Eran enormes!

En ese tiempo yo desconocía los materiales ligeros, así es que armaba las formas con estructuras que me hacían en un taller automotriz. Entonces, un artista amigo mío, de California, que es escultor pero también un genio de la física, me ayudó a diseñar las armazones de forma que sostuvieran bien todo el sistema. De ahí nos comenzamos a sentir más animados. Esto duró tres años. Y cada clase, como el Santo Grial, nos trasmitían esta idea, y ellos [los administradores] todavía no creían que yo fuera a lograrlo.

Decían, ¿quién es la loca que está jugando en la arena con los estudiantes? ¡Córranla! Tengo los diarios que escribieron los estudiantes.[69] Tengo los archivos completos de toda la obra. Allí están, arrumbados en un closet de mi casa. Los [archivadores locales] no parecen quererlos, pero allí están. Cuando el Colegio estuvo listo, el arquitecto nos dio carta blanca para escoger el lugar donde sería empotrado el mural a la pared. Había dejado una pared de doble espesor para que pudiera sostener el mural.

En ese momento, cuando íbamos a mover el mural desde la arena en Fort Bliss hasta el campus de Valle Verde, recibí una llamada telefónica y el jefe de mantenimiento me dijo:

Mago, no queremos tu mural. Tenemos sillas, escritorios y un chorro de cosas que hacer. Esto no me hizo ninguna gracia, después de tres años de un trabajo durísimo, hecho con amor y paciencia, de estímulos y fracasos y mucha reconstrucción. Construimos ese mural tres veces antes de que quedara bien, y es enorme.

De alguna manera, los espíritus siempre me cuidan, Dios o este creador infinito, me cuida o esta potencia de creación —comoquiera que lo llamemos—y siempre se aparece como mi guía. En ese momento había un hombre de San Francisco, un hombre chaparrito que lucía como un jipi, pero era un hombre de edad, no un joven. El se convirtió en el enlace entre los arquitectos y la escuela. Así que siempre decían: "Vaya y hable con él". Hice una cita y llevé mi maqueta. Los estudiantes me ayudaron con la maqueta, que estaba hecha de pequeños pedazos de papel de lija; era muy hermosa y él la vio. Yo miré a ese flaquito con un chorro de collares y dije: "¿Y ahora qué?" El se limitó a mirarme—en ese momento yo ya estaba muy desanimada. Pensé que ya todo estaba perdido. El se me quedó viendo y me dijo: "Mago, se va a levantar el mural".

Así es que fue y luchó por mí. Fue a Mantenimiento y dijo: "Esta obra se va a levantar. ¡Quítense del camino!" De modo que conseguimos grandes plataformas de trocas y las llenamos de arena. Yo tuve que dirigir la cosa. Tuve que realizar personalmente la idea. Con la ayuda de ocho o diez hombres a un tiempo, tuvimos que levantar cada forma, ponerlas en la cama de arena, traerlas al campus a través de toda la ciudad y descargarlas, apilarlas y prepararlas para colocarlas en la pared.

Tuvimos que hacer tres o cuatro viajes. Fue tremendo. Es una de las cosas más espectaculares que he presenciado en mi vida. Y todavía no sé, hasta el día de hoy, cómo tuve las agallas para realizarla.

El mural comenzó a levantarse. Un escultor de California se ofreció para dirigir el levantamiento. Inventó unas abrazaderas increíbles para sostener el peso sobre la pared. Yo había inventado unos tubos que atravesaran la obra. Precisamente íbamos a atornillarlos cuando él inventó las abrazaderas. Todavía está en pie, es fantásticamente fuerte. Todos dijeron: "Se va a romper, se va a caer, está loca, no sirve". Todas estas cosas para animarte. Erigimos el mural. Yo lo dirigí. Trazamos donde quisimos las formas y las ajustamos y cuando estuvo terminado, mis amigos ya se habían ido y yo estaba sentada en el porche, exhausta, y estaba sentada allí una noche y tuve la más horrible sensación. Me sentía terriblemente enferma y no sabía por qué. En ese momento, sin yo saberlo, se reunió un comité sin el rector del Colegio y dijeron que querían derribar el mural, que no servía. ¡Imagínate! Bueno, fueron los de mantenimiento los que me vieron trabajar en esto, a mí y a mis estudiantes, y dijeron: "No lo vamos a tirar. Sabemos lo que costó levantarlo; es demasiado pesado. Sabemos lo que ella ha hecho y no les vamos a ayudar a tirarlo". Así que se salvó. Y allí está el día de hoy y es magnífico, simple y sencillamente magnífico.

El hombre que quería tumbar el mural me hizo firmar un contrato en el que se decía que yo no podía pedir ningún dinero por ese mural, lo cual es ridículo, puesto que se me habían pagado 265 dólares mensuales porque yo estaba dando clases. Me estaba muriendo de hambre, literalmente estaba hambrienta. Me hicieron firmar ese contrato. El se fue. Lo corrieron—era una mala persona. El muralismo siempre llega a ser una competencia entre el bien y el mal. No sé por qué. Somos como una fuerza espiritual al descubierto; asustamos a la gente.

Pero ellos ni siquiera quisieron una inauguración. Cuando iban a inaugurar la escuela les dije: "Oigan, estos estudiantes hicieron esto y se les debe informar y se les debe dar reconocimiento". Se suponía que iban a ponerse en contacto con los estudiantes, pero no lo hicieron. Hicieron algún tipo de inauguración. Dijeron: "Mago está aquí. Ella pintó el mural." No hubo un reconocimiento real, no hubo honores.

Años después, daba yo una clase en la Universidad Autónoma de Ciudad Juárez, por medio de la oficina de Programas Internacionales del Colegio Comunitario. Me dijeron que trajera a mis estudiantes del colegio para un banquete. Así lo hice. Y fíjate cómo marchan las cosas en tiempo diferido, en el tiempo de Einstein. Estaba sentada cuando van entrando todos estos meseros con charolas llenas de comida. Yo no sabía de qué se trataba, pero nos estaban honrando a mi mural y a mí. En español el hombre dijo: "¡*Este no es un mural, es un muralazo!*"

Me llevó casi seis años (1982) conseguir que alguien reconociera la enormidad de esta obra y lo que significa su presencia. Hasta la fecha, [el Colegio] no les ha permitido a los diarios que se presenten, ni que se presente la maqueta, para dar una explicación al público. Le hacen caso omiso. Puedes ir a Stanford y obtener miles de dólares para material de archivo y aquí ellos ni siquiera lo aceptan. A lo mejor lo envío a Stanford. A lo mejor se interesan y puedo obtener una buena tajada, si son lo suficientemente tontos para desdeñarlo.

Después de *Tiempo y Arena* recibí la comisión para pintar un mural en la pared de adobe que fue construida por Mac Caldwell [en 1980 en la esquina sudeste de Paisano y Piedras]. Construían el Edificio de Energía Solar [hoy Centro Ambiental]. Yo siempre escojo mis paredes. Me dicen que pinte una pared y yo voy y la escojo. No tomo cualquier pared; la pared me tiene que hablar y esta pared era magnífica porque parecía tener forma humana.

Así que diseñé y pinté un mural [*Señor Sol*, 1982-83], y esta vez, en lugar de sólo insertar pedazos de vidrio en la arena fui un paso más allá y comencé a usar cualquier material que encontrara. El presupuesto para materiales era muy bajo, así que utilicé vidrio, losetas, conchas, alfarería, lo que fuera, e hice una sola figura grande. Este fue un nuevo escalón para mí. En lugar de muchas figuras,

yo quería una figura individual que tuviera el poder, o que pudiera interceptar el poder, para transferir lo bueno de la divinidad, la belleza, porque casi siempre es el individuo de agallas el que puede hacerlo, no la masa. Quería rendir tributo al individuo. Ese fue un nuevo paso para mí; había progresado.

Desde entonces, estoy pintando este mural [*La niña cósmica*, 1993]; se encuentra exactamente en medio de una escuela para niños pequeños. Les hice algunas insinuaciones a los administradores; quería formar un programa para aprendices, pero ellos castigaban a los estudiantes. En lugar de dejarlos asistir a mi clase para que mejoraran, los castigaban por cualquier otra cosa y los sacaban de la clase.

Pero todo esto es progreso, se lleva tiempo. Ahora comienzan a entender. Una vez más, un mural hace explosión con sus ideas, con su tamaño mismo. Pero aquí de nuevo había avanzado un paso más—tenía suficiente dinero para materiales, así que decidí retarme a mí misma y hacer vidrio, loseta y mosaico. Y aquí lo ves, Mike, va progresando y se va logrando. Es muy cinético y energético y es el tema de una Niña Cósmica, una niñita más o menos de la edad de los niños de esta escuela, que lleva en ella toda la cultura que es nuestra: la cultura precolombina, la luna, el sol, la guerra de los planetas, la guerra entre el bien y el mal y el valor de ciertos poderes para avanzar con el bien. Ciertamente lo necesitamos con el drama que hoy en día se desarrolla en el ambiente chicano y nuestra cultura chicana. Toda nuestra forma de vida va a ser o magnífica o vamos a empezar a matarnos y a destruirnos unos a otros.

Así que ella está aquí para recordarnos, para recordarnos que estamos muy por encima de eso, que tenemos maravillosos poderes infinitos y que somos muy bellos. También lo hago porque me gusta. Hay mucha filosofía en ello, pero tuve la intención de hacerlo en esta pared y pienso hacerlo para comunicárselo a los niños.

Así que se acabó. Ya no quiero hablar, ya apágale.

Lupe Casillas-Lowenberg
Entrevistada por Mike Juárez
Centro Mercantil del TLC, centro de El Paso
20 de junio de 1993

El mural en Sunland Park [*La aparición de la Virgen de Guadalupe*, 1981] evolucionó a partir de una clase de la escuela preparatoria Gadsden en Anthony, Nuevo México. Querían hacer un proyecto en la comunidad. Por lo visto, los muchachos más talentosos vivían en Sunland Park. Gloria Irigoyen, entonces una estudiante, habló con los dirigentes de la iglesia de San Martín de Porras acerca del proyecto. Su madre trabajaba en la iglesia. Vivían allí en Sunland Park, y era una comunidad muy solidaria. Les dije que podíamos pintar un mural si conseguíamos un muro. Les preguntamos a todos los de la comunidad qué querían en el muro, y por supuesto todos querían Nuestra Señora de Guadalupe. El diseño fue creado por los estudiantes, Roberto Salas y yo. Todos trabajamos en él, incluyendo a Bobby Salas, que por casualidad se encontraba entonces en el lugar. El se convirtió en mi asistente y, para los estudiantes, en un importante modelo a imitar. Yo hice los rostros de Juan Diego y la Madre Santa. Nueve años después, volví a pintar el rostro de ella. Había unos 15 muchachos, y realizamos el trabajo durante las vacaciones navideñas de 1981.

El muro estaba en buenas condiciones porque estaba hecho de bloques de hormigón. Limpiamos el muro y rellenamos los hoyos. No teníamos mucho dinero, pero hicimos la imprimatura y le aplicamos sellador. La pintura fue donada por Hanley Paint. Utilizamos esmaltes acrílicos, un sellador polivinílico y un tapaporos. Estaba a prueba de la intemperie. La pintura tenía garantía de 50 años. Usamos el andamiaje del Sr. Irigoyen. La gente del Big 8 en la calle Doniphan nos regaló fruta, y los residentes del barrio nos preparaban burritos. Hacía un frío helado. Tardamos dos o tres semanas en terminarlo, trabajando todos los días de seis de la mañana hasta muy entrada la noche. Creamos más diseños, y Bobby y los estudiantes pintaron las canchas de rebote, pero eso fue después de que él había trabajado conmigo. Aunque nunca había creado murales, hizo muy buen papel, magnífico, porque ahí estaba dándole ánimo al grupo, porque era más bien un proyecto de grupo, una labor colectiva y no individual.

En otra ocasión mis estudiantes y yo pintamos diseños originales en el interior de un restaurante. Las pinturas incluían diseños de los indígenas norteamericanos, y trabajamos de nuevo con los mejores materiales, con los mejores estudiantes, para crear estos murales. Todos los veranos, en colaboración con el programa migratorio, pintábamos murales con los niños. Pintábamos paneles

de 4 por 4 pies, ilustrando cuentos que ellos escribían. También creábamos enormes murales en la escuela primaria Sunland Park, incluyendo uno intitulado *La leyenda de los volcanes*. Fue una obra maestra. Eran murales portátiles, pues íbamos a las escuelas y relatábamos las historias con la ayuda de los murales.

A pesar de que los muchachos eran católicos, no sabían la historia de Nuestra Señora de Guadalupe, así que aprendían acerca de la iglesia y cómo funcionaba. Se erigió una cerca alrededor del mural hace aproximadamente cinco años; es algo sumamente extraño. Antes la gente podía acercarse al mural en carro por la noche e iluminarlo con los faros del coche, pero al poco rato alguien salía a ver qué estaban haciendo, pues tenían muchos deseos de proteger al mural.

Siempre me he relacionado con los muchachos en situaciones de aprendizaje práctico, y por eso los murales son fabulosos. En la preparatoria Coronado habíamos un grupo de estudiantes que hacíamos murales portátiles para ilustrar las historias que leíamos. Una de mis antiguos estudiantes fundó un negocio en Dallas llamado Sticks and Stones and Ice Cream Cones (Palitos, Piedras y Barquillos de Nieve), un nombre muy raro. Ella viaja por todo el mundo creando murales, y esto es algo que aprendió en la prepa. Siempre me he dedicado a hacer obras a gran escala sobre masonita o grandes lienzos estirados. En todos los lugares que he trabajado he producido murales creados para las escuelas, los chicos y sus comunidades.

En una época yo tenía un estudio en la Cervecería Falstaff [ahora Brewhouse] y otro en el centro. Vivía en las habitaciones de los bomberos, en el segundo piso de una casita de madera. A mí me interesan los estudiantes, enseñar en la comunidad y concientizar a la gente sobre lo que es el arte. Estoy dispuesta a trabajar con cualquiera, con todos. Crear arte es una participación dinámica; no es uno simplemente un espectador pasivo. Cuando uno crea arte, hay una conciencia del medio ambiente: es emoción, una acción espacial y espiritual con respecto a un público o una comunidad. Lo importante es la relación que existe entre los dos, la interacción mutua a cada paso del desarrollo de la obra.

Yo creo que el arte fue creado por Dios para permitirnos utilizar ambos lados del cerebro y comunicarnos con nosotros mismos en un plano superior, vincularnos con la fuerza creadora y continuar el proceso de la creación, no la destrucción, y gozar del sentido de la felicidad de la vida cotidiana. Si no me dediqué a crear más murales fue porque en realidad no había fondos. Yo tenía que poner todo de mi parte. Tenía que estudiar el muro, prepararlo, trabajar con los muchachos, enseñarles. Yo era joven y tenía mis propios hijos, a los que no podía dejar solos. Con frecuencia, ellos participaban en mis proyectos. Yo tenía que trabajar tiempo completo para poder mantener a mi familia, y a mí me encantaba la enseñanza. Me hallaba limitada por las circunstancias de mi vida. Ahora no me arrepiento. Tengo libertad. Soy joven y sana todavía y puedo crear murales. He influido en varias personas que han

pintado murales, entre ellos Becky Bencomo, Susie Kratzer Davidoff, Karla Fausto, Hal Marcus, Irene Soto—y hay muchísimos más que todavía trabajan en las artes, pero todos empezaron conmigo en la preparatoria Coronado. Me parece que si puedo enseñarle bien a alguien, y si esa persona puede enseñarle a su vez a otros, entonces sé que ha aprendido lo que quise inculcarle. Ahora mis sueños se vuelven realidad. Ahora puedo pintar un mural y puedo hacerlo yo sola o junto con mis estudiantes de la comunidad.

Me parece que la razón por la que no ha habido más participación por parte de mujeres en este campo es que no se les ha dado capacitación. Yo no tuve capacitación en UTEP. Entonces había un curso de tres créditos sobre el arte mexicano, y el profesor nunca había visitado México. Por fortuna, mis padres me llevaban a México durante los veranos y me permitían trabajar con muralistas restaurando sus obras. En Guadalajara, ayudé a muralistas en detalles, mezclando la pintura o ayudando en general. También aprendí a esculpir, metiéndome de aprendiz con Militón Salas, que tallaba en piedra. Aprendí a tallar la piedra. Yo trabajaba en todo lo que me permitieran hacer, y me mantenía muy humilde. Tomaba el autobús para llegar a los lugares donde había que trabajar. Comía lo que comían los demás. Asistía a cursos de verano en la Universidad de Guadalajara y trabajaba allí.

Cuando mis hijos eran chicos, los dejaba con una persona que los cuidaba y me matriculaba en clases de dibujo. No tenía un plan formal. Si no fuera porque Dios me ayudó y por el hecho de que mis padres son de México y nos enseñaron nuestra cultura, yo no habría desarrollado mi obra. Nuestros padres nos llevaban a todas partes en México—cada mar, cada lago, cada parque, cada museo, cada santuario y cada iglesia—y a nosotros nos encantaba porque alimentaba nuestro espíritu. Aprendimos acerca de la historia de México a través de los murales de la Revolución mexicana. Y a mis padres les dio mucho gusto y mucho orgullo enseñarnos la historia mexicana.

Soy madre, maestra y miembro de la comunidad. ¿Qué puedo hacer yo para que la comunidad sea mejor, un lugar más emocionante y lleno de significado para los niños? He participado en numerosos proyectos fuera de la comunidad para los cuales nunca recibí ningún pago, pero mis muchachos aprendieron mucho y pude compartir mis habilidades. Siento que una parte de mí está en Sunland [Park]. Parte de mí está en Mesquite y parte en San Miguel [Nuevo México]. Parte de mí está con cada estudiante, y a cada estudiante lo llevo dentro de mi ser. No tengo queja alguna. En cuanto al ser mujer y pintar murales, es duro porque es difícil mover los andamios. Da miedo estar en lo alto de un andamio; hay que estar en muy buenas condiciones físicas para poder aguantar. Las limitaciones físicas son considerables.

Compadezco a Mago [Gándara] porque creo que no le han tocado las mejores condiciones de trabajo. Ha optado por trabajar con un medio que es difícil y requiere mucho tiempo. La aprecio. La quiero. Y he aprendido mucho de ella, pero digo para mis

adentros: yo no voy a hacer mi trabajo así. Me gustan el salón de arte, los estudios y algunos muros. Mago trabaja de modo diferente que yo, pero me parece estupenda. Otro ejemplo de una artista excepcional es Ysela O'Malley, quien ejerció también una influencia sobre varios artistas de El Paso.

Al crear el mural para el congreso Unite El Paso [1993], trabajé con Melvin Moore, un arquitecto local.[70] El diseñó un dibujo en blanco y negro, y nosotros agregamos el color. Las proporciones quedaron muy bien, considerando que querían que midiera 25 por 50 pies. Si me hubieran dado al menos un mes, tal vez habría pintado un mural mejor. Nos dieron cuatro días de plazo para pintar un mural de 15 por 25 pies, que en realidad era una obra de bellas artes.

Llevé a los muchachos a explorar los edificios [del Centro Cívico de El Paso] para que se dieran una idea de la inmensidad del lugar y sintieran la atmósfera que crea el lugar. Teníamos fotografías y un croquis cuadriculado a escala. Le enseñé a mi ayudante, Rosa Salazar, cómo seleccionar la gama de colores con los que íbamos a trabajar. No pude llevar a todo el mundo. Por lo general, llevaba al grupo entero porque necesitaban saber adónde ir y llevar el equipo, cuánto costaban los materiales, y por qué se usan algunos productos y otros no. Yo escogí los colores, calculé cuántos pies cuadrados cubría un galón, etcétera.

Cuando uno trabaja con estudiantes, no hay que utilizar los materiales más baratos. Se escogen los materiales más caros o mejores, porque si se comete un error, se puede corregir. Los mejores materiales no se rompen, no se deshacen. Así lo hacíamos. Algunos no habían pintado nunca. Fueron los alumnos que estudiaban diseño gráfico y sabían manejar las computadoras los que descollaron en esta ocasión. Un estudiante había mezclado pinturas anteriormente. Otro estudiante había trabajado en escenarios teatrales pero no había creado murales. Ni siquiera teníamos un lugar para pararlo verticalmente, porque los primeros dos días trabajamos en él sin estirarlo.

Trabajamos en el auditorio de la escuela preparatoria Ysleta. Yo trabajé tres noches y cuatro días, pero los muchachos estaban tan entusiasmados que llegaban a tiempo todos los días, y por la noche no tenían ganas de parar. En realidad, le dedicaron más horas de lo que ellos pensaban. Todos creían que no habría suficiente tiempo para terminar, pero les dije a los muchachos: "Yo tengo experiencia y les puedo decir cuánto tiempo llevará hacer un panel". No teníamos agua ni aire acondicionado, porque apagan el aire cuando cierran la escuela. Los muchachos se dieron cuenta de que eso de ser artista no es todo glamour.

No tengo dudas en cuanto a mi capacidad como maestra de arte, como artista, porque sé que puedo hacer el mejor trabajo y que puedo enseñar a la gente a hacer el mejor trabajo, y ahora he llegado a una coyuntura en mi vida donde mis sueños se están

realizando, y eso es hermoso. Y estos sueños pueden volverse realidad en El Paso. Yo no quise irme a otro lugar. Me gustaba aquí. Me gustó criar a mis hijos aquí. Espero que todo lo que he creado y que sea duradero, puedan verlo algún día mis nietos.

Lo que estoy haciendo se tiene que hacer de la forma correcta. Seguí un curso de pintura comercial, y hasta me afilié a un gremio de pintores, donde di clases. No conozco a muchos artistas que hayan hecho un esfuerzo así. Estudié la composición química de las pinturas y cómo mezclarlas y otras cosas. A las personas que trabajan conmigo les enseño a hacer esto de la forma correcta. El chiste es combinar la tecnología con el acercamiento tradicional a la creación de murales, el mensaje social, el contexto de la obra, todo esto, y tengo suerte porque puedo enseñarlo todo. Puedo conseguir que se comprometan los de la comunidad porque trabajo con muchachos de diversas partes de la ciudad. Trabajan juntos y les encanta. No ven al chico de la preparatoria Coronado como un presumido, sino como un buen trabajador. Y el chico de Coronado ve que el estudiante del Valle Bajo tiene el pelo largo y la tez morena, pero que es un artista fabuloso y muy inteligente y les gusta la misma música. Para mí, un mural representa casi una época de la vida. Es mi vida, comparto mi vida con ellos y ellos conmigo—una vida en comunidad. Y es así como uno desarrolla el sentido de comunidad.

Un filósofo francés dijo: "Si me das un pescado, comeré por un día. Si me enseñas a pescar, comeré por toda la vida." Y eso es lo que yo busco. El mundo artístico crea presiones sobre el artista: un criterio es la riqueza material, el premio del artista, pero la riqueza verdadera está en cómo se incorpora el artista a la totalidad integrada, a su propio yo, la moral, la ética y la vocación. Los que trabajamos en la comunidad colaboramos a beneficio de todos, para hacer el bien.

Me da gusto cuando reflexiono sobre mi vida como madre-artista-maestra y miembro de mi comunidad. Comprendo que ha sido una bendición el trabajar con toda la gente que Dios ha puesto en mi camino. No puedo hablar por los demás, pero yo he llevado una vida ideal. Mis hijos y yo experimentamos la vida juntos, con mis estudiantes, mis escuelas y mi comunidad. Las imágenes que utilizo están arraigadas en estas experiencias y se manifiestan en las respuestas creativas ante la existencia. No tengo las manos vacías, y sigo anhelando hacer más y mejores obras. Mi meta a largo plazo es lograr la superación.

Hoy en día, enfrentamos importantes cambios que afectan los paradigmas en que vivimos, y tendremos que solidarizarnos encontrando formas más creadoras y curativas dentro de nuestra cultura. Estoy de acuerdo con Charlene Spretnah su ensayo intitulado "Retejiendo el mundo", donde dice que debemos trabajar por la ecopaz, la ecojusticia, la ecoeconomía, la ecopolítica, la ecoeducación, la ecofilosofía, la ecoteología . . . Debemos sanar. Debemos conseguir el equilibrio.

El arte juega un papel crucial en ese proceso curativo. Nos tranquiliza, nos brinda oportunidades para experimentar lo nuevo, para crecer y volver a ser entes integrales. El arte proporciona ese equilibrio y nos devuelve nuestra integridad. Mas no conquistaremos solos esta integridad: únicamente al trabajar juntos podremos emplear el arte para hacer el bien.

Felipe Adame
Entrevistado por Cynthia Farah, Mike Juárez y Mona Padilla-Juárez
Clínica La Fe, El Paso
13 de julio de 1989

Yo soy diferente en el sentido de que no considero que las obras que he hecho sean propiamente mías. Todos los proyectos que he pintado en El Paso, con excepción de dos, han sido proyectos comunitarios donde un grupo de personas ha sido responsable por llevar a cabo las obras. Es cierto que yo fui el artista que pintó el mural, mas fue la comunidad en conjunto la que trabajó en el proyecto. Por eso quiero recalcar que todos los murales que he pintado han sido esfuerzos colectivos. La comunidad escogió el tema, el artista y el lugar—esa es mi filosofía al respecto.

Pinté mi primer mural en El Paso en 1981. He pintado murales en California, Colorado, Montana, Kansas, Washington, D.C. y México. Considero que los murales que he pintado son un medio para conservar la cultura, perpetuar una herencia y valorar el esfuerzo por parte de la comunidad que da impulso a una obra de arte.

Pinté murales en el Centro de Recreo Armijo. Estos proyectos fueron iniciados por los Thunderbirds, un grupo de personas de edad afiliadas al Centro Armijo, y Junior Robles, director de este centro. Robles fue quien me invitó a participar en el proyecto. El Departamento de Parques y Recreación del municipio nos facilitó el muro, y recibimos donativos de individuos y negocios.

Todavía conservo el dibujo original en papel, tomado de un calendario de Jesús Helguera [véase el Apéndice D]. Lo tengo aquí mismo. Simplemente lo copié al muro. Lo dibujé a escala en papel, perforé el papel y lo trasladé al muro. Era un muro de ladrillo, y nos hacían falta los materiales para convertirlo en una superficie plana. Los Thunderbirds,[71] que pasaban el rato a veces en esa esquina, consiguieron que el padre de uno de ellos, un diestro yesero, pintara el muro. Aunque padecía de artritis y estaba jubilado, [Ignacio Guerrero] salía materialmente de su cama y nos enseñaba a enyesar la pared. Nos enseñaba cómo preparar el cemento, la arena, el yeso y cómo prepararlo para un mural. Las señoras del Programa de Nutrición para Ancianos celebraban rifas y vendían piezas de cerámica [para recaudar fondos para el proyecto]. Hasta daban de comer a los artistas y los jóvenes que pintaban el mural. Fue un verdadero esfuerzo colectivo.

Los maestros de la escuela Aoy llevaban a sus estudiantes de primaria para ver cuando pintábamos el mural. Les contábamos a los niños la leyenda que había detrás del mural. Después llegaban los niños de nuevo con sus propios dibujos y sus pequeñas historias. Todavía vemos a esos niños, que ahora están en séptimo u octavo grado. Aún recuerdan haber participado en el proceso de crear el mural. Nos tardamos aproximadamente 12 semanas para pintarlo, trabajando a toda hora, sin parar. Eramos yo, Elizabeth Joyce, Raúl Macillas, Nacho Guerrero y Jesús "Chuy" Hernández, Machido.

Lo hermoso de crear el mural fue que el proyecto no fue financiado por la ciudad, sino por el Departamento de Parques y Recreación. No recibimos fondos de ningún organismo establecido. Recurrimos al Departamento de Recursos Artísticos y a la Alianza para las Artes [de El Paso]. Nos llegaron donativos muy pequeños, como veinte dólares, treinta dólares, pero nada de consideración. Todos trabajaron en él, pero nadie recibió pago por su trabajo. El apoyo de la comunidad es necesario. En San Diego hay un Consejo para las Artes Chicanas, que ayuda en la producción de murales. Es un esfuerzo colectivo. Ellos pagan por desarrollar el programa y por las propuestas. El artista no tiene que ocuparse en nada de eso, sólo con el tema de la obra. En El Paso carecemos de ese esfuerzo unido.

Yo diría que el Concejo Municipal de El Paso, o llámese como se quiera, formaría un grupo de apoyo. Yo tenía entendido que la Alianza para las Artes fue establecida con ese propósito.[72] Así pensaba yo cuando por primera vez conocí la Alianza para las Artes. Pensé que iban a formar una coalición. Ha sido muy difícil obtener algo de ellos en lo que respecta a realizar proyectos en la comunidad. Les he suplicado en sus reuniones. He sometido propuestas, y no he recibido jamás ningún respaldo ni apoyo de ninguna especie, pero cuando estoy inaugurando un mural resulta que allí están participando en la ceremonia.

También pinté el *Cuauhtémoc* (1981-92) en un edificio histórico en las calles Octava y Santa Fe [antes Villalva's Grocery].[73] En ese muro había un mural pintado por un muchacho de 14 años, que pintó la historia de Pancho Villa y el presidente Taft. La comunidad me pidió que lo pusiera al corriente. Empecé con la cultura azteca. Iba a avanzar desde los aztecas a los españoles a los indios y luego a la evolución de [otras] figuras históricas. Pero me dejaron solo porque toda la gente a la que yo había recurrido me decía: "¿Otro mural? Es todo lo que quieres hacer. Sólo quieres poner tu nombre ahí en lo alto de un muro." Así que yo dije, "¿Sabes qué? ¡Olvídense!" y lo dejé por la paz.

Yo pinté la Virgen el los Apartamentos Salazar [*La Virgen de Guadalupe con Juan Diego,* 1983, restaurada en 1991] después de terminar el mural de Armijo. En 1982, la familia Cornejo consiguió que la Administración de Vivienda enyesara el muro. Fueron el primer comité en obtener permiso de Vivienda para pintar un mural en El Paso. Los Thunderbirds también participaron en el

proyecto. De hecho, el Comité de Vivienda Salazar, que ya estaba formado, me reclutó a mí para el proyecto. Me puse al servicio de la comunidad. Yo no cobro por hacer mis murales, porque se trata de un esfuerzo colectivo. El comité dijo: "Queremos que Felipe Adame pinte una Virgen de Guadalupe". En ese momento yo estaba pintando una Virgen de Guadalupe para la Iglesia de Nuestra Señora de Guadalupe en la calle Alabama.

Pinté ese tema porque ellos querían una pintura de Juan Diego y las rosas. Mucha gente participó en la creación del mural. Todos los días me llegaban cinco jóvenes nuevos para ayudarme a pintar. Se quedaban un par de días, y luego venía otro grupo y los reemplazaba. Fue una evolución muy hermosa, en que casi todos los de la comunidad tuvieron la oportunidad de contribuir algo al mural.

Una señora de 62 años de edad se levantó a las cinco de la mañana para que nadie viera que estaba trabajando en el mural. Se levantaba conmigo antes del amanecer, cuando todavía estaba oscuro, para pintar una de las rosas. Hacia las cinco de la tarde, una niña de unos cuatro años llegaba y trabajaba durante unos cuantos minutos, y luego se iba. Pero la mayoría de los muchachos que trabajaron tenían 13, 14 o 16 años y estaban dispuestos a colaborar. Financiamos el mural dividiendo el muro en pies cuadrados y conseguimos un patrocinador para cada pie cuadrado.

La Liga de Ciudadanos Latinoamericanos Unidos (LULAC) compró una gran parte del mural. Ruidoso Grocery Store también compró una gran parte. Todos los días conseguíamos tres o cuatro patrocinadores, 30 ó 40 dólares destinados a pagar el mural, y así se financió. No le costó a la comunidad ni un centavo. Hasta la fecha hay gente que cree que yo gané mucho dinero con ese proyecto. El mural tardó unos seis meses en terminarse.

Empezamos a pintar el mural en la primavera de 1983 y terminamos en el otoño del mismo año. Bobby Adauto, director del Centro de Artes Culturales Lincoln, me ofreció el parque y los pilares. [El quería que yo pintara] murales parecidos a los que se encuentran en Chicano Park en San Diego. *La Virgen de Guadalupe con Rosas* [1981] está allí porque la comunidad lo quería allí. En un tiempo había allí una iglesia a la que llamaban El Santuario. Era una iglesia histórica hecha de roca volcánica en bloque.

Cuando el Departamento de Carreteras construyó el Spaghetti Bowl [un cruce de la Carretera Interestatal 10], derribaron muchos edificios en esa zona. El municipio prometió a la comunidad que, aunque no podían conservar la iglesia, sí podían celebrar misa en el Centro Lincoln. Creo que la fuerza orientadora de Dios me condujo a ese pilar. Yo no sabía que en ese lugar había habido una iglesia. Lo único que yo sabía era que tenía unos deseos muy fuertes de pintar la imagen allí. En el otro lado del pilar yo iba a pintar un Cristo.

Iba a seguir pintando las figuras revolucionarias [*Emiliano Zapata*, 1981] debajo del Spaghetti Bowl, pero hasta ahí no más llegué. El municipio no ha hecho nada para cubrir estas obras. Llegan ahí para quitar el graffiti, pero no quitan estas obras. No lo entiendo. Ahora que tengo un poco de color, pienso en la posibilidad de regresar para terminar mi obra. Aun la compañía de acero, que me prestó el andamiaje, estaba dispuesta a comprometerse. La Easy Electric Company y la Triangle Electric Supply Company— ambas hicieron un donativo. Tengo planes y diseños para los pilares. Lo que yo quisiera ver sería mucha gente joven de todas las edades trabajando sobre un pilar a la vez. Cada escuela de la comunidad puede tener su pilar. Cada grupo de la comunidad puede tener su pilar. Es un lugar lindo. Las artes se encuentran allí.

También dejé un mural en el interior [del Centro de Artes Culturales Lincoln], Bambi, en uno de los salones de la planta baja que dedican al cuidado diurno de niños, una hermosa Bambi con una mariposa en la cola y Thumper y, ¿cómo se llama ese...? Flower. Las señoras del centro de cuidado diurno me pidieron que lo pintara.

El que estoy haciendo en la calle Campbell [*Iztaccíhuatl y Popocatépetl,* 1987] es un óleo esmaltado. Todo es óleo esmaltado. Es caro. Esto es cuando un grupo aborda al artista, en lugar de que el artista o pintor de la comunidad se acerquen a un grupo. El grupo vino y me reclutó a mí. Calle Quinta. Varrio Quinta Street (VQS). Esa esquina es muy conocida porque se usa mucho el spray y los inhalantes. Una de las ideas que tuvimos como muralistas fue la de fomentar actividades positivas en lugar de criticar sus acciones negativas, poniéndolos a trabajar en cosas constructivas en vez de criticar lo negativo o la falta de actividad. Lo que vimos allí durante muchos años eran los "spooks", como se les decía. Eran muchachos que vestían abrigos largos de cuero y se dedicaban a inhalar spray. Y a veces se pintaban las caras de plateado. De noche se veían como fantasmas, y por eso les decían spooks.

Yo les decía repetidamente que no usaran el spray en sus pulmones sino en los muros. Les dije que si querían trabajar conmigo en el muro, no podían ponerse locos o borrachos. Qué bien se siente cuando se puede decir: "Oye, hermano, mírame, estoy derecho. Hace más de dos días que no le pongo al spray." Te subes al muro con ellos. Tal vez los afectas, tal vez no, pero se hace el esfuerzo. Y el mural es un mecanismo para comunicarte con ellos. Tengo otra obra en Chihuahuita, en la calle Canal. La calle de Nico. Ese mural [*Easy Rider/In Memory of Nuni,* 1985] está dedicado a la memoria de su hijo, que perdió la vida mientras montaba en motocicleta.

El mural de las calles Quinta y Campbell [VQS] fue pintado con óleos esmaltados. He recibido un donativo de We the People, 300 dólares. Es la única donación que he recibido, y fue mediante el Renacimiento 400. Se trataba de una campaña para celebrar el 200 aniversario de la Constitución de los Estados Unidos. Ese mural se originó en el hecho de que a Albert Gómez—le dicen

"Spider"—lo fotografiaron porque trae un emblema de Madonna en la espalda, un tatuaje. El departamento de policía había declarado públicamente, una semana antes, que no había nada que la policía pudiera hacer con respecto a las pandillas, que habían hecho todos los intentos posibles para cambiarlas. Era un artículo muy negativo acerca de las pandillas del sur de El Paso. Albert Gómez cuestionó este dictamen y dijo: "Oye, no todos somos malos. Algunos de nosotros estamos haciendo algo bueno."

Cuando yo leí ese artículo lo conocí a él. Con dos de sus socios, El Cuate y El Sobeck, me habló, ya que yo había trabajado con los Thunderbirds, los Mestizos y todos los demás en la comunidad. "¿Por qué no haces uno con nosotros?" Y yo dije, ésta es la oportunidad que estoy esperando, de impedir que estos jóvenes rayen las paredes con spray. Así, sin que ellos lo supieran, yo estaba haciendo un trabajo social como agente independiente. Y entonces fue cuando la Clínica La Fe me reclutó para ir a trabajar con ellos.

También pinté el *Dale gas* [1982]. Es un juego de palabras que tiene que ver con la compañía de gas. Primero lo pintamos en los tubos, porque hay una expresión chicana *dale gas*, que significa súbete al carro y vámonos. O tú le gustas a alguien y te está echando los perros: "¡Dale gas!" Así que lo que hicimos, el Zoot Suit está diciendo: "Dale gas". Pero en cierto modo, estamos procurando que la compañía de gas efectivamente nos dé gas. Es una yuxtaposición. El propietario de la tienda [Arturo García] quería un pachuco y su carro y el panorama de los edificios de El Paso y Juárez.

Pintamos ese mural en la época cuando la película Zoot Suit llegaba a El Paso. También pintamos obras a la memoria de los jóvenes que han perdido la vida en los conflictos entre pandillas. Al otro lado de la calle hay ocho Thunderbirds que fueron pintados [en 1981] en la banqueta. Pintamos la Virgen de Guadalupe [en La Corona Grocery], a ver si ella nos traía la paz.

El *Calendario azteca* [1981] fue pintado por Jesús Hernández, "Machido". El se ha desaparecido también, desde hace un año y medio. Su hijo se ahogó en el Centro Armijo. Luego, hace unos cuantos años, su hijo pequeñito se cayó en una de aquellas zanjas en la calle. Estaban excavando para poner el alcantarillado, y el pequeño se murió—fueron muchas tragedias. El fue uno de los muralistas de aquí del Segundo Barrio. También trabajó en la Virgen [de La Corona Grocery]. Tengo otro mural en Canutillo. Representa a unas carretas entoldadas que cruzan el Río Grande. Está ubicado al lado de la tienda Harris Western Wear. Lo pinté en 1981, también con acrílico. Ese fue un mural puramente histórico, porque eso fue lo que sucedió en Canutillo. Canutillo antes era un lago, un pantano, y sólo se podía cruzar el río en determinada época del año.

La cancha de rebote *Thunderbirds, El Chuco, Tejas* fue pintada por ellos [los Thunderbirds] en 1981. La *Virgen de Guadalupe* lo pintaron el mismo año en conmemoración de los Thunderbirds que han muerto, en cierta forma tal vez para hacer las paces con el

barrio. Todos los años celebran una misa y hacen una ofrenda. Es bonito. Es como una iglesia al aire libre el día de Nuestra Señora de Guadalupe, el 12 de diciembre.

Tengo otro mural en la Cocina del Oso [el oso es la mascota de la escuela preparatoria Bowie; la Cocina del Oso estaba situada al otro lado de la calle, enfrente de la escuela]. Tú has visto los osos allí adentro, ¿que no? Ahora es un lugar de mariscos en la esquina de las calles Sexta y Cotton. Hay dos osos grandes pintados que ocupan toda la pared.

Conocí a José Antonio Burciaga en Washington, D.C., en 1971. El estaba haciendo ilustraciones para una serie de compañías. Nos reunimos en el sótano de su casa de Arlington, Virginia e hicimos una pintura juntos. Utilizamos todos los medios que se nos ocurrieron. Y después de terminarla, no sé qué hicimos con ella. Creo que la doblamos en cuadritos, lo envolvimos y lo mandamos a alguien por correo.

Cuando trabajó en Stanford, Burciaga pintó un Cristo que estaba siendo desvestido antes de la crucifixión. Era una réplica de una obra maestra original hecha por un artista del siglo XV. Lo hizo con un collage de recortes de revistas. Lo veías y pensabas que era idéntico al original. Pero ¡hijo, ése!

Unos murales del restaurante El Cerezo, en la esquina de las calles Mesa y Missouri, también eran míos. Cuando el restaurante cerró, el dueño pudo comprar todas las pinturas al banco por 2,000 dólares. El [John Salpas] las tiene en un garaje. Tengo algunas diapositivas de esas obras, que fueron hechas específicamente para el primer Festival de la Calle El Paso. Esa fue mi contribución a la Alianza para las Artes. Estaban decorando el vestíbulo del Centro Cívico cuando estaba el gran pastel [la celebración de Cuatro Siglos '81]. Fue un incidente en que Rob Hankins me invitó a llevar las pinturas allí para exhibirlas, como una contribución de la comunidad. Pero los otros artistas no lo vieron como una contribución, sino como un artista que conseguía una exhibición gratis. Y yo no había pagado por el espacio, como ellos lo hicieron.

No reconocieron el hecho de que yo era un artista que trabajaba en la comunidad sin fines de lucro y que la mía fue simplemente una contribución al festival. Ellos se preguntaban: ¿por qué no paga él cuando tenemos que pagar nosotros? Y además, yo estaba pintando retratos delante de los murales y ganando dinero, y se oponían también a eso.

Un guardia me sacó del Centro Cívico porque llegó la orden de que había que sacarme. Y yo dije: "Si me sacan de aquí, ¡me voy con todo!" Y agarré todas mis pinturas y las coloqué afuera. Y puse un letrero que decía "¡Estos murales han sido desalojados por la Alianza para las Artes!" Rob Hankins llegó y dijo: "No era mi intención que se retiraran sus pinturas con escolta". Yo le pregunté: "¿Cómo voy a retirarme de este lugar y dejar aquí mis obras?" Vieron lo que estaba sucediendo [el diputado estatal] Paul Moreno y [el

concejal del municipio] Jim Scherr y dijeron "¡Esta es una locura!" De manera que se resolvió la cuestión en un minuto y me volvieron a instalar en mi puesto. Pero desde entonces no creo que la Alianza para las Artes haya querido asociarse conmigo. Y no les culpo, porque yo critico la facilidad con que un grupo solicita dinero para las artes y se queda con cantidades tan grandes para cubrir gastos administrativos.

Varias de mis pinturas también se quemaron en Sal's II, la cantina que antes estaba ubicada en la calle Alameda. Yo había dejado mis pinturas allí para garantizar un préstamo que me hizo el propietario para viajar a Corpus Christi y exhibir mis obras. Cuando regresé, el establecimiento había sido destruido por un incendio. Todas mis pinturas se quemaron también. Era como si se hubieran esfumado diez años de trabajo duro. Nunca recibí compensación alguna porque no estaban aseguradas.

También tengo dos pinturas en la Iglesia Católica Guadalupe, en la calle Alabama. Otro mural, *La adoración de los magos*, mide 7 por 14 pies, y otro, en el restaurante Hong Kong, que mide seis por seis pies, es de cien pájaros.

Me encanta pintar.

Carlos E. Flores
Entrevistado por Mike Juárez
Chamizal National Memorial
9 de marzo de 1994

Bueno, yo nací en Chihuahua. Me trajeron cuando no tenía ni el año a Cd. Juárez. Yo me desarrollé y tuve mis estudios primarios en Cd. Juárez. En el lugar donde yo me desarrollé, fue el centro de Juárez, en el ferrocarril, en frente de la Plaza de Toros. Ahí tenía yo mi casa. En el grupo que habíamos ahí en esa época, la idea era sobrevivir en una forma o en otra. La mayoría de los muchachos teníamos motivaciones para ser algo en la vida.

Esto se predecía, había para escoger: eras torero, eras boxeador o eras cantante. Casi todos mis amigos de esa época terminaron siendo toreros, boxeadores o cantantes. Yo, gracias a Dios, tuve la suerte, ¿no?, de ver unos trabajos de Berumen cuando él estaba haciendo apenas unos murales ahí en el Hotel Río Bravo. Y estaba yo todavía muy chico; iba a la escuela primaria. Esos murales fueron pintados como en los cuarentas o cincuentas.

Jesús Helguera era importante porque llegó a ser el artista más popular. El arte de Diego Rivera todavía no entraba muy bien entre la gente; era más sofisticado. Era más histórico, más didáctico, enseñaba. El arte de Helguera era popular. Estoy seguro que él tuvo una educación clásica dentro de la pintura porque sus composiciones son todas típicamente clásicas.

Son indios parados a la griega, ¿no? La composición [está] muy bien hecha. Pero sus indios están muy bien hechos, muy bien trabajados, su anatomía muy bien trabajada. Y las leyendas que reproducía cada año en unos almanaques que se regalaban a la gente, ¿no?, de la Compañía Cigarrera El Aguila. Entonces esos almanaques fueron muy populares por muchos años en México. Y de ahí los otros pintores populares, los que estaban pintando murales y todo eso para negocios comerciales agarraban mucho material de ahí. Inclusive uno de los primeros murales, no de los primeros, pero sí más o menos de los que hay aquí en El Paso aparte de los que ya había de Tom Lea y otros pintores, ¿no?, que para mí son mas ilustración que mural.

Son muy ilustrativos de la historia. Pero Lea es un buen ilustrador. Cisneros también hace ese tipo de trabajo, muy bueno. Aquí en el Armijo se hizo una copia de, precisamente, Helguera por Felipe Adame. Muy buena copia. Se hizo muy bien. Es la única que he visto de ese tipo.

Y luego ya después en México, Berumen empezó a hacer unas copias magníficas, muy superiores a las de aquí, en el Hotel Río Bravo [en Cd. Juárez], que todavía existen ahí. Todavía están ahí, puedes ir a verlas, ves. Si no está todo a la vista es porque pusieron una lavandería o quién sabe qué pusieron ahí; así se hizo, y taparon, así pusieron una divisiones. Taparon las magníficas reproducciones de esos cuadros. Está uno que se llama El Rapto, que va un chinaco con una muchacha en los brazos y se la lleva en la noche. Se la acaba de robar, la lleva en su caballo y toda la cosa, muy romántico en idea, pero muy bien pintados, muy bien pintados.

Berumen me inspiró a pintar, porque en realidad yo siempre he dibujado. Yo no me acuerdo ni cuándo comencé a dibujar. Yo me acuerdo cuando estaba en la primaria, en kinder, a veces me pasaba la maestra al pizarrón y me ponía a hacer ahí los mapas de México. Después cuando ya estaba en los años más avanzados de la primaria, o sea en tercero, cuarto, quinto o sexto año me la pasaba haciendo mapas en todos los salones. Me los sabía de memoria. Yo me acuerdo que desde el kinder empecé yo a dibujar lo que yo veía—los toreros.

En esa época, ahí en México o aquí en Cd. Juárez, estaba el tiempo muy bonito porque estaba la guerra. Había muchos soldados en Juárez, entonces la Plaza de Toros se llenaba. Se ponía desde el sábado: ya empezaba el movimiento de gente de aquí a El Paso que se venía a divertirse en Juárez. Era como un pueblo grande, Juárez, no era una ciudad todavía. El centro nada más llegaba hasta la calle Constitución y ahí se acababa el centro. Y luego para allá la calle Altamirano y se acababa; ahí estaba el fin de Juárez. Y luego el ferrocarril, pues nomás hasta la estación. Y de allá para acá, pues aquí el Río Bravo, eso era. Pero me acuerdo muy bien que los toreros ni siquiera llegaban en carro o en algún otro vehículo, no, sino que llegaban a un hotel que se llamaba el Hotel San Carlos que estaba allí por la Avenida Juárez.

De ahí se dirigían a pie con todos los picadores, los banderilleros, toda su cuadrilla. A pie se dirigían hasta la Plaza de Toros, puntual con el chavalerío gritándoles y eso. Y yo formaba parte de ese chavalerío porque yo vendía a veces banderillas. Andaba vendiendo cojines. Me daban chanza de entrar a la Plaza de Toros. Y en ese ambiente me desarrollé yo en principio.

Entonces, como te digo, yo siempre dibujé. Poco a poco fui dibujando todas esas imágenes, inclusive las tengo vivas en la mente, así que en cualquier momento puedo ponerme a dibujarlas. Y las puedo sacar otra vez. Después de eso yo estaba en mi primaria y empecé a ver el trabajo de Berumen y me empezó a interesar mucho cómo mezclaba los colores, cómo hacía su composición. No me daba yo cuenta de cómo empezaba precisamente en la pared en blanco, porque no se veía que había trazo. Probablemente, él nada más se iba parte por parte de lo que estaba viendo. Pero es probable que sí tuviera trazado ya algo porque

siempre le quedaba muy bien, y no había distorsión que digamos. Esos cuadros están ahí todavía. Están muy bien hechos. De ahí en adelante me dediqué exclusivamente a la pintura. Y desde entonces pinto.

La primera oportunidad que yo tuve de estudiar verdaderamente con un maestro de pintura, que pueda haber sido bueno o malo o mediocre, fue cuando se hicieron unas clases en la Escuela 29, de la que yo salí, en la noche, nocturnas. Empezaron a dar clases ahí varios maestros. Entonces yo encontré, gracias otra vez a mi buena suerte, libros como el de Leonardo da Vinci de la pintura. Entonces yo cargaba ese [libro] como si fuera mi Biblia aquí en la bolsa. Todo el tiempo andaba con ese y otro libro para dibujar en el otro lado. Porque eso era lo que él [da Vinci] decía: que tenía uno que dibujar todo lo que veía. Cuando yo crecí más, empecé a trabajar más, pero no lo hacía profesionalmente. Estuve trabajando en una maderería que se llamaba el Kilómetro Cinco, que traían madera cruda del monte. Mi trabajo consistía en llevar la cuenta de la madera y preparar las tarjas para pasarla para acá los Estados Unidos. Acá pasaba toda la madera buena. Tenía mucho tiempo para dibujar; siempre traía mi tajo de papeles, y me puse a dibujar a los trabajadores. Ahí es donde yo aprendí la mayor cantidad de información que yo pude tener acerca de la anatomía humana en movimiento.

Yo dibujaba a los trabajadores. Hice miles de dibujos. Aparte de eso, siguiendo los preceptos del libro de Leonardo, dibujaba yo lo demás. Todo lo que encontraba: encontraba piedras, las ponía, las cambiaba de modo, agarraba los papeles, los hacía así y trataba de lograr todas las variaciones de tonos de lo que veía—pájaros, todo lo que encontraba. Hasta lagartijas, todo lo que hubiera porque en ese tiempo estábamos en el desierto. El Kilómetro Cinco estaba a la salida de Juárez. En esa época puse mis primeros cuadros en una exposición que se hizo en Juárez, "La Exposición de Libro" ahí por la salida. Ahí por la carretera.

Entonces después de eso mi familia se vino aquí a los Estados Unidos. Cuando vine ya aquí a los Estados Unidos, el siguiente año de que pasé tuve que ir a Corea, en los cincuentas. Mientras estuve en el ejército me pusieron como ingeniero militar. Entonces, me dedicaba a hacer dibujos para los hospitales transportables y todo eso. Y eso era mi trabajo, pero al mismo tiempo yo ya tenía el gusanito de la pintura muy adentro porque yo siempre estaba pintando. Yo siempre estaba haciendo dibujos de los soldados y todo eso. Me quedaron miles de dibujos de eso cuando regresé yo del Army. Nada más que ahí se fueron perdiendo con el tiempo. Pero cuando regresé [a los EE.UU.] yo ya no pude aguantar más y me fui a México. Nada más llegué, dejé mi duffel bag aquí con mi mamá y me fui a México.

Entonces en México me metí a la Academia San Carlos [en México, D.F.] de oyente, no de alumno regular. Estuve con el maestro Luis Nishizawa, que sigue siendo todavía mi gran amigo. Creo yo que él es uno de los mejores paisajistas que hay en México ahorita desde hace 30 años.

El vino a juntar lo que quedó del Dr. Atl [Gerardo Murillo] y sus ideas de cómo pintar el paisaje mexicano.[74] Vino a juntar eso y lo de [José María] Velasco, del paisaje de Velasco, que era todavía muy académico, y luego del paisaje del Dr. Atl se brincó al otro lado y era ya muy moderno. Pero que a veces le fallaba la técnica porque era de uno de esos tipos renacentistas que trataba de inventar colores y todo eso. Entonces a veces sus colores no le salían.

Entonces el maestro Nishizawa vino a formar un puente entre esas dos tendencias y su pintura de hace 25 ó 30 años hacia acá se dedicó exclusivamente a hacer paisaje y hacer obra de tipo completamente moderno, inclusive abstracto. Y como buen japonés, ¿no?—aunque el fue nacido en México y todo, de todos modos su papá era japonés—tiene esa cosa de ser muy estudioso y muy metódico y todo eso. Entonces su trabajo para mí es de los más valiosos que existen hoy en México porque tiene la técnica.

Estudié con el maestro [Ignacio] Asúnsolo. Fue mi maestro de escultura y aprendí mucho de él también porque el maestro Asúnsolo fue el creador de la mayoría de los escultores que hay ahorita en México, profesionales, buenos—él es un señor, desde abajo hasta arriba. Y el maestro Asúnsolo es de Chihuahua también. Esa es la cosa: ha habido muchas gentes de Chihuahua de mucho talento, por ejemplo Siqueiros, que fue tan mundialmente conocido. Desgraciadamente, en Chihuahua no se les da el crédito que se les debería haber dado. Por ejemplo, no existe un solo mural hecho por Siqueiros en Chihuahua. Existen de otros. ¿No? Existen de Aaron Piña Mora, existen de Alberto Carlos, que todos son amigos míos también.[75]

Yo me vine en el '69 de allá. Y me vine porque la cosa se puso muy dura con el movimiento de los estudiantes. Entonces muchos de mis amigos eran estudiantes ahí en San Carlos y yo ya era un adulto.

Entonces, la cosa se puso políticamente muy dura en México para los estudiantes porque empezó el movimiento estudiantil, hasta la matanza que hubo. Y se vino en esa época la cosa de las Olimpiadas de México. Yo anduve envuelto en todos esos movimientos. Entonces una de las veces que había yo regresado a mi casa, la señora de ahí del edifico me dijo: "¿Sabe qué, joven? Más vale que no entre aquí a su casa." Entonces le dije yo: "¿Por qué?" Yo no me esperaba nada. Y me dijo: "Parece que anda la policía ahí".

Entonces dije yo, bueno, pues ni modo, hay que salirse, no tiene caso. Me vine para los Estados Unidos otra vez yo. Aquí en UTEP estudié con todos los maestros que estaban en el departamento en los setentas: Jansen, que estaba en grabado, [Sally] Bishop y

los demás, que no me acuerdo. No, pero estudié grabado, cerámica, todo. Todo, porque todo me interesaba, inclusive me interesaba hacer una cosa que todavía tengo en la mente, de hacer murales en cerámica pero usando las técnicas de la cerámica.

Yo tuve la suerte también de tener contacto con David Alfaro Siqueiros. El nació también en Chihuahua. En sus últimas épocas él trató de juntar la escultura con la pintura. En el último trabajo que él hizo, en un mural, trató de juntar eso y lo logró hasta cierto punto en el Poliforom. A mí se me quedó muy grabado eso, y me gustaría volver a hacerlo aquí.

Porque el mural no es en realidad nada más un cuadro grande. El mural es otro medio, se tiene que hacer la composición diferente, se tiene que tener muy en cuenta la luz, el espacio que hay enfrente del muro. Se tiene que tomar en cuenta la arquitectura del edificio para que no choque una cosa con la otra, y al mismo tiempo tratar de hacerlo lo más libre posible. De que la arquitectura no te vaya a hacer una sola cosa, sino que te ayude nada más, para darle más énfasis. Agarré yo un grupo de muchachos e hicimos un mural ahí en UTEP, que fue el primero en realidad en esa época. Después pintaron otros.

Ese mural [*Pollution*] fue pintado en el '73. Cuando yo estaba haciendo ese mural, fueron unos muchachos de aquí del Segundo Barrio a preguntarme qué podrían utilizar, qué colores y todo eso. Yo les di toda la información e hicieron unos murales que fueron los primeros que se hicieron en el Segundo Barrio [murales La Campaña]. Yo fui uno de los consejeros en ese proyecto.

El tema del mural era acerca de la contaminación y la resolución a eso. En otras palabras, yo ponía como principios básicos de la creación, ponía desde el punto de vista de la religión y desde el punto de vista de la ciencia. Desde el punto de vista de la religión eran Adán y Eva desnudos. Esa fue la razón por la que lo borraron después. Y como te digo, este [mural] duró como diez años ahí. El mural era como de unos ocho o diez pies de alto y como unos 30 pies de largo. Se llamaba, me parece que era *Pollution*, o algo así. Era acrílico sobre polvo de mármol, y toda la combinación que hice yo para eso.

Después de ese mural estuve haciendo casi pura pintura de caballete, porque aquí en El Paso no había todavía, y todavía no hay, suficiente respuesta, ves, a las necesidades de la pintura muralista. La pintura muralista es muy especial y necesita de apoyo del gobierno o, más que nada, privado. La gente no está muy acostumbrada a ver murales aquí.

Después de eso trabajé por tres años con una asociación que se dedica en la época de vacaciones a darle trabajo a los muchachos de las escuelas. El PIC, sí, Private Industry Council. Entonces con ellos hice tres murales. No me gustó mucho como quedaron porque desgraciadamente tenía que utilizar muchachos que muchas veces no sabían dibujar y luego ponerlos a hacer un mural en menos de un mes.

También por casi diez años trabajé por Ballet El Paso. Todavía cuando me necesitan me hablan. Estuve haciendo todos los trabajos del ballet, los sets, junto con el Sr. [Albert] Ronke, de la Universidad de Texas [UTEP]. A veces él tenía la manera de hacer el diseño y yo lo hacía y hacía la pintura al mismo tiempo.

En la Brewhouse, donde vivía, pinté yo una cosa. Pinté al final del corredorcito ese, está un señor de la Budweiser, o una de esas cervezas, porque ésa era una cervecería[76] ahí—un ruco panzón ahí. Pero nomás fue por un favor. Pero en realidad no hay arte ahí todavía.

El mural en el Chamizal [*Nuestra Herencia/Our Heritage* (1992)] fue una cosa en realidad de que se juntaron, tanto mi necesidad de encontrar un lugar donde pintar un mural como la necesidad de pintar un mural en ese momento. Ese mural se lo habían dado a otra persona, pero parecía que esta otra persona iba a hacer una cosa más sencilla. Iba a utilizar muchachitos de la escuela, de las clases de la primaria, de a tiro de primero o segundo año. Y hacer una cosa probablemente muy agradable, no. Pero era una cosa más chica. El pensaba en una cosa más chica.

Después de eso yo andaba precisamente buscando un lugar. Originalmente, los planos que yo hice, yo los hice completos a la escala, y todo eso iba a ser hecho en el Centro Cívico. En la entrada del Centro Cívico, en los dos lados. Pero la ciudad parece que me estaba dando muchas largas. Me decía que se tenía que esperar hasta dos años y nadie quería agarrar la responsabilidad de darle el sí, y que se hiciera. Entonces por eso, pues, buscamos otro lugar. Y en eso que andábamos buscando, esta persona que iba a hacer el mural les dijo que si querían podrían buscar otra persona, y vinimos a ver el espacio.

Yo hablé con Sontag [Bill Sontag, Superintendente del Chamizal National Memorial]. Es el que está encargado aquí, y llegamos a una conclusión de que sí era ideal el espacio porque era inclusive. Lo hice yo el doble del tamaño que iba a ser y yo necesito más espacio. Para poder meter todo lo que necesito aquí necesito más espacio.

Entonces básicamente el mural se trataba al principio de poner énfasis en lo que es El Paso, después de tantos años, y todo eso, aparte de la imagen que se tiene del Southwest, que en realidad es un mito. Porque eso nomás duró 20 años en la historia de los Estados Unidos. Pero se ha vendido al público por siglos. Y esos mitos nunca existieron, los cuentos de gunfighters y todo eso, ¿no? Aquí se tiraban como en cualquier otra parte. Se tiraban de escondidos y se deshacían del enemigo fácil, ¿no? No se ponían a la mitad del día y con las pistolas en los lados y todo eso. Es puro mito, ¿no? Nunca existió eso.

Pero es un mito agradable. Entonces la gente lo ha creído y sobre todo porque lo hizo John Wayne y todas esas personas, ¿no?, que fueron muy famosas. Por ejemplo, cuando he viajado en otras partes del mundo, yo fui a Japón y he andado por varias

partes, ¿no?, en España y todo eso. Entonces, cuando saben allá de los Estados Unidos, lo primero que se habla es del Southwest, y allá creen que sí existió. Creen que todavía andan los wagons y todo eso, ¿no? Entonces a mí se me hace chistoso hasta cierto punto. Si no fuera trágico en otros aspectos. Porque eso no ha permitido que la verdadera historia del Southwest sea contada con todos sus pelos y todo. Todas sus malas y buenas horas que tuvo. Es más bonito vivir en el mito, ¿no?, que vivir en la realidad.

Entonces, eso no ha permitido que se le dé el nombre a muchas cosas que dejamos. Pero en este caso yo tenía todo puesto en el mural. Tenía la parte de ciencias, tenía el movimiento después de Kennedy, de la NASA, ¿no? Tenía las cosas particulares de esta región: la música, los bailes. Tenía mucho más de lo que estaba en el proyecto. Lo tenía en el proyecto e hice el otro. Hice los dos lados que iba a hacer el principio.

Y se los presenté a Sontag y le dije: "Mire, estos pueden servir porque es básicamente lo mismo. Es una celebración de nuestra región. Lo que tengo que cambiar un poco es unos aspectos de ello." Entonces quise poner los tres representantes principales del americano, que en realidad debe ser norteamericano. No americano, porque todos somos americanos, todos. Pero nos han robado el nombre. En realidad así es. Los Estados Unidos se ha tomado el nombre y se lo ponen como si fueran nomás americanos ellos. Pero en realidad todos somos del continente americano. Ya sea del norte, del sur o del centro, todos somos americanos. Entonces para más o menos dividir, puse yo al negro, al americano, "el blanco", y al indio, que son de todas la regiones de aquí en los Estados Unidos, porque hay el indio de acá del sur, del centro, y del norte y todo eso.

Entonces los puse como símbolos nomás—al anglo, al indio y al negro. Entonces Sontag me dijo que por qué no ponía en vez de la cara de un negro que era completamente impersonal. Era nada más simbólica. Que por qué no ponía a una cantante muy famosa que yo había oído de ella pero no estaba muy seguro qué había hecho en su vida. El me ayudó a entender quién era. Me sugirió que pintara a Marian Anderson en vez de la cara del negro. Anderson era la cantante que estuvo muy envuelta en el movimiento que se llevó a cabo aquí antes que Martín Luther King y todos esos.

Ella desde un principio sola levantó la bandera del negro aquí en los Estados Unidos. Y nunca se había reconocido. Y le pasaron cosas terribles, como no la dejaron quedarse en hotel aquí en El Paso. No la dejaron porque era negra.

Pero aparte de eso, dividí el primer mural así, y luego el segundo mural con el águila de los Estados Unidos también en el primer mural. Como es lógico, yo también tengo mis creencias acerca de la derecha y la izquierda en Estados Unidos, y cómo se mueve, y he visto como le hace y todo eso. Y para mí , yo soy liberal y a mucho orgullo. Entonces puse las garras del águila, la derecha siempre con las flechas y todo eso, con lo guerrero. Y la hoja de olivo en la izquierda. Porque para mí la izquierda siempre ofrece más

oportunidades. Aunque no sean de aquí del país. Aunque yo me siento americano de este país desde hace muchos años, cuando yo fui a Corea y todo eso, porque ¿qué mayor prueba puede uno darle a un país que ofrecerle su vida?

Entonces, en el segundo mural puse también el indio como principal, como origen; y luego puse al español en el otro lado y el resultado de los dos es que somos todos mexicanos, nomás la diferencia es que en México al invasor le dimos una patada y lo mandamos otra vez para Europa. Después que le quitamos muchas cosas que han sido todo el tiempo positivas para todos los mexicanos, como es la religión y la cultura, el lenguaje—el español.

Y para nosotros es una segunda madre. España. España para nosotros es mucho más que un hermano por su cultura que nos ha dado. Entonces por eso puse a los tres representantes. Y luego, enseguida están los Voladores de Papantla, porque para mí representan algo de lo que hay antes que llegaran los españoles aquí a México. Representan la unión entre el cielo y el hombre. El flautista se está poniendo en comunicación con los dioses en el cielo y está pasando el mensaje a los cuatro puntos cardinales cuando vienen bajando los Voladores de Papantla hasta que caen al suelo y ya pasan el mensaje a la gente.

Entonces eso me sirvió a mí como motivación y como símbolo para meter eso ahí. Después, en el otro lado, como punto principal está Kennedy, porque fue el primero que tuvo la visión necesaria para darse cuenta que el embrollo que tenían con el Chamizal, que iba cambiando cada año con el curso del río, y eso llegara a una solución pacífica y buena para los dos países. Y tuvo la visión de hacerlo. Y al mismo tiempo él tuvo la visión de ver las posibilidades de viajes espaciales y todo eso y de la NASA. Es por eso que está una figura desnuda tratando de alcanzar las estrellas, porque es eso, representa esa parte. Y luego, después está el dios Tláloc, porque representa el dios de las aguas en México para los mexicanos. Y el problema precisamente aquí era por las aguas que cambian de curso.

Y luego están otras cosas del folklore mexicano y el folklore americano también de aquí de Estados Unidos, de aquí del Southwest. Los bailarines, como le llaman aquí del Tex-Mex. Bailarines, la música que se ha creado en estas regiones y todo eso. El baile del águila, de aquí de los indios tiguas y todo eso, y luego las primeras iglesitas que se hicieron, muy primitivas y todo eso, pero que son también representantes de esta región.

Y básicamente es eso, es una celebración, se puede decir, de lo que tenemos aquí que se puede hacer todavía mucho más amplio. Pero que yo en este caso me vi poco limitado por el espacio. Pero el espacio se me acabó. Tuve en realidad ocho meses para pintar el mural.

Se me pasaba mencionar también que está Cortés, y Cortés no está como Conquistador en el mural sino está como hombre, como ser humano. Y es su primera derrota contra los indios. Está llorando en el árbol de la Noche Triste, ¿no? Con Marina, que le llamaban Marina porque era del mar, doña Marina, La Malinche, ahí en un lado. Y luego los padres, que tanto dieron a los indios. Les dieron protección, les dieron cultura, les dieron muchas cosas. Y los salvaban muchas veces de lo horrible que era la explotación en esa época de los españoles.

Básicamente eso es todo lo que es el mural. Aproveché toda textura que tenía originalmente la pared, nomás le di una base para que se detuviera más, y es acrílica. La mayoría es acrílica de base industrial porque es la que más aguanta el sol y la lluvia y todo eso por eso está igual, no le ha pasado nada. Y en pequeña escala utilicé la pintura más fina para retoques para cosas pequeñas. Pero esa no resiste mucho el sol ni la lluvia y por eso tiene que utilizarse muy poco. Pero es básicamente pintura en ese estilo,; es lo mejor que hay ahorita para pintura de mural.

Más que nada, sí me gustaría comentar algo. La gran mayoría de los murales han sido hechos en condiciones muy difíciles, y eso lo sé yo por experiencia. Entonces yo sé que los muchachos que han pintado mural aquí en El Paso lo han pintado en condiciones muy difíciles, en que les ha faltado materiales, se les ha pagado muy poco dinero a la mayoría de ellos. A mí también. El dinero no es abundante, es muy escaso. Y luego ha sido desviado el movimiento muralista de aquí de El Paso porque no están unidos todavía. Cada quien tiene una idea y la pone, y otro acá, y todo está desperdigado, ¿no? Así como están desperdigadas las ideas, está desperdigado el conocimiento de cómo hacerlo. Hay muchos errores en la cosa de la técnica que se debe usar para pintar mural. A veces se debe a que unos de los murales ya no existen. Se han caído porque estaban mal pintados. Aunque la idea haya sido muy original. Aunque el pintor haya sido muy bueno, pero su técnica no es suficiente y pues por lógica se han perdido algunos de los murales. Y se ha pintado hasta con pintura de botes, para pintar muebles, de todas he usado. Entonces sí sería muy conveniente crear una biblioteca, se puede decir, para poderse enseñar exclusivamente cómo hacer murales. Para que todos tuvieran la información necesaria para poder hacer un mural como debe ser y que les pueda durar muchos años porque se pone mucho esfuerzo en ello. Se pone mucho esfuerzo personal. Algunas de las ideas magníficas que he visto en los murales aquí han sido un poco rebajadas por la parte de la técnica. O por la parte que faltó el dinero suficiente para llevarlas a cabo.

Entonces la mayoría de los pintores muralistas de aquí tienen posibilidades de hacerlo muy bien, sobre todo en el futuro. Pero sí hay algunos cuantos, no tiene caso ni siquiera mencionar que les falta mucho. Les falta mucho como muralistas. Y tienen la idea

errónea de que hacer un mural es hacer un cuadro grande, cuando no es eso, ¿ves? Pero son contados y no vale la pena siquiera mencionarlos.

El mural es el resultado, aquí en los barrios, de la desesperación por existir, por decir que aquí estoy. Hágame caso, yo vivo, existo. A eso se debe también la gran cantidad en los principios—no ahorita, en los principios—del graffiti. Porque también quería decir, aquí estoy, me llamo Raúl, me llamo Manuel, me llamo esto. Ahorita el graffiti ya es otra cosa. El graffiti nunca ha sido un arte, ni será. Pero la razón que los movía antes a los muchachos a pintar las paredes es la misma básicamente del artista que quiere ser algo, que quiere hacerse notar.

Desgraciadamente, se ha bastardizado y ha resultado que ahora es una cosa criminal, porque así como ves el graffiti, así es como si estuvieras viendo la mente adentro de los individuos que lo pintan—la confusión, el embrollo, el borrón. No piensan claro, no saben.

La mayoría es acerca de violencia. Es una violencia que no debería existir porque están tomando parte o se están creyendo que ellos tienen esta propiedad o aquella propiedad nomás con ponerle el nombre encima. Y es una estupidez. Las víctimas de toda esa violencia somos nosotros mismos los mexicanos, que es lo más estúpido que puede haber.

Entonces, yo detesto el embrollo, ¿ves?, que trae la mente que les hace producir el graffiti. Porque el graffiti no te dice nada. Nomás te dice que aquel barrio no quiere a este barrio y se la están rayando y tú sabes, eso es todo lo que dice, ¿ves? Y no trae nada estético, no te dice nada que tú ya no sepas acerca de los que están haciendo el graffiti.

Más que nada, el graffiti que cae en Cd. Juárez y en otras partes en la República Mexican es por la necesidad de la copiada, ¿ves? Estados Unidos es un país tan poderoso y, quiera que no, transmite imágenes por medio de la televisión, por medio de la música.

Bueno, ya es hora de irme. A echar mis pulgas a otra parte...

Gaspar Enríquez
Entrevistado por Mike Juárez
Galería Mi Casa, San Elizario, Texas
Septiembre de 1994

Nací en El Paso, Texas, en el Segundo Barrio. Es irónico que haya nacido y me haya criado en el Segundo Barrio y, después de algunos años, haya regresado para enseñar y trabajar allí. Asistí a la escuela cerca de donde ahora enseño, en la escuela primaria Beall y la preparatoria Jefferson.

No puedo decir que un solo individuo me haya influenciado para convertirme en artista mientras yo me criaba. Hubo, sin embargo, muchos incidentes que me ayudaron a lograr mi destino de hacerme artista, aunque no se me ocurre nada específico. En la primaria hubo una maestra que me alentó a seguir una carrera en las artes. Y Mel Casas [un artista chicano de San Antonio conocido en todo el país], quien ha triunfado como artista, vivía en el mismo conjunto de apartamentos donde yo vivía. Nos solía llevar a sus clases, donde vi su trabajo. Mis clases en la prepa no me interesaban en lo más mínimo, y no aprendí mucho allí. Nadie me orientó; no había personas que emular, y yo no vi el arte como una carrera viable.

Varios años después, cuando trabajaba en California, decidí dedicarme al arte como carrera. Siempre me había gustado dibujar, y cuando era niño y vivía en California, visitaba galerías y museos. Lo que me ayudó de veras a hacer carrera como artista fue el apoyo y el aliento que me dio mi esposa. Una caja de pinturas que ella me obsequió me encaminó por el camino de las artes, y todavía sigo el viaje. Mi padre había sido artista en cierto modo, pero trabajaba como mecánico para mantenernos.

El barrio donde enseño y donde crecí ha sido la fuente de donde surgen mis obras. Todavía ejerce una gran influencia sobre mis imágenes. Mi trabajo es un reflejo de mi ambiente y mi experiencia allí. El barrio no ha cambiado gran cosa desde los tiempos cuando yo vivía allí. La historia del barrio sigue repitiéndose de generación en generación. Una de mis obras tiene como tema este tipo de actitud generacional de que el pasado se repite. Cuando mis estudiantes [de la preparatoria Bowie] crean diseños para pintar murales en las paredes, pintan algunas de las mismas imágenes que se pintaron hace años, que reflejan las mismas preocupaciones que teníamos nosotros cuando crecíamos en este barrio. Yo todavía utilizo algunas de estas imágenes y símbolos, pero en un contexto diferente. Mi trabajo es un producto de mi ambiente—su pasado, su presente, su futuro.

El papel que he jugado en hacer murales ha sido más bien el de consultor, coordinador y educador para las obras producidas. Los estudiantes a quienes he ayudado han creado sus propios diseños. Los ayudé con la composición y los elementos del arte, como el color, etc., pero han elaborado esencialmente sus propias obras. Todos los murales que he supervisado, ya sea en la preparatoria Bowie o en la comunidad, han sido pintados de esta forma. En 1994, diseñé y pinté un mural con la ayuda de varios estudiantes talentosos de preparatoria y de la universidad en Socorro, Texas. Espero que transmitan sus experiencias a otras personas y que mantengan vivo el muralismo.

Mis pinturas de caballete tienen que ver con mi gente. Yo pinto a la gente y sus actitudes. Mi trabajo en metales [la serie *Mi familia*], expuesta en la última exhibición CARA, se ocupa de la herencia y la cultura y las memorias personales. Mi obra mural abarca una amplia gama de imágenes y símbolos. Mis obras de arte público se basan en cuestiones propias del tema y el tiempo. Como es un arte público, el artista debe transigir a veces.

Creo que la calidad es un aspecto importante de la creación de las obras. Un mural bien realizado impresiona favorablemente a la gente, sea cual sea el contenido. Para tener apoyo, el muralismo debe ser de buena calidad. Debe impresionar al público, la gente que lo ve. No se puede dar pintura y una pared a las personas, sin proveerles ningún tipo de instrucción, y esperar que produzcan obras de alta calidad. Necesitan educación, experiencia y orientación. Hay que felicitar a Los Murales y otros programas que apoyan la producción de murales en El Paso porque se esfuerzan por resucitar el muralismo en El Paso. Todos les agradecemos a personas como tú y Cynthia Farah, que siguen documentando y escribiendo sobre los murales. Por lo que respecta al Departamento de Recursos Artísticos [de El Paso], a veces tienen otras prioridades.

Empezamos a pintar murales en la Bowie a finales de los setentas. Joe Olivas, entonces instructor de arte, y sus estudiantes pintaron *Mesoamérica* en la cafetería en 1976. Los otros murales han sido pintados por estudiantes, demasiado numerosos para mencionar aquí sus nombres, pero sus nombres aparecen en sus obras. Seguimos pintando murales todos los años escolares y seguiremos pintándolos hasta que decline el interés en los murales, y no es probable que esto suceda pronto.

Como dije anteriormente, tenemos la tendencia [en la cultura chicana] a repetir el pasado en el barrio. Mientras haya opresión, prejuicios, injusticia y codicia y mientras la gente siga viviendo en condiciones de pobreza, habrá murales. Existen suficientes causas y preocupaciones en nuestra cultura para mantener vivo el muralismo durante mucho tiempo. Nuestro anhelo por conocernos mejor y apreciar nuestro propio valor nos obliga a mirar hacia atrás para ver dónde estamos, de dónde venimos y hacia

dónde vamos. Al alcanzar nuestras raíces podemos comenzar a fortalecer nuestro orgullo, nuestro amor propio y nuestro futuro. Es por esto que vuelven apareciendo las mismas imágenes en los murales de nuestra comunidad. Nuestra cultura rebasa el tiempo y debe sobrevivir, aunque sea en los muros, antes de que nuestra gente sea asimilada, si es que esto ocurre.

Carlos Callejo
Entrevistado por Mike Juárez
Estudio Callejo, Canutillo, Texas
2 de junio de 1993

Nací en El Paso y me crié en Ciudad Juárez, Chihuahua, desde la edad de cuatro a nueve años. Nací en 1951 en la Clínica San José en el Segundo [Barrio], que ahora es la Casa de la Anunciación [un refugio para desamparados]. En noviembre u octubre de 1987, fui contratado como trabajador social por la Clínica La Fe. David Romo [fundador del Centro Educativo Southside] me preguntó si yo quería pintar un mural. Yo estaba haciendo el mural que nosotros hacíamos entonces. El llegó adonde estábamos. La cosa de la Galería Bridge [*Cuántos hermanos (han muerto)/How Many Brothers Have Died (Crossing the River)*, 1987]. Empecé el proyecto con dos semanas de retraso. Habían comenzado ya a reparar los callejones, ¿te acuerdas?

Teníamos unos 18 muchachos trabajando en el mural. La mayoría eran los muchachos de siempre. Me gusta involucrar a los jóvenes en el proceso total de pintar un mural, y no sólo en pintar el muro. En para ese mural en especial, los muchachos intervenían en la selección del tema. Antes de empezar el proyecto, les había dado una tarea, la de pensar en algo que podían pintar y no limitarse al área inmediata, o sea el barrio, sino pensar a nivel nacional y universal. Me trajeron muchas sugerencias positivas, preocupaciones como la guerra nuclear y otras parecidas.

El que más me llamó la atención fue un tema propuesto por una señorita que se acababa de graduar de la preparatoria Bowie: su idea era que a pesar de los avances de la tecnología en todo el mundo, todavía había niños que se morían de malnutrición. Así surgió el concepto, pero naturalmente no queríamos insultar a nadie con imágenes negativas de niños hambrientos. Más bien, representamos a la humanidad en forma de niños que jugaban en la luna o que controlaban la tecnología, pues la luna simbolizaba la tecnología.

El mural luego fue borrado y recubierto de pintura, y eso me duele porque no lo consideraba como una obra mía, sino como una obra que pertenecía a la comunidad. Los muchachos tuvieron mucho que ver con su origen. Cuando yo empecé a pintar murales [en Los Angeles] era una cosa de mucho prestigio que uno de tus murales fuera borrado y recubierto. Un mural era borrado cuando había hecho el suficiente impacto. Pero *Niños en la luna* pertenecía a los muchachos y no a mí. Después de eso empecé a trabajar en la

[Clínica] La Fe, en el verano de 1988. Yo ayudé a diseñar el mural [*En memoria de Rubén Salazar*, 1988, Complejo Habitacional Salazar, Edificio 31, avenida Cypress #1000]. Pero los muchachos lo pintaron todo. En esa obra no hay ni una marca con lápiz ni una pincelada mías. Los muchachos fueron quienes realizaron el diseño.

Trabajábamos con dos grupos de muchachos. Un grupo había sido contratado bajo el programa de empleos de verano para jóvenes, mediante el Consejo de Industrias Privadas, y el otro grupo estaba compuesto de muchachos del Segundo Barrio que habían sido reclutados para participar en un programa educativo sobre el SIDA. Este programa les enseñaba a los muchachos cómo resistir las presiones creadas por los compañeros de su misma edad, o sea que los muchachos enseñaban a adolescentes en lugar de que los adultos enseñaran a los muchachos. Era también una oportunidad para enseñar de una manera no tradicional.

Era un triple proyecto. A los muchachos se les dividió en tres grupos. Un grupo trabajó haciendo un video informativo. Otro produjo una obra de teatro, que representaron en las escuelas de los distritos de El Paso e Ysleta. El tercer grupo, que era el que coordinaba yo, era el proyecto mural, que también advertía sobre los peligros del SIDA.

Eso fue en 1988. El mural sobre el SIDA [en la cuadra 800 de la Sexta Avenida] estaba dirigido a los jóvenes que habían abandonado la escuela y que corrían varios riesgos. El mural se valía de métodos no tradicionales para prevenir a estos jóvenes en contra de los riesgos del SIDA, utilizando el tornado [en el centro del mural] como símbolo del virus del SIDA, y había gente alrededor del mural tomando parte en actividades de alto riesgo. En el extremo izquierdo del mural se aprecia a unas personas que buscan refugio, pero a través de la unidad y de los esfuerzos colectivos tal vez podamos vencer este fenómeno del SIDA. Al otro extremo se ven unas avestruces, escondiéndose en la tierra, que representan a los políticos. Muchos expertos en medicina creen que si no fuera por los políticos que enterraban la cabeza en la arena, esta epidemia no hubiera asumido proporciones tan grandes.

Después del mural del SIDA pinté el mural de San Miguel, financiado por el Consejo de Arte del Condado de Doña Ana. Se pusieron en contacto conmigo primero porque habían obtenido unos fondos para el proyecto. Tenían otros artistas en mente. Pensaban patrocinar tres proyectos diferentes con tres artistas distintos. Querían un mural en el Centro Comunitario de San Miguel [Nuevo México], pero el artista nunca había pintado un mural. Fui a hacer una presentación para la gente del Centro, y eso fue todo. Más adelante el otro artista se retiró y me llamaron a mí para ver si todavía estaba interesado. Yo sí tenía interés, pero el dinero estaba muy limitado. Era éste un proyecto de verano; los muchachos estaban tomando cursos de arte. Juan Lucero estaba enseñándoles el método de cuadriculación. Después de aprender este sistema, decidieron hacer el mural. Programamos reuniones con algunos de los ancianos, quienes nos relataron sus historias e impresiones de lo que el valle significaba para ellos. En base a esas historias, los

muchachos pudieron idear los conceptos. Había muchachos de todas las edades: el menor tenía ocho años y el mayor 18. Asistían a escuelas primarias, secundarias y preparatorias.

Los muchachos del campo no se enorgullecían de su herencia como trabajadores agrícolas, pero después de hacer el mural sí desarrollaron un sentido de orgullo [de esa herencia]. En ese mural hay dos trabajadores agrícolas que sostienen al mundo, porque si no fuera por los trabajadores agrícolas, no tendríamos comida en nuestras mesas. Así, los muchachos empezaron a ver a los trabajadores agrícolas desde otra perspectiva. Los murales tienden a cumplir múltiples propósitos. Uno de éstos es llenar los huecos: en San Miguel esta experiencia ayudó a llenar los huecos entre las edades porque los ancianos hablaban con los jóvenes acerca de la historia de San Miguel.

El proyecto comenzó en 1988. A los muchachos se les pagaba mientras se les enseñaba, pero trabajaban en el mural por la mayor parte como voluntarios. El mural de San Miguel tardó más tiempo en terminarse porque trabajábamos sólo los fines de semana. El proyecto siguió hasta finales del invierno. No había fondos dedicados a la preservación del mural. Por eso se está destiñendo el azul, porque compramos la pintura en Ciudad Juárez. No teníamos dinero para comprar pintura. También pintamos sobre madera. La madera no estaba bien aprestada. Y luego llegaron las lluvias y se aplicó un recubrimiento impermeabilizante a la madera, pero así quedó peor la cosa porque empezó a resquebrajarse en todas partes.

En 1989 vino el Dr. Tom Drescher para asistir a un congreso de muralistas en Las Cruces y lo invité a que dirigiera la palabra a Los Murales. Los comentarios que hizo eran de carácter político. Había muchos artistas allí—Carlos Rosas, Felipe Adame y yo, algunos de Los Murales y Adair Margo. El les dio algunas ideas en cuanto a cómo establecer normas para que el proceso de solicitar resultara justo. Algunas de sus ideas fueron puestas en práctica, otras no. Pero nada quedó decidido de forma permanente. Así es como empezaron Los Murales.

No creo que las normas propuestas por el comité asesor de la comunidad fueran llevadas a la práctica. No se formalizó nada, ni siquiera la forma de solicitar para realizar murales. En los proyectos que yo he hecho, generalmente han venido a pedirme a mí. Pero está muy claro que hay que trabajar con muchachos. Una vez entregué el contrato después de haber terminado el mural. En cierta forma está bien, porque mantiene a raya la burocracia y se logran más cosas. Con el tiempo, estará bien.

Yo creé el mural del Ejército de Salvación [*Personajes de libro de cuentos*, 1989, Paisano Drive #4300]. Hice un mural para la escuela preparatoria Ysleta [*La danza, arte universal/Homenaje a Rosa Guerrero*, 1989]. Rosa Guerrero se puso en contacto conmigo porque quería un mural cuyo tema fuera la danza. Eso fue cuando Marta Arat acababa de crear el diseño del poster intitulado *La danza*

es un arte universal. Quedaron muy impresionados con ese diseño y me preguntaron si yo podía hacerlo en un mural. Dije que sí y me pareció una magnífica oportunidad simple y sencillamente porque me agradaba la idea de hacer un proyecto en colaboración. Un artista hace el diseño y el otro pinta el mural. Invitaron a la señora Arat a la inauguración de la obra y le dio mucho gusto porque el diseño era suyo. Le hablaron a ella antes que a mí. Lo manejaron todo a través de Rosa.

Le dije a Cindy [Farah] que en los folletos de Los Murales y los agradecimientos mi nombre aparece unas tres veces, que es bastante. Y una de las primeras menciones es *El Chuco y qué*, con el que realmente no ayudaron. Yo no les estaba ayudando a estructurar y desarrollar su programa, y quería comenzar a ampliar mi propio repertorio, de modo que les dejé que me ayudaran con la dedicatoria.

Los Murales pusieron la comida y los paracaídas para la inauguración y esas cosas, para que les tocara un reconocimiento. Pero ahora se les está dando más crédito que simplemente eso, y deberían aclarar el papel que han desempeñado. No fueron más de un par de cientos de dólares. Ese no debe contar, pero fue uno de los primeros. *El Chuco y qué* fue patrocinado por ARD [Departamento de Recursos Artísticos de El Paso] y la Clínica La Fe a finales de 1989. Fue la primera vez que John Valadez visitó El Paso. Era invierno, y me acuerdo que yo llevaba guantes y sombrero para pintar el mural y había nevado.

También pinté un mural que doné a la escuela secundaria Canutillo. Pinté dos murales más sobre lienzo para los banquetes de instalación de la Cámara de Comercio Hispana en 1992 y 1993. En la primera de estas ocasiones vino y habló el actor Eddie Olmos ante el grupo; la segunda vez habló el actor Anthony Quinn.

El título del mural para el primer banquete es *El umbral de la sabiduría*. Mide 20 por 11 pies. Tuvimos que pintarlo en una fábrica porque no cabía aquí en mi estudio. Hace un año y medio de eso. El mural para el segundo banquete medía 20 por 9½ pies. También el año pasado pinté un mural para Greg Acuña, el propietario de Superior Solutions, intitulado *Labores del algodón*, que mide 5½ por 16 pies.

Luego pinté el mural para el Centro de Detención [para Menores] [*Escoge tu destino*, 1993], para lo cual hacía falta un poco de diplomacia. En esencia, entrevisté a los muchachos, y en base a las historias que me contaban los detenidos fui definiendo el concepto, aunque hubo objeciones y había que llegar a un acuerdo haciendo concesiones. Cambié algunas cosas pero otras no. Les dije que no se podían cambiar porque eran las ideas de los muchachos y no creía yo que fuera de mi competencia el cambiarlas. Acabaron por aceptarlas. Para mi sorpresa, los empleados me dieron mucho apoyo y ayuda, debido a la naturaleza del centro. Los

fondos los dieron la Junior League y el Departamento de Libertad Vigilada para Menores. Había unos 30 muchachos del centro que trabajaban en el mural en diferentes turnos.

Me parece que yo he desarrollado un estilo propio. Cuantas más obras realizo, más se distinguen, sólo los murales. Tratándose de mis obras de caballete y de estudio hay más variedad porque creo que soy muy versátil en lo que se refiere a los estilos. En los murales estoy comenzando a desarrollar un estilo característico, y es un proceso de refinamiento. He llegado a la etapa en que creo que me gustaría hacer otra cosa, la etapa de realizar trabajos diferentes, incorporando otros estilos. Las pinturas de caballete tienen más refinamiento, y los temas son más suaves, no tan dramáticos. De alguna manera, el que ve estas obras debe sacar sus propias conclusiones. En cambio, las imágenes y símbolos en mis murales son más fáciles de comprender, mientras que mi pintura de caballete es más subliminal.

El mural de la Corte del Condado de El Paso [*Nuestra historia*] es esencialmente histórico. En cuanto a las imágenes, debí hacer frente al dilema de que el espacio es reducido. Para que los murales tengan un gran impacto, tienen que representar grandes imágenes. Si yo pintara sólo imágenes grandes, ocuparían la mayor parte del espacio, y así se restaría mucho espacio de los elementos históricos que he planeado incluir. Tuve que decidir si iba a crear una obra estética o un mural informativo-histórico. Tuve que transigir. Tuve que pasar por un proceso de eliminar algunas de las imágenes históricas. Me pregunté cuáles de ellas se podrían quitar. Todavía había abundante información, así que reduje la cantidad de imágenes. Para comunicarlo todo, formulé el diseño y el concepto en forma de una especie de collage. Pero funciona. Hay mucho flujo, mucho movimiento, y todavía existe un concepto planeado detrás de la obra: todo cabe donde debe, aunque parezca collage. Opté por crear un collage de imágenes porque las paredes tienen sombras proyectadas por el marco que sostiene el vidrio en el atrio. Estas sombras están en constante movimiento.

Yo preveo que participará mucha más gente. Acabo de ir ayer a una inauguración donde no había más que gente joven en la ceremonia de develación [*Murales en el mall*, patrocinado por Recursos Artísticos y la Junior League]. Preveo que habrá más artistas que van a intervenir. Están formándose. Van a traer nuevos estilos y formas. Creo que la principal influencia a nivel local ha sido de los artistas de El Paso o los distintos períodos en El Paso, muy característicos de esta área. Creo que esto va a cambiar. También creo que habrá mucho más apoyo. Ahora estamos en una cumbre, estamos avanzando. Para mí, ese apoyo y ese interés van a dejar de crecer porque la gente va a decir, "Ah, ¿otra vez un mural?" Es la saturación. Por eso pido obras innovadoras, no sólo en el estilo sino también en las técnicas. Tal vez unos bajorrelieves murales. Quizá mi idea que estoy proponiendo de poner un espejo ovalado en uno de mis murales. La gente llega a formar parte de la obra porque se ven a sí mismos en el espejo. Ese tipo de cosas. Incluir unas

imágenes donde se toman algunas fotografías de fuera de la pared, de manera que haya un intercambio. Hay un intercambio físico. Todas esta cosas vienen en camino. Pero en este momento no quiero animar a los recién llegados a seguir este camino porque todavía necesitamos crecer y superar esta etapa. Debemos refinar nuestro estilo, tomarlo más en serio. Debemos llevarlo al más alto nivel de calidad, y entonces podremos seguir adelante.

Las obras tienen validez por sí mismas. Creo que es un asunto delicado. Yo diría que sería mejor dejarlo sencillamente al criterio individual. Si el individuo no hace un mural de suficiente calidad, no se le pedirá que haga otro. El artista puede hacer sus obras buscando una autoexpresión o por necesidad económica, pero en todo caso tendrá que exigirse una mayor calidad de trabajo. Quiero decir que el artista debe desarrollar para sí unas normas de trabajo superiores. Jan Wilson [investigadora de murales en el Segundo Barrio] tiene razón: a mí siempre me ha hecho reflexionar la cuestión de la calidad. Yo le animaría a cualquier novato a crear obras, sin importar el nivel de su trabajo, porque todavía tiene validez. Cuanto más hace uno, mayor es su crecimiento.

Es muy difícil juzgar. La calidad de los murales como "arte" ha sido cuestionada con mayor frecuencia que la autenticidad de su expresión. Este escepticismo es natural en parte, porque los murales son un fenómeno [relativamente] nuevo, disparejo, disperso, y en el mejor de los casos semipermanente y de calidad variable. De hecho, resulta difícil adquirir la suficiente perspectiva como para juzgar bien. Al mismo tiempo, el silencio por parte de los críticos obedece en parte a prejuicios sociales y un desconocimiento de la estética de las pinturas murales. Con demasiada frecuencia los voceros del "mundo artístico" oficial clasifican a los murales de la manera más cómoda, como estereotipos del folklore, como arte de protesta y como arte minoritario, arte pobre para gente pobre, para no tener que estudiarlos en serio.

Sin embargo, los murales no son sólo expresiones de protesta ni simplemente pinturas de grandes dimensiones en las paredes: son pinturas fusionadas con la arquitectura, arte público concebido en un espacio dado, arte arraigado en un contexto humano específico. Los murales son obras de arte que hablan de temas y preocupaciones sociales. Constituyen una forma artística por derecho propio, y desde hace demasiado tiempo están faltando perspectivas críticas serias y encargos importantes.

No se le puede llevar a las calles simplemente. Hay una diferencia entre el arte por el arte y el arte con arraigo en el contexto social humano contemporáneo. Hay que llevarlo a las comunidades y los contextos, porque las raíces de los murales hablan de la dignidad de la gente, de sus luchas, sus necesidades y la celebración de tradiciones y la dignidad de nuestra cultura.

Tal vez falten lugares para encontrar el material, pero a veces uno puede encontrar bastante para empezar a ir hilvanando la historia. Se podrá observar la ignorancia, la falta de interés en contar estas historias, sobre todo para nuestras áreas. Creo que es

importante para El Paso, y aunque suene exagerado, este país le debe mucho a El Paso. Muchas cosas han surgido de esta área a las cuales no se les ha dado el reconocimiento que se merecen. Cada vez que hago investigaciones en diferentes archivos, veo cosas que han sido importantes, especialmente cuando dicen que nos falta identidad. Eso no es cierto, carajo.

Hay una declaración del artista que yo escribí para una obra que me encargaron y que quisiera incluir en esta entrevista. En los sesentas me dejé llevar por las energías callejeras, que al parecer no he podido abandonar. Comprendí que durante esos tiempos mis pensamientos se parecían a los de otros artistas minoritarios de la época, pues creía que en general nuestras fuentes de financiamiento y nuestras instituciones académicas de arte no nos apoyaban y tenían muy poco compromiso con los proyectos culturales y comunitarios. Llegamos a depender de nuestros propios recursos, de nosotros mismos, de nuestras comunidades. Estos recursos empezaron a ser y todavía son, para mí, la inspiración primordial para los temas de nuestro arte, que habla de la historia y la cultura, de las tradiciones y celebraciones, de las necesidades y las luchas, de la dignidad y de las aspiraciones y los proyectos de la gente—una visión de un futuro exento de guerra y de explotación. Yo he hecho arte utilizando una variedad de técnicas, pero el éxito y el reconocimiento me han llegado principalmente por medio de la pintura mural.

Los murales pueden ser un medio maravilloso de llegar a miles y miles de personas, ya que están situados en lugares públicos y están al alcance de todos. Son una forma magnífica para educar e inspirar. Los murales tienden a sentir una necesidad de comunicación honesta entre todas las personas en un nivel no verbal. Los muralistas transmiten muchas veces ideas que con demasiada frecuencia pasan inadvertidas por nuestros políticos y medios de comunicación o periódicos, ideas que necesitan ser exploradas abiertamente. Yo en especial veo en los murales mucho más que simples adornos. Aunque es innegable que los murales aportan colorido a un barrio, éste no es el objetivo principal mío o nuestro. A mi parecer, los muralistas más impactantes son los que utilizan los colores y las formas no como productos finales, sino como herramientas para comunicar un tema específico, el cual encuentra su expresión mediante simbolismos fácilmente comprendidos por un público general en lugar de una audiencia privada, empleando símbolos personales o esotéricos interpretables sólo por minorías selectas. Los murales que hablan con la auténtica voz de su comunidad sobre preocupaciones sociales son verdaderamente inspiracionales, tanto para los artistas como modelos a imitar, como para la comunidad en calidad de monumentos a sus luchas y aspiraciones.

Manuel Gregorio Acosta
Entrevistado por Cynthia Farah y Mike Juárez
Estudio Acosta, calle Buena Vista #366, El Paso
27 de mayo de 1988

Hay uno [un mural] en la calle Lisbon. Fue realizado mediante los esfuerzos de Aliviane [un centro de rehabilitación para drogadictos]. Algunos de los concejales del municipio estuvieron presentes cuando lo inauguramos. Lo pintaron los muchachos que viven en los apartamentos. El tema viene del poster de Helguera [véase el Apéndice D]. ¿Conocen ustedes al famoso Jesús Helguera, de México, con todos sus hermosos indios y leyendas? De repente, todos le copiaban a él; el guerrero junto a la doncella fallecida. Pintaban este tema en el mural. Les dije que hicieran otra cosa, que no copiaran, pero eso [pintar murales] era una cosa muy nueva para ellos.

Así que lo copiaron, bastante mal, pero hicieron el intento. Yo les ayudé como pude. Nadie más lo tocó; lo hicieron todo ellos mismos. Para que vean. Hay otro mural en la calle Carolina, al norte de la Alameda. Es otro complejo habitacional. No sé el título, pero fui a observarlos mientras lo pintaban. Chevo Quiroga te puede llevar a por lo menos cuatro que yo sé que han hecho juntos. Pueden preguntarle a Alicia Chacón, porque [como concejal del municipio] ella tuvo algo que ver con algunos de ellos. Ella siempre asistía a las recepciones y las inauguraciones. Y por supuesto, ustedes ya conocerán todos los murales del sur de El Paso.

Hay uno horrible cerca de la autopista y la calle Stanton [*Cuantos hermanos (han muerto)/How Many Brothers Have Died (Crossing the River)*, 1987]. Desocuparon el edificio y les dejaron a varios artistas hacer de las suyas. Es un desastre. No tiene ni pies ni cabeza. En el interior del restaurante Cerezo, cerrado desde hace tiempo, había dos murales de Felipe Adame [basados en la serie de *La leyenda de los volcanes*, de Jesús Helguera]. Estaban en las paredes. No sé qué se hicieron. Creo que el edificio sigue allí. En un tiempo tenían buena comida. No sé por qué cerró. No se me ocurre otra cosa.

Empecé a trabajar en el mural para [la Clínica] La Fe [*Nosotros, el pueblo*, 1988] en marzo, me parece. Tenía muchas fotografías de todos los procesos. Sí, pienso que antes, si algo se iba a hacer, yo tendría los documentos y fotografías, que yo mismo había sacado. Todas a color. Hay muchas de ellas en secuencias. Así que si más tarde alguien quisiera armar la cosa como empezó, desde los dibujos hasta la gente que posaba y todo eso, ¡szss! ¡Fotografías!

Cuando me dijeron que tendríamos un pequeño muro ahí y muy poquito dinero, pues dije sí, el sur de El Paso. Fui a ver el muro, un reto, y comprendí que ésa era una oportunidad en que de veras podía ordenar mis pensamientos sobre dónde vivía yo y de dónde me ha venido siempre la inspiración: el sur de El Paso. Me dije: ¿por qué no lo meto todo en este mural? Ellos dijeron: "Tenemos personajes históricos". De modo que pinté a algunos de ellos y también a mis sobrinos y toda la cosa. Incluí al dueño de la tienda de comestibles, al soldado, a mi abuelita y luego una mesa de banquete, que muestra el gusto de haber nacido y haberse criado [en el Segundo Barrio] con las tradiciones que todos trajimos de México: están representadas sobre la mesa de banquete la comida, la fruta, las flores, la alegría—¡todo está allí! Esa fue mi oportunidad para poner [en el mural] mis propios sentimientos. Aquí puse pan dulce. Mi perrito Pati estaba allí; ya creció.

Cuando lo contemplan van a ver pequeños pedazos de—y les di un chasco a todas estas gentes. Les pregunté si de veras habían buscado. Sí, hemos buscado en todas partes. Pero hay un ratón escondido en alguna parte del mural. Decían que no lo habían visto. Y yo no le voy a decir nunca a nadie.

Hice el mural [en mi estudio]. Vino mucha gente a verlo, iban y venían. Muchísima gente. Tenía dos pedazos de masonita que medían 16 pies de largo y cuatro pies de ancho, pegados en la parte de abajo. Agregué un armazón de madera. Trabajé en él, en el andamio, cables, ollas y cacerolas, y terminé. Luego lo cambiamos para acá [apuntando hacia el extremo del estudio] para que James Dean, un fotógrafo de la compañía de gas, pudiera fotografiarlo, porque era el único ángulo desde el cual cabía todo en la foto.

Así que ésta es la única fotografía perfecta del mural, porque el fotógrafo yo no pudo captar la misma perspectiva. Resultó fácil: movimos todo el armazón con unas dos cajas de cerveza y unos sandwiches de carne, pero lo conseguimos y se tomó la fotografía. Luego lo transportábamos [a la Clínica La Fe] los fines de semana porque hay gente enferma todo el tiempo. Esa es una de cosas que tienen las clínicas.

Allí entré varias veces y alguien me tomaba el pulso y yo les decía: "¡Oye, todavía estoy calientito!"

Hay ocurrencias para todas las ocasiones. Así que permanecen ahí sentados y lo contemplan, y claro que por eso está, y les ayuda. Le puse mucha alegría, nada deprimente en lo absoluto porque sabía adónde iba a parar. Y es pacífico, comunica consuelo. Y nadie espera más de 20 minutos. Hay un letrero que dice: "Si Ud. espera más de 20 minutos, avise al gerente". Es una hermosa operación. Y el mural intensifica el efecto. Si tienen la oportunidad, tómenle una fotografía.

Voy a organizar un concurso cuando tenga unos 90 años, y si nadie ha pintado graffiti en el mural—es asombroso, pero han respetado el mural. Al principio, sucedía como todas las cosas. Entraban ¡y no lo veían! Es verdad, entraban como si nada. Así que el Dr. Domingo Reyes se enojó y dijo: "¿Por qué entra la gente sin darse cuenta?" Por poco se apoyan en él sin fijarse. Por fin, comenzaron a verlo, y así siento mucho orgullo.

Mario Colin
Entrevistado por Mike Juárez
Parque Memorial, El Paso
17 de septiembre de 1994

Soy un artista local de El Paso. Nací en Ciudad Juárez, pero vivo aquí desde la edad de tres años. Antes vivíamos cerca de las calles Findley y Piedras [en la zona central de El Paso], pero luego nos cambiamos al área de Five Points, donde asistí a la escuela Houston. Después fui a las preparatorias Austin y Bowie. Desde que era niño me ha interesado el arte. En la escuela me gustaba dibujar. Cuando me gradué de la preparatoria, para mantenerme me dedicaba a hacer trabajos de construcción durante unos diez años. Pensé que iba a ser carpintero por el resto de mi vida. La carpintería es creativa también, y valiosa. Cuando tenía 27 años, creí que iba a poder vender algunas de mis obras de arte. Quería tener algo que hacer durante la vejez, así que decidí ser un artista y desde entonces me he dedicado a ello. De eso hace por lo menos ocho años.

A ti te conocí primero en la Galería Bridge. Yo acababa de llegar a la ciudad y no conocía a ningún otro artista. No conocía ninguna técnica; mis obras eran crudas. Trabajaba con lápices número dos y dibujaba en cualquier pedazo de papel. Aprendí mucho estando en la Galería Bridge. Decidí ser voluntario allí porque necesitaba espacio para mi arte, y Al [Harris], el director de la galería, me brindó la oportunidad de conocer a muchos artistas y hacerles muchas preguntas. No estudié para ser artista. Aprendí varias técnicas preguntando y observando a otros artistas.

La exhibición "Obras en papel", patrocinada por la Asociación de Arte Juntos en 1987 [en la Galería de Recursos Artísticos en el Palacio de Gobierno Municipal de El Paso], fue la primera ocasión en que expuse mi obra. Antes de eso, yo nunca había participado en una exhibición. En realidad, tú me invitaste a exhibir. ¡Fue maravilloso! La primera vez que presenté mi obra. Me hicieron muchos comentarios muy positivos. En adelante, la gente empezó a fijarse y me invitaron a figurar en otras exhibiciones con artistas profesionales. Entonces me consideraba todavía un aficionado. Aún no había vendido muchas obras.

Por haber participado en la exhibición "Obras en papel" conocí a Chuck Zavala y también a Joan Shepack. Ella le animó a su esposo, el Dr. John Shepack [presidente del Colegio Comunitario de El Paso] para que me ayudara a inscribirme en cursos de arte en el colegio. Ellos me dieron una beca para asistir a un ciclo de verano. Uno de mis maestros fue Philip Behymer. El me influyó y me

enseñó muchas técnicas que por cuenta propia yo habría tardado años en aprender. Yo ya tenía mi estilo. Allí empecé a aprender acerca de la pintura y la pintura mural. A través del fotógrafo Rigoberto de la Mora conocí al artista Chuck Zavala.

Un amigo mío era propietario de la tienda en las calles Piedras y Sacramento [la tienda de abarrotes Esparza]. Quería que yo pintara la Virgen de Guadalupe con las banderas mexicana y norteamericana en el fondo. Le dije que pintaría la Virgen pero que no quería meterme en política. Yo ya había pintado un mural en el Colegio Comunitario de El Paso, pero todavía no sabía mucho que digamos acerca de la pintura mural.

En 1988 pintamos [el mural en el recinto Valle Verde del Colegio Comunitario] en la sala de computación; se intitula *Datos procesados visuales*. El mural estaba en tres paredes, para representar el pasado, el presente y el futuro de las computadoras. Esa fue la primera vez que pintaba un mural así de grande. Después pinté la Virgen de Guadalupe. Necesitaba ayuda, y en realidad todavía no sabía por dónde comenzar. Chuck Zavala, que manejaba muy bien los colores y tenía estudios formales y sabía de técnicas, me ayudó. Pensé que íbamos a hacer primero un dibujo, pero Chuck sacó la pintura desde el primer día y se puso a pintar. Eso me impresionó bastante, porque yo era más tímido. Le entramos con ganas. El primer día ya teníamos una parte del mural hecha y comenzamos a agregarle los detalles. Ambos pusimos lo mejor de nosotros: los colores de Chuck le salían muy bien y yo con mi técnica de pintar, y luego agregamos rosas alrededor. ¿Sabes? Las mamás de mis amigos que nunca antes me habían hablado, que creían que yo era una especie de delincuente, de repente se portaban muy amables conmigo, como si yo hubiera hecho algo positivo por la comunidad.

Pintamos el mural en septiembre de 1989. Tardamos más o menos una semana en terminarlo, y eso porque al final le poníamos menos empeño. Trabajábamos un día y descansábamos un par de días. A raíz de que terminamos el mural, en noviembre de 1989, se murió Chuck. Se murió de cáncer. Para entonces el mural se había convertido en un santuario. Me asombraba porque la gente iba allí y se persignaba. Qué raro, estábamos pintando y de repente aparece la Virgen. Se persignaban.

El dueño del terreno, Sr. Raúl Meza, les encargó a los hermanos Ortiz, del Valle Bajo, construir la gruta. La construyeron y vino el cura a bendecirla. La tienda cambió de dueños, y los nuevos propietarios instalaron iluminación para que se pudiera ver de noche. El santuario era cada vez más grande. Ahora la gente lleva flores y echa monedas de a centavo a la Virgen. Se ha convertido en un santuario de barrio—es un sentimiento muy positivo. Se conserva en bastante buen estado. Así es como le entré a la pintura mural. Al principio dibujaba, principalmente con lápiz, buscando un realismo fotográfico, pero en realidad lo que quería era pintar murales.

Habían encargado un mural en las calles Eucalyptus y Magoffin [*La herencia hispánica y los desamparados*] primero a Carlos Callejo, pero él estaba muy ocupado. Querían que él lo pintara, pero él me preguntó si yo quería solicitar para hacerlo. Me presentó al dueño. Le enseñé algunas de mis diseños y dibujos a lápiz. Le enseñé mi Virgen, y parecía gustarle mi obra. En el momento de mi entrevista, él recibió una llamada informándole que su esposa estaba embarazada, y eso me ayudó mucho porque él se puso contentísimo. Me dijo ahí mismo, "Tú tienes el trabajo", pero todavía había que hacer los trámites con Los Murales porque ellos iban a pagar la mitad del costo. Me dieron cinco mil dólares para pintarlo. Cinco mil por todo. ¡Regalado! Los cinco mil incluían la pintura, el andamiaje y todo lo demás. Cinco mil dólares. Les salió barato.

Empecé a pintar el mural en 1990. Tuve que someter el diseño. Querían un diseño a color, pero para mí presentar un diseño a color inhibe el proceso creativo. Con un dibujo a lápiz creo que disfruto de mayor libertad para crear lo que yo quiero. Querían un cartón a colores para el mural. Todo iba incluido.

Yo tenía también otro dibujo sobre el tema de los desamparados, la gente que vive en la calle, y quería incluirlo como parte del mural. Me habían hecho muchos comentarios favorables acerca de este dibujo; a la gente le gustaba. Yo había tenido siempre la intención de convertirlo en un mural, y ésta era mi gran oportunidad. Se lo propuse [a Los Murales], pero les pareció una imagen negativa. Se les hacía que no iba a encajar, porque al otro extremo habría imágenes positivas sobre aspectos chicanos: su experiencia, la religión, la familia y la historia, las artes y la música, y del otro lado iban a estar los desamparados.

Eran en realidad dos murales distintos [uno intitulado *Los desamparados*, de frente a la calle Eucalyptus, y el otro intitulado *Herencia hispana*, de frente a la avenida Magoffin, vinculados los dos por un diseño geométrico.

Tardamos mis amigos y yo seis meses en hacerlo. A veces me tomaba como una semana libre. Al principio nos faltaba el andamiaje. De hecho, el lado de Magoffin lo hicimos utilizando escaleras y escaleras plegables con una tabla en medio. Lo colocábamos encima del carro de mi amigo Greg García. Usábamos el carro de él todas las noches cuando había poco tránsito, porque en ese barrio hay mucha circulación y entraban y salían del edificio muchos camiones de carga. Teníamos que luchar contra el ambiente para pintar el mural. Era como intentar estudiar al aire libre y leer un libro en la esquina de una calle muy transitada. Teníamos que concentrarnos, y al mismo tiempo sucedían todas esas cosas a nuestro alrededor. Ibamos por la noche y trabajábamos cuatro o cinco horas, y eso era todo lo que podíamos hacer. Greg García, Chilo Meza, Raúl Meza—éstos son hermanos—y Ernesto Ruiz también me ayudaron a pintar el mural. Greg sabía algo acerca del arte, pero los demás no. Simplemente tomaron la decisión de unirse al proyecto. Ni siquiera tenía yo dinero para pagarles porque los fondos eran muy limitados.

Yo había pedido opiniones, no tanto en ese mismo barrio, sino a mis amigos, les pedía su parecer. También miré hacia adentro, dentro de mí, porque soy parte de la experiencia. Me pregunté qué sería bueno para la gente. Pensaba mayormente en los muchachos que van a crecer allí. Quería pintar imágenes positivas para los muchachos, para infundirles una mayor autoestima y un orgullo por ser quienes son. Ese fue mi principal objetivo.

Utilicé acrílicos, Novas [NovaColor], para pintar el mural, pinturas Nova de California.[77] Carlos [Callejo] me consiguió la pintura. No escatimé gastos. Gasté mucho en la pintura. Hace ahora tres años, y la pintura aún se conserva en buen estado. Los colores todavía están ahí. Le da la luz del sol durante todo el día.

¡La respuesta de la comunidad ante el mural fue maravillosa! Mucha gente me dice que es su mural favorito. Cuando pintaba el mural, era la gente la que me daba ánimo para seguir. En muchas ocasiones pensé qué bárbaro, en qué lío me he metido, nunca la voy a hacer. Era un muro grande. Luego pasaba alguien en su carro y pitaba y me hacía una señal de aprobación con el dedo hacia arriba, y eso me levantaba el ánimo y me estimulaba como no te imaginas. Luego también hay los críticos.

El único problema que tuve mientras trabajaba en el mural fue que no tenía dónde guardar la pintura y el equipo, así que acabé guardándolo en el techo. Había muy poco dinero. En esa época este mural era el más grande de El Paso, más grande aún que Entelequia, de Carlos Rosas. Mi mural tiene unos 2,000 pies cuadrados más que el de él. Gasté todo el dinero que tenía para terminar el mural. Lo mejor que salió de todo aquello fue que por fin mi obra quedaba expuesta. He hecho muchas otras obras, pero se me conoce por haber pintado ese mural. Es curioso, como te dije, la esposa de Greg [Acuña] estaba embarazada cuando me adjudicaron el mural, y cuando tuvimos la ceremonia de inauguración ya había nacido el bebé.

Desde entonces he pintado mayormente retratos, murales para restaurantes, letreros cuando sea necesario, pero nada realmente importante. Todavía tengo esperanzas de que me encarguen otra obra grande. El mural de Magoffin y Eucalyptus sigue siendo mi proyecto más importante. Acabo de pintar un mural para el restaurante italiano Capetto's y otro para el Old West Steakhouse [and Pub] y otras Vírgenes de Guadalupe para individuos. Siempre me están pidiendo que pinte la Virgen. Pinté una para la Iglesia de Santa Lucía y varios murales religiosos para los patios de casas particulares.

Definitivamente hay espacio para más murales en El Paso. Los murales parecen estar de moda ahora. Creo que la gente necesita identificarse con su medio ambiente de la misma forma en que los muralistas necesitamos pintar lo que la gente acepte. Si no les gusta el mural, lo van a estropear. Mi obra es un reflejo de la época y de las personas. Los murales son para todo el mundo. Las obras que hago en mi estudio son diferentes de mis murales. Las obras que hago en el estudio están más centradas en mí mismo,

mientras que los murales son arte público. Debemos seguir mejorando la calidad de nuestras obras. Mucha gente piensa que los murales y el arte de la calle son una misma cosa, pero es una de las bellas artes por derecho propio. Muchos creen que los murales son proyectos que se les dan a los muchachos durante el verano para que no anden en la calle, pero los murales deben de ser de alta calidad, una calidad que provenga de artistas diestros. Para mí, los murales no son un recreo. Debemos ser más exigentes con nosotros mismos. John Valadez acaba de dar el máximo ejemplo a este respecto para todos los muralistas de El Paso con la obra [*Un día en El Paso del Norte,* 1990-93] que pintó en el Edificio Federal. Es sensacional. ¡Ojalá que un día llegue yo a esa altura!

John Valadez
Entrevistado por Mike Juárez y Mona Padilla Juárez
Residencia Juárez, El Paso
15 de mayo de 1993

Creo que en determinado momento me di cuenta de que quería mantenerme alejado de algunos de los lugares comunes del El Paso nostálgico, donde se ven siempre las mismas fotografías. Ahí están los conquistadores, la época mexicana, la partición de la frontera, las antiguas rutas comerciales, Pancho Villa, imágenes que se repetían por dondequiera, y esto está bien, pero yo quería mostrar cómo todo se ha combinado ahora en la ciudad. Los murales que hice por encargo se encuentran en dos edificios. El del Edificio Federal [*Un día en El Paso del Norte*] muestra un corte transversal de las gentes de aquí. Para el cruce de Ysleta [*Llega la lluvia*], quise mostrar los aspectos rurales y agrícolas de la región, mientras que en el mural del centro se perciben las dos sierras—las montañas Franklin y la sierra de Juárez—enfocándose en el centro histórico de El Paso para hallar los puntos destacados del área. [Era mi intención] hacerlo algo diferente y al mismo tiempo retratar al conquistador o al indígena, el colono anglo, el hacendado español, el agricultor norteamericano; tú sabes, la lucha entre los rancheros y los campesinos, que fue un combate descomunal.

El diseño del mural me lo dejaron a mi criterio. Creo que cuando les enseñé el dibujo a los miembros del comité ellos se sintieron un poquito preocupados. Yo quería reflejar la historia en el escaparate de la tienda y en los espejos, en el tren y en la iglesia de Guadalupe [en Juárez]. Quise incluir más cosas, pero sin agobiarlo de reflejos. En lugar de acumular toda clase de imágenes históricas hasta el exceso, lo que resulta bastante fácil, todavía se puede incluir un buen número de ellas. Todavía estoy intentando poner [elementos variados], cositas arqueológicas, hasta objetos turísticos como las mandalas de los indios. Todas ellas cosas pequeñas que en su conjunto retratan al área [y la familiaridad con éstas] que tiene la gente que se ha criado aquí.

Decidí trabajar en mi estudio por mi familia. Me hubiera gustado pintar el mural aquí, pero hubiera tenido que rentar un estudio y vivir en él durante un par de años. Se me hacía mucho. Si fuera soltero, tal vez lo hubiera hecho, pero con familia es difícil. Me dieron dos años y medio de plazo, pero me va a llevar tres. No son tres años de pintar, sino tres años para investigar, dibujar, construir y estirar el lienzo, aprestarlo, ponerle el yeso y aplicarle el dibujo.

Me dieron cinco meses y medio de plazo para realizar el dibujo. Tuve que aprender cosas acerca del área y hacer el dibujo en cinco meses. No es un tiempo suficiente. Preferí utilizar parte del tiempo para madurar el dibujo y agregarle detalles. Y me gusta la idea de que las cosas se confundan, que mi conquistador no sea correcto desde el punto de vista histórico, cosas por el estilo. Me atraen las escenas del centro. Me interesa el área junto al puente de peaje. Quiero que el mural sea un poco más edificante, en tanto que en mi otro trabajo [hecho en el estudio] hago cuestionamientos de valores, la moral, las clases sociales y otros conceptos y percepciones. El mural [*Un día en El Paso del Norte*] muestra un corte transversal de la comunidad, y la esperanza son los niños que corren por la calle.

La idea era que los jóvenes se van de El Paso, porque aquí las oportunidades son limitadas y ellos acaban trasladándose a diversos puntos del país. Pero al parecer lo que ocurre—y me da gusto comprobarlo después de mis investigaciones—es que después de obtener su educación estos jóvenes regresan. Muchos de ellos vuelven, y eso está bien. Tal vez por eso se está calentando el clima político por acá, porque los alborotadores están regresando, y tú sabes. No voy a mencionar nombres. Me da gusto verlo, y tal parece que desde que empecé mis investigaciones e hice la pintura, tengo una idea y la gente juzgará la obra.

Lo que he observado es una especie de auge positivo por parte de la gente que adquiere una mayor conciencia del lugar. Quizá haya existido siempre durante los tres años que llevo yendo y viniendo, pero yo veo un cambio, aún en ese pequeño catálogo de murales ["Guía de Murales de la Liga Juvenil"] y aún en los últimos años desde que regresé. Se ha abierto el panorama, y esto ayuda a crear oportunidades para los artistas de aquí. Cuando inicié el proyecto me sentí un poco desconfiado porque no quería que nadie viniera de fuera de El Paso para realizar aquí un proyecto importante. Claro que en Los Angeles la cosa era diferente porque allí estamos compitiendo constantemente, pero ¿en El Paso? Aquí las oportunidades están limitadas.

Me sentí muy honrado por haber sido seleccionado, y me doy cuenta de que lo que estoy haciendo representa una gran responsabilidad. Yo soy de Los Angeles, y por eso utilizo esa área del centro. El mural del cruce de la frontera [*Llega la lluvia*] me costó mucho más trabajo porque nunca hago ese tipo de paisajes. No sé nada acerca de los [paisajes e imágenes] agrícolas, y sigo aprendiendo y tratando de dominarlos. Hice una especie de dibujo a lápiz, pero lo importante es mostrar los efectos benéficos del río en esta región del desierto. Ayer que venía llegando, seguí un poco más allá de Fabens por la carretera rural 20 ¡y lo vi! Me emocioné mucho simplemente al verlo: a un lado mío, donde el sedimento del río no llegaba, había sólo arena y matorral, pero del otro lado estaba la finca, ahí mismo. Supongo que esta carretera 20 sigue una ruta que en ciertos tramos viene siendo la divisoria entre el desierto y donde empieza el terreno fértil. Las cosas así de fáciles me emocionan mucho porque me doy cuenta al contemplarlas que

ahí está: ¡la línea divisoria entre el río y el desierto! Es muy hermoso, aún donde el canal de riego pasa al lado de los cultivos y un hombre abre la esclusa y el canal se llena de agua. Para una persona que viene de la ciudad esto es muy emocionante. Lo has leído en libros, tratas de imaginártelo, y luego lo ves: la lucha entre los ganaderos vacunos y los ovinos, y todo aquello.

Los artistas pintan temas bien definidos. Lo chicano, lo méxico-americano de este lado, esa historia, ¿qué quiere decir eso? Para mí, eso es diferente. Y eso en realidad lo tienen que resolver los artistas mismos, porque el público general. . . Nosotros vivimos en una especie de mundo aparte. Intercambiamos información e ideas y temas, pero el público general, creo que ellos piensan que "los artistas de veras están empezando a pintar y hacer cosas", y eso es una ayuda aquí en la región, en la ciudad y hasta en el condado. [Lo que estoy haciendo] tiene que ser bueno, y, en la medida en que está influido por toda la idea de la ida a Los Angeles, creo que eso ya cambió definitivamente, porque ahora no hay tanta oportunidad en Los Angeles como la gente parece creer.

Aquí es difícil conseguir trabajo, pero es difícil en todas partes. Pero aquí, la gente que regresa puede efectuar cambios. Eso es lo que a mí me estimula. Ustedes saben que aquí pueden hacer cambios efectivos, mientras que en Los Angeles acabamos siendo tragados por tantas cuestiones y tanta complejidad. Allí el cambio llega más despacio o desvirtuado.

Existe una tendencia a clasificar [la pintura mural chicana] en una categoría o en otra. Creo que es mejor exhibir nuestra obra, sin esperar hasta encontrar la categoría apropiada. Me parece que todavía es discutible, y tú te entras bajo la clasificación que sea, y encuentras que el trabajo es un desafío. ¿Debes explicarlo de palabra o dejar que las obras lo expliquen? Hay lo que dices y lo que pintas. Por una parte está la expresión y la articulación visual y por otra está la vocal, y a veces, sobre todo tratándose del arte conceptual y abstracto, la obra está bien, pero lo que importa es lo que se dice. A veces la gente responde más ante la retórica que ante la obra misma. Tú te preguntas: "¿Qué es eso?" Y luego, cuando escuchas lo que andan diciendo al respecto, entonces dices: "Ah, ya veo". Algunos lo verán de una manera, pero no necesariamente lo ves tú primero así. Todo depende de las impresiones de la gente y de quién es tu público. Todo este tipo de cuestiones.

Ese es el debate entre nosotros, en el mundo del arte. [Como activistas sociales] siempre se nos desprecia, así que somos sensibles ante muchas cosas. Pero a veces me parece que debemos retroceder un poco porque estamos siendo demasiado sensibles, pero eso está bien. Así soy yo, porque en Los Angeles escucho los debates y las batallas políticas de la pura estética, y las obras institucionales de las clases altas tiene que ver con el arte por el arte. Nosotros estamos desafiando ese concepto. Y se va a producir una resaca. Ellos no lo quieren comprender. Nos apoyan hasta cierto grado. Conseguimos que nos patrocinen el gobierno y la comunidad, y ese apoyo se convierte en un filtro. Tenemos que estar pendientes del contenido e incluso del mercado.

Corremos el riesgo de que las obras pierdan su dimensión política, pero se ha demostrado siempre que eso está mal, casi siempre está mal. Un ejemplo es el mural [*Escoge tu destino,* 1993] que pintó Carlos [Callejo] en el Centro de Detención para Menores [Enrique Peña], que es una obra muy fuerte. Esa obra no la podrías colocar dondequiera. Entré allí con él y la fotografié. Está en el gimnasio. Tiene un montón de vicios y corrupción, y por encima de todo, la muerte. Y están como fundiendo toda esta corrupción y vicios en forma de ladrillos para el futuro y el juez, y todo esto allí en ese lugar donde están estos jóvenes, los que están detenidos por varios cargos, inclusive asesinato, ¿sabes? Siempre estamos intentando enseñarles una iluminación y como castillos en el aire. Es algo así como un monstruo amontonado, en cierta metáfora, así es. Y te lo recuerda, y hay una esperanza en otro sentido que viene desde otra perspectiva en lugar de tratar de negarlo o ignorarlo y decirles a los muchachos, "Olvídense".

[El público no irá a verlo] si no lo fotografían y lo publican en el periódico. Dirán, ¿qué es esto? Se les enseña esto a estos muchachos? Es muy fuerte. Lo que digo es que no hay que transigir siempre con el contenido. Quiero que mi mural [del Edificio Federal] sea edificante. Quiero que la gente se vea a sí misma ahí y se sienta aludida o que perciba el sentido de la ciudad sin ver todo el—se ven algunos de los mismos lugares comunes y estereotipos de la historia que todavía necesitan ser estudiados. Lo ves, pero es muy distinto. Se verá allí un poco más de cómo la vivimos. Eso es el mural: es como un escenario, el centro comercial y luego el paisaje, y nos he puesto ahí a nosotros, el modo como interactuamos, para incluir una muestra representativa del área.

Incluso el conquistador, es probable que sea un guardamontes del Servicio de Parques Nacionales y que monte en un caballo de raza fina en lugar de los caballos que trajeron los españoles. Y la silla de montar es distinta, pero así es como somos de verdad. Cuando acepté hacer el proyecto me di cuenta de que representaba una gran responsabilidad, porque realmente yo no soy de aquí. Pero luego, cuando mi mamá me dijo que éramos de aquí, fue una cosa casi espiritual. De parte de mi papá también tengo primos en Ciudad Juárez. No los conozco ni sé quiénes son. Así que mis familiares de ambos lados de la frontera son de aquí. Vivieron aquí desde 1900 hasta los años veintes. Era gente pobre del campo. Se fueron hacia el oeste, primero a Phoenix y luego a Los Angeles antes de la Segunda Guerra Mundial. Cuando mi madre me dijo esta parte de nuestra historia familiar, me sentí mejor. Me ayudó a sentirme aún más vinculado.

Cuando fui [a San Elizario] durante uno de sus festivales me puse todo nostálgico. Pensé: ¿y si me hubiera criado aquí? ¿Sería yo muy diferente? Tal vez no. Pero sería más tranquilo, porque me gusta mucho la tierra. Es muy solitaria. Supongo que tengo un espíritu solitario. Hay algo dentro de mí que se siente muy cómodo cuando estoy allí—es muy espiritual.

[Nuestra historia] es un gran secreto. Nos inspira mucho cuando la escuchamos. Es muy subversivo que aprendamos nuestra historia, porque nuestra identidad ha estado siempre en duda. No somos como los anglos, pero es algo así como si ellos nos hubieran engañado para que deseemos ser como ellos. Creo que nosotros somos parte de la generación que comienza a cuestionar eso o incluso rechazarlo totalmente. No creo que debamos rechazarlo del todo, porque tenemos que vivir en la sociedad de ellos.

No podemos regresar al pasado. Pero necesitamos aprender la historia de ellos, la perspectiva de ellos, como visitar un museo de historia. Es todo Fort Bliss. Es todo los soldados. Recuerdo que yo vi todos esos telescopios [allí]. En El Paso había más miras telescópicas para rifles que en ningún otro lugar del país. Todo tiene su razón de ser. Yo vi toda una caja llena de miras telescópicas y pregunté: "¿Por qué están exhibiendo miras telescópicas de rifle?" Luego me di cuenta de que esos artefactos habían sido donados por una familia acomodada de El Paso para perpetuar su nombre familiar. Están en un museo ellos y lo que hicieron como familia. Y los mexicanos, la mayor parte de esa historia está del lado de Ciudad Juárez, como me di cuenta al hablar con la mujer del museo. Así que sigue la ruptura. Por eso le pregunté a ella si hay comunicación entre ambos.

Todavía existe una animosidad tácita, y ahora con el Tratado de Libre Comercio, no sé si va a resultar. Sigue la animosidad, como si los norteamericanos intentaran de nuevo insinuarse en el Segundo Mundo. Esto hay que estudiarlo.

Nosotros simplemente no valemos tanto. Esa es la verdad. Porque tuvieron que quitarnos nuestras tierras. Tuvieron que quitarnos lo que teníamos. Teníamos que vendérselas o no más nos mataban y se apoderaban de ellas. Todavía vivimos con esa herencia. Todavía tiene vigencia. Pero nos convertimos en los hijos. Nos educamos y empezamos a aprender acerca de esta historia y los presionamos. Presionamos a los hijos de ellos.

[Nuestra historia] no se enseña en los cursos escolares. Tenemos que luchar. Nos da rabia y nos sentimos defraudados y descartados. Es el racismo institucionalizado lo que los llevó a tomarlo todo y esto ha sucedido recientemente. La herida sigue abierta, sigue allí. Ha sucedido dentro de este siglo, dentro de los últimos noventa años [las últimas dos generaciones].

Por ejemplo, podemos enfocarnos en el período entre 1910 y 1920, para ver cómo la Revolución mexicana afectó las tierras fronterizas. Los mexicanos usaban la Revolución como un medio para justificar la expulsión de los anglos y el quitarles todo lo suyo. Y fue entonces cuando llegaron los Texas Rangers y a lo largo de la frontera asesinaban gentes inocentes para crear un clima de terror, para que los insurrectos pudieran ser aprehendidos. Ellos [los Estados Unidos] no creían que fuera una conspiración creada por la gente misma, porque nos tenían en tan baja estima a nosotros como pueblo. "No es posible que estén haciendo esto como movimiento organizado."

[Durante todos nuestros años escolares se nos ha dicho que no podemos hacer ciertas cosas] y les permitimos que nos digan eso, pero no te digas estas cosas a ti mismo. Ocurrió un poco lo contrario en mi caso. Cuando yo salía de la universidad, trataba de conseguir un empleo en una fábrica y no me quisieron contratar. No pude encontrar trabajo. Fue mi personalidad. Parecía un joven con muchos problemas y preocupaciones, pero no era cierto, así me criaron simplemente. Así que no pude encontrar empleo. Solicité en la Ford Motor Company y los ferrocarriles Santa Fe. Iba a ser vendedor, pero no pude hacer eso. Mejor regresé a la escuela.

Por suerte asistí a la Universidad Estatal de California en Long Beach. Eramos dos. Fuimos juntos y llenamos los formularios. Yo tenía miedo, pero decidí hacerlo. Y me di cuenta de la educación que me faltaba cuando llegó el momento de tomar apuntes en las clases. Esto nos remite a la razón por la que nuestros hijos no aprenden la historia de la frontera, tal vez porque algunos de los anglos temen que hicieron algo malo—apoderarse de la tierra y utilizarla para prosperar. Veo el desarrollo que hay a lo largo de la frontera, la maquinaria, los tractores, las casas bonitas—éste es el legado nuestro.

Es necesario [enseñar la historia mexicana y chicana] porque le brinda a la gente una conciencia de su ubicación, su identidad, la continuidad de ser quienes somos. Porque ya la generación joven ni sabe quién fue César Chávez ni por qué lucharon los trabajadores agrícolas ni cómo evolucionaron estas luchas.

Cuando se enseña esta historia, también hay que enseñar qué hacer con la ira, porque habrá ira. Yo la sentí mucho, pero tenía apenas unos 25 años. Pero un joven que todavía se identifica con la ira y ve el racismo al revés—todo eso tiene que ser parte del curso. Es muy controvertido.

Tenemos que canalizar esta ira, no deshacernos de ella. Otra vez, es lo mismo que dejar de ser pecador. ¿Y cuál es el pecado? Yo sé que esto parece un poco traído de los cabellos, pero es como cambiar tu vida—es difícil. La ira es una emoción humana espontánea y nos mueve no sólo a destruirnos sino también a cambiarnos. Y eso es subversivo.

Aun el deseo de enseñar esa historia, lo horrible que es esa historia, es necesario porque no emigramos desde el sur hacia el este. Aquí estábamos. Y estamos aquí todavía. Se nos impusieron las fronteras.

[Los conflictos entre pandillas es un reflejo de] la cultura norteamericana. Ese es su origen. Es la perversión de la competición. En ciertas de sus formas, es la perversión del espíritu de competencia norteamericano. La gente compite unos contra otros. En el caso nuestro, se combina con la poca autoestima y la identidad de no ser anglo, la identidad de no ser de esa raza "superior", combatiendo por un terreno que ni siquiera es tuyo.

También es la moda, la perversión total. Es el último grito, lo indispensable. Por mucho que nos horrorice lo que sucede con nuestros hijos, hay una excitación que la gente prefiere pasar por alto. No quieren mencionar que es emocionante.

He visto a veces en los noticieros como alguien que ha presenciado un hecho horrible sonríe mientras lo relata. Es muy extraño. Se ponen eufóricos. Y esas cosas que nunca comentamos, esos conceptos que se ocultan bajo la superficie. Para los muchachos es algo que les llena la vida de emoción, el ser retado y saber que tal vez mueras tú hoy o muera tu amigo el día de mañana.

Te sientes más conectado a la vida en lugar del idealismo de seguir en la escuela y empeñarte y luchar con los libros con la esperanza de que todo eso rinda fruto. Ellos ven que no necesariamente rendirá ese fruto, que faltan las oportunidades. Sin articularlo lo captan. Los muchachos son muy listos. Ven más allá de lo que vemos nosotros. Cuanto más aprendes, más se ofuscan las cosas, pero en un cierto nivel—se ve claro.

Apéndice B: Murales escolares

Además de los murales ya enumerados, vale la pena mencionar varios más que se encuentran en las escuelas, ya que ha proliferado el interés en esta forma artística que existe en El Paso desde hace tantos años.

En las bibliotecas de dos escuelas se encuentran pinturas hechas por Audley Dean Nicols (1886-1941), un artista profesional de la localidad. Poco después de que la Preparatoria Austin abrió sus puertas, en 1930, Nicols creó un mural de una escena montañosa. En 1925 fue comisionado por el First National Bank de El Paso para pintar un mural, de 4 por 16 pies, del perfil de la ciudad según se aprecia desde la esquina de las calles Montana y Trowbridge. Seth Orndorff adquirió la pintura después de que cerró el banco, en 1931, y dos años más tarde lo obsequió a la Preparatoria El Paso.

La Preparatoria Bowie cuenta con una abundancia de murales en todo su recinto, pintados por artistas y estudiantes de nuestra ciudad. La tradición fue iniciada por Ernesto P. Martínez en 1975. Posteriormente, el instructor de arte José Olivas siguió pintando murales junto con sus estudiantes. Gaspar Enríquez, con sus propios estudiantes, ha continuado la tradición, pintando murales deportivos en el gimnasio de las mujeres, ensanchando su repertorio más recientemente con murales realizados con botes de pintura aerosol en las canchas de frontón de mano. Estas obras ejemplifican claramente lo que pueden lograr los instructores talentosos que trabajan con afán y creatividad al enseñar esta técnica artística.

Se pintaron dos murales en la cafetería de la Preparatoria Ysleta en 1976-77 bajo la supervisión del instructor de arte Richard Holguín. En 1981, Holguín dirigió la creación de un mural de 9 por 120 pies, ubicado al lado del laboratorio de composición (Write Place) en el segundo piso y dedicado al aprendizaje. Se les permitió a los estudiantes que pintaran imágenes populares de la época. Otro mural, realizado en el edificio de matemáticas en 1990, quedó recubierto de pintura al ser remodelado el edificio en 1992.

En 1981, los estudiantes de la Primaria Alamo, en el sur de El Paso, produjeron un pequeño mural en el patio de la escuela, una escena típica del Sudoeste con indios pueblo.

En 1991, algunos estudiantes de la Preparatoria Austin pintaron, en el segundo piso del plantel, su propia escuela y, en el fondo, las montañas Franklin. Entre los participantes estaban: Jesús Alva, Frank Camacho, Víctor Carreón, John Castañeda, Jay Guerra, Zandra Fierro, Adriel Lozano, Frank Rodríguez, Ben "GeJoe" Rodríguez, John Pacheco, Pete Santiago, Ron Winkelman, Edgar Rodríguez, Jethro Armijo, Eva Richie y Louis Martínez. Después siguieron otros murales en esta escuela.

En 1992, el artista e instructor de arte Armando Villalobos, y uno de sus estudiantes, pintaron en el gimnasio de la Preparatoria Irvin, en el noreste de El Paso, el lanzamiento de un transbordador espacial. Adornan el recinto escolar numerosos obras pintadas por estudiantes, las cuales ostentan diversas versiones de su nave mascota.

La pintora y educadora María Natividad, y varios de sus alumnos de la Primaria Del Norte pintaron, en mayo de 1993, una obra que mide 5 por 15 pies intitulada *Celebremos la historia norteamericana*. El mural, realizado con acrílico sobre madera, ilustra los diversos documentos históricos—la Constitución, la Declaración de Derechos, el Tratado del Chamizal—además de la bandera y mapas de los Estados Unidos y figuras recortadas de niños. Los artistas, de once y doce años de edad, fueron Gabriel Macías, Andy Castillo, Fide Rivera, Alex Gallardo, George Hernández, David González y Antonio Alcántar. La obra fue exhibida en el Chamizal National Memorial de junio a septiembre de 1993.

En el verano de 1993, Al Díaz, instructor de arte en la Preparatoria Hanks, y sus estudiantes pintaron un mural de 20 por 90 pies en la cafetería intitulado *Visiones del tiempo, lo que fuimos, somos y seremos*. Participaron en este proyecto Sandra Alba, Xóchitl

Araujo, Greg Berglund, Jennifer Brehm, José Bustillos, Erick Estrada, Jesús Luna, Michelle Montoya y Richard Vega, supervisados por el mismo Díaz y la instructora de arte Teri Yasger.

En 1994, Emilio Quiroz, artista y subdirector de la Primaria Scotsdale, pintó varios murales. Hay dos escenas marinas en la cafetería, uno de 7.5 por 35 pies y el otro de 9 por 17 pies. Para agregar otra dimensión al espacio, los arquitectos de la escuela diseñaron olas formadas por telas colgantes para crear un efecto submarino. Quiroz fue asistido por sus estudiantes Verónica Loy, Ruby Quiroz y Cristina V. Ramírez. En 1995, Emilio puso los últimos toques a unos paisajes desérticos para la biblioteca.

En 1993, el Grupo de Extensión Pro Arte de la Preparatoria Parkland, bajo la supervisión de Eva Kutscheid, pintó dos murales de las montañas Franklin a los dos lados del Ace Drive-In Grocery, ubicado en la avenida Quail (159 en el Apéndice A). Al año siguiente, crearon murales en las paredes de varios salones de clase, y luego hicieron otros en el sector noreste, incluyendo seis sobre temas multiculturales en el Parque Nations-Tobin.

El artista y maestro Steve Beck y sus estudiantes del Colegio Comunitario de El Paso trabajaron de septiembre a diciembre de 1993 pintando un mural de 15 por 30 pies en una cancha de frontón de mano en el recinto Valle Verde (171, Apéndice A). La pintura del muro este está dedicado a James De Cracker, empleado desde hacía mucho tiempo en el colegio y un aficionado al jazz. Representa el espíritu africano del jazz: tres niños que observan a un grupo de músicos representan falta de comprensión del jazz, la contemplación y apreciación genuina de la música, y la pobreza y la carencia cultural que imperan en la sociedad contemporánea. En el muro oeste, realizado de septiembre a diciembre de 1994, está Nuestra Señora del Monte Carmel de Ysleta, la misión más antigua de Texas. La obra está hecha en tonos de blanco, negro y azul para impedir que se descolore con la intensa luz solar y fue diseñada para repeler el calor radiado por el asfaltado, que habría desteñido la pintura.

Durante el verano de 1994, Roberto Dozal, asistido por su colega, el maestro Porfirio Garza, pintó un mural de 8 por 24 pies en la Escuela Intermedia Eastwood. La obra, sin título, está conformada por seis paneles, cada uno con su tema: "La ciudad", "la tecnología", "el futuro", "la tierra", "el mar" y "el aire". Dozal, un artista consumado, tardó dos semanas en terminar el mural.

En 1994, la Junior League de El Paso patrocinó "Murales en los tranvías". Para este proyecto se les invitó a estudiantes de varias escuelas en los distritos de El Paso, Ysleta y Socorro y el Centro de Empleos David L. Carrasco a que pintaran murales para la El Paso-Juárez Trolley Company. Entre los participantes de la Preparatoria Burges se cuentan: Eric Aguilar, Omar Contreras, Darío Farina, Kati Hammukaiman, Ben Matera, Vanessa Pacheco, David Rojas, Adam Rosas, Claudia Sepúlveda y Paul Villia, con sus maestros de arte Ethel Burns y Leilani Calzada. El estudiante Sergio Sáenz y sus maestros, Miguel D. Carrasco y José Silva, representaron al Centro de Empleos. De la Preparatoria Hanks participaron Steve García, Jesús Luna, Jr.,Rosa Erica Martínez, Rosa L. Pérez, Robert Reyes, Tiffany M. Tomberlin y Gene White, junto con los maestros de arte Al Díaz, Bruce Lee y Teri Yasger. Los estudiantes de la Preparatoria Socorro fueron Adrian Arellano, Diana Corral, Nancy Escamilla, Sinai Flores, José Luis Girón, Claudia Hernández, Robbie Jones y Miriam López, con su maestra, Dolores Dueñez.

El resumen anterior no abarca toda las actividades relacionadas con la pintura de murales en las escuelas de esta área, pero sí demuestra el gran interés que existe en este campo. Los distritos escolares locales están haciendo listas de todos los murales que se encuentran en sus escuelas. No cabe duda de que el muralismo en las escuelas del área de El Paso persistirá hasta bien entrado el siglo XXI.

Apéndice C: Otros murales

Además de los murales catalogados en los Apéndices A y B, hay varios otros que merecen mención especial por lo que se refiere a la historia local y la importancia de los artistas.

T. J. Kittilsen

1917: *Col. Alexander W. Doniphan at El Paso, Cabeza de Vaca Trading With a Manso Indian, Meeting of Mexican President Benito Juárez and Gen. James H. Carleton of the California Rifles, Apache Indians Attacking a Stagecoach West of El Paso, Coronado Seeking the Seven Cities of Cíbola, Arrival of a Pioneer Caravan at the Juan María Ponce de León Ranch* y otros dos.

Ocho murales sobre lienzo de T. J. Kittilsen estuvieron en exposición en la Corte del Condado de El Paso durante cuarenta años antes de ser retirados en 1957, durante la renovación del edificio. El vestíbulo del edificio, donde estas obras habían estado, fue rediseñado y resultó demasiado pequeño para volver a exhibirlos allí. Estaban basadas en temas sugeridos por el Mayor R. F. Burges.

Seis de estos murales se encuentran actualmente en la colección del Museo de Arte de El Paso.

Edward Holslag

1922: *The Buffalo, The Indians, The Pioneer, In the Beginning, The Ysleta Mission, The Burro, The Roundup, The Smelter, The Rio Grande* y *The Mountains.*

En 1922, James G. McNary, presidente del First National Bank of El Paso, le encargó a Edward Holslag, de Chicago, pintar para el banco una serie de diez paneles, de 6 por 10 pies cada uno, basados en dibujos hechos por la Sra. McNary. Al quedar terminadas las pinturas, el banco publicó un folleto, *Southwestern Milestones,* con poemas escritos por el autor local Owen P. White, que acompañaban a fotografías de las pinturas. El banco se cerró en 1931, y posteriormente los murales fueron adquiridos por la familia de Lee Orndorff, antiguo director del banco.

Durante la década de los cincuentas, uno de los murales fue exhibido en el Centro Estudiantil de la Universidad de Texas en El Paso. Otros dos fueron prestados por los herederos de Lee Orndorff al Aeropuerto Internacional de El Paso, donde pueden apreciarse al pie de las escaleras móviles.

Aldo Lazzarini

1949: *El Paso del Norte/The Pass of the North*

Este mural, que mide 26 por 7 pies, pintado por Lazzarini, oriundo de Milán, Italia, fue develado en el Grill Room del Hotel Paso del Norte en marzo de 1949. El pintor había estudiado en Italia y París antes de llegar a los Estados Unidos en los años veintes. Pintó numerosos murales para hoteles y compañías navieras. Este mural fue pintado sobre un lienzo adherido a la pared. Aparece fotografiado en un librito acerca del hotel (ahora el Hotel Camino Real), "Under the Dome—Footsteps Through History" (1989).

Hal Marcus

Estas óleos sobre lienzo se encuentran en la colección del artista:

1975: *My World, My Life, My Friends*

1988: *El mercado,* asistido por Fernando Flores, Sergio Villanueva, Paul Seitz y Susi Davidoff

1990: *Avenida Juárez*

1992: *Plaza de los Lagartos/El Paso Navidad,* asistido por Fernando Flores y Sergio Villanueva

1993: *El Paso Gracias a Dios*

1994: *Children of the Sun*

1995: *Peace Corps*

Marcus depende de su herencia árabe-judía y de la comunidad de El Paso en su arte. Asistió a la escuela preparatoria Coronado, donde estudió arte con Lupe Casillas-Lowenberg.

Bassel Wolfe

Tres murales sobre lienzo, cada uno aproximadamente 5.5 por 7.5 pies fueron pintados en 1990, 1992 y 1996 para el restaurante Jaxon's, Airway Boulevard #1135, con el tema *The History of El Paso*. El patrocinador fue Jack Maxon.

Wolfe ha enseñado dibujo de la forma humana en San Francisco y dibujo y diseño en la Universidad de Texas en El Paso. Ha recibido varios premios por sus obras, las cuales están en exhibición en colecciones en el Oriente, Europa y Norteamérica.

Apéndice D: Jesús Helguera

Las pinturas de Jesús Helguera han sido, desde hace mucho tiempo, fuente de inspiración de los artistas chicanos y mexicanos. Llegaron a conocerse en gran medida a través de reproducciones de almanaques. Las imágenes de Helguera, vinculadas a las leyendas mexicanas, celebran la herencia y la identidad de este país, así que no es de extrañar que, cuando los muralistas novatos empezaron a buscar temas más allá de la Virgen de Guadalupe, hayan recurrido a las obras de Helguera. Sus imágenes han influido, además, en artistas chicanos contemporáneos como el escultor Luis Jiménez, en su *Southwest pietà*, una versión estilizada en fibra de vidrio de uno de los temas más famosos de Helguera.

Helguera nació el 28 de mayo de 1910, en la ciudad de Chihuahua.[81] Treinta días después, su familia se trasladó a la Ciudad de México. Fue bautizado en la Iglesia de San Cosme con el nombre Jesús Enrique Emilio de la Helguera Espinosa. Cuando el pequeño Jesús cumplió los dos años, su familia se mudó a Córdova, Veracruz.

A la edad de siete años, el artista se separó de su familia para ir a España, donde su talento artístico se despertó en la escuela primaria.[82] A la edad de nueve años, fue puesto a cargo de su clase de arte, y pintó murales que evocaron las aventuras de don Quijote. También ilustró lecciones de historia y mapas, sin que se le dificultara la escala de estas obras.[83]

Terminados sus estudios primarios, fue a vivir con sus abuelos en Madrid. A los 14 años se matriculó en la Academia de Bellas Artes de San Fernando. Se le concedió una beca como paisajista en la residencia del gobernador español en la provincia de Segovia. Ganó un premio de exhibición que le permitió estudiar en Granada, en La Alhambra. Con el tiempo, Helguera ganó varios premios más, incluyendo el premio Círculo de Bellas Artes. En España estudió con Cecilio Plá, Moreno Carbonero, Manuel Benedicto y Julio Romero de Torres. Con frecuencia visitaba el Museo del Prado, en Madrid.[84]

Después de terminar sus estudios, Helguera fue contratado por la Editorial Araluce in Barcelona para ilustrar colecciones como *Los grandes hechos, Los grandes hombres, Páginas brillantes de la historia, Colección folklórica seleccionada de todas las razas y de todos los pueblos* y la revista *Estampas y Blanco y Negro* y otras publicaciones.

Cuando comenzó a enseñar en el Instituto Miguel de Unamuno de Bilbao, en San Fernando, sus colegas le decían "el niño". Influyó en muchos estudiantes, y ganó reconocimiento en toda España. En Granada conoció a la madrileña Julia González Llanos, quien se convirtió en su esposa y modelo e inspiración para muchas de sus pinturas. Tuvieron dos hijos: Fernando y María Luisa.

Durante la Guerra Civil española, la familia pasó tiempos difíciles porque Helguera no pudo ganar mucho dinero. Por añadidura, sus hermanos Luis Felipe y Fernando pasaron mucha hambre y por lo tanto desarrollaron problemas de salud. Helguera regresó a México mientras el general Lázaro Cárdenas repatriaba a los ciudadanos mexicanos.

En 1985, el yerno de Helguera, Ismael Popoca Salas, en un catálogo de exhibición, describió así el regreso de su suegro: "Con un tostón en el bolsillo, llegó a la Ciudad de México y estableció su residencia en un hotel frente a la estación San Lázaro. Visitó la oficina de la revista *Sucesos Para Todos* y presentó sus dibujos y cartas de referencia. Los propietarios no creyeron que un hombre tan joven pudiera haber pintado tales obras, y así le dieron la tarea de crear una ilustración para entregar al día siguiente. El joven Helguera regresó a su hotel y a la luz de una vela hizo su obra. Al día siguiente volvió a la revista y fue contratado en el acto."

Durante los fines de semana Helguera viajaba por todo el país estudiando la historia y la cultura mexicanas. Estas investigaciones serían la base de sus pinturas de imágenes del México precolombino y colonial. Muchas de sus obras fueron influidas por el estado de Veracruz. Consciente de que muchas de sus obras serían reproducidas mediante una impresión "offset", utilizó colores muy vivos. Durante este período muchas de sus pinturas

aparecieron en almanaques, llegando a ser bastante conocidas.

Hacia finales de 1940, Helguera pintó su famosa *Leyenda de los volcanes*, basada en la mitología azteca. Esta serie fue adquirida por la editorial LITOLEOSA, que desde 1941 hasta los años ochentas la introdujeron en millones de hogares mexicanos.[85]

La leyenda de los volcanes es un mito nahua sobre Izcozauhqui, hijo de Tonatiuh, el Sol, y Coyolxauhqui, hija de Metztli, la Luna. La pareja se enamoró y fue castigada por los dioses por haber visitado la tierra. A ambos les encantó la tierra, pero Coyolxauhqui se enfermó y murió. Izcozauhqui, por el intenso amor que sentía por ella, permaneció a su lado. Los dioses se conmovieron al ver su devoción y, para que los amantes pudieran estar juntos para siempre, los convirtieron en piedra y los cubrieron de nieve. La leyenda continúa: "En la lengua náhuatl, ella se conoce como Iztaccíhuatl, la mujer de nieve o la mujer dormida, y él se llama Popocatépetl, la montaña humeante.[86]

Millones de personas en todo el mundo han visto Volcanes, y esta obra ha sido copiada por muchos artesanos en cerámica, piedra, metal y empleando otras técnicas.

Helguera falleció el 4 de diciembre de 1971 en la Ciudad de México, a la edad de 61 años. En 1985, el Instituto Nacional de Bellas Artes patrocinó en el Palacio de Bellas Artes una exhibición de 26 pinturas suyas realizadas para la Cía. Cigarrera La Moderna. Después de permanecer allí del 21 de noviembre de 1985 al 26 de enero de 1986, fue trasladada a Chihuahua, Tijuana, Monterrey, San Antonio y León, Guanajuato.[87]

Miguel "Mike" Juárez, Jr., es un historiador de las artes culturales y nació en El Paso. En 1985, se tituló en periodismo por la Universidad de Texas en El Paso e hizo estudios de posgrado en administración de arte y estudios investigativos chicanos en la Universidad Estatal de California en Dominguez Hills y en museología en la Universidad Estatal de California en Long Beach. Con su colega, el artista Paul H. Ramírez, organizó "Juntos 1985, Primera Exhibición de Arte Hispánico", precursora de la Asociación de Arte Juntos. Juárez ha coordinado docenas de exhibiciones de arte comunitario y lecturas. De 1985 a 1989, fue integrante del Texas Regional Planning Committee for Chicano Art: Resistance and Affirmation (CARA). Su poesía, prosa, obras de arte y fotografías han aparecido en numerosas publicaciones en Texas y California. Ha enseñado historia del arte en el Instituto Tecnológico y de Estudios Superiores de Monterrey (ITESM) en Ciudad Juárez, en calidad de investigador visitante, mediante el Programa de Estudios Internacionales del Colegio Comunitario de El Paso. Juárez es miembro de la Asociación para la Historia Oral del Sudoeste (SOHA) y del Comité para el Multiculturalismo de la Asociación de Historia Oral nacional (OHA).

Cynthia Weber Farah, fotógrafa y escritora, tiene su Licenciatura en ciencias de la comunicación de la Universidad Stanford y su Maestría en literatura de UTEP. Su libro de semblanzas de autores del sudoeste, *Literature and Landscape: Writers of the Southwest*, ganó el Premio C. L. Sonnichsen, otorgado por Texas Western Press, y un premio Southwest Book Award, presentado por la Border Regional Library Association. Desde 1987, la señora Farah ha sido integrante de la mesa directiva del El Paso Arts Resources Department y fue miembro de la mesa directiva del Texas Committee for the Humanities y del consejo consultivo del Harry Ransom Humanities Research Center de la Universidad de Texas en Austin. En 1991, fue galardonada con el Conquistador Award, el premio de mayor prestigio otorgado por la ciudad de El Paso, por su contribución a las artes. En 1992, ingresó al Salón de la Fama de las Mujeres Paseñas. Actualmente es instructora de estudios cinematográficos en la Universidad de Texas en El Paso.

Notes/Notas

1 Maren Jannette Wilson, unedited transcript of UTEP Mural Conference, November 2, 1992, p. 1.

2 *Memories of Chicano History: The Life and Narrative of Bert Corona* (University of California Press, 1994), 341.

3 *El Paso Then and Now*, p. 17.

4 *El Paso in Pictures* (The Press, El Paso, Texas, 1971), 10.

5 *The Course of Mexican History* (Oxford University Press, 1983), 343.

6 Ibid, p. 342.

7 *El Paso in Pictures* (The Press, El Paso, Texas, 1971), 11.

8 *The Course of Mexican History* (Oxford University Press, 1991), 442.

9 *El Paso in Pictures* (The Press, El Paso, Texas, 1971), 25.

10 *A Short History of South El Paso* (The City of El Paso Department of Planning, 1976) lists El Paso's South side churches as: the First Mexican Baptist Church at Fourth and Kansas streets established in 1890, the Mexican Congressional Church south of Fourth Street and Kansas established in 1899, Sacred Heart Church on South Oregon Street established in 1893, the Presbyterian Church at Fourth and Hills streets established in 1912, the Methodist Episcopal Church and Mexican Commuity Center on South Campbell Street established before 1900, and later moving to Park Street in 1919, El Mesais Church which served as the church for Lydia Patterson Institute at 505 Florence in 1913 and St. Ignatius Church which opened in 1905.

11 *The Course of Mexican History* (Oxford University Press, 1983), 501.

12 *Occupied America: A History of Chicanos* (Harper and Row Publishers, 1988) 147.

13 *Memories of Chicano History: The Life and Narrative of Bert Corona* (University of California Press, 1994) 33.

14 *Southwestern Milestones* (El Paso: First National Bank, 1922).

15 Carol Ann Price, *Early El Paso Artists* (Texas Western Press, 1983), 51.

16 "Select Mural of E.P. Artist: Work of Tom Lea Jr., To Adorn Federal Courthouse Wall, *El Paso Times*, 23 April 1937, 2:4.

17 Drawings from some of his mural projects were included in a retrospective of his work at the El Paso Museum of Art in spring of 1994. In 1995, Texas Western Press published *Tom Lea, An Oral History*, edited by Adair Margo and Becky Craver. The book chronicles his life and his work.

18 "Western Scene Painted for Borger Post Office," *El Paso Herald-Post*, 26 January 1939, 3:2.

19 "El Paso Artist Paints Mural for Texas Post Office," *El Paso Herald-Post*, 14 November 1939, 9:2.

20 *Nosotros* magazine, 1 January 1987, 6.

21 See obituary, *El Paso Times*, 17 August 1968.

22 Esther Thompson Cornell, "The El Paso Centennial Museum, 1935 to 1946." *Password* (Spring 1981): 21-22.

23 Telephone interview with James M. Day, 17 August 1993.

24 Cornell, 22.

25 Gertrude Goodman: "Tribute to Manuel Gregorio Acosta." *Password* (Spring 1985): 21-26

26 "Artist from El Paso Assisted Peter Hurd in Painting Mural for Texas Western Museum." *El Paso Times,* 11 November 1954, 10-B:1.

27 *El Paso Times,* 13 July 1958, 1-B:1.

28 Goodman, 23.

29 *Las Cruces Sun-News*, C-5, shows a photograph of Frank O. Papen, chief executive officer of the bank, standing in front of the mural in the bank lobby.

30 Goodman, 23.

31 Bertha Rodriguez, "Mural on Project Wall Keeps Graffiti at Bay," *El Paso Times,* 26 January 1986.

32 Interview with the Mr. and Mrs. Francis Fugate, 3 July 1988

33 Ibid, 227.

34 Interview, 27 July 1995.

35 Ed Curda, "La Campaña Opposes EP Grant," *El Paso Times,* 30 March 1978.

36 *Memories of Chicano History: The Life and Narrative of Bert Corona* (University of California Press, 1994), 276. According to Bert Corona, "while Chicanos represented about eight to twelve percent of the population of the Southwest, we were twenty-two percent of the war casualties from the region. We were also about sixteen to eighteen percent of the armed forces. A clear and unfair discrepancy existed between our representation in the population and how we were being used as cannon fodder. Together with blacks, Native Americans, and Asian-Americans, Chicanos and other people of color of the country were damn near half of the casualties and half of the armies."

37 Interview with Ignacio "Nacho" Acosta, 27 July 1995.

38 Listed in the project proposal were: Soledad Olivas; Rita Chávez; Raul Valdespino; Oscar Lozano; Daniel Solís; Carmen Rios; Maria Arellano; community representatives Prof. Homero Galicia; Felipe Peralta; Attorney Daniel Anchondo; Dr. Julian Rivera; Nina Cordero; Hector Bencomo, Director of Project Bravo Southside; Manuel Pallanez, Director of Bravo Southside; the Rev. Frank Gafford; and the Rev. Tomas Parra.

39 Murales del Movimiento Chicano: Chicano Murals and Discourses of Art and Americanization," in Eva Sperling Cockcroft, Holly Barnett-Sánchez, Shifra Goldman, Tomás Ybarra-Frausto, and Marcos Sanchez-Tranquilino, *Signs From the Heart: California Chicano Murals* (SPARC: Social and Public Art Resource Center, 1990), 62.

40 Interview 12 July 1988.

41 Ramon Renteria, "Struggle of Barrio Life Reflected in Mural," *El Paso Times,* 21 November 1975.

42 Ernesto P. Martinez, "My Artistic Tribute," *Palette Talk,* Number 36 (1977): 10.

43 Personal interview, 9 June 1993.

44 Work no longer exists.

45 Interview 18 July 1988.

46 For an extensive interpretation of prison art and symbolism see *Paño Art: A New American Folk Art, Handkerchief Art* (Albuquerque: Paño Arte Project/Youth Development, Inc., 1991) and *Imagery in Motion: Prison Envelope Art, 1992-94* (Long Beach, Calif.: Homeland Neighborhood Center, 1994).

47 "Mural Honors Woman Who Helped Forge La Fe Clinic," *El Paso Times*, 23 August 1991.

48 Maren Jannette Wilson, unedited transcript of UTEP Mural Conference, November 2, 1992, p. 7.

49 In the exhibit catalogue for "The Pachuco Era" (UCLA Department of Special Collections, 1990) Dan Luckenbill writes: During this period [the forties and the early fifties] the Andews Sisters recorded "Zoot Suit," with its jitterbug rhymes: reet pleet, stuff cuff, and drape shape. From the

beginning the zoot fashion was reported negatively. In 1942 *Newsweek* wrote that Harlem was the "breeding ground" where "the disease appeared." Young Mexican Americans adopted the style, which they referred to as being "draped out." They maintained the style longer than did others. They added distinctive speech, body movement, and body adornment. These young persons were known as pachucos, the style having originated in El Paso, which is called Chuco in the patois they used.

50 Interview 27 May 1988.

51 For a listing of early Chicano mural themes, see Shifra Goldman, "How, Why, Where, and When It All Happened: Chicano Murals of California," in *Signs From the Heart: California Chicano Murals*, ed. Eva Sperling Cockcroft and Holly Barnett-Sanchez (Albuquerque: University of New Mexico Press, 1993).

52 "History On Walls With Art—In South El Paso," *El Paso Times*, 12 October 1975.

53 Salazar was born in Cd. Juárez and grew up in El Paso. He studied journalism at Texas Western College (now UTEP), served in the military, and returned to complete his degree in 1954. He worked for the *El Paso Herald-Post* before moving to Los Angeles where he joined the staff of the *Times*. He covered the Vietnam War, the U.S. intervention in the Dominican Republic in 1965, and became the newspaper's bureau chief in Mexico City. In 1968 he returned to Los Angeles and wrote a column about the Mexican-American community. Two years later, he became news director of KMEX, a Spanish-language radio station, while continuing his popular front-page column. He was covering the National Chicano Moratorium on the Vietnam War, which was organized to protest the disproportionately large number of Spanish-surname deaths in Vietnam, for both the *Times* and KMEX at the time of his death. What had started as a peaceful rally by 25,000 people ended with thirty-five dead, dozens wounded, and dozens more arrested. The officer who fired the canister that killed Salazar was never charged in the death.

54 Her posters include "Celebrate Chicano Poetry" (1994, El Paso Community College); "Inauguration of the El Paso County Courthouse (1992); commemorative for Maestro Abraham Chávez, El Paso Symphony director, 1963-1992 (1992); "Festival de la Zarzuela" (1991); Nureyev, (1988, El Paso Symphony Orchestra); Juntos 1987; National Association for Bilingual Education Conference (1987, Denver); Texas Teachers of English Speakers and Other Languages (1986); Adelante Mujer Hispana (1985); Kermezaar (El Paso Museum of Art, 1979). She has exhibited in El Paso, Cd. Juárez, and Las Cruces and her work has appeared in numerous magazines, newspapers, and books.

55 *El Paso Times,* 10 May 1989.

56 *El Paso Herald-Post,* 8 May 1989.

57 In 1988 Farah and I had begun documenting the city's murals. Because of my absence in 1989 to attend graduate school, I did not participate in the work of committees that developed Los Murales, although I kept in close communication with Farah and the artists involved.

58 Interview with Carlos Callejo, 2 June 1993.

59 Ibid.

60 *Los Murales: Guide and Maps to the Murals of El Paso* (El Paso: 1990).

61 *El Paso Times,* 27 March 1991.

62 Ho Baron, a sculptor has created and placed his work , which is frequently associated with "primitive" and "outsider" imagery, around his home in the Manhattan Heights District. His pieces resembling primitive figures such as the Chac Mool and other images are cast in concrete, resins, and bronze. The artist has exhibited extensively in the Western United States and in Cd. Juárez.

63 *El Paso Times,* 21 August 1991.

64 They included Olivas Aoy, the founder of school, Dr. Ray Gardea, one of the founders of Clinica La Fe, the late El Paso City Council Representative Tony Ponce, Felipe Gallegos, Rossas' stepfather and assistant on the Entelequia mural, Lucy Acosta from LULAC Project Admistad, Carlos Villanueva, a film maker who attended Aoy School, Farm worker's leader Cesar Chávez, and Joe Silva Sr., founder of the Grocer's Association in El Paso and owner of Silva's Market in South El Paso.

65 For a discussion on the politics of images and processes of making community murals see "Enemies Within and Without, Pressures to Depoliticize Community Murals" by Tim Drescher in *Reimaging America*, p.148-153.

66 Martínez's uncle Felix Martínez from Durango was accused of being a Cristero and was shot in front of a firing squad. In the 1926 Cristero Rebellion in Mexico, President Plutarco Elías Calles deported foreign priests and nuns and closed church schools, monasteries, and convents.

67 The Medici family known as the House of Medici, bankers subsidized the arts during the Renaissance. Under Lorenzo the Magnificent's patronage and support, Florence became the jewel of the period.

68 José Vasconcelos (1882-1946) was part of the group Ateneo de la Juventud who formulated the philosophical idea of "positivism." Vasconselos was later appointed as the Minister of Education under President Alvaro Obregón. As Minister of Education in post-Revolution Mexico he created educational and health programs and employed Mexican artists to such Diego Rivera, David Alfaro Siqueiros, José Clemente Orozco and others to paint murals in public buildings.

69 Gandara's students kept diaries of their experiences in creating the mural.

70 The Unite El Paso Congress was a community effort to unite the varying segments of the community and present a new vision for El Paso. The congress included members of the community from all areas. Critics of the project charged that because of the rising El Paso Hispanic demographics, Unite El Paso was just another interest group organized for their own purposes.

71 South El Paso youth group.

72 The El Paso Arts Alliance, a now defunct non-profit group in the city was created to organize the El Paso Street Festivals, which were held starting in 1981 with the Four Centuries '81 celebration.

73 According to Chihuahuita Historian Arturo Morales the wall above Villalva's Grocery is one of the few locations, if not the only building in South El Paso which has several bullet holes from the Mexican Revolution.

74 Born in Guadalajara, Mexico in 1875, Gerardo Murillo Cornadó (1975-1964) changed his name to Dr. Atl in 1911. "Atl" means "water," the source of life in Nahuatl, the Aztec language. Dr. Atl taught at the Escuela National

Preparatoria in Mexico City in the early 1900s. José Clemente Orozco and Diego Rivera were among his students.

75 Aaron Piña Mora has painted murals on the first and second floors of the Federal Government Building in Chihuhuahua City, Mexico, in a hotel in Delícias and in Mora, New Mexico. In prior years, the artist exhibited with Diego Rivera in Mexico City. Piña Mora lives in Allende, Mexico.

76 The Brewhouse, today an artist complex was the former Falstaff Brewery.

77 NovaColor Paints, Culver City, California.

78 Format recommended by Dr. Timothy Drescher. Similiar to format in his book *San Francisco Murals: Community Creates Its Muse, 1914-1994* (Pogo Press, 1994), 69.

79 Valadez went on to create another spectacular mural at the new Federal Courthouse in Santa Ana, Calif.

80 "Students' Mural to 'Save the Planet' Brightens Overpass," *El Paso Times*, 29 March 1992.

81 Chihuahuan artists have historically held ties to Cd. Juárez and El Paso.

82 Ismael Popoca Salas in "Bosquejo Biografico de Jesus Helguera," catalogue of exhibit of Helguera's work, 1984, Instituto de Bellas Artes, p. 5.

83 Ibid.

84 Ibid, p. 6.

85 Ibid.

86 Biographical sketch of Jesús Helguera based on his biography by Osmael Popoca Salas, in Voices of Mexico (July/September 1992): 77.

87 Ismael Popoca Salas in "Bosquejo Biografico de Jesus Helguera," catalogue of exhibit of Helguera's work, 1984, Instituto de Bellas Artes, p. 11.